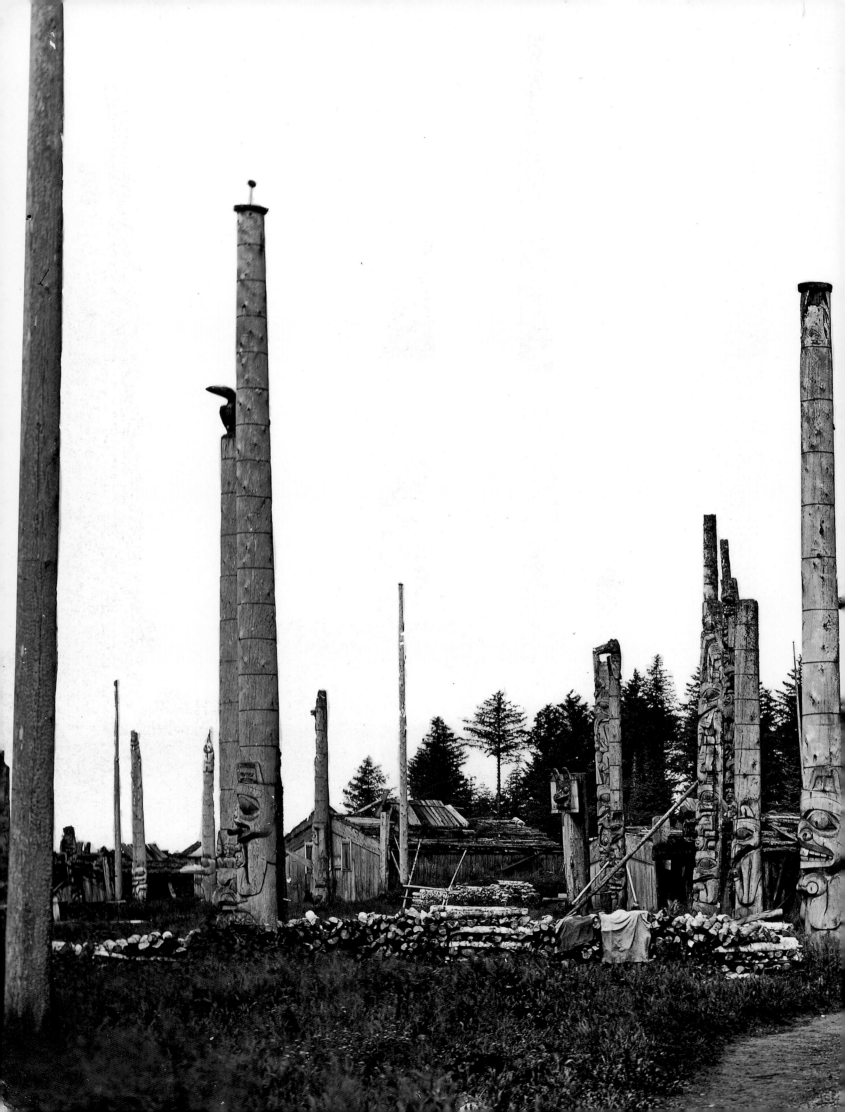

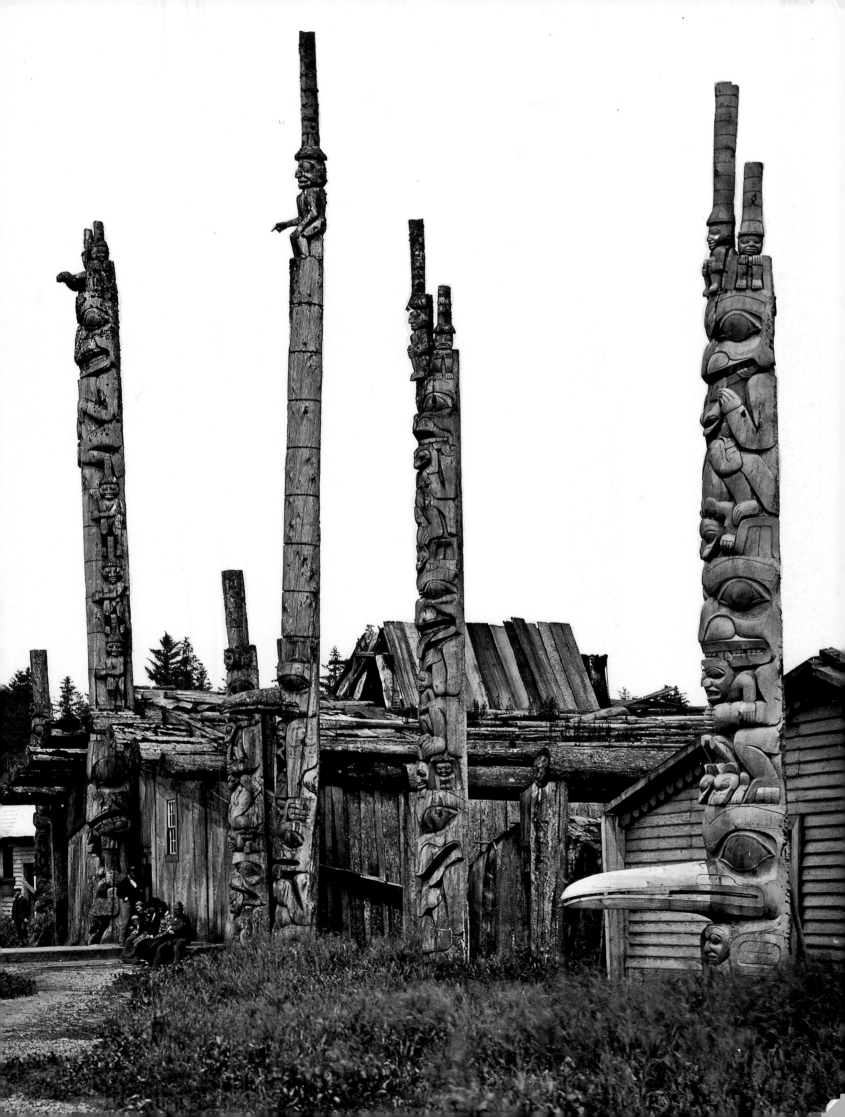

From the Land of the Totem Poles

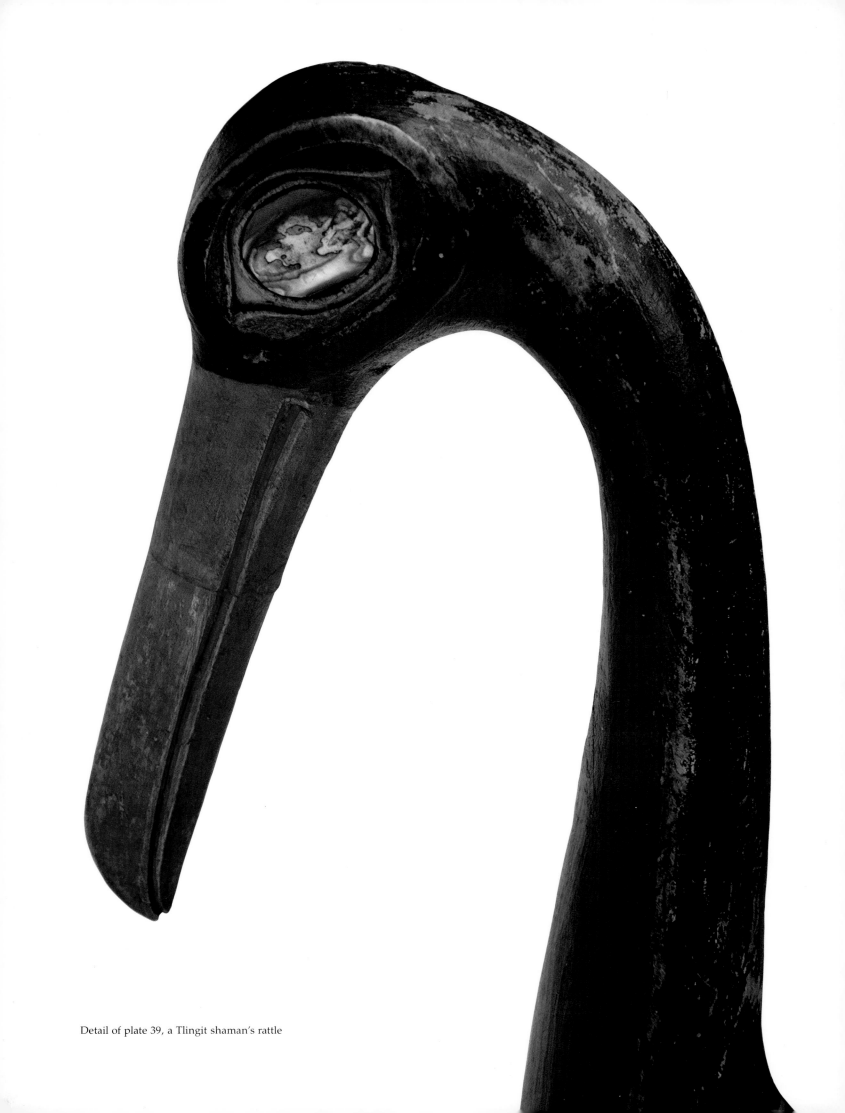

Detail of plate 39, a Tlingit shaman's rattle

From the Land of the Totem Poles

The Northwest Coast Indian Art Collection at the American Museum of Natural History

Aldona Jonaitis

Color photographs by Stephen S. Myers

American Museum of Natural History *New York*

University of Washington Press *Seattle*

Douglas & McIntyre *Vancouver/Toronto*

To Jesse and Ethan

This book is published with the assistance of a grant from the National Endowment for the Humanities, a federal agency.

University of Washington Press, PO Box 50096, Seattle, Washington 98145-5096.

Douglas & McIntyre, 2323 Quebec Street, Suite 201, Vancouver, British Columbia, v5T 4S7.

The Library of Congress and Canadian Cataloging-in-Publication Data will be found at the end of the book.

Unless otherwise stated, the historical photographs are in the possession of the American Museum of Natural History, and all negative numbers in the black-and-white figure legends refer to that institution's photograph archives.

The paper used in this publication meets the minimum requirements of American National Standard for Information Sciences—Permanence of Paper for Printed Library Materials, ANSI z39.48-1984. ∞

Endsheet illustrations: Front: Haida village of Masset.
Back: Kwakiutl village of Newetti. *Dossetter photographs,* 1881. 44309, 42298

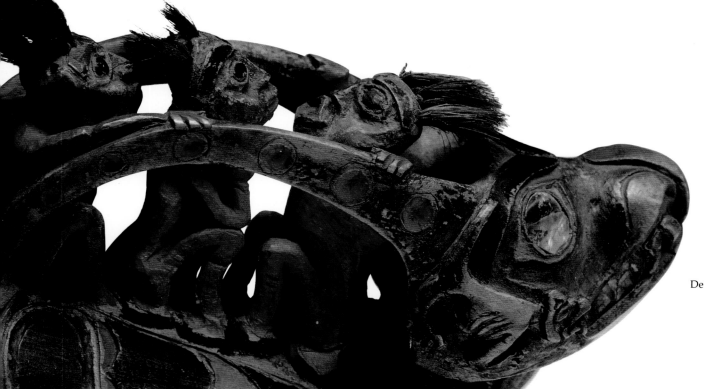

Detail of plate 39

Contents

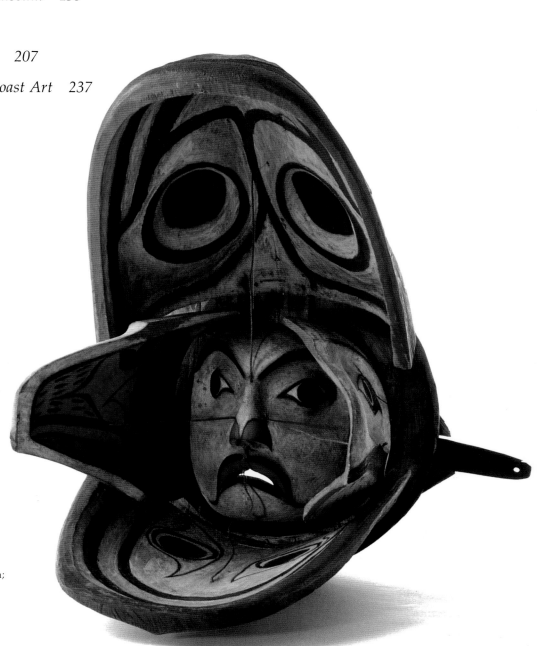

Kwakiutl articulated mask in fully open position;
see plate 79 for closed and partially open
positions

Illustrations

Color plates

Black and white figures

Map

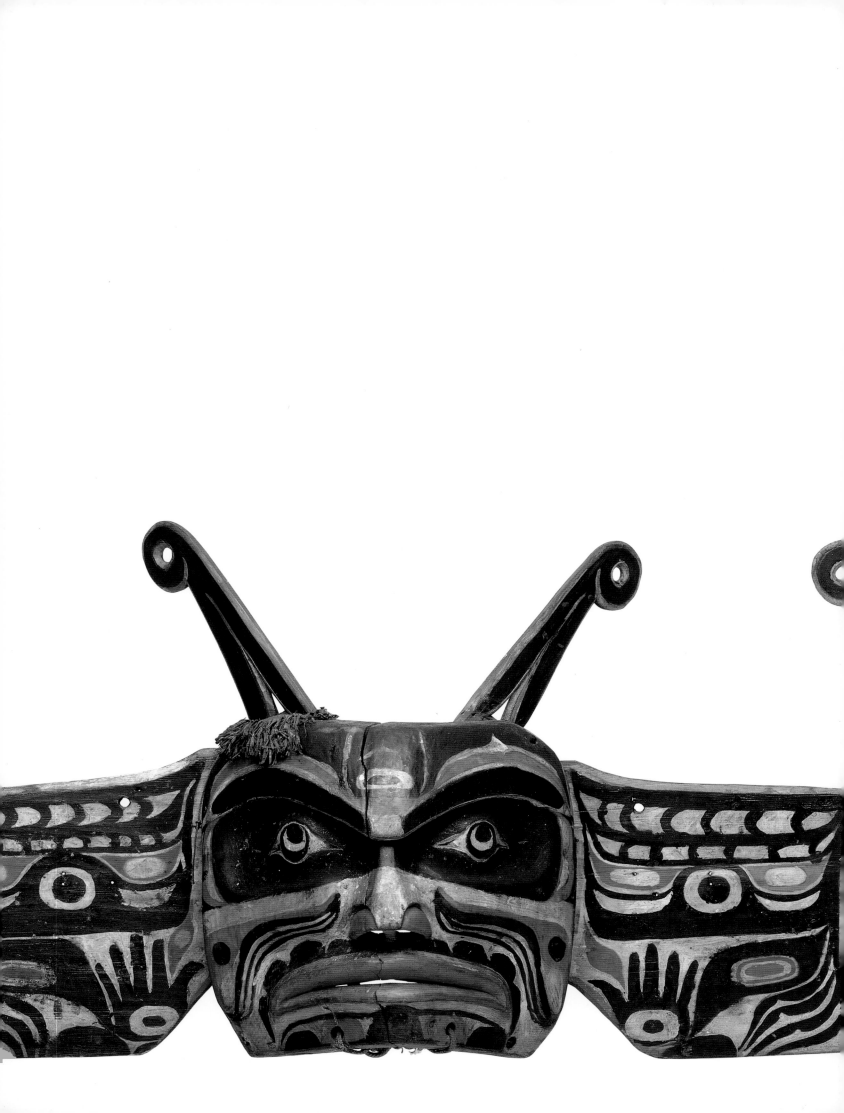

Foreword

THE American Museum of Natural History possesses the finest collection of Northwest Coast Indian art in the world. Although many pieces from our collection have been featured in books and catalogues on Native American art, until now no single publication has concentrated on the Museum's Northwest Coast holdings. I am pleased to see *From the Land of the Totem Poles* fill this lacuna in the literature.

The idea for the book came to us from Aldona Jonaitis, a historian of Northwest Coast art, and in her proposal we recognized the opportunity to familiarize the public with our great Northwest treasure. A generous grant from the National Endowment for the Humanities enabled us to proceed with the project. We are also very fortunate to be able to reproduce here Steve Myers' beautiful photographs of the Museum items that Dr. Jonaitis selected for her work.

From the Land of the Totem Poles is far more than a collection of handsome photographs of rare art treasures, however, although it certainly is that as well. Nor is it strictly a survey of the meaning and function of the illustrated artworks. This book also tells of the interconnections among people of different cultures who made our fabulous collection possible: the Northwest Coast Native Americans who created and used these artworks in their ceremonials and in their daily lives; the collectors and anthropologists who traveled to what were in the late nineteenth century the remote regions of British Columbia and Alaska; and the Museum trustees and the philanthropists in New York City who provided the funds necessary to acquire these pieces. It is a fascinating tale.

Thomas D. Nicholson
Director

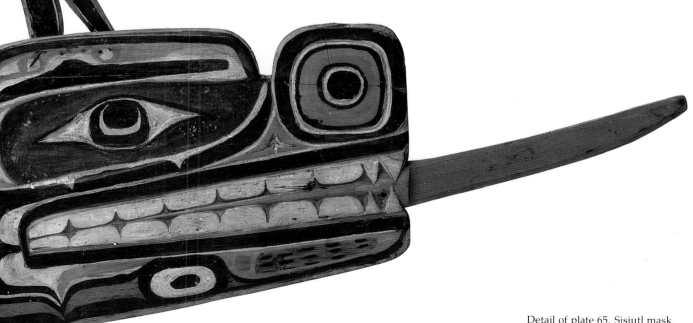

Detail of plate 65, Sisiutl mask

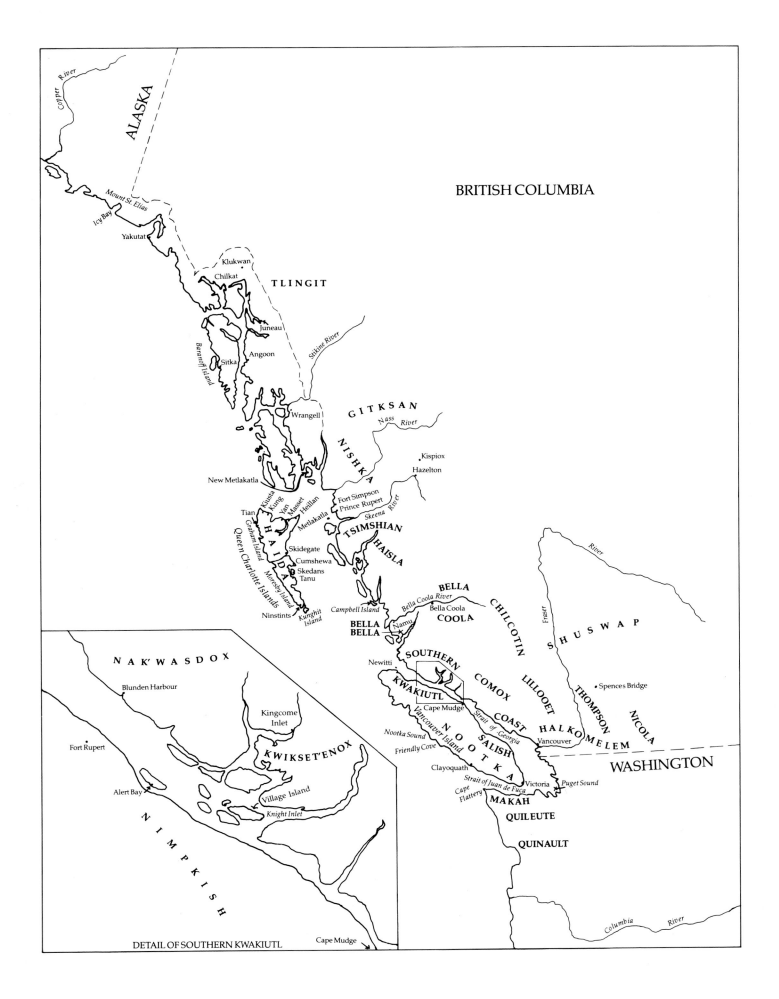

BRITISH COLUMBIA

ALASKA

Copper River

Mount St. Elias
Icy Bay
Yakutat

Klukwan
Chilkat
TLINGIT

Juneau

Baranof Island

Sitka

Angoon

Stikine River

Wrangell I

GITKSAN

Nass River

NISHKA

Kispiox
Hazelton

New Metlakatla

Kiusta
Kung
Yan
Masset
Heillan
Tian
Metlakatla

Fort Simpson
Prince Rupert

Skeena River

TSIMSHIAN

HAISLA

HAIDA

Queen Charlotte Islands

Graham Island

Skidegate
Cumshewa
Skedans
Tanu

Moresby Island

Ninstints

Kunghit Island

Campbell Island

BELLA

Bella Coola River

Bella Coola

COOLA

CHILCOTIN

Fraser River

SHUSWAP

Namu

BELLA
BELLA

SOUTHERN

Newitti

KWAKIUTL

Cape Mudge

COMOX

LILLOOET

Spences Bridge

THOMPSON

NICOLA

COAST

Strait of Georgia

HALKOMELEM

Vancouver

Vancouver Island

N O O T K A

SALISH

Nootka Sound
Friendly Cove

WASHINGTON

Clayoquath

Strait of Juan de Fuca

Victoria
Puget Sound

Cape
Flattery

MAKAH

QUILEUTE

QUINAULT

Columbia River

NAK'WASDOX

Blunden Harbour

Kingcome Inlet

KWIKSET'ENOX

Fort Rupert

Alert Bay

Village Island

Knight Inlet

N I M P K I S H

DETAIL OF SOUTHERN KWAKIUTL

Cape Mudge

Preface

LIKE many New Yorkers, I frequently spent rainy Saturday afternoons of my youth wandering the cool marble corridors of the American Museum of Natural History. Although I found the dinosaur skeletons impressive and the dioramas interesting, what fascinated me most was the Hall of the Indians of the Northwest Coast, with its immense Haida Indian dugout canoe, forest of totem poles, and cases filled with miniature ivory shamans' charms. This art, simultaneously complex and minimal, at once undecipherably abstract and hauntingly naturalistic, appealed to my taste in a way the art across Central Park in the Metropolitan Museum never could.

The luxurious surface relief, the vivid intense coloration, and the stylized humans, birds, fish, and mammals that adorned these totem poles, ivory charms, and other Northwest Coast Indian carvings and paintings on display in the Museum seemed to me exotic. With the assistance first of museum labels, then of guidebooks, and later of extensive reading on this subject, I came to understand the highly symbolic style that represents an impressive array of mythic beings of both human and animal form. Rather than naturalistically modeled and correctly proportioned images, here were abstracted beings with the conventionalized eyes (large, with pinched corners) and eyebrows (long, inverted Vs) that appeared consistently on almost every piece of art. Perspective was absent in the paintings and shallow relief carvings of animals and humans whose bodies seem to have been flattened out and stretched in order to lie flat and also to fill every surface they decorate.

This art style, created during the nineteenth century and even before by Indians living on the misty shores of coastal British Columbia and Alaska, spoke to me so clearly that by the time I was an adult and embarking upon a career in art history, I decided to dedicate my scholarly investigations to learning more about the art that had touched me as a girl. To do this properly, I had to go to the region in which this exquisite art had been produced. I visited first the cosmopolitan city of Vancouver, surrounded by snow-capped mountains, and then ferried across the Strait of Georgia to the lovely city of Victoria, situated on an unusually sunny southeast corner of Vancouver Island. Pleasurable as I found these sophisticated cities, I really wanted to experience the natural environment that had nurtured the culture of the Northwest Coast Indians.

So I boarded a ferry sailing northward along the "Inside Passage," a waterway that stretches from Puget Sound to the Alaskan panhandle, weaving between the indented mainland shores and coastal islands, passing spectacular fjords. Lying between 3,000-meter-high mountains descending precipitously to the sea and innumerable islands facing the Pacific, this ferry route offered natural views of extraordinary splendor. The mild, moist climate caused by the Japan Current guaranteed a luxuriant growth of evergreen forests, predominantly fir, hemlock, and cedar, which mask the rocky slopes. Bald eagles, as common here as pigeons in a city, perched atop dead trees and scanned the water for a sign of salmon. Tiny white specks moving above the treeline turned out to be sure-footed mountain goats which seem capable of climbing the steepest cliffs and leaping over the widest chasms. Everything on the Northwest Coast seemed exaggerated.

The ferry landed for a few hours at a small cannery town, leaving me some time for a stroll through the misty evergreen forest. Mosses covered the floor beneath the lacy foliage of the immense red cedars and other conifers, enshrouding the living tree trunks and rotting branches alike with soft spongy green. Spanish moss drifted from boughs, shuddering at any small breeze. The perpetual gray of the sky blended with this jungly growth and momentarily carried this modern city dweller into a surreal world. My reverie ceased on reaching a weed-infested clearing where some lumber company had clearcut an entire forest slope. Even in this magnificent wilderness, humans had made their mark.

After I reboarded the ferry, the ride became rougher as we passed over open ocean on the way to the Queen Charlotte archipelago some hundred kilometers out at sea. It was on one of these remote and fogbound islands that I found totem poles still standing in their original village. Ninstints, a provincial park recently designated a World Heritage Site by UNESCO, is an old Haida village on one of the most southerly of the Queen Charlottes. Approaching this ruin by water, I first saw a line of totem poles along a sandy beach, many at raking angles and some with small evergreen saplings growing at their tops; behind them, buried within the encroaching forest and covered with soft moss appear the skeletons of old plank houses. These poles were ancient cedar remnants of the town's past glories. The frogs, eagles, beavers, and killer whales, carved from wood now devoid of color and deeply split with age, peered toward the water. They almost seemed to be seeking their creators, who abandoned Ninstints in the nineteenth century after a smallpox epidemic decimated the town.

AFTER returning to New York from this trip, enriched and inspired by an environment that seemed mysteriously familiar, I began writing analyses of the symbolic significance of the art made during the nineteenth century by the Tlingit of southeastern Alaska. Much of my research was done in the dusty storerooms of the American Museum of Natural History, which I had by that time discovered held the largest and finest collection of Northwest Coast Indian art in the world. I blithely pursued my scholarly interests until one day an obvious, but previously unasked, question came to my mind: why was it that the most marvelous array of this art was here in New York City, thousands and thousands of miles away from where it was made? Why was it preserved here, not left to rot in sites like Ninstints? How did it get here? When did it come? And who brought it?

These questions seemed as interesting to me as my iconographic analysis of Tlingit art, and I began researching the history of the Northwest Coast collection at the American Museum of Natural History. The pleasurable hours I spent in the Museum's archives revealed to me far more than just an interesting story that occurred during the last decades of the nineteenth and first years of the twentieth centuries. Personalities emerged. There was a noble-visioned, socially liberal millionaire president, Morris Ketchum Jesup, who funded many of the acquisitions. There was a naval lieutenant, George Thornton Emmons, who, when stationed in Alaska, spent long hours paddling about the panhandle, speaking Tlingit with the Indians and removing treasures from shamans' graves. And then there was Franz Boas. Irascible, proud, brilliant, devoted to defeating the racism prevalent at the time, Boas revolutionized anthropology as profoundly as Freud changed psychology, and Marx, economics and history. A passionate commitment to his beliefs, a deep social egalitarianism, and a genuine warmth for those about whom he cared came across clearly in the correspondences filed in the American Museum's archives. I must admit that by the end of my research activities I had become quite smitten by the great Dr. Boas.

The rich history of this collection has broad cultural significance, for it describes the relationships between whites and Indians, some of whom lived on the Northwest Coast, others who lived thousands of miles apart. The story of the American Museum of Natural History's collection of Northwest Coast art tells in microcosm of the several shifts in white perceptions of Indians from a relatively favorable impression during the late eighteenth and early nineteenth century to a more racist attitude at the end of the nineteenth and beginning of the twentieth century. *From the Land of the Totem Poles* will follow the attempts by Boas and others to challenge the prevailing negative stereotypes of their day. Their successes resulted in a gradual shift during the twentieth century in attitudes toward Indians and their art. And today we enjoy the renaissance of Native American culture which includes public-funded projects for totem pole restoration and establishment of heritage sites, and the creation of new, distinctly modern works of Northwest Coast art for native rituals as well as for the commercial art market.

When I now return to the North Pacific Hall at the American Museum of Natural History, I not only appreciate the splendid art produced by an impressive group of Native Americans, I also feel myself in the presence of the fascinating group of people who made this collection possible. Indeed, their spirits pervade the hall. This glorious display is for me now a monument to the interactions among humans from vastly different cultures who treasured these artworks for their beauty, their symbolism, and their eternal magic.

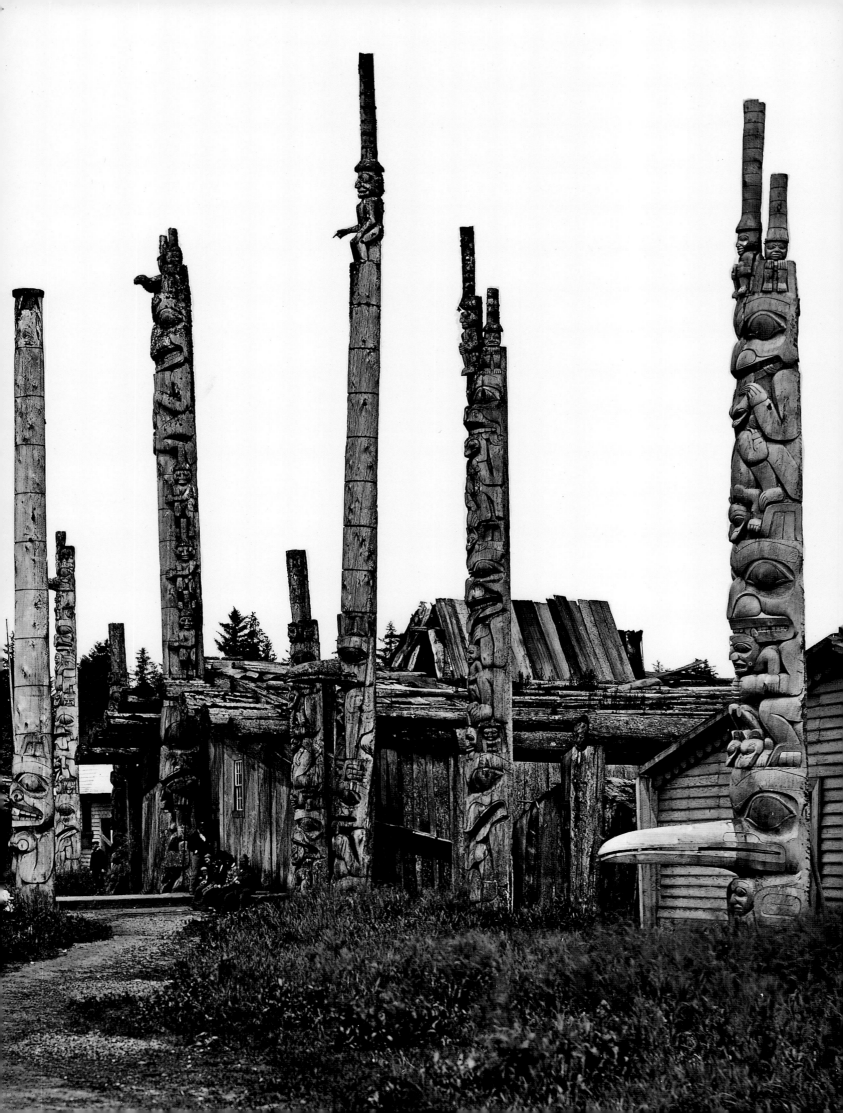

From the Land of the Totem Poles

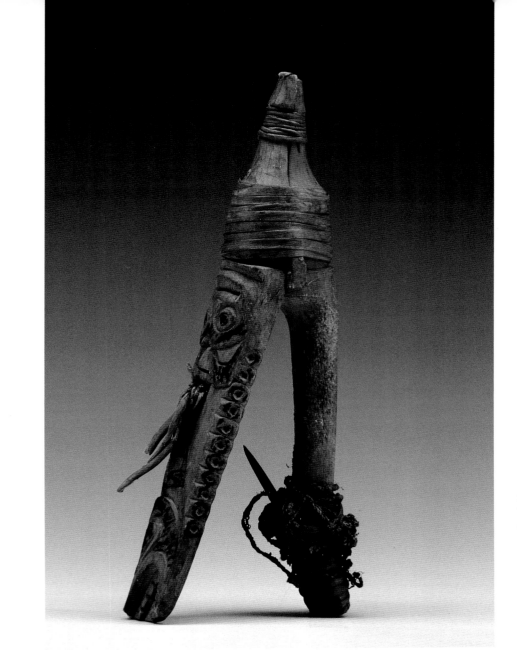

Pl. 1. Tlingit wooden halibut hook with iron barb, decorated with carving of a shark and a devilfish. Chilkat. L 27.5 cm. *Collected by Emmons, 1882–87. 19/1153*

Pl. 2. Tlingit wooden floats for halibut fishing. Angoon. L 33.6 cm. *Collected by Emmons, 1888–93. E/1022, 1023*

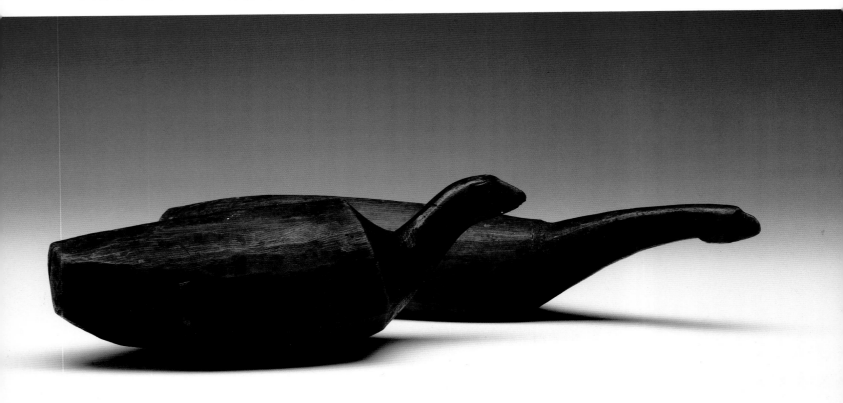

1 / The Meeting of Two Cultures

TWENTY thousand years ago a sheet of ice a thousand meters thick covered the mountainous coastal region where now the cities of Vancouver and Juneau flourish. So much water went into the creation of such massive glaciers that the sea level itself dropped some 150 meters, exposing the shallow ocean floor between Siberia and Alaska. Over this land bridge, now called Beringia, peoples from Siberia crossed to the New World. Although the earliest date for the human habitation of North and South America is still being debated, most experts agree that by 13,000 years ago, Asians had entered the New World.

These newcomers to North America could not settle anywhere they wanted, since immensely thick icefields covered much of what is now Alaska and Canada. They did find some ice-free passages to the south, such as corridors leading through the Yukon Valley and the Brooks Range foothills to the MacKenzie River Valley and the plains east of the Rocky Mountains. By 13,000 years ago, the glaciers that had covered the Northwest Coast region started to melt, and tundra vegetation soon colored the land. In another thousand years forests—first of birch and alder, and later of spruce, hemlock, and especially cedar—covered the coast with lush growth, providing food and cover for the birds and mammals which arrived from more southern regions. Humans followed the plants and animals into this area from the Columbia River north to the Alaskan panhandle and settled along the rivers, streams, and estuaries of the mainland as well as on the myriad islands that form the complex Northwest Pacific coastline.

The glaciers, having not yet completely receded from higher elevations and certain portions of the interior, still held much of the sea icebound. As the ice slowly melted, the ocean level rose. The resulting instability of the estuarine environment prevented shellfish from flourishing, since viable populations of clams, mussels, and oysters can survive only when the salinity and level of bays and inlets remain constant. In addition, anadromous fish found the glacial rivers and lakes unattractive as spawning grounds and thus did not migrate periodically from salt to fresh water as they would later. In order to survive, the early Northwest Coast Indians, living in a region as yet unblessed by abundant salmon and easily harvested shellfish, had to hunt whatever game they could find and gather the vegetables and berries that grew wild. These earliest Northwest Coast Indians probably lived in small, nomadic, and relatively egalitarian bands totally different from their hierarchical and sedentary descendants (Fladmark 1986).

Cultures that resemble ones about which we have ethnographic records began developing around 3500 B.C., when the sea level and the environment stabilized. A shift from an egalitarian to a hierarchical social order occurred in large measure as a result of the increasing reliability and abundance of the anadromous fish runs. At that time, as is the case now, five species of salmon hatched in fresh water lakes and streams of the interior of the Northwest Coast region, descended to the sea during their first year and, after three to seven years in the open ocean, returned in great numbers to their spawning grounds.

To harvest and process the salmon and the other types of fish that were now abundant in the North Pacific waters, the natives devised a technology of fish weirs, traps, dams, nets, spears, hooks, lines, lures, and harpoons. It was presumably at this time that the Indians invented the prototypes of the nineteenth-century hooks and floats for catching halibut (pls. 1, 2), basket traps for smaller fish (pl. 3), and sieves used in the process of rendering the oil from eulachon, or candlefish (pl. 4). So efficient was this technology and so regular the fish run, that now the Indians had a guaranteed adequate and predictable food supply (Stewart 1977). As time went on, archaeologists believe, a relatively small number of extended families came to control the best fishing grounds and as a result became wealthy. This was the beginning of the hierarchical structure that would later characterize the social organization of the Northwest Coast Indian groups (Carlson 1983).

Groups of related people lived together in large communal houses lining sandy beaches. Members of the most noble houses probably occasionally invited other high-ranking extended families to large feasts at which they boasted of their status and gave their guests gifts. These early feasts were in all likelihood the prototypes of what would later become splendid gift-giving and food-consuming rituals— the famous Northwest Coast potlatches. By A.D. 500 the Northwest Coast Indians were living in large permanent villages not unlike those encountered by the first Europeans to explore the region in the eighteenth century (Carlson 1983).

The rich lineages (as we call these extended families) of these early coastal Indians also devised visual means of communicating their wealth and consequent status by decorating their large communal houses with zoomorphic images of family crests. Before A.D. 500, these simple and crude animal depictions barely resembled the Northwest Coast art with which we are familiar, for they lacked the visual complexity, the elegant finish, and the baroque decorative style of the nineteenth-century artwork. However, after A.D 500, artists on the Coast developed a style easily recognizable, antecedent to the one with which we are familiar (MacDonald 1983c).

By the time of the Middle Ages in Europe, the Northwest Coast Indians had developed an elaborate and sophisticated culture. They had invented a fishing technology that allowed them to take advantage of the sea's abundance. Lineages made wealthy by skillful exploitation of these natural resources manifested their rank by displays of art both impressive and refined. When in the late eighteenth century, the first European ships arrived on the shores of what is now British Columbia and Alaska, they encountered Indians quite unlike those they had met anywhere else in the New World. Not only were these status-conscious nobles proud, dignified, and extremely aware of their position, they also evidenced a skill and shrewdness in trading that impressed every European with whom they dealt.

Pl. 3. Nootka fish trap for small fish. Clayoquath. H 39.2 cm, D (base) 24 cm. *Collected by Jacobsen during Jesup Expedition, 1897. 16/1765*

Pl. 4. Bella Coola sieve used in boiling eulachon fish for rendering oil. L 94 cm. *Collected by Boas and Hunt during Jesup Expedition, 1897. 16/1641*

The First Europeans on the Northwest Coast

One day in 1786, twelve years after Europeans began to explore the Northwest Coast region, some Tlingit Indians from the area that is now close to Juneau were paddling their canoes across a bay en route to the source of copper, the Copper River to the north. Suddenly they saw what they believed to be two great birds with white wings at the mouth of the bay. Frightened, they landed and ran for cover, fearing that one of these birds was Raven, a potent spirit that could, like Medusa, turn those who looked at him to stone. To avoid looking at the birds directly, the men rolled up the large leaves of skunk cabbage and used the tubes as telescopes to observe the "birds." One very old man, not fully convinced that confronting Raven would necessarily cause petrifaction, paddled out to the middle of the bay for a close look at these creatures. Instead of turning into stone, this man met his first European on a French ship that was exploring the Alaskan coast.

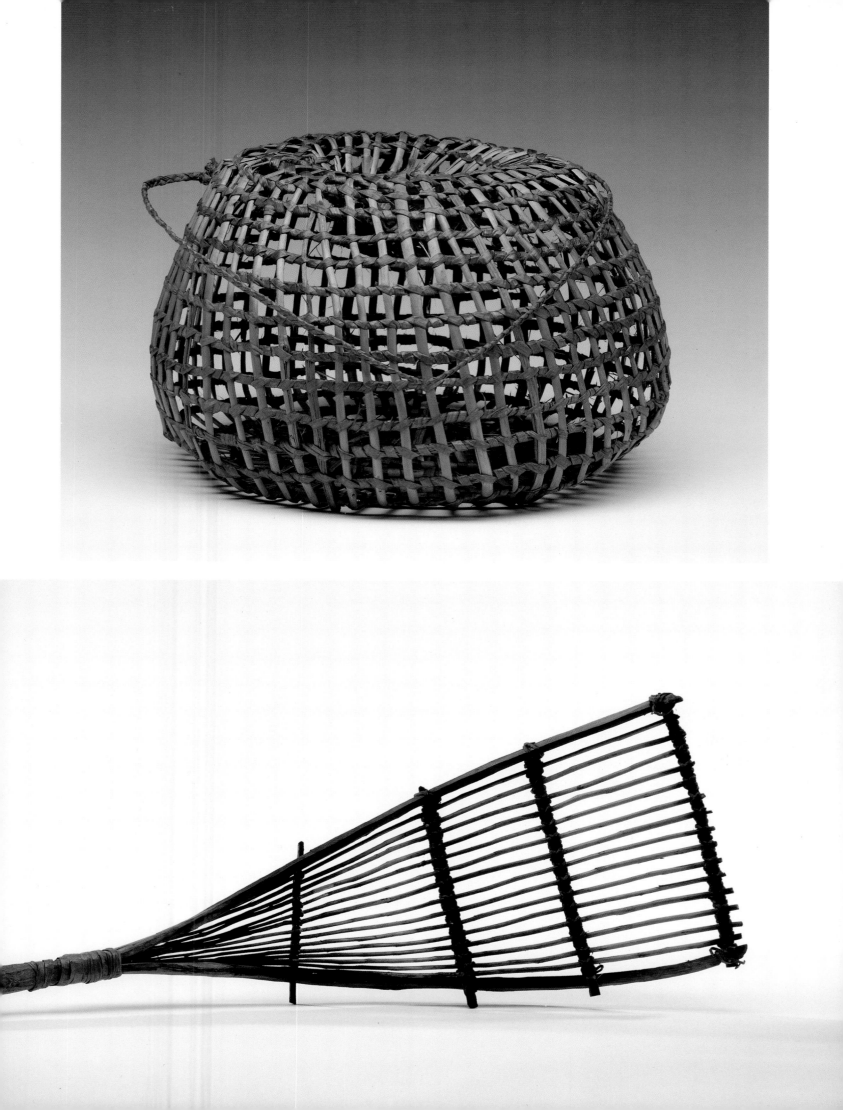

He quickly learned that these whites wanted just one thing from the local residents—sea otter furs, which they could sell for a fortune in China (Emmons 1911).

The earliest Europeans to see the Northwest Coast region were members of the expedition of the Dane Vitus Bering, who explored the Pacific on behalf of the Russians. Since the two boats Bering sent to scout out the area of Cross Sound in 1741 never returned, presumably the victims of an Indian attack, no one on this early expedition lived to describe the Northwest Coast Indians. It was not until thirty-three years later that Europeans—Spaniards on the 1774 voyage of Juan Pérez, sent by the Spanish king from Mexico to explore the coast—actually established contacts with the Northwest Coast Indians, the Nootka.

Pérez anchored in Nootka territory where he stayed for several days. After two more Spanish ships explored the area, Captain James Cook, on his third voyage for England, arrived in 1778 at Nootka Sound (Duff 1964:54–55). Although British, Spanish, American, and French ships all explored these waters in subsequent years, it was the British whose claim to the land south of the 55th parallel ultimately prevailed. The Russians, who sailed the northernmost reaches of the Pacific, claimed the land north of the 55th parallel, and in 1799 established the permanent settlement at Sitka called New Archangel (Krause 1956:30).

During the month Cook spent among the Nootka in 1778, he purchased some sea otter skins. The Indians, who coveted the metal objects of brass and iron owned by Cook and his crew, were willing to part with numerous pelts in exchange for metal. Although Cook died in Hawaii after his stay on the Northwest Coast, his crew traded the pelts in China, where some of the best sold for the then enormous amount of $120 (Fagan 1984:215). The news of fabulous profits inspired others to travel to the Northwest Coast, and soon many ships were making the lengthy voyage to this remote part of the world to buy pelts for the China trade (Vaughan and Holm 1982).

The promise of great wealth from commerce in sea otter furs, what the Russians termed "soft gold," created an active trade. American ships, which were most successful in this endeavor, took approximately 350,000 pelts, mainly from the Nootka and Haida; in return, the Indians received goods estimated at a value of seven million dollars (Blackman 1982:42). The first few years of the fur trade were almost unbelievably profitable for the Europeans, as the Indians eagerly traded their abundant furs for relatively small amounts of the highly prized metal. In 1785, one trader who bartered 560 pelts for metal pieces sold them for $20,000 in China; in 1789, the American John Kendrick traded one iron chisel for each of 200 pelts (Fagan 1984:216).

The whites did not maintain this trading advantage indefinitely, for as soon as the natives realized they possessed a commodity greatly esteemed by Europeans and thus were actually in a powerful bargaining position, they proceeded to display formidable and extremely shrewd trading skills. The Northwest Coast natives, who had first established trade routes for obsidian at least two thousand years earlier and continued to engage in active trade across the mountains as well as up and down the coast, had much experience in driving hard bargains and now applied their talents to dealing with the whites, who found their behavior infuriating. In addition, as the Northwest Coast market became glutted with metals, the resulting decline in the value of iron and brass, coupled with the Indians' increasingly sophisticated bargaining skills, drove up the price of furs considerably by the end of the eighteenth century (Fisher 1977:6–12).

The captains of trading ships had to be increasingly inventive to satisfy the demands of the Indians. For example, Joseph Ingraham, a literate Bostonian and captain of the American brigantine *Hope*, came in 1791 to the Queen Charlotte Islands hoping to exchange iron rods for pelts. The Haida greeted his overtures with indifference, disdainful of the iron pieces that by now were commonplace.

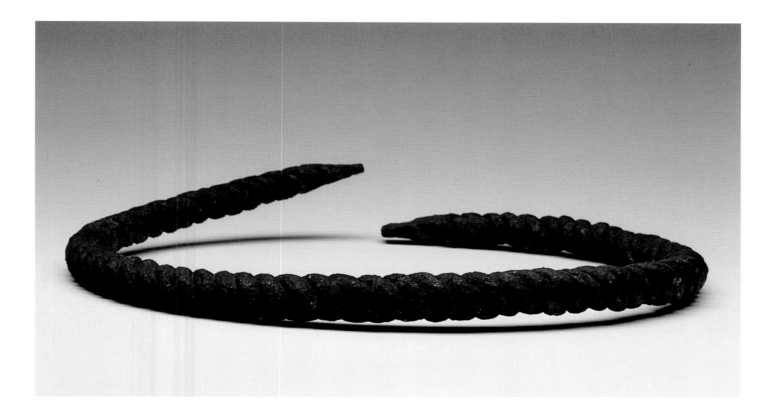

Ingraham noticed that these people held copper necklaces in great esteem and in a stroke of genius asked his blacksmith to fashion his rods into twisted iron collars imitating the native neckrings (pl. 5). Certain powerful individuals eagerly took up these new emblems of social position and soon the iron necklaces, which became fashionable status symbols worn at all the best potlatches, sold for three pelts each. As quickly as these collars became a fad, they went out of fashion, much to the dismay of Captain Ingraham's emulators who filled their boats with like ornaments in hopes of making a killing. A Captain Bartlett, who visited the Queen Charlottes later in the 1790s, offered the Haida iron collars, only to be informed that they would now accept only sheets of copper, valued at five pelts per sheet, in order to make the shield-shaped objects called "coppers," which were given out at potlatches (Gunther 1972:124–36).

Pl. 5. Tlingit iron ring. Angoon. L 35.6 cm. *Collected by Emmons, 1888–93. E/942*

A LTHOUGH during the late eighteenth and early nineteenth centuries few whites settled in the region that became British Columbia, the Russians colonized their territory and established two permanent villages in the region populated by the Tlingit. Unlike the Aleuts whom the Russians found sufficiently timid and tractable practically to enslave, the Tlingit greeted the newcomers to their region with hostility. Since some of them had acquired guns and ammunition through trade with other Europeans, they had especially effective means of dealing with Russian threats to their land. Despite the Indians' aggressiveness, the Russians did establish two settlements in Tlingit territory, New Russia in Yakutat and New Archangel in Sitka. The relationship between the natives and the newcomers was never consistently friendly.

In 1799, the Emperor Paul granted the Russian-American Company a charter, permitting it a twenty-year monopoly over all fur trade in Russian territory in the New World. Alexander Baranov, an independent merchant who had arrived in Alaska in 1791, was appointed manager of the company, thus becoming the most powerful European in Alaska. He had the task of putting down a terrible uprising in the New Archangel settlement that broke out in 1802 when he was in the company headquarters on Kodiak Island. Emboldened by their guns and ammunition purchased from English and American ships, Indians in a large flotilla destroyed the Russian fort at Sitka. Sixty or more canoes came to that village carrying Tlingit from as far north as the Chilkat area and as far south as Stikine, as well as some Haidas. There was even a rumor that three American sailors who had abandoned their ship joined the Tlingit in this bloody battle. Six hundred warriors came from several directions on both land and water in an attack that began at noon and took only a few hours to destroy the fort (Krause 1956:31).

The Tlingit warriors, dressed in armor and wearing heavy helmets depicting animals (pl. 6), reportedly charged through the settlement, imitating cries of their crest animals, shooting the Russians with guns and stabbing them with daggers (pl. 8). Of the handful of Russians manning the Russian-American Company fort that afternoon, all were killed, as were their companions who had been out fishing and berry-picking but rushed back on hearing the commotion. In total, the Tlingit killed 20 Russians and 130 Aleuts and took captive a group of women and children whom they ransomed to Baranov for exorbitant sums (Krause 1956:31).

Baranov, after hearing of this massacre, became obsessed in his desire for revenge, and in 1804 sent four ships with 120 Russians and 900 Aleuts to Sitka Sound. There his fleet met the *Neva*, a large, intimidating warship sent by the Russian government to assist him. After a short fight, the Russians reasserted their dominance over the Indians. In 1808 the Russians moved their center of administration from Kodiak to Sitka so that Baranov, a man who inspired considerable fear among the Tlingit for his strength and bravery, could make his presence felt (de Laguna 1972:166–76; Khlebnikov 1976).

To commemorate this peace, Baranov presented the Sitka chief with a special brass hat that he had had made to order in Russia (pl. 9). This remarkable object was a metal copy of a common type of Tlingit hat made of basketry (pl. 10), painted with the crest of the family that owned it, and surmounted with a series of basketry rings that indicated the number of times it had been worn at potlatches. In an unusual display of sensitivity to Tlingit culture, Baranov replicated in an extremely valuable medium an object of high value; his bestowal of this prestigious object upon a defeated chief can be interpreted as a gesture of honor (Emmons n.d.).

As the only white settlers on the Northwest Coast, the Russians posed a continual threat to the sovereignty of the Indians. Although the British and Americans who traded for sea otter furs did not remain for any lengthy periods on the Northwest Coast, they still were not immune to Indian hostilities, for the natives often retaliated fiercely for real and perceived insults on the part of the white traders.

In 1789, American John Kendrick, captain of the *Lady Washington,* became incensed over some minor pilfering aboard his ship by some Haida of Ninstints village. These Haida, it seems, had stolen the captain's laundry as it hung to dry on the deck. To punish the "thieves," Kendrick had his men seize and then bind, whip, shear, and strip the Haida chief, Koyah. Being subjected to the kind of degrading treatment usually reserved for slaves resulted in a complete loss of face for the chief; in order to restore his noble status he had to sponsor an elaborate feast. When Kendrick, perhaps arrogantly, returned to the Ninstints area in 1791, Koyah's men boarded his boat and initiated a bloody battle which, to the Haidas' dismay, the Americans won. After this second humiliation of Indians by whites, this region became an unsafe place for ships, since the Haida attacked several vessels, English as well as American, to avenge Kendrick's treatment of their chief (MacDonald 1983b:43–46).

Pl. 6. Tlingit wooden helmet worn during warfare and decorated with crest image of killer whale. H 39.4 cm, D (base) 38.8 cm. *Collected by Emmons, 1888–93. E/1380*

Pl. 7. Tlingit seal skin fighting headdress ornamented with pieces of abalone; represents the ears of a bear. L 92.2 cm. *Collected by Emmons, 1888–93. E/2534*

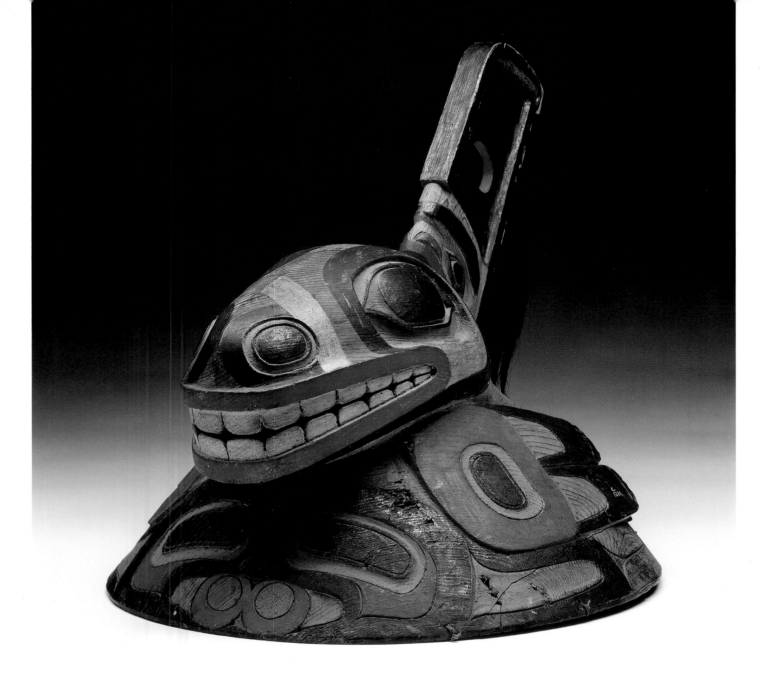

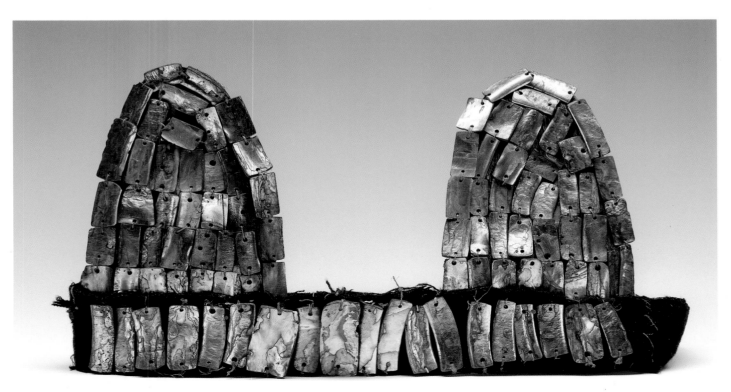

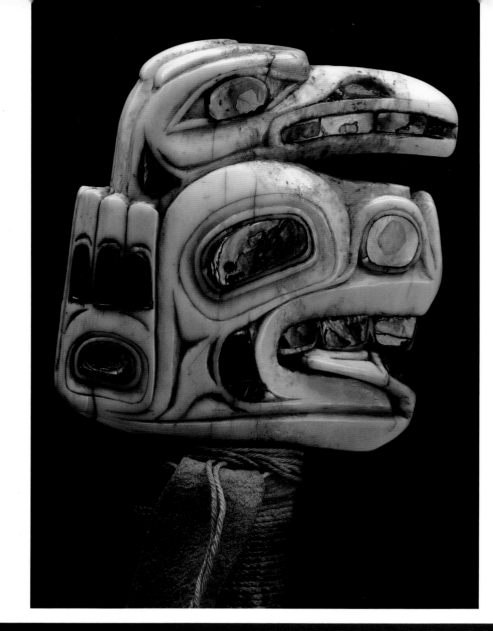

Pl. 8. Tlingit knife, with iron blade, walrus ivory handle inlaid with abalone shell. The handle is carved to represent a brown bear's head surmounted by a headdress depicting a raven. L 45.5 cm. *Collected by Emmons, 1888–93. E/1535*

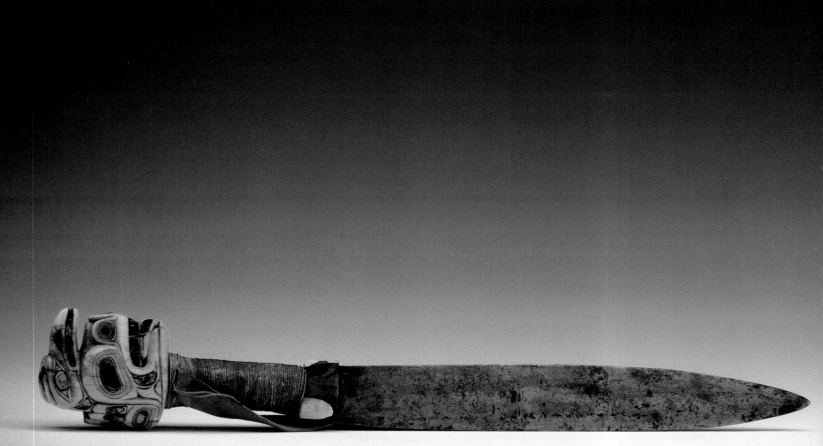

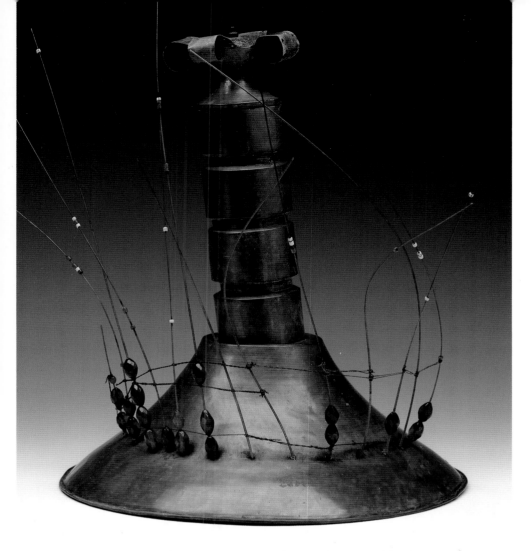

Pl. 9. Tlingit brass hat ornamented with sea lion whiskers and Russian beads. Sitka. H 39.8 cm, D (base) 32.5 cm. This hat, made to imitate the traditional basketry hat, was manufactured in Russia for Baranov, who presented it to Chief Michael of Sitka to celebrate the peace treaty between the Tlingit and the Russians. *Collected by Emmons, 1888–93. E/2308*

Pl. 10. Tlingit spruce root basketry hat topped with ermine fur; the five basketry rings indicate that this hat has been worn at five potlatches; painting on rim depicts crest animal. H 30 cm, D (base) 26.2 cm. *Collected by Emmons, 1882–87. 19/1009*

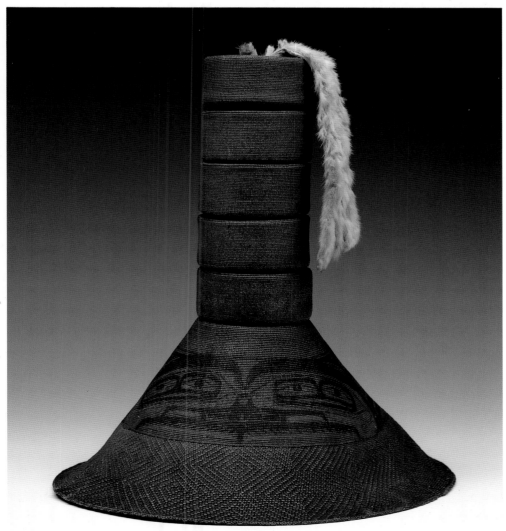

Although many whites perceived the Indians as fierce and untrustworthy, there was at least one contemporary trader who viewed them in a different light. He contradicted another writer who had made negative comments about the Indians:

He ascribes it [Indian violence toward traders] to the treachery and ferocity of the Indians; I, with better opportunities for investigating and ascertaining the truth, find the cause in the lawless and brutal violence of white men; and it would be easy to show that these fatal disasters might have been averted by a different treatment of the natives and by prudence and proper precaution on the part of their civilized visitors (MacDonald 1983b:47).

This was a rare sympathetic view of the Northwest Coast Indians. The more typical white attitude at the time toward the natives was suspicion and arrogance.

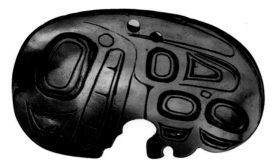

Pl. 11. Kwakiutl abalone nose ornament, incised with design of killer whale. L 6 cm, W 4 cm. This piece was made on the northern Northwest Coast and traded to the Kwakiutl. *Collected by Boas during Jesup Expedition, 1900. 16/8078*

European and American Reactions to the Northwest Coast Indians

The Europeans and Americans had little good to say about the culture of the Northwest Coast Indians. Most whites took little interest in their customs and, indeed, were often disdainful of practices which to them seemed exotic and bizarre. For example, one of the most significant native means of simultaneously expressing friendliness and exhibiting social status was hosting elaborate feasts. In 1792, British Captain George Vancouver and Spanish Captain Bodega y Quadra met in Nootka Sound to negotiate a settlement of their countries' opposing claims to possession of the Northwest Coast lands. To honor their visit, the Nootka chief, Maquinna, invited the two Europeans to a feast at his house. The sumptuous food, prepared by Maquinna's four wives and other female relatives, included fricassees of porpoise, whale, and seal, and other rich and oily creations. Even though Vancouver and Bodega y Quadra knew that Maquinna would be serving an elaborate meal, they had decided beforehand to avoid eating his foreign cuisine and instead brought their own meal, with the Spaniards supplying the food and the British, the drinks. This remarkable arrogance must not have passed unnoticed by the powerful chief in whose culture refusal of food was the grossest of insults (Gunther 1972:50–51).

One offering made by the Indians that traders rarely rejected was a woman. It was not uncommon practice during the sea trade period for Indians to place women at their white visitors' disposal, either as another expression of friendliness or possibly as an accommodation to the Europeans' demands. When in 1792 the Spaniard Jacinto Caamaño refused the offer of some Haida women, "the natives were greatly surprised . . . since they are accustomed to the English and others who trade in these parts, not only accepting, but also demanding, and choosing them." The status of these women is not clear; many might have been slaves whom the chiefs deceptively identified as "noblewomen." At one point Caamaño was offered a woman described to him as the chief's daughter, about whom he wrote in his journal: "she had no tablet in her lower lip and was [thus] quite pleasing in appearance" (Blackman 1982b:42–43). It is likely that the chief duped Caamaño because all women of any significant rank among the Haida, Tsimshian, and Tlingit wore lip plugs (or labrets) from the age of puberty on. In most cases, the only women not to wear labrets were slaves; it is therefore probable that the Spaniard was offered the services of a woman of the lowest social echelon rather than the highest. Like many women throughout the world, northern Northwest Coast women adorned themselves with a variety of ornaments, such as nose decorations (pl. 11), earrings (pl. 12), and labrets (pl. 13) (Jonaitis 1988).

European visitors reacted with disgust to this face ornament worn proudly by northern Northwest Coast women (fig. 1). A French traveler, Jean François de la Pérouse, described the Tlingit women he had seen wearing labrets in 1786:

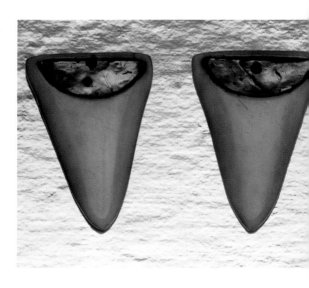

Pl. 12. Kwakiutl shark tooth earrings inlaid with abalone. L 4 cm. *Collected by Powell, 1880–85. 16/657*

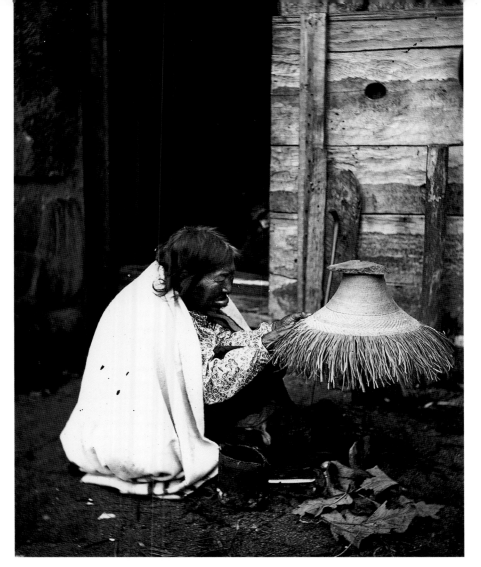

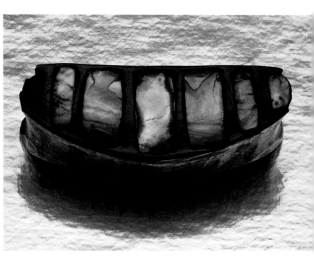

Pl. 13. Tsimshian labret of wood inlaid with abalone. Kispiox. L 4 cm, W 1.4 cm. *Purchased from Emmons, 1914. 16.1/1259*

Fig. 1. Haida woman of Yan, wearing a large labret and weaving a hat. *Dossetter photograph, 1881. 42290*

Fig. 2. Woman wearing a pin in her lower lip. *Smith photograph, 1909. 13960*

Their faces would be tolerably agreeable [were it not for their labrets]. This whimsical ornament not only disfigures the look, but causes an involuntary flow of saliva, as inconvenient as it is disgusting. . . . I could hardly have believed [this custom] had I not seen it. All without exception have the lower lip slit close to the gum the whole width of the mouth and wear in it a kind of wooden bowl without handles, which rests against the gum, and which the slit lip serves as a collar to confine, so that the lower part of the mouth projects two or three inches. . . . This custom [is] the most disgusting perhaps that exists on the face of the earth (de Laguna 1972:123, 433).

Some men asked women to remove these ornaments in order to see what their faces really looked like. The sight of a stretched lower lip with a hole in its middle, hanging limply and exposing the gums, did not enhance a woman's desirability to white men and it was not long before most Northwest Coast women ceased wearing labrets.

The European men who found the labret so repulsive had little interest in why Tlingit, Tsimshian, and Haida women would want to pierce their lips and insert plugs into the holes. A few of them learned that there were two reasons for this custom. Given to a girl at the onset of her menses, a lip plug showed that she was eligible for marriage. It also marked a woman's status, and the most aristocratic women wore the largest plugs. Although white disapproval led women gradually to abandon labrets, which became increasingly rare, the tradition of lip piercing continued among the Tlingit, who replaced the large shelf-like labret with a small silver or ivory pin that, like the large lip plug, communicated to the world its wearer's status (fig. 2) (Jonaitis 1988).

Another practice that created a stir among the European visitors was what seemed to them to be cannibalism. When Captain Cook visited the Nootka he heard stories of horrible feasts of human flesh, and was actually offered for sale "human skulls and hands not quite stripped of the flesh, which they made our people plainly understand they had eaten and, indeed; some of them had evident marks that they had been upon the fire" (Wike 1984:246). In 1786, another British traveler, James Strange, asked to what use he could put the three hands and a head one Nootka offered him. "My hero gave me ocular demonstration, and very composedly put one of the hands in his mouth and stripping it through his teeth, tore off a considerable piece of the flesh, which he immediately devoured, with much apparent relish" (Wike 1984:247–48).

Does all this mean that the Nootka were cannibals? Not everyone today agrees on the answer to that question, for while some believe these people did eat human flesh during ceremonial occasions, others are of the opinion that the whites misinterpreted the Indians. Although most white visitors were quick to believe what they understood to be descriptions of cannibalism, Cook's Lt. Charles Clerke wondered whether the difficulties in communicating with the Nootka, which frequently resulted in misunderstandings and confusions, might have led the English to misread what appeared to be "motions seemingly of having eat (sic) the parts from the Heads and Hands" (Fisher and Bumstead 1982:18). In addition, the rarity of eyewitness accounts by Europeans of cannibalism as a regular feature either of ceremonialism or of daily life on the Northwest Coast creates a serious doubt about Nootkan cannibalism. One of Cook's officers, presumably curious as to whether the Nootka really did eat people, tried to persuade an Indian to eat some human flesh in his presence but failed, for no amount of iron and brass would convince the Nootka actually to engage in cannibalistic acts (Fisher and Bumstead 1982:18).

No clear proof exists that cannibalism was a feature of Nootka culture. We do know that in the late nineteenth century several Northwest Coast groups staged elaborate ceremonies during which performers pretended to eat human flesh. These rituals centered about a mythic man-eating monster which was said to possess certain selected men and inspire them to act irrationally. The only way the possessed man could pacify this spirit was by feeding it—by himself eating—human flesh. During these "cannibal dances" young men acted as if they were possessed by the man-eating monster, sometimes pretending to gnaw on skulls and other body parts as well as entire corpses of killed slaves, sometimes rushing up to an observer, pretending to bite a chunk out of his arm. Whites who described this ceremony noted that the Indians used well-conceived sleight-of-hand tricks and ingenious mechanical devices to fool the audience into believing that the possessed dancer was really eating human flesh (see chapter 5).

Both cannibalism (or the perception of cannibalism) and wearing labrets elicited reactions of disgust on the part of the white traders. There was, however, one element of Northwest Coast culture to which these first Europeans and Americans on the Northwest Coast responded favorably: the art. Several early travelers to Nootka Sound commented very positively on the Indians' conical woven hats topped with pear-shaped bulbs and decorated with scenes of whaling (pl. 14). Joseph Ingraham was intrigued by his first viewing of Haida totem poles and commented that he went "to view 2 pillars which were situated in the front of a village . . . they were about 40 feet in height and carved in a very curious manner indeed—representing men, Toads, and the whole of which I thot did great credit to the naturale genius of these people" (Henry 1984:183).

Etienne Marchand, a Frenchman who visited the Haida in the 1790s, had the following to say about their art:

I remark however that the voyagers who have frequented the different parts of the Northwest Coast often saw there works of painting and sculpture in which the proportions were tolerably well observed, and the execution of which bespoke a taste and perfection which

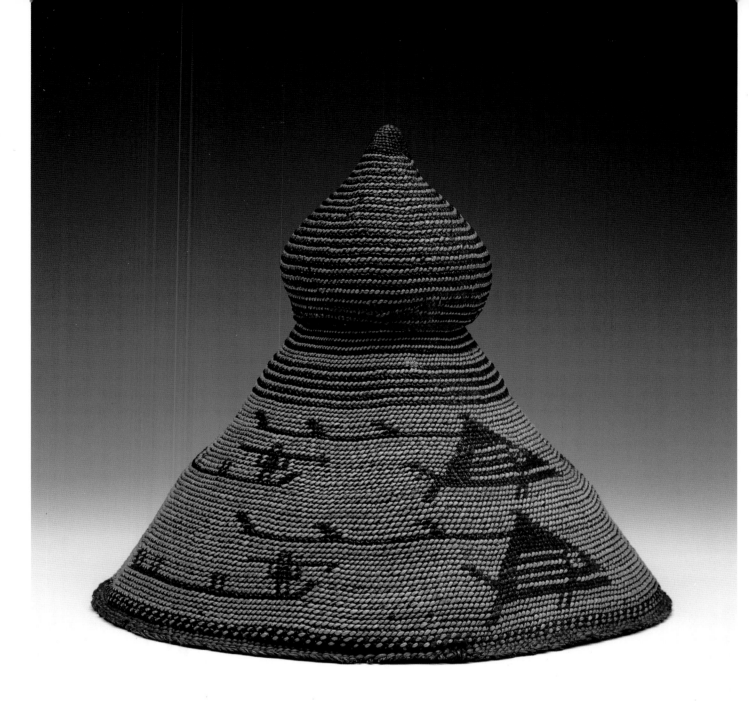

we do not expect to find in countries where the men seem still to have the appearance of savages. But what must astonish most . . . is to see painting everywhere, everywhere sculpture, among a nation of hunters (Gunther 1972:130).

Art, then, was one manifestation of the remarkably advanced level of culture of the Northwest Coast Indians that many Europeans recognized. The beautifully carved and painted sculptures, elegant costumes, and huge, well-appointed houses, all impressed the whites who on occasion stopped long enough on the Coast to draw a picture of a man wearing a costume or of a totem pole standing before a building, and to purchase a mask, a blanket, or a spoon. These eighteenth-century artifacts that the traders brought to Europe were the first of many such pieces removed from their context to be ultimately exhibited in alien surroundings; the drawings of the artworks in context became the earliest attempts to describe visually the exotic but impressive world of the Northwest Coast Indian.

Pl. 14. Nootka basketry hat decorated with images of whale hunting. H 23.2 cm, D (base) 26 cm. *Acquired from the Peabody Museum, Massachusetts Historical Society, 1899; original cat. no. 268c. 16/7959*

The Maritime Fur Trade

The fur trade brought Europeans and Americans to the Northwest Coast who fought with the Indians, disdained their food, and found them savage, but admired their art. The traders made huge profits from the luxurious sea otter furs, but so did the Indians. Sometimes the whites dealt only with particularly friendly families who by monopolizing the fur trade became exceptionally wealthy. This was the case for the Nootka chief, Maquinna (host of Vancouver and Bodega y Quadra's feast), whom the whites singled out. As the principal middleman between the Indians and the whites, Maquinna made immense profits by selling the furs collected by Indians who lived on the east coast of Vancouver Island.

The wealth pouring into the Northwest Coast stimulated ceremonialism, since the noblemen who had always given away gifts at their feasts were now much richer and could offer guests many more goods than previously. Maquinna, for example, was said to have hosted a truly great potlatch in 1803, at which he distributed to his invited guests "two hundred muskets, two hundred yards of cloth, one hundred chemises, one hundred looking glasses, and seven barrels of gunpowder" (Fisher 1977:18). This kind of conspicuous gift-giving, in the eyes of the Nootka and surrounding peoples, enhanced Maquinna's status and supported his position as a paramount chief of the region.

There were artistic consequences to the maritime fur trade, for the wealthier the Indians became and the more sumptuous their potlatches, the greater the necessity to commission art that could display their enhanced status. To answer this new demand for more art, the carvers had at their disposal metal axes, adzes, and chisels, which made their creative tasks infinitely easier than in the past. Using metal implements technically far superior to their traditional stone tools, the Northwest Coast carver could more speedily produce taller totem poles, larger canoes, and finer and more complex relief sculpture. In addition, the artist's use of trade pigments, including the rich vermillion from China, resulted in much brighter paintings on the wood sculptures. Northwest Coast art, which had developed into a distinctive style prior to white contact, became far more splendid as artists obtained better tools and as patrons acquired greater wealth.

Much of the artistic activity on the Northwest Coast went into creating costumes to be worn at the potlatches (fig. 3). Plate 15, for example, illustrates a Haida wooden headdress depicting a beaver crest. The buck-toothed beaver, carved in relief on a rectangular plaque inlaid with abalone, has a small frontal face of another crest, the dragonfly, nestling in its stomach. This headdress, with its luxurious mother-of-pearl, its crown of tall sea lion whiskers and brilliant flicker feathers, and its lengthy train of soft white ermine skins, declared to all the immense wealth and power of its owner. Such a headdress would often have been worn in association with a Chilkat blanket (pl. 16). Made of mountain goat wool and shredded cedar bark, the Chilkat blankets contained an image of the owner's crest animal. Composed of three panels, the central one of which held a frontal depiction of the crest animal and the side ones representing its profile, the Chilkat blanket was the most abstract work of art on the Northwest Coast. When worn, the frontal face in the central panel of the blanket appeared on the wearer's back while the side profile faces appeared over his shoulders; it was as if the nobleman wearing this elegant textile was literally enveloped in his crest animal. As he danced, the long fringes at the blanket bottom would sway to the rhythm of the percussive beat that characterized Northwest Coast music (Emmons 1907; Samuel 1982; Holm 1982).

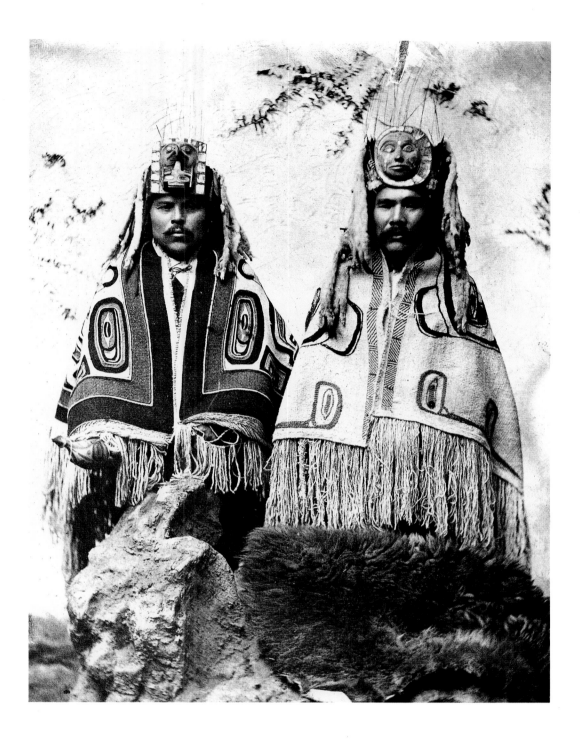

The presentation of food was extremely important at every potlatch. Like many families who use only their best silver at dinner parties, the Northwest Coast Indians took out and used their intricately carved spoons of mountain goat and mountain sheep horn at the potlatch (pl. 17). One of the great delicacies at these feasts was the eulachon fish oil into which dried salmon was dipped. To hold this pungent-smelling oil, the natives had grease bowls, such as the Haida example in plate 19, which represents a lively seal lifting its wide eyes to look at the sky and energetically raising its rear flippers. Another fine bowl (pl. 20) depicts a bird whose back formed an oval cavity for this rich cuisine.

Fig. 3. Haida men wearing frontlets and Chilkat blankets. At left is Tom Price, and at right, John Robson—two Haida artists. *Fleming brothers photograph, 1885–1900. 45608*

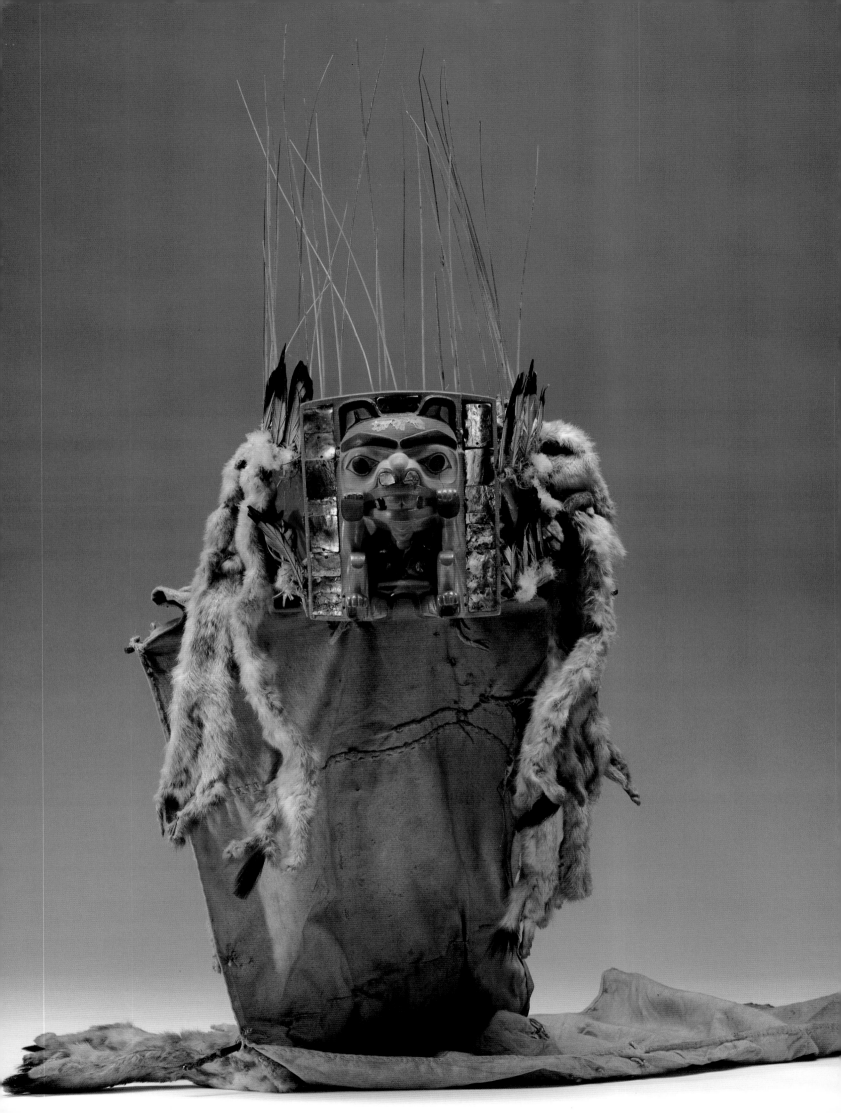

Pl. 15. Haida wooden dancing headdress with abalone, flicker feathers, sea lion whiskers, and ermine pelts; carving represents beaver with a dragonfly on its belly. Plaque: L 18.6 cm, W 15 cm. *Collected by Powell, 1880–85. 16/245*

Pl. 16. Chilkat blanket made from shredded cedar bark and mountain goat wool; design made by a man and painted onto a "pattern board," then copied onto textile by a woman (see fig. 78). L 140 cm, W 162 cm. *Purchased from Emmons, 1928. 16.1/1842*

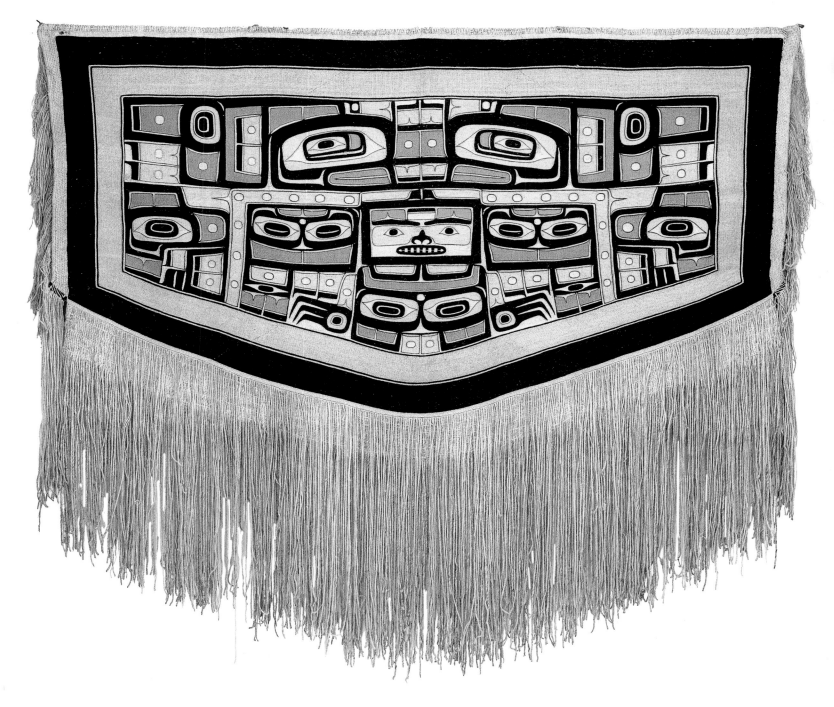

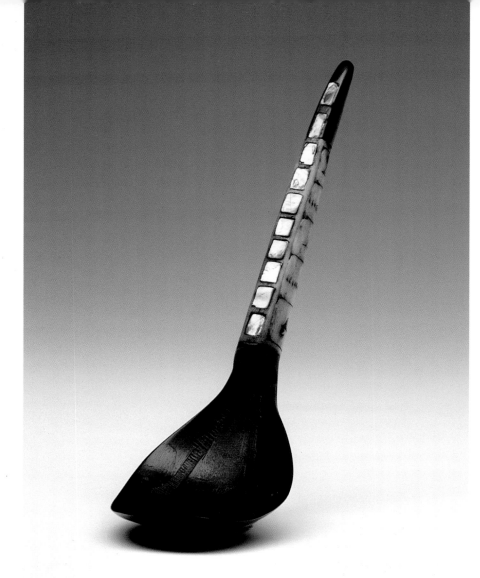

Pl. 17. Tsimshian horn spoon. L 20.4 cm. *Acquired from Emmons, 1915. 16.1/1563*

Pl. 18. Tlingit wooden bowl. L 28.6 cm, W 20 cm, H 18.8 cm. *Collected by Emmons, 1882–87. 19/1025*

Pl. 19. Haida wooden bowl representing a sea lion. L 28 cm. *Collected by Powell, 1880–85. 16/42*

Pl. 20. Tlingit wooden bowl depicting a bird. L 43.1 cm. *Acquired from M. Tidball, 1926. 16.1/1789*

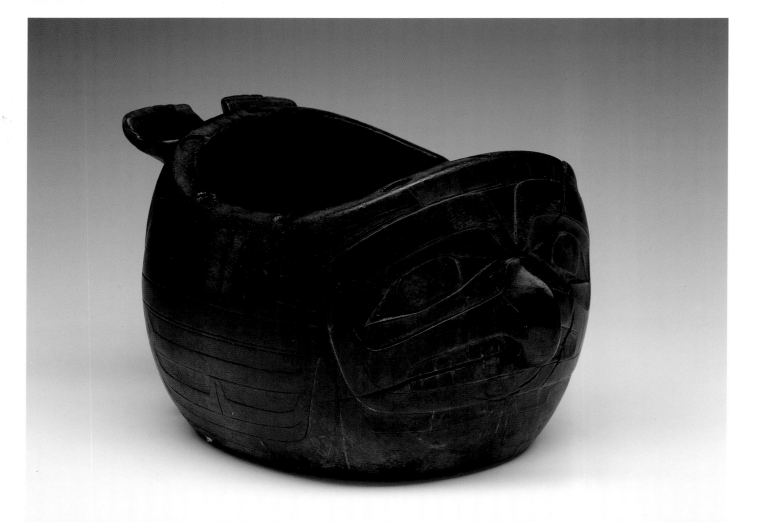

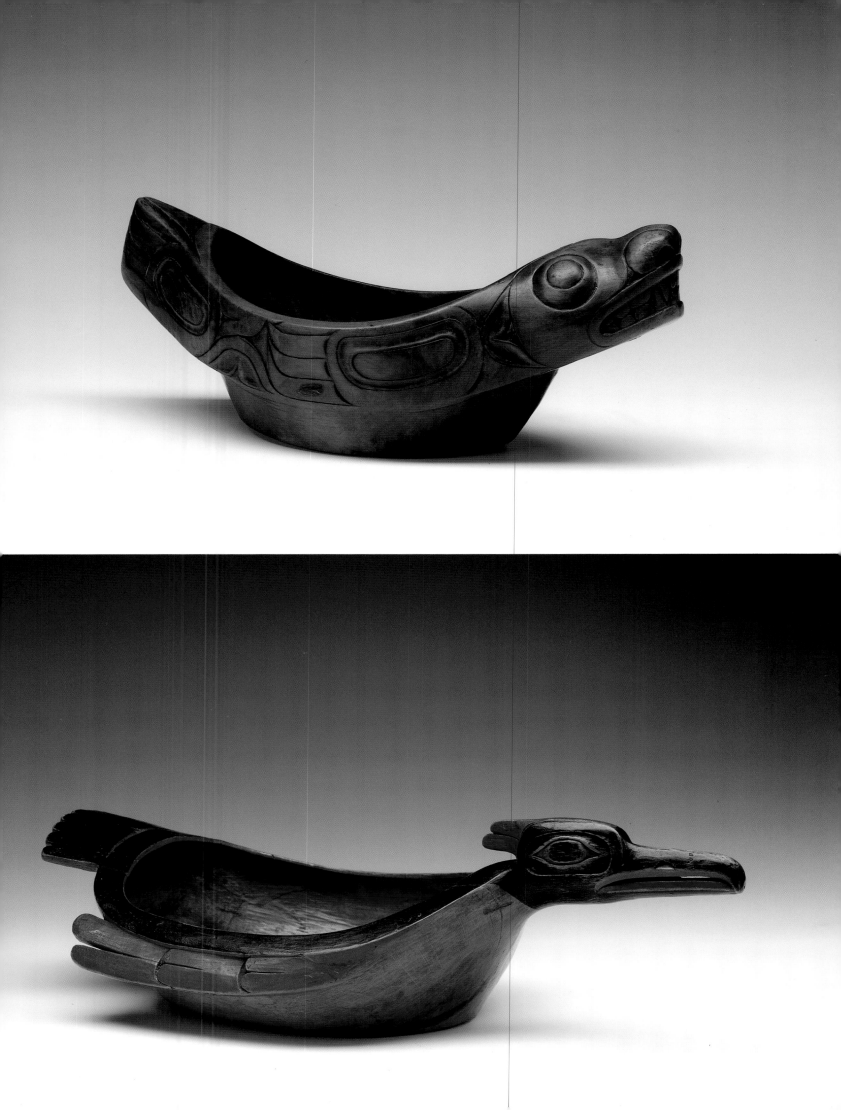

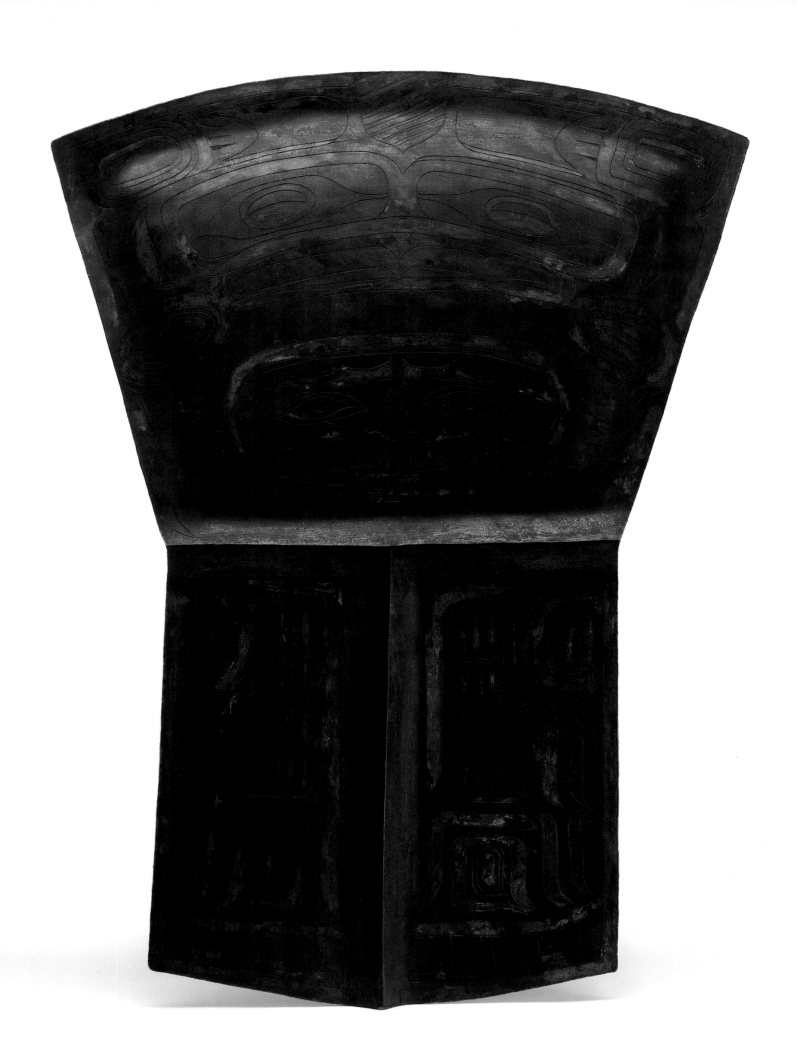

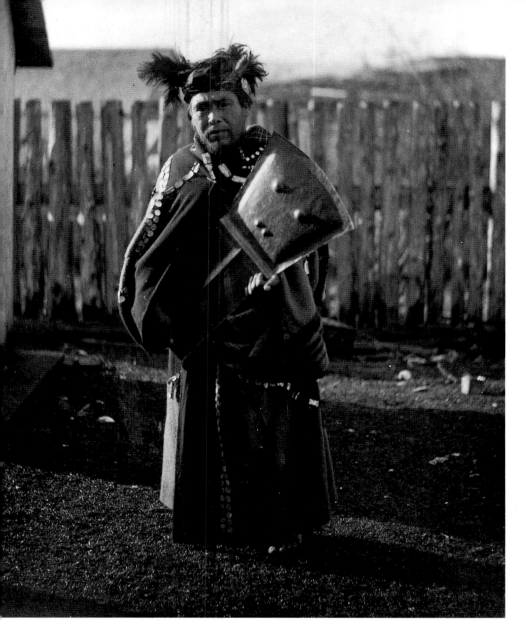

Fig. 4. Kwakiutl chief Wakgas of Koskimo holding a copper. *Hastings photograph, 1894. 336106*

During the potlatches, many Northwest Coast Indians displayed the most precious items in their possession, the so-called "coppers" (pl. 21, fig. 4). A shield-shaped object of beaten copper, painted or engraved with a crest image, coppers were worth vast quantities of wealth. A man displaying a copper was demonstrating to all his tremendous prestige and status. So significant was this enigmatic object as a symbol of riches that images of the copper often appeared in other artworks, such as in the mouths of the two wolves supporting the Kwakiutl bowl in plate 59 (Widerspach-Thor 1981; MacDonald 1981; Lévi-Strauss 1982).

Although many scholars agree that coppers as symbols of wealth were invented by the Northwest Coast Indians before their contact with whites, the relatively easy access to metallic copper during the fur trade period probably resulted in greater numbers of these items being made. Similarly, while carved poles certainly predated the earliest traders, the nineteenth century saw a remarkable flourishing of a variety of different types of poles that contained imagery depicting clan legends. Totem pole types included house posts used to support the beams on the inside of houses (fig. 5), frontal poles standing next to house facades, the bases of which served as entrances to the houses (fig. 6), memorial or commemorative poles that honored deceased noblemen, mortuary poles containing the remains of the dead (fig. 7), and grave markers indicating the location of burials. When seen from a distance, the poles, lined up on the beach, formed a forest of elegantly carved declarations of the wealth of those who lived within the houses before which they stood (fig. 8) (Halpin 1981).

Pl. 21. Haida copper engraved with a crest image; these shield-shaped objects signified great wealth and were displayed at potlatches. H 75 cm, W (top) 53 cm. *Purchased from Emmons, 1909. 16.1/404*

The Land-Based Fur Trade

Although they were the objects of disdain by the whites, the Northwest Coast Indians, for the most part, benefitted from these brief and profitable early contacts with Europeans and Americans. They sponsored more and more lavish potlatches and produced finer and more monumental art. Even in Alaska, where the Russians settled in Tlingit territory, the natives prospered. Northwest Coast culture, which was sophisticated and elaborate before the coming of the Europeans and Americans, became all the more so. There was, however, soon to be a change in the source of wealth pouring into the Northwest Coast.

In 1785, the Englishman Alexander Walker commented in his travel journal that so "craving and rapacious" were the traders who indiscriminately encouraged the killing of the otter that "numbers of the Animal will be reduced, and less valuable Skins brought into the Market" (Walker 1982:146). Few heeded Walker's advice to conserve this precious resource, and by 1830, the sea otter was virtually extinct in the Pacific waters off Canada and Alaska. To satisfy the continued demand for furs, traders began to exploit the large populations of furbearing land animals such as marten, otter, bear, and mink. Before long, ocean-going vessels had given way to permanent land-based trading establishments, the most famous of which was the Hudson's Bay Company. The company first located its coastal headquarters in 1824 at Fort Vancouver near the mouth of the Columbia River and remained there until 1849 when they moved to Fort Victoria on Vancouver Island (Duff 1964:55–56).

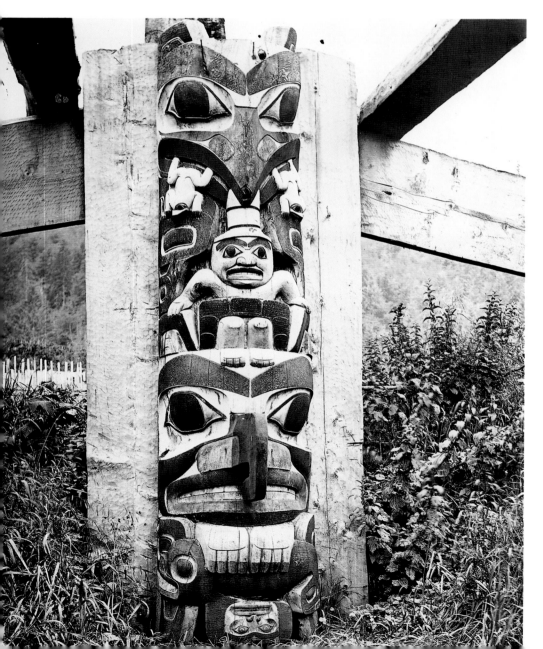

Fig. 5. Haida housepost, Skidegate. Lower figure represents a thunderbird holding a whale in its talons; upper figure is the raven with two frogs and a man in its mouth. *Dossetter photograph, 1881. 42288*

Fig. 6. Haida frontal pole, Masset. House of K!oda'-i, a powerful shaman who stands second to the left in figure 27. Figures from top to bottom depict three watchmen, eagle, bear with a frog in its mouth holding a human, beaver with a human on its tail, and bear eating a human. *Dossetter photograph, 1881. 39991*

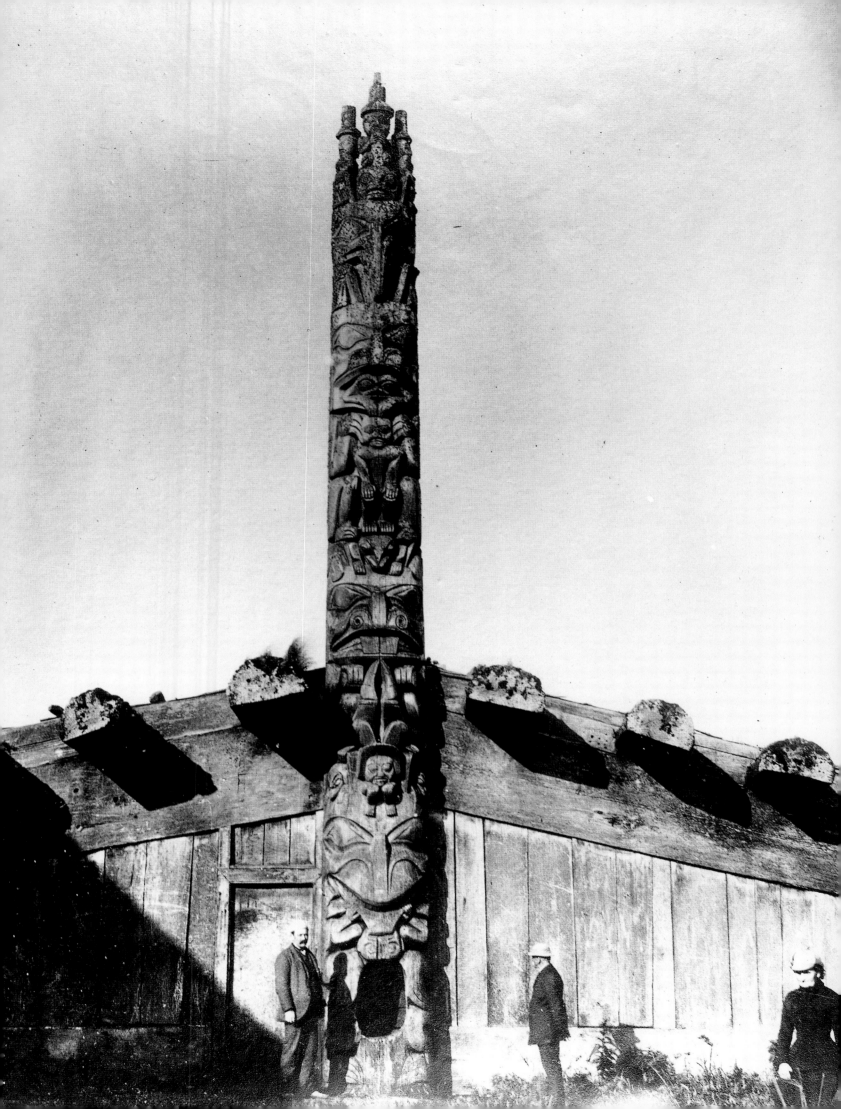

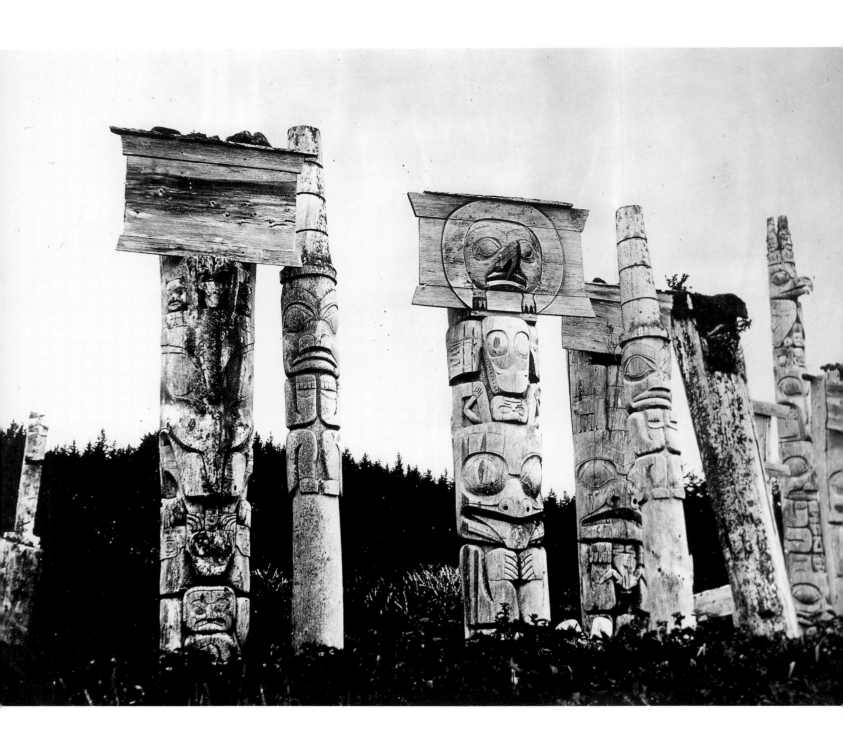

Fig. 7. Haida memorial poles, Ninstints.
Newcombe photograph, 1901.

The Hudson's Bay Company established local trading posts which were popular with the Indians who had grown accustomed to the influx of white trade goods into their economy. Some Indians, anxious to have easier access to these goods, actually left their traditional homelands and settled near the trading posts. For example, in 1834, when the Hudson's Bay Company established Fort Simpson near the mouth of the Nass River, nine groups of Tsimshian who had previously lived along the Skeena River and at Metlakatla abandoned their villages in order to live in proximity to the fort and together formed a new, very large permanent village.

The Hudson's Bay Company granted special privileges to certain Fort Simpson Tsimshian families, who became enormously wealthy as middlemen between the white traders and the interior Indians who trapped the furs. One such privileged family was that led by Legaic, an already high-ranking chief who had the good fortune of marrying his daughter to the first chief factor of the Hudson's Bay Company post at Fort Simpson. Legaic soon monopolized trade with the Gitksan who

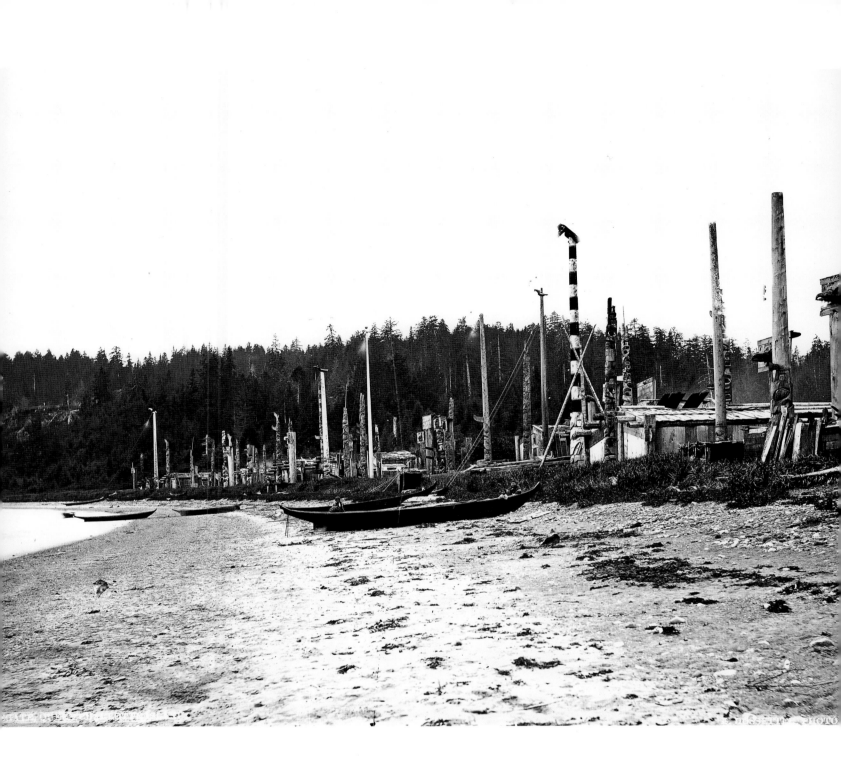

Fig. 8. Haida village of Skidegate. *Dossetter photograph, 1881. 42264*

lived on the upper Skeena River, close to the source of the furs, and prohibited them from trading directly with the whites (Duff 1964:58; Fisher 1977:31,46). Legaic hired artists to mark his possession of these trails with pictographs of both his face and the symbol of his tremendous wealth and power, the copper (MacDonald 1984:78). This artistic declaration of his monopoly of trade routes was supported by his formidable military strength.

Legaic and other Tsimshian elite who settled around Fort Simpson had to devise a means of determining their relative statuses. Over the previous centuries, each Tsimshian village had developed a hierarchical arrangement of its constituent families in which some families had very noble status, while others were quite lowly. No mechanisms existed to rank the chief of any particular village with the chiefs of any other towns, since leadership on the Northwest Coast rarely extended beyond the limits of a village. Only on the rarest of occasions and under

the most unusual of circumstances—as in the case of a group of villages banding together to battle a common enemy—did any chief have authority over Indians from outside his own community, nor was it relevant *which* of the assorted village chiefs was most powerful. Thus, when the nine Tsimshian villages moved near the Hudson's Bay Company post, and for the first time several highest-ranking chiefs from different communities lived side by side, it became necessary to establish a new ranking order. To determine which chiefs would be paramount, these newcomers to Fort Simpson hosted a series of more and more elaborate potlatches that revealed to the public which were the wealthiest families who deserved to be considered the highest ranking lineages in the village.

Some of these potlatches at Fort Simpson became exceptionally lavish and competitive as certain families attempted to outdo others in the amount of wealth and food they could give away. Thus, the function of the potlatch at Fort Simpson gradually changed from a simple validation of the host's position to a demonstration of his superiority over other families in this recently consolidated village.

Kinship groups devised various methods to display prestige, in addition to the traditional distribution of large amounts of food and gifts. One powerful chief named Tsibasa had an ingenious device, the so-called "revolving steps," installed in his house. Specially constructed so as to move and thus throw off balance an unsuspecting climber, these steps were intended to humiliate Tsibasa's arch rival, Chief Legaic. Like the emperors of Europe, Legaic typically arrived last to a ceremony, making a grand entrance. When he came late to a feast at Tsibasa's house, the steps "revolved" and hurled him into the house, disgracing him in full view of the assembled guests (Guédon 1984:152).

Legaic himself was not above using stagecraft to demonstrate social position, and once staged a spectacular theatrical show of reincarnation. First he located among the Tlingit a slave who strikingly resembled him and had him dressed in chief's garb. All the villagers mistook the slave for Legaic, who went into hiding until his family killed and cremated his double. In a sensational display that impressed everyone who saw it or heard of it, Legaic rose from the box containing the slave's ashes, "magically" restored to life. This display of supernatural abilities greatly enhanced Legaic's already very high secular status (Halpin 1984:286).

The Tsimshian, like the Kwakiutl and the Chilkat Tlingit, all of whom lived near the source of furs, benefitted as a result of the switch from maritime to land-based fur trade, adding to their wealth and prominence during the nineteenth century (Fisher 1977:47). In contrast, the Nootka, who had flourished from the maritime trade, became relatively obscure during the Hudson's Bay Company era, as few whites traveled to the more remote west coast of Vancouver Island. With few fur-bearing animals living on the Queen Charlotte Islands, the Haida could no longer be central to the fur trade. Being ever resourceful and intensely desiring the continued influx of European, American, and Indian trade goods, the Haida became involved in a variety of economic activities such as cultivating potatoes, manufacturing ocean-going canoes, which they sold to other groups of Indians, and carving wooden and shale "curiosities" for sale to whites (Fisher 1977:44). Haidas also canoed to Fort Simpson on a regular basis to trade with both whites and Indians at the Hudson's Bay Company store.

During this era two Haida villages, Skidegate and Masset, assumed great importance. The village of Skidegate had such a strategic location that all people coming from the west shores of the Queen Charlottes had to pass it. The village chief, Skidegate (after whom the white traders named this prosperous village), monopolized the trade of all these west coast Haida with the Hudson's Bay Company, in keeping with an honored Northwest Coast tradition of powerful chiefs controlling access to wealth. Figure 9 illustrates Chief Skidegate's house with its notable raised veranda, and figure 10, the mortuaries of his wives.

Pl. 22. Bella Coola mask representing Komokoa, chief of the undersea world. Talio. H 49.3 cm, W 35.8 cm. *Purchased from Boas before 1895. 16/771*

Another important Haida town was Masset, with its tremendously rich and powerful chief, Wiah. In order to communicate to the world their fabulous wealth and concurrent status, both Chief Skidegate and Chief Wiah built enormous houses with towering totem poles and ceremonial boardwalks leading from the beach. Wiah's house, erected when he assumed the chieftainship of Masset between 1840 and 1850, was so immense—it was twenty-one meters wide and held one hundred people—that people called it the "Monster House" (figs. 11, 12). Legend has it that two thousand Haidas helped construct this great house (MacDonald 1983a:131–54; Blackman 1981:116–20).

It was not merely pride that motivated Wiah to construct such an impressive house, it was social necessity, since his title to the village's leadership was disputed. To understand what happened one must understand Haida inheritance rules. The Haida divide themselves into two halves, or moieties, called the Eagles and the Ravens, and permit marriage only between opposites. Since inheritance is reckoned through the female line, a child belongs to the moiety of his or her mother rather than father. Because his son is not of his kin group, a father does not normally will his property to his own son, but rather to the son of his sister, who is of his own moiety. So deep is the feeling of moiety affiliation that at the age of puberty among the Haida, as well as among the Tsimshian and Tlingit who share this matrilineal descent pattern, a boy will leave the house of his father and enter the home of his maternal uncle.

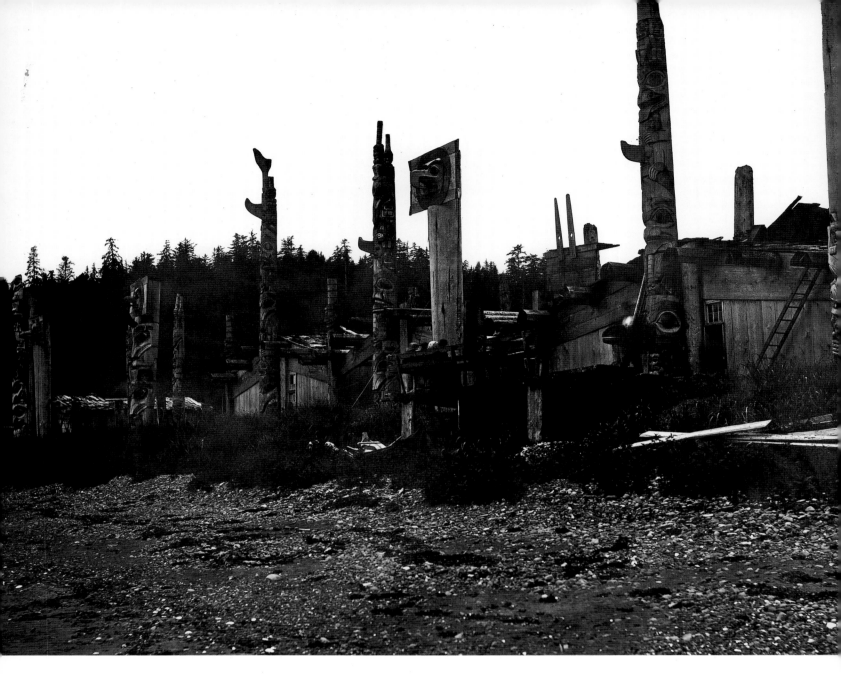

Fig. 9. Haida village of Skidegate. *Dossetter photograph, 1881. 42267*

Wiah was preceded as chief by his own father, Sigai, who should have identified some maternal nephew to succeed him. In an affront to tradition, however, Sigai willed his chieftainship to his own son. Wiah, it seems, had impressed his father by accruing much wealth and marrying one chief's daughter from the village of Tian on the west coast of the Queen Charlottes. Since Sigai thought so highly of Wiah, he made the following eyebrow-raising announcement at a feast: "I got a son; he became very wealthy by his own right. I don't want him to be a common member of this village, so I give him this village" (Blackman 1981:115). Although many people found this bequest appalling, a chief's word is law, and everyone had to accept Wiah as the new chief. Possibly because his new position had come about because his father had violated tradition, Chief Wiah felt it all the more necessary to build a house with a facade twenty-one meters wide, and nine totem poles, one of which soared to fifteen meters, using art that ostentatiously displayed status to justify a questionable succession.

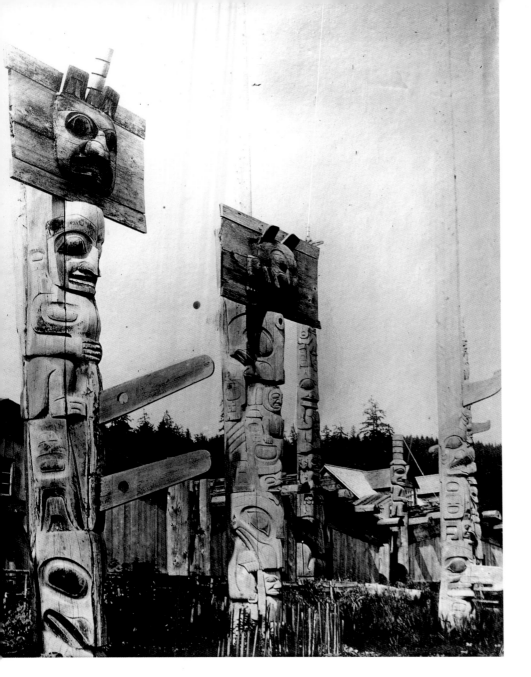

D URING the period of land-based fur trade, few whites, except for the Russians in Alaska, settled permanently on the Northwest Coast. In British Columbia only the employees of the Hudson's Bay Company spent much time in the region, and often became genuinely friendly with the Indians. As had been the case during the age of maritime trade, art and ceremonialism flourished as a result of increased wealth. The only major social change that occurred during this time was the establishment of new consolidated villages such as that at Fort Simpson; these movements of entire Indian villages to form larger communities usually benefitted both the Hudson's Bay Company, which did not have to seek out trading contacts, and the Indians, who prospered as a result of their proximity to sources of wealth. Many of those who actually lived with the Indians, such as the Russians and some Hudson's Bay Company employees, developed rather positive attitudes toward Northwest Coast Indian culture. The benign consequences of white contact were not to continue, however, as settlers began to enter the coastal region, for the goldminers, settlers, missionaries, and government agents who moved into the Northwest Coast after the mid-1800s were responsible for an irreparable alteration of traditional Indian culture.

Fig. 10. Haida village of Skidegate. Mortuary poles for wives of Chief Skidegate. *Maynard photograph, 1888. 39992*

45 *The Meeting of Two Cultures*

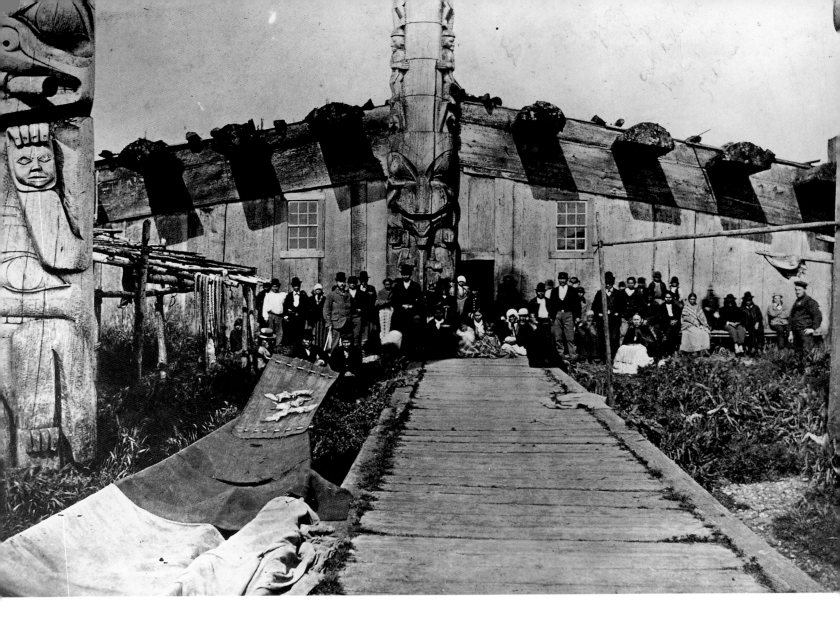

White Settlers on the Northwest Coast

In 1846, the Canadian and American governments agreed upon the boundaries separating what would become Washington and British Columbia, in effect opening the land to immigrants. Three years later, the British government gave Vancouver Island to the Hudson's Bay Company on the stipulation that it encourage settlement, and named as governor James Douglas, the factor of the Victoria settlement. Like many fur traders, Douglas had certain sympathies for the Indians and admired elements of their culture. In contrast, the newer settlers despised the native peoples who inhabited lands they desired.

The populating of British Columbia proceeded quite slowly until the 1850s, when gold was discovered first in 1852 on the Queen Charlotte Islands and then in 1857 on the Fraser River. If any date can be said to separate the period of the fur traders from that of the settlers, it would be 1858. During the summer of that year, the town of Victoria, which the previous year had been a village of 300, swelled to 3,000 permanent inhabitants, surrounded by 6,000 transients camped on its outskirts (Fagan 1984:228). By 1871, British Columbia had become so well populated with whites that it became a Province of Canada, subject to the federal government in Ottawa.

Fig. 11. Haida village of Masset. Residents of the Monster House with Israel Powell. *Hastings photograph, 1879. 334106*

Fig. 12. Haida village of Masset. Interior of Monster House. *Maynard photograph, 1884. 24482*

The new immigrants to British Columbia, many of whom arrived from England, brought along European ideas about the hierarchical arrangement of the races of the world, and the natural and permanent superiority of white to nonwhite races. Often they revealed their feelings of racial superiority in their descriptions of Indians: according to one man, Indians were "dirty greasy nasty-smelling creatures," while to another they were "the most hideous . . . beings imaginable" (Fisher 1977:87). One book written about the area, *British Columbia and Vancouver Island* by Duncan George Forbes MacDonald, contained the following:

Prominent Features in the Life and Character of the Indians—Slaves Horribly Abused—the 'Medicine Man' and the Dead—Modes of Scalping—Young Indians More Savage than Old—Horrible Modes of Torture—Barbarous Conduct of an Old Squaw—Shocking Cruelties to an Old Man and Instance of Cannibalism—Horrible Massacre of Emigrants—Cruel Custom of Getting Rid of the Aged (Fisher 1977:88).

Such negative attitudes extended to the newcomers' reactions to Northwest Coast art; unlike those fur traders and maritime explorers who reacted favorably, many settlers found Indian carvings and paintings abominations, and one person described them as "hideous" and "grossly obscene" (Fisher 1977:90).

THE attitudes of whites in British Columbia changed radically from the time of the fur trade when Indians were seen as partners in a mutually beneficial endeavor to the period of settlement when the natives were viewed as impediments to progress. A parallel switch in white men's attitudes toward Indians occurred in Alaska, which the United States purchased from Russia in 1867 for $7,200,000. Except during times of hostilities, the Russians in southeast Alaska had lived relatively comfortably with the Tlingit, often sharing their customs and habits. The Russian priest Ivan Veniaminof, who lived in New Archangel (Sitka) in the 1830s and 1840s, had sincere words of praise for the Tlingit, who he felt were the most intelligent and gifted peoples on the entire Pacific coast down to California (Krause 1956:104). In contrast, the new Americans who came to Alaska in larger numbers when gold was discovered in the 1870s and 1880s, like their British Columbian brothers, had only disdain for the Indians (Krause 1956:46–47).

In Sitka, once the American flag was raised in October 1867, the American general, Jefferson Davis, seized the Russian-American Company's property to create barracks, with disregard for the rights of those who had previously lived there. Settlers were encouraged to emigrate to Sitka, where soon people of all sorts arrived, promoting gambling, drinking, and prostitution. Since no real laws applied to this territory until 1883, little protection for life and property existed. Stories abounded of soldiers, whose ostensible role was to maintain law and order, harassing both Indians and Russians, arbitrarily and indiscriminately arresting, beating, and sometimes even killing men and molesting their wives. And, while the sale of alcohol to Indians had been forbidden by both the Hudson's Bay Company and the Russian-American Company, now the Tlingit could buy liquor cheaply. Soldiers even taught Indians how to distill their own alcohol. Although federal law prohibited this practice, nobody was around to enforce it (de Laguna 1972:180–81; Gordon 1967:169–80).

Although Sitka was, after the American purchase of Alaska, a rough town, Victoria was an even more unpleasant place for a Native American during this period. In response to the boom town wealth of this growing city, many Indians went to the southern part of Vancouver Island to earn a living. In 1853, for example, a group of five hundred Haidas left the Queen Charlotte Islands to visit Victoria in the hope that they might increase their trading contacts. Many people in Victoria found this invasion by five hundred Haidas alarming and frightening, and Governor Douglas asked them to leave. They did, but, to his consternation and that of many citizens of the city, several canoes full of Haidas returned several weeks later to begin a pattern of annual migration to Victoria that would continue for decades (MacDonald 1983a:40)

Squalid slums grew up around Victoria to house the growing number of both visiting and permanently resident Indians. The white colonists found their presence disturbing, since drunkenness and prostitution flourished in the crowded Indian environs, and violence between different ethnic groups occasionally broke out. The white population, unable to recognize that their own increased numbers were in large measure causing these social problems among the Indians, started pressuring the colonial government more and more strongly to remove the Indians from the proximity of Victoria. A letter to the *British Colonist* in 1859 asked, "how much longer are we to be inflicted with the intolerable nuisance of having hundreds upon hundreds of hideous, half-naked, drunken savages in our midst . . . teeming in droves of these disgusting objects, reeling about and shouting" (Fisher 1977:114; Woodcock 1980:36–42).

In addition to alcoholism, another social problem that arose as a direct result of white contact was prostitution and its not uncommon consequence, venereal disease. Although during the sea otter fur trade period women were sometimes offered to white explorers and traders, after 1858, many women spent much of their time in "dance halls," the euphemism for brothels. According to some observers, the Indians themselves did not see prostitution as a dishonorable activity and applauded families whose women could return home after a season in Victoria laden with goods to be distributed at potlatches (Blackman 1982b:44).

Victoria's "Indian problem," prostitution and all, became less serious after 1862. The burgeoning Indian population, living in squalid slums, proved to be a perfect host for an epidemic. In March of 1862, someone, perhaps a sailor, arrived from San Francisco infected with smallpox, and soon the disease was rampaging through the Victoria slums, giving authorities justification to evict the Indians and to burn their houses. Many Indians, now infected themselves, left the Victoria area and traveled north to their traditional lands, only to spread the disease further up the coast. Many people died along the way. These trips were by all accounts horrible; the *British Colonist* of June 21, 1862 (quoted in Blackman 1982b:63) reported that "forty out of sixty Hydahs who left Victoria for the North about one month ago, had died. The sick and dead with their canoes, blankets, guns, etc. were left along the coast. In one encampment, about twelve miles above Nanaimo, Capt. Osgood counted twelve dead Indians—the bodies festering in the noonday sun."

As a result of this fierce epidemic the Northwest Coast Indian population was, according to some sources, reduced by one-third. Some villages lost so many inhabitants that they could no longer function as whole communities and their survivors had to move into larger villages. Many Haida families from the central Queen Charlottes, for example, moved into Masset, leaving abandoned villages that soon became ruins (fig. 13). Although the population of Masset, like all the Queen Charlotte Islands towns, had declined drastically as a result of the smallpox epidemic, it was still a flourishing community and, moreover, in 1869 became the site of a Hudson's Bay Company post.

Fig. 13. Haida village of Tanu. *Photograph probably by Newcombe, 1901. 248614*

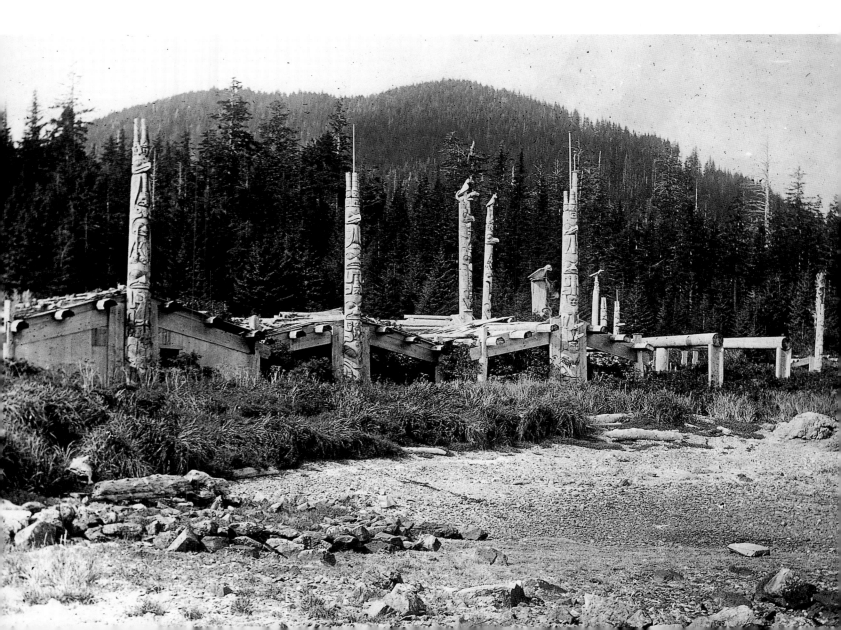

Sometimes families moved several times before ending up in Masset. For example, the traditional village of the prestigious Edenshaw family was Kiusta. When Kiusta's population became depleted, Edenshaw moved to Kung. Before long, Kung became as depopulated as Kiusta, and Edenshaw had to move once more to Masset, where he lived in the structure illustrated in figure 14. When Chief Edenshaw came to this village, he paid homage to the great Chief Wiah by bringing one of his ancestor's valuable poles into the Monster House and dancing before it for a quarter of an hour. Then Edenshaw had this precious pole, the symbol of his ancestors, his wealth, and his status, burned, in what some interpret as an expression of submission to Wiah's higher rank (MacDonald 1983a:136).

As a result of the population decimation, certain elite families died out, leaving power vacuums in their villages. Other families had to prove their worthiness for the now vacant positions of village chiefs. Continuing the pattern begun when the Hudson's Bay Company attracted whole villages to their forts, the inhabitants of these post-smallpox-epidemic communities engaged in ever more competitive potlatches, which required in turn the creation of even greater numbers of more splendid artworks. Thus, almost ironically, during this period of increasing oppression by whites and population decimation, Northwest Coast artwork flourished as never before, as taller totem poles, more impressive houses, and more dazzling costumes had to be made in order to satisfy the needs of the remaining Indians who wished to use their art to convince the world of their prestige and importance (Blackman 1976; Wyatt 1984).

Fig. 14. Haida village of Masset. Property House, at left, owned by Chief Albert Edenshaw. *Maynard photograph, 1879. 24421*

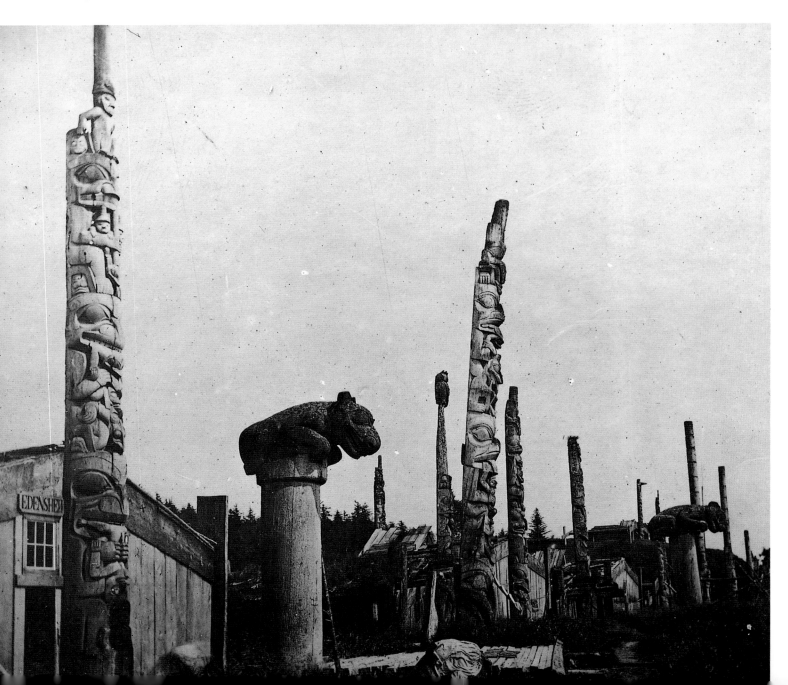

The Missionaries and the Potlatch Law

Although many white settlers firmly believed that the Indians were so inferior that they should simply be done away with, one group, the missionaries, attempted to redeem them from their heathen ways. These bringers of Christianity played an ambivalent role among the Northwest Coast Indians, since their genuine concern for the natives resulted in their supporting numerous measures meant to eradicate Indian traditions. To be "saved" often meant becoming westernized.

Both Catholic and Protestant clergymen and lay missionaries came to the Northwest Coast to convert the Indians. Among the Tlingit the Russian Orthodox church attracted a certain following, those who may have found appealing the beautiful churches and glorious rituals of that faith. The German explorer who visited the Tlingit in the 1880s, Aurel Krause, remarked that these Indians liked Orthodox Catholicism because the "revelation of the rich splendor of the Greek faith found sympathetic appreciation among these Indians and made such an impression on them" (Krause 1956:229–30). Also active on the Northwest Coast were the Protestant missionaries who arrived in British Columbia and Alaska in ever increasing numbers after the mid-nineteenth century and had a profound impact on the lives of the Indians. These Protestants worked strenuously both to Christianize and to westernize the natives, encouraging them completely to abandon their traditional ways of life and assume a western mode.

Sometimes the natives found appalling the missionaries' suggestions for leading the virtuous life. The missionaries believed it proper for a wife to assume the last name of her husband, and addressed Indian women by their spouses' names. Although this might seem innocuous enough, it created some difficulties among the Haida (as well as the Tlingit and Tsimshian who had similar marriage rules), who associated certain names only with the Eagle moiety and others only with the Raven moiety; although marriages had to occur between Eagles and Ravens, husbands and wives maintained strict affiliation with the moiety of their birth. In her autobiography, Florence Edenshaw Davidson, a modern descendant of Chief Edenshaw, describes the following episode that her mother experienced at the end of the nineteenth century: "When the missionary called my mother Isabella Edenshaw, she wouldn't take the 'Edenshaw' for a long time. She couldn't understand it; 'How can I take Eagle's name?' she kept asking. Finally she gave up" (Blackman 1982b:72). In a culture for which names had tremendous importance connoting the history and greatness of one's lineage, to assume the name of what was in effect an alien and opposed family meant rejecting one's identity and losing a deep sense of belonging.

One of the most important missionaries on the Northwest Coast was the Anglican William Duncan, who came to work among the Tsimshian in 1857. The Tsimshians' intelligence and artistic skills greatly impressed Duncan but, like most other missionaries, he found their winter dances, shamans, and potlatches deplorable, their drunkenness and violence shocking, and their prostitution abhorrent. In his words:

To attempt to describe the condition of these tribes on my arrival would be but to produce a dark and revolting picture of human depravity. The dark mantel of degrading superstition enveloped them all, and their savage spirits, swayed by pride, jealousy and revenge were ever hurrying them to deeds of blood. Thus their history was little else than a chapter of crime and misery (Fisher 1977:128).

In order to communicate better with these desperate souls, Duncan learned to speak Tsimshian fluently, and by 1862 had converted fifty-eight Indians. Believing that these converts had to be protected from the multiple evils of those Tsimshian who refused conversion, the alcohol-supplying whites of Fort Simpson, and the temptations of Victoria (Fisher 1977:130), Duncan, in 1862, took his group of Christianized Tsimshian to the site of an old village, Metlakatla, abandoned during the migration to Fort Simpson, to establish a new community.

Duncan insisted that the residents of his utopian community abandon their traditional ranking and become egalitarian, cease dancing, drinking, and patronizing shamans, and attend school. Instead of living in communal houses lined up in a row facing the beach, the new citizens of Metlakatla lived in Victorian-style homes arranged in a grid and obeyed strict rules of behavior imposed upon them by the exceedingly autocratic and almost fanatical Duncan (figs. 15, 16) (Fisher 1977:130–33; Duff 1964:92–94; Fagan 1984:232).

By 1879, Metlakatla was a thriving community of 1,100 which the Indian commissioner, Israel Powell, described as "one of the most orderly, respectable, and industrious communities to be found in any Christian country" (Duff 1964:93). By now Duncan had established a sawmill, blacksmith shop, trading post, and other small business operations which were intended to make the natives self-sufficient. Grave problems occurred when, in the same year as Powell's visit, British Columbia became the Diocese of Columbia and the strong-willed Bishop William Ridley joined the equally assertive Duncan at Metlakatla. The two men disagreed vehemently on most issues, from the nature of the ritual to the desirability of encouraging capitalistic ventures on the part of the Indians. Ultimately, Duncan left the town he had established and, with 823 Tsimshian, moved to Alaska where he transformed New Metlakatla into a modern industrial town governed by Christian principles.

Like other missionaries, Duncan was committed to the eradication of those Indian traditions such as communal living, shamanism, and winter ceremonials that prevented the native from becoming fully integrated into the dominant culture. Perhaps the most offensive custom to the missionaries was the potlatch, which Duncan described as "by far the most formidable of all obstacles in the way of the Indian becoming Christian, or even civilized" (Fisher 1977:206). By the late nineteenth century, many potlatches had become competitive affairs during which, in the missions' views, entirely too much alcohol was consumed and winter food supplies were unnecessarily squandered. In order to participate in these great feasts, students left school and workers abandoned their jobs in what was seen as flagrant disregard of the Protestant work ethic.

Although most missionaries worked hard to get the Indians to stop potlatching entirely, some tried ingenious methods of "Christianizing" the affair. The Reverend W. H. Collison described his attempts to alter a Masset Haida potlatch in 1878.

The usual custom of dancing with painted faces and naked slaves with their bodies blackened casting property into the water was dispensed with and instead I had trained about 100 adults and children to sing the anthem, "How Beautiful Upon the Mountains." All were dressed and clean both on shore and in the canoes and after hearty cheers the visitors disembarked and were conducted to the various houses which were to receive them. The unanimous opinion of all was that the new and Christian welcome was far superior to the old heathen custom (Blackman 1981:26).

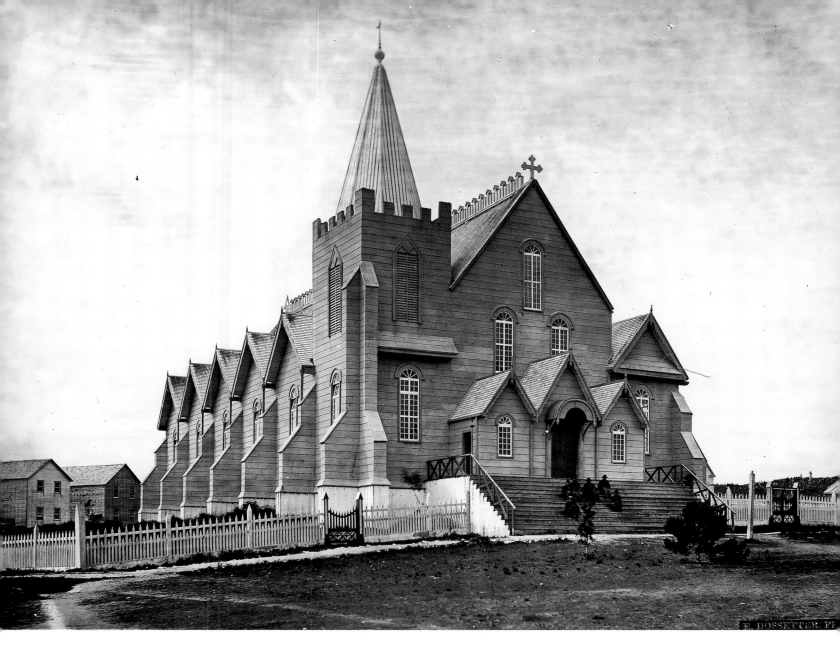

Fig. 15. Church at Metlakatla.
Dossetter photograph, 1881. 42293

Although a few such attempts were made to integrate the traditional and Christian customs, most missionaries, along with the government agents, launched an intense campaign to eradicate the potlatch. As a consequence of the combined pressure of missionaries and agents, in 1884 the federal government amended the 1880 Indian Act to include the statement that "every Indian or other person who engages in or assists in celebrating the Indian festival known as the 'Potlatch' or in the Indian dance known as 'Tamanawas' is guilty of a misdemeanor and shall be liable to imprisonment" (Fisher 1977:207). A ritual that for centuries had united members of villages with each other, and thus ensured the proper hierarchical organization of the Northwest Coast natives, had, with the stroke of a pen, been declared not just undesirable, but actually punishable by the law.

Fig. 16. Indians sitting on front steps of church at Metlakatla. *Dossetter photograph, 1881. 42304*

When Franz Boas arrived among the Newitti Kwakiutl in 1886 on an early Northwest Coast field trip, the Indians greeted him with great suspicion, assuming him to be a government agent. After Boas made it clear that he was a German anthropologist who wanted to learn about their customs rather than destroy them, the Indians explained to him that they had no intention of obeying the anti-potlatch law (Rohner 1969:33–36).

Although this law was virtually unenforceable, and many groups continued sponsoring potlatches either overtly or furtively, it symbolized the entirely negative attitudes most whites had toward Northwest Coast Indian culture by the 1880s. Only a few people like Franz Boas had a sympathetic attitude toward the Indians and wanted to learn as much as possible about their culture before the unstoppable process of "civilization" destroyed them completely.

Collecting Northwest Coast Art

One way to preserve this rapidly vanishing culture was to collect Northwest Coast Indian art for exhibition at museums. During the late nineteenth century, a large number of people, including Boas, purchased from the Indians objects ranging in size from minute shamans' charms to monumental totem poles and crated them to be shipped east by railroad. Those museums that received these collections became transmitters of information about Northwest Coast culture to the public in cities such as Ottawa, Chicago, Washington, D.C., and New York. The interactions of whites and Indians, which earlier had been direct, could now be mediated safely by museum displays that described to people who had never met a Kwakiutl, a Haida, or a Tlingit the cultures of Northwest Coast natives as they once lived.

In this early period of museum anthropology, the reactions of many visitors to Northwest Coast art displays were most unfavorable. For example, during the 1876 Centennial Exhibition in Philadelphia, the Smithsonian Institution displayed a large portion of its Northwest Coast collection at its 8,000-square-foot space in the United States Government Building. Displayed alongside life-size papier-mâché and wax manikins of natives wearing traditional costumes, the Smithsonian's Northwest Coast objects, as well as other American Indian pieces, elicited intensely negative comments from the public at the Philadelphia fair. William Dean Howells, editor of *Atlantic Monthly,* said, "The red man, as he appears in effigy and in photograph in this collection, is a hideous demon, whose malign traits can hardly inspire any emotions softer than abhorrence." Another writer for the same journal described the Northwest Coast art at Philadelphia as "daubed with the most grotesque and barbarous devices, among which a lidless, browless eye recurs with disquieting frequency," and complained of totem poles "rudely carved into a series of hideous monsters one on top of the other, painted in crude colors" (Cole 1985:30).

The negative attitude toward the Indians that was held by the settlers who wished them removed from desirable lands, by the missionaries who wished to convert them to western ways, by Philadelphia Centennial fair visitors appalled by the grotesqueness of their art, was typical of many whites during the latter part of the nineteenth century. It is one of the ironies of history that a great institution founded by New York City millionaires would ultimately play a significant role in dispelling this attitude by means of splendid public displays of Indian culture. The American Museum of Natural History acquired the greatest collection of Northwest Coast art in the world as a result of a felicitous combination of supportive trustees, dedicated staff anthropologists, and a uniquely sympathetic president.

Fig. 17. "Reception Day at the American Museum of Natural History, 1875" (then located in the Arsenal in Central Park). *From Frank Leslie's* Illustrated News, *June 5, 1875. New York Historical Society photograph 33066, courtesy of the New York Historical Society.*

2 / The American Museum of Natural History

THE story of the establishment of the American Museum of Natural History has nothing whatever to do with Indians, for the group of New York millionaires who founded the institution had no notion that their museum would ultimately possess the most important assemblage of Northwest Coast art in the world. What really inspired the original trustees to establish a natural history museum was jealousy over the founding in 1860 of a science museum in Cambridge, Massachusetts. A charming and charismatic Swiss naturalist there, Louis Agassiz, accompanied by a following of faithful admirers, had persuaded the Harvard Corporation, the Massachusetts legislature, and several wealthy Bostonians to help finance a museum of comparative zoology.

When this new museum in Cambridge opened in November 1860, newspapers throughout the country carried laudatory stories describing its impressive array of scientific exhibits: row upon row of containers filled with preserved animals. To the modern museum-goer, accustomed to dramatically illuminated plexiglass cases, often explicated with slide shows and recordings, Agassiz's lines of bottles and jars might sound prosaic at best and uninteresting at worst. However, during the nineteenth century, a time of less sophisticated exhibition techniques and audiovisual display technology, this collection created quite a stir.

The Cambridge museum was noticed by several members of New York society. In December 1860, Henry Blodgett, wrote his friend William Haines that "Agassiz' success has started a lot of our people thinking" about the desirability of having such a museum in New York City." In 1861, the treasurer of Central Park, Andrew Haskell Green, included in his annual report a lengthy treatise on the value of having both an art museum and a natural history museum in his newly built park (Kennedy 1968:31–32). Although many other members of the New York City elite shared these opinions, the Civil War prevented anyone from seriously considering a money-raising campaign at that time.

At Harvard, Agassiz had trained a naturalist, Albert Bickmore, who observed with fascination his mentor's skillful handling of potential patrons and powerful legislators. Bickmore, intent on imitating and possibly even passing his mentor, decided that he too would one day establish a great natural history museum, in the richest metropolis in the nation—New York City. Not a man of great wealth who could himself endow such an institution, Bickmore had to await the opportunity to present his dream to prospective patrons.

Not long after the end of the Civil War, Bickmore learned of the availability of certain major European natural history collections consisting of several thousand mounted birds and mammals, as well as fish and reptiles preserved in alcohol. Bickmore believed that these specimens could form the nucleus of a new museum, and began in earnest to contact those New Yorkers who might be willing to purchase them. The well-educated young man enjoyed good connections, through whom he met Theodore Roosevelt, Sr., Joseph Choate, and J. Pierpont Morgan. These millionaires responded with interest to Bickmore's suggestion that a support group be assembled to raise money, first to purchase these collections and then to establish a museum for their display.

BEFORE long, Roosevelt, Choate, Morgan, and other wealthy New Yorkers had met to draw up plans for a natural history museum. In January 1869, a group of nineteen men passed the following resolutions:

Whereas, nearly all the capitals of Europe and more important cities in our own land, including Boston, Philadelphia, Washington, and Chicago possess instructive and valuable Museums of Natural History, while New York, notwithstanding its metropolitan position, is still destitute of such an institution. Resolved: that recognizing the necessity of such an institution as a means of recreation and education and desiring its establishment upon a scale commensurate with the wealth and importance of our great city, we have heard with much satisfaction that the opportunity is now presented of securing by purchase in Europe, the largest and most valuable collection of Natural History objects which have been offered for sale in many years. Resolved: that in our judgement immediate action should be taken to secure this or some other collection as a nucleus of a great Museum (Kennedy 1968:42).

On April 6, 1869, the governor of New York State signed legislation for the "purpose of establishing and maintaining a museum and library of natural science, of advancing the general knowledge of kindred subjects and to that end of furnishing popular instruction" (Oliver 1970:1199). And so the American Museum of Natural History was chartered with a dual mission: to promote scientific research and to provide public education. This institution would ultimately be supported jointly by public and private funds, with New York City providing the land, buildings, and maintenance, and private donations supporting the scientific staff and acquisitions.

Why were members of New York's upper crust so anxious to help found a museum to which they themselves would contribute substantial funds? A partial answer can be gleaned from the document drawn up by the original nineteen trustees, who pointed out that New York simply had to have a natural history museum similar to those that other cities already possessed. Philadelphia's Academy of Natural Sciences, Washington's Smithsonian Institution, and Cambridge's Museum of Comparative Zoology posed serious threats to New York City's desired hegemony over other American cultural and educational institutions. Immense competition existed between the various metropolitan centers of the young country, and while the citizens of New York felt justifiably proud that by the second half of the nineteenth century theirs had become the largest and wealthiest American city, they regretted the lack of a major emblem signifying its primary position. Like other Americans at this time, New Yorkers believed that cultural and educational institutions housed in impressively large buildings functioned admirably as symbols of the wealth, power, prestige, and importance of the metropolis in which they were situated.

Numerous members of the New York City elite believed that it was time to establish not only a major natural history museum, but an art museum as well, and soon the American Museum of Natural History and the Metropolitan Museum of Art had become realities. Albert Bickmore's intention in proposing the name "American Museum of Natural History" was to reflect what he hoped would be its ultimate position of scientific significance equal to that of the British Museum.

The desire to enhance New York's image was not the sole reason so many individuals supported the establishment of the American Museum of Natural History. After the Civil War, philanthropic humanitarianism and generosity had become valued qualities which the rich were expected to demonstrate; these late nineteenth-century capitalists gave back to their communities in the form of hospitals, libraries, colleges, universities, parks, concert halls, relief societies, old age homes, orphanages, and museums, a certain part of the vast fortunes they had accumulated through means both virtuous and suspect. Some of these donations were inspired by benevolent sentiments, a *noblesse oblige* on the part of the ruling class; others stemmed from a desire for immortality in the form of a brass plaque on a building (Bremner 1960).

Philanthropy at the end of the nineteenth century had a social dimension, for it was commonly believed that money spent for institutions such as libraries, schools, parks, and museums could uplift and educate the members of lower classes. The poor, particularly of immigrant populations, which in the 1860s and 1870s consisted mainly of Germans and Irish, and in the 1880s and 1890s of equally poor and more exotic-appearing southern and eastern Europeans, presented a serious problem to America, which many philanthropists believed education could solve. Many feared that without such socializing education, the poor would become disruptive.

During the Civil War, to protest the draft the Irish had instigated riots which left over a thousand dead, causing many native-born New Yorkers to lose confidence that law and order could be maintained among these restless newcomers. With almost half the city's population foreign-born, many living in horrible disease- and crime-ridden slums, others wandering destitute and homeless throughout the city, the native-born Americans of English descent felt their traditional way of life seriously threatened. In 1872, Charles Loring Brace drew the following frightening picture in his *Dangerous Classes of New York*:

All these great masses of destitute, miserable and criminal persons believe that for ages the rich have had all the good things of life, while to them have been left the evil things. Capital to them is the tyrant. Let but Law lift its hand from them for a season, or let the civilizing influences of American life fail to reach them, and, if the opportunity offered, we should see an explosion from this class which might leave this city in ashes and blood (Hammack 1982:8).

Since a constantly expanding work force was crucial for the continued growth of the American economy, curbing immigration was not a feasible option. The only possibility available to the old guard of American society to reduce the dangers posed by these newcomers was to develop a variety of means for their socialization. One method was to build parks, for it was believed that the natural world could help "civilize" the new Americans. Frederick Law Olmsted, designer of Central Park, clearly recognized the destructive potential of the "dangerous classes" in whose crowded slums disease flourished and among whom "disorders and treasonable tumults" were not uncommon. Believing that Central Park could promote calm, Olmsted described how its trees, lakes, and meadows would "supply the hundreds of thousands of tired workers, who have no opportunity to spend their summers in the country, a specimen of God's handiwork that shall be to them, inexpensively, what a month or two in the White Mountains of the Adirondacks is, at great cost, to those in easier circumstances" (Bender 1975:179).

In addition to offering the healthful benefits of the out-of-doors, Olmsted also believed that parks, by imposing on these people a sense of control and stability, "order and system," could play a significant social role (Tractenberg 1982:109). In 1870, Olmsted described the effect of Central Park on its poorer visitors: "No one who has closely observed the conduct of the people who visit the Park can doubt that it exercises a distinctly harmonizing and refining influence upon the most unfortunate and lawless classes of the city, an influence favorable to courtesy, self-control and temperance" (Bender 1975:180). He also hoped that the park, surrounded as it was by the elegant townhouses of the very rich, might educate the poor in a special way, by refining and uplifting them, and make them into desirable citizens of the city. Thus, parks would both expose the lower classes to the delights of nature, and also instill in them a profound sense of democracy and citizenship. Although Olmsted and his colleagues failed to spell out exactly how this uplifting and education was to occur, many of his day accepted without question the social value of parks.

Even more valuable for socializing the immigrants was education, which museums as well as schools provided. In a country being inundated with immigrants from Europe, to educate meant both to create loyalty to the new country and to inspire ideals of hard work, punctuality, and honesty (Carnoy 1974:245). At this time, both native-born Americans and many of the new immigrants truly believed education to be a panacea for all sorts of social ills. In order ultimately to ensure a pool of conscientious laborers and to promote social stability, many rich patrons donated substantial amounts of money to "educational" philanthropies.

When Albert Bickmore first proposed a natural history museum to members of the New York City ruling class, many supported his vision because they believed such an institution could play an important social role. John David Wolfe, a millionaire who had made his fortune in the hardware business (Tomkins 1970:71), wrote to Joseph Choate in 1869 that the presentation in a museum setting of the natural world would "add to the useful knowledge of the population of New York City . . . train them in useful habits of observation . . . and provide them with innocuous amusement" (Kennedy 1968:40). The museum would provide a valuable adjunct to the city's educational system, and serve to instill in both children and workers the values of the leaders (I. N. Phelps to William Dodge, 1869, in Kennedy 1968:41). When the first members of the board of trustees of the American Museum, in their 1869 resolution to establish "a great Museum," described the institution's potential for contributing to public education, they envisioned it as a means of socializing the newcomers to their city as well as diffusing useful knowledge about the natural world.

At about this time, George Goode of the U.S. National Museum in Washington, D.C., actively promoted the belief that museums of science could acculturate the country's masses to its values and social expectations. Even though he never explained the mechanism by which such socialization occurred, Goode fervently believed that museums could serve a major role in enhancing the educational and cultural level of all American citizens, new and old. Museums would provide continuing education to the country's working men and women and in so doing influence, for the public good, the morality of all Americans (Hinsley 1981:92).

The Museum in Manhattan Square

In April 1871, the newly chartered American Museum of Natural History opened its collection to the public in the Arsenal Building in Central Park (fig. 17). At the gala reception to celebrate the opening, the elite of New York City had the opportunity to see galleries of glass cases filled with stuffed and preserved animals, labeled with their Latin names and with descriptions of their salient features. This opening was a smashing success, and J. P. Morgan wrote the very next morning to Bickmore: "Every man I met today has congratulated me on the success of the Museum. I cannot tell you how pleased I am" (Kennedy 1968:58).

Before the Museum even had opened, the trustees knew they needed a far larger building than the Arsenal, and petitioned the legislature to pass a bill enabling the city to construct a permanent home for the Museum. At first the park commissioners offered the American Museum a site on the eastern edge of Central Park, called Deer Park, which was most appealing to the trustees; to their deep disappointment, the commissioners later changed their minds and offered Deer Park to the Metropolitan Museum of Art. In exchange, they gave an area then called Manhattan Square to the natural history museum. These rocky eighteen acres had originally been planned for a zoological park, but were abandoned when the numerous stagnant pools could not be drained. A museum employee left a colorful description of this area that would later become the West Seventies:

The region around was an unsettled district *in transitu* to something permanent and homogeneous. It was compounded in its pictorial aspects of several discordant yet picturesque el-

ements; it embraced old farms, ruinous landmarks of ancient New York, brand-new stores, sanitary of modern tenements, bewildering mazes of hovels clustered together over swelling knobs of rocky ledges, and pretty kitchen gardens lying in its deep depressions (Gratacap 1900:36–40).

Although few people lived in the area of Manhattan Square, and public transportation was not yet adequate—indeed, the "El" only went as far as 59th Street—predictions were that the city would expand northward. Finally the trustees accepted the site, and construction began in 1872.

The Park Department architect, Calvert Vaux, who also designed the Metropolitan Museum of Art, envisioned an immense building for the natural history museum that would reflect the significance of science in this greatest of American cities. At this time bigness was considered by many to be a primary American value—factories were big, corporations were big, farms were big, cities were big, and the country itself was big. As greatness was measured by bulk, it made sense for Vaux to design a monumental structure for the American Museum.

According to his original plan, the building was to be a huge square 270 meters on each side, surrounding four interior courtyards. An enormous central tower would rise from the building's center (fig. 18). Since such an architectural monument could not be built all at once, the first phase of construction completed only 7 percent of the entire proposed structure. In 1877, President Rutherford Hayes spoke at the opening of the first permanent building of the American Museum of Natural History in Manhattan Square (fig. 19). The guests at this event saw stuffed and skeletal mammals and shells on the first floor, birds on the second, Indian implements in cases lining the third floor gallery above the second floor, and fossils on the fourth floor (Kennedy 1968).

Fig. 18. Proposed plan of the American Museum of Natural History, 1875. 573

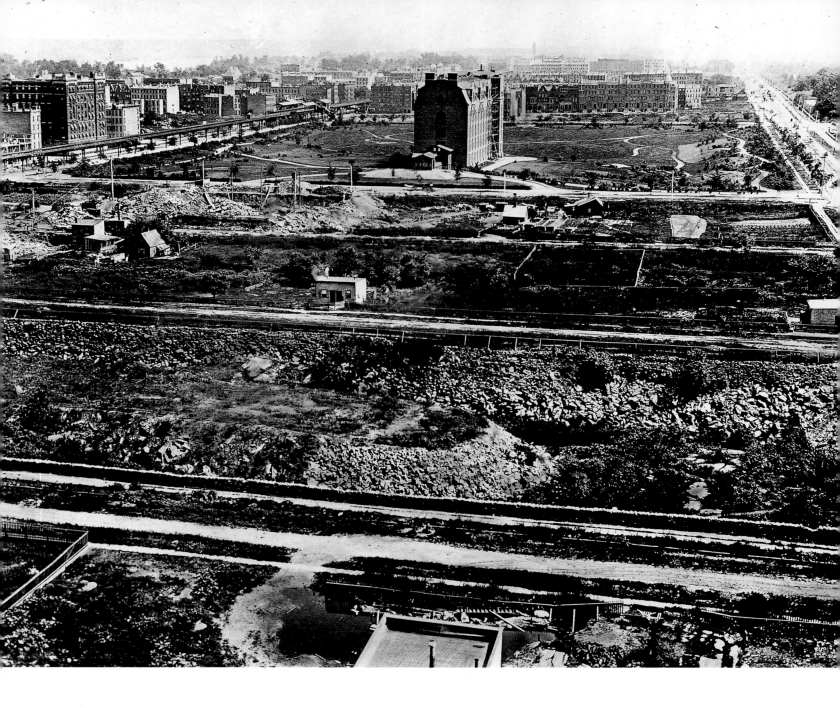

This splendid evening at which many trustees expressed great satisfaction over the final realization of their dream was unfortunately to be one of the last opportunities for enthusiasm and optimism about their institution for several years. As he wandered through the empty halls of an almost deserted museum just one day after the opening festivities, Bickmore was aware that "the Museum was too far from the settled part of the city to render it easy of access for the casual visitor. We could only wait and hope that the elevated railroad company would soon extend its lines north to 77th Street" (Kennedy 1968:69). It was not long before the trustees became concerned that the Museum's educational function was not being properly served since so few of their desired audience visited the institution. "No matter how fine the exhibits are," James Constable wrote to William Haines, "if no one saw them, what good are they" (Kennedy 1968:72–73).

Fig. 19. First section of the American Museum of Natural History, as viewed from the roof of the Dakota apartment building, Central Park West and 72nd Street. *H. B. Jackson photograph, 1879-81, 326322*

The poor attendance in these early years of the American Museum exacerbated its increasingly dismal financial situation. Between 1873 and 1879 the entire United States experienced an economic depression which contributed to the Museum's difficulties in fund raising, as pledges for support that had been made in good faith had to be withdrawn. The Museum fell deeper and deeper into debt, inspiring grave concern over its financial management and even some talk by certain trustees of the desirability of withdrawing support entirely (Kennedy 1968:73).

The situation became so critical that in 1880 the trustees decided to ask a member of the executive committee, Morris Ketchum Jesup (fig. 20), to study the future needs of the Museum in order to guide their planning. Like the other trustees, Jesup, a self-made millionaire, had little sympathy for the curatorial staff who, many believed, had caused the Museum's financial woes by purchasing for extravagant prices collections that these nonscientists believed were of dubious merit. He also had little interest in what Bickmore felt was the most important function of this institution, namely, scientific research.

Although Jesup started off his investigation skeptically, he soon came to admire and respect the professional staff. To the great surprise of the more critical trustees, his conclusion was that funds to the Museum should not be cut; instead, the institution should receive a larger income, reorganize its business, and erect better exhibits. Of particular concern to Jesup was the Museum's acquisition policy. Not long before, the trustees had purchased an invertebrate fossil collection for $65,000 which had scientific merit but little public interest; instead of acquiring such assemblages, Jesup recommended, the Museum should present for display those exhibits that appeal to the public most—like "lions and other big animals" (Kennedy 1968:79).

Jesup concluded his report with the comment that the Museum could be a "power for great good" for the city and its citizens (Kennedy 1968:79). He may have been responding, consciously or unconsciously, to a scathing attack on his class made July 4, 1880, by a *New York Times* writer identified only as RGW. This writer severely criticized the New York elite for their lack of support for cultural institutions and asserted that no "real museum" or cultural institutions existed that could be "regarded with pride by the citizens of the City, be useful for students, or be shown to visitors." Maybe Jesup wanted to demonstrate to New Yorkers like "RGW" that he shared their vision of this city becoming a cultural mecca. He certainly came to believe that value was not always to be measured with dollars; in his report to the trustees he asserted that "the highest result in life is often something that cannot be measured on the scales of the merchant (Kennedy 1968:79).

Because of Jesup's keen interest in the Museum and new understanding of its workings, when Museum President Robert Stuart resigned because of poor health in 1881, the trustees unanimously elected Jesup as his successor. During Jesup's twenty-seven-year tenure, the Museum realized its potential. Once president, Jesup devoted himself completely to his task, going each day to the Museum, spending time in the halls, speaking with visitors, studying labels to be certain they were properly instructive, and attending to the institution's finances. The trustees had appointed a remarkable and dedicated man to head the American Museum, for during the years of the Jesup presidency, the Museum was transformed into the institution equal in stature to the British Museum, as Bickmore had dreamed. By the first decade of the twentieth century, this great museum had become, largely as a result of the devoted service of Morris Ketchum Jesup, both an institution dedicated to educating the masses of New York and a major scientific research center.

Morris Ketchum Jesup 1828–1908

Morris Ketchum Jesup was one of the principal members of New York City's society during the second half of the nineteenth century. By the time he was twenty-four, in 1852, he had successfully entered into the then new field of railroad supply distribution. Through that and related business ventures, Jesup became a multimillionaire. This was a good period for entrepreneurial men to become involved in the railroads, for from the time Jesup began his railroad-supply business to the turn of the century, the railroads in the United States expanded from less than 13,000 miles to 230,000 miles. Such a constantly increasing market meant substantial profits for men willing to devote enormous energies to business.

As Jesup's wealth increased, so did his involvement with philanthropic activities. From the time he was in his twenties, when he helped found the Young Men's Christian Association, Jesup supported a large number of philanthropies with contributions of both time and money, often ending up assuming positions of leadership in these organizations. In addition to having been president of the American Museum of Natural History from 1881 to 1908, Jesup, at various periods in his life, was president of the Young Men's Christian Association, the New York City Mission and Tract Society, the Syrian Protestant College in Beirut, and the New York State Audubon Society; he also served as vice-president of the New York Institution for the Instruction of the Deaf and Dumb, the Union Theological Seminary, the American Society for the Prevention of Cruelty to Animals, and the Society for the Suppression of Vice; and he had been treasurer of the John F. Slater Fund for the Education of Freedmen (W. Brown 1910:2). These activities consumed so much of his time that in 1880, at the age of fifty-one, he decided to retire from business and devote himself full time to philanthropy.

Morris Jesup had no formal education beyond elementary school, although many members of his Connecticut family, including his own father, had been educated at Yale. With his impeccable pedigree—the Jesup lineage dated back at least to 1649; his mother's Sherwood line first arrived in the New World in 1632—coupled with a family tradition of supporting education, Jesup should have easily been admitted to Yale College. Unfortunately for the young boy, the senior Jesup, a businessman, lost his own fortune as well as his wife's inheritance in the great economic panic of 1837, plunging the family into financial crisis. Shortly thereafter, Morris Jesup's father died suddenly, leaving his wife to raise their eight children. This independent woman did not want to live with her father-in-law in Connecticut, and decided to move her entire family to New York City.

This change in circumstances forced the young Jesup to leave school at the age of twelve in order to support his widowed mother, depriving him of the future luxury of a college education. This great disappointment for the boy, whose family had a long tradition of ivy-league education, perhaps explains his commitment (which was at times almost an obsession) to educational philanthropy. In addition to his service at the Museum, Jesup made donations to Yale, Harvard, Princeton, Union Theological Center, Syrian Protestant College in Beirut, and to the black educational institutions, Hampton Institute and Tuskegee Institute. He also maintained a deep appreciation for the scholarly profession, and at one point expressed indignation at the low salaries and status of college and university faculty: "It is a shame that men who have given their lives to the highest cause should not receive from us the highest honor" (W. Brown 1910:236).

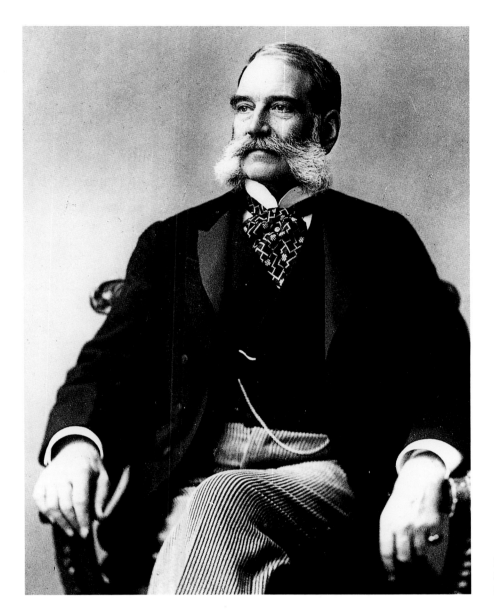

Fig. 20. Morris Ketchum Jesup, American Museum of Natural History president, 1880-1906. *2A5200*

Jesup had a profound sense of social commitment colored by a deep Presbyterianism. Like many other liberal-minded Protestants of the period, he concerned himself with the welfare of the poor and homeless, and supported missions which provided them food and shelter. One of his deepest objections to some contemporary Protestant churches was their ignoring of social problems; he felt that many people, rightly seeing the churches as class institutions concerned only with the rich, had become alienated from the "way of Christ." At one time he bemoaned the exodus of churches from the lower east side to more northern Manhattan neighborhoods, suggesting that this caused the area's "wickedness." "Do you suppose . . . that the wickedness would be what it is to-day if the churches which once stood on Grand Street and Broome Street and East Broadway and Henry Street and all those streets still remained as beacon lights of the gospel of Christ? No, it is the removal of the downtown church that has brought about in great measure the difficulties from which the city now suffers." (W. Brown 1910:89). Of course, by the time he spoke these words at the turn of the century, rather few people of Protestant denominations lived in this tenement area teeming with East European Jews and southern European Catholics, who would not likely have attended Presbyterian and Episcopal services if the Protestant churches had remained in the area.

JESUP'S faith in the potential of all, regardless of class, was genuine. This greatly influenced his belief in the educational mission of the American Museum, as is evident in his following statement made in 1884:

The advantage of your Museum to the multitude, shut up within stone walls, is that it affords opportunity to become acquainted with the beauty of natural objects and to study them in their usual aspects and conditions, and, out of the great number who look on vaguely and experience only the healthful excitement of a natural curiosity, one here and there may be found endowed with special aptitude and tastes, perhaps some child of genius whose susceptibilities and faculties, once aroused and quickened, will repay your expenditure a thousandfold (W. Brown 1910:157).

These words were in his report to the trustees when he urged them to see that a museum's value cannot be measured in terms of dollars.

Another noteworthy quality of Morris Jesup was his devotion first to abolitionism and then to the cause of black education. His abolitionist principles were reinforced shortly before the Civil War when he went to Richmond, Virginia, to negotiate a railroad project. After coming to a basic agreement on the terms of this project, Jesup's host invited him to see the "sights" of Richmond, which included a slave market. Jesup was horrified by the scene of a married man being stripped and examined—as he described it, like an animal—by prospective buyers who would remove him from his family. Later on he said, "I left the scene a sad and sober man, and took away with me a vivid idea of the horrors of slavery. I made up my mind that no State or community could prosper that sanctioned or allowed it. I thought the State of Virginia must sooner or later fall into disgrace, because her people could not maintain any idea of honor" (W. Brown 1910:71). Although an agreement on the Virginia railroad had been virtually completed, Jesup decided to disconnect himself from any business ties with the state, and quickly left Richmond to return north. (History proved him wise since war would soon destroy the economy of the South.)

After the Civil War, many northern liberals believed that education would solve all the social problems created by the recent freeing of the slaves. In 1882, Jesup and a Norwich, Connecticut, businessman, John F. Slater, launched a fund-raising drive to collect one million dollars to support schools which trained blacks for skilled and unskilled jobs. Funds from this and other sources supported the Slater-Armstrong Trade School in Hampton, Virginia, and a similar institution at Tuskegee. Jesup felt great enthusiasm for these schools of industrial education, and once said in reference to the Hampton Institute: "To me there have been many sides to the question of the uplifting of the negro. It is a question of sentiment, a question of education, and a question of industrial training. These three factors were combined . . . in this magnificent institution, where we see love and sentiment on the one side, education on another side, and work and the dignity of labor on the third side" (W. Brown 1910:78). Although such industrial schools had their drawbacks, educating as they did semiskilled and even unskilled laborers for industry rather than providing an academic training for future members of the upper middle class, Jesup's support of them reveals him to have been a concerned humanist, with deep sympathies for blacks and other oppressed peoples.

The Sunday Opening of the Museum

Despite Jesup's practical concern for the victims of social inequities, he maintained one firm opinion that many critics believed demonstrated a crass lack of sympathy for New York's working men and women. A profoundly religious man, Jesup insisted that the American Museum of Natural History be closed on the sabbath, as did the director of the Metropolitan Museum of Art across the park. The product of a strict and religious upbringing, Jesup later defended his sanction:

My parents were strictly orthodox, and, like other good people of their communion, believed in severe restrictions in regard to amusements, especially on the score of their danger to the young. I grew up believing that the rigid Sunday laws which I had seen enforced at home ought to be binding on all, and that such amusements as theatre-going, card-playing, and dancing were wicked (W. Brown 1910:18).

Jesup and other Museum trustees failed to recognize until rather late how seriously their attitudes on the Sunday opening affected their relationships with the city government. In 1881, Jesup tried to persuade the city's Irish Catholic mayor, William Grace, to support, along with the park commissioner, legislation in Albany for financing a new wing for the Museum, which had already grown too large for its current quarters. Although friendly with Jesup and the other trustees, the mayor was firmly negative, and even Joseph Choate and J. P. Morgan could not convince him of the desirability of helping the museum. Although Morgan claimed that Grace was simply uneducated and thus unable to understand the value of a museum (Kennedy 1968:89), it is quite conceivable that the mayor's reluctance was due to the unpopularity of President Jesup's and the Presbyterian trustees' insistence that the Museum be closed on Sunday.

The only day many workers who lived in New York City had off was Sunday, the one day they could not visit the American Museum (or the Metropolitan for that matter). A good number of recent immigrants to New York were Irish Catholics, who interpreted the refusal of the trustees to open the museum, which was partially supported by public funds, on Sunday as "just one more bit of Protestant meanness" (Kennedy 1968:91). It certainly prevented the Museum from realizing its goal of educating the masses, if those very people could not view the "civilizing" and "socializing" exhibits.

The question of the Sunday opening was actively debated in the newspapers. One man wrote to the editor of the *New York Times* (9 June 1885), objecting strenuously to the *de facto* prohibition against workers visiting the museums. The writer asserted that "there is not more harm in looking at a stuffed sea horse on Sunday than at the obelisk," referring to an Egyptian monument recently erected in Central Park, and, tongue in cheek, accused Mr. Vanderbilt of not being a good Presbyterian because he hadn't insisted on covering the obelisk on Sunday. A *Times* editorial (18 Nov. 1885) criticized those men of comfortable means (like Jesup) who recommend that all people stay at home or at church on Sundays; "to those who know what the allurements of New York tenement houses are, the advice to people who are doomed to inhabit them to spend Sundays 'at home' seems a piece of nasty satire." Another *Times* editorial (3 Jan. 1886) answered those trustees who seemed ready to withdraw their financial support for the Museum should it open on the sabbath with the statement, possibly ironic, that "they would be within their rights in resigning from the directorship of a horse railroad company that ran its cars on Sunday or of a club that opened its doors to its members on that day."

The *Times,* like most other newspapers of the city, objected to the imposition of these rich men's views on every New York citizen. Early in his presidency, Morris Jesup had provided funds for a large collection of specimens of wood from American trees used for building and manufacturing. This Jesup Collection of North American Woods, consisting of sections of tree trunks, polished planks, made from those trees, sketches of the trees' leaves, flowers, and fruits, was favorably received by the public and the press as soon as it went on exhibition. The media took this opportunity to encourage the Sunday opening. A *New York Times* editorial on the collection (30 Dec. 1886) first complimented Jesup's generosity and then suggested that if he so adamantly opposed the Sunday opening, he could insist that the collection he donated be "screened from the sacrilegious gaze of Sunday visitors" or bear a sign requesting that "his gift should not be looked at by them." The clamour increased for a change in policy, with petitions, articles, and letters.

Jesup argued vigorously against a Sunday opening, claiming that the sabbath was a rest-day and should remain basically religious. This was, he felt, for the benefit of the working man: "Break down this popular reverence for the day as a holy day, destroy this distinction between it and the week-days, and it will inevitably become a working day. . . . Open the Museum on Sunday, and it will be impossible to stop there." In addition to fearing the transformation of Sunday from a day of rest to one of work, Jesup had the frightening vision that if one opened the Museum, theaters, operas, circuses, and minstrel shows would follow, creating the terribly wicked "Parisian Sunday." In response to the argument that workers could visit the Museum only on Sunday, Jesup proposed that employers give their help Saturday half-holidays to enjoy the city's cultural and educational institutions (W. Brown 1910:176).

During the late 1880s as the Museum acquired more and more collections, it found itself with a serious space shortage and needed more money from the city to expand its exhibition halls. Although the mayor by that time, Abram Hewitt, was somewhat more friendly toward the institution than Grace had been, he refused all help unless it opened on Sundays. The Board of Estimate at one point had actually recommended that the American Museum and the Metropolitan each receive $5,000 more per year to cover the costs of Sunday openings; the trustees, ever firm in their principles, turned down the offer.

Despite all the pressures, Jesup and the Museum held firm. Although they did finally agree to open the Museum on two evenings a week as a compromise in 1888, this did not satisfy their critics, who became even more vociferous in the early 1890s. Finally, in April 1891, the Metropolitan Museum of Art's trustees, led by the politically practical realist Joseph Choate, voted to have a Sunday opening. The American Museum waited to see what would happen to the museum across the park.

Newspapers followed the Metropolitan's opening with great attention. On the day after the first Sunday opening in June 1891, the *New York Times* carried an article referring to the opening as "a grand success." According to that story, the crowds were orderly, no one was injured, and the eleven park police assigned to duty at the museum that day had nothing to do. Apparently many people had voiced concerns over the kinds of people who would attend the Sunday opening; some had feared that decidedly poor, potentially disruptive people might come; "Those who expected to see Essex Street Polish Jews and Thirty Ninth Street and Eleventh Avenue residents in ragged clothing and delapidated hats were agreeably disappointed." Instead of the feared working class hoards were well-dressed and well-behaved citizens of the city including workers, clerks, and salespeople (*New York Times,* 1 June 1891).

It was not long before the astute Joseph Choate, also a member of the American Museum's board of trustees, convinced several fellow members to change their votes and accept the offer of more funds from the city for Sunday opening. Finally the American Museum of Natural History became accessible to all the public. Although Jesup voted against the Sunday opening, his official biography, written twenty years after this episode, claims that he discerned a difference between demoralizing amusements and uplifting, educational ones which were appropriate for the sabbath. In addition, he "recognized that a policy which allowed the rich to enjoy pictures and works of art in their own homes on Sunday, while it denied the poor the privilege of similar recreation in the public galleries, to the support of which they contribute by taxation, was an intolerable discrimination" (W. Brown 1910:177).

After the Protestant officials acquiesced to the demands of Irish politicians, the Museum found it much easier to deal with the city government. Jesup, Bickmore, and the city leaders worked together to obtain funding to expand the Museum, which acquired five more wings and a completed south facade. Jesup soon realized the benefits inherent in this new collegiality, and claimed in a letter to Choate that he and Bickmore "could work with the Irish politicians more easily than the so-called honest Yankees of twenty-five years ago." Later, Jesup actually made an arrangement with Tammany leader G. W. Plunkitt in which he gave available jobs to the politician's constituents in return for support in City Hall and Albany for the Museum's expansion (Kennedy 1968:106–8).

U NDER the leadership of a man committed to excellence, who finally formed new alliances between the politicians and the American Museum of Natural History, the stage was set for the flourishing of a great institution. As soon as he assumed the presidency of the Museum, Jesup made it clear that he wholeheartedly supported its dual mission, for he firmly believed that it should become a great research institution, with many funds expended for expeditions and scientific publications. Coupled with this research mission was an educational one, for Jesup also believed that the Museum should be an agency for popular instruction, and, as his biographer stated, "nothing delighted him more than to see its rooms thronged with working men and children from the tenements studying the labels which set forth in simple language the nature of the objects which the cases contained" (W. Brown 1910:5).

During the period of the Jesup administration, New York City increased its contributions to the support of the Museum from less than $1,500 per year before 1880 to $120,000 per year at the turn of the century. The value of the collections, as well as the amount of the private endowment, was in the realm of several million dollars. From six people, housed in three departments in the 1880s, the scientific staff grew to twenty-eight by 1905, representing eleven departments (Osborn 1911).

During the early years of his administration, Morris Jesup became especially interested in anthropology. Other museums, such as the Smithsonian Institution, had already started assembling impressive arrays of Northwest Coast Indian artworks, and Jesup felt it was time for the American Museum of Natural History to begin acquiring such remarkable Native American objects as well. Soon after Jesup became president, the American Museum would receive, through the generosity of a fellow trustee, Heber Bishop, a sizeable collection of Northwest Coast art, including one of the Museum's most treasured possessions, the twenty-one-meter-long canoe that now sits proudly in the 77th Street lobby. During the following years, thousands of Northwest Coast artworks would pour into this institution, providing the people of New York City with a wealth of information about the Indians who lived thousands of miles away from them on the rainy, foggy Northwest Coast.

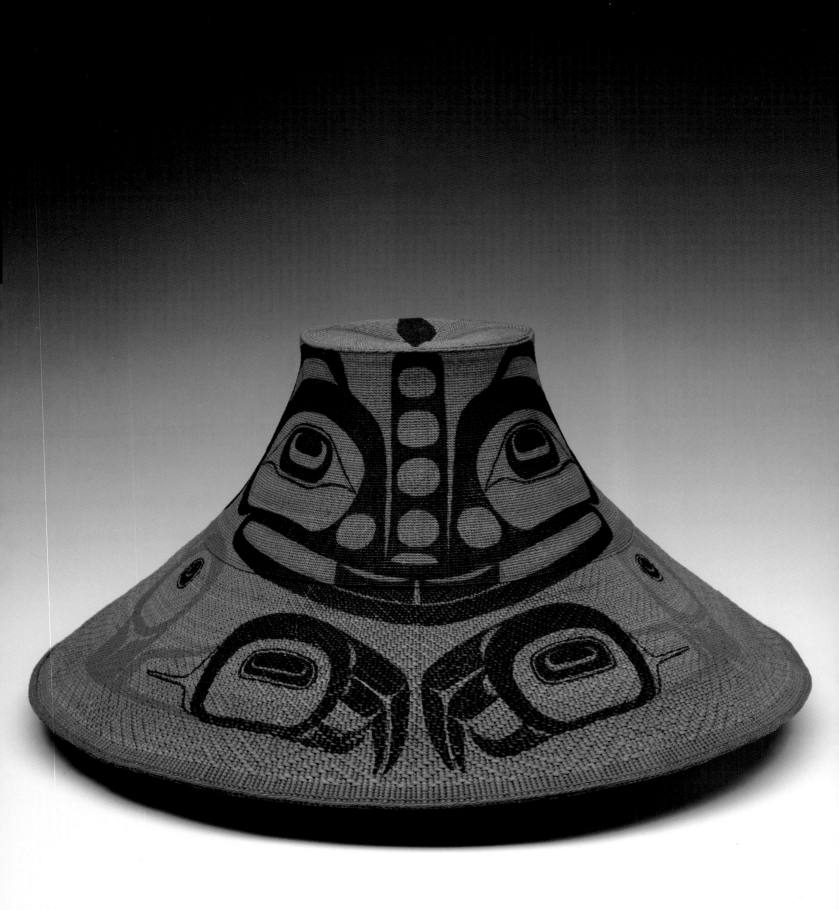

3 / The Earliest Collections

I N 1883, the *New York Times* carried a story entitled "One Credible Museum" (15 May 1883). In this article the writer praised the American Museum of Natural History, complimenting the systematic arrangement and excellent cataloguing of its collections, describing it as a place for serious study of, among other subjects, ethnology, and recommending that it be granted an extension and more facilities for its educational work. Its growth was due, according to this article, to the devotion and enthusiasm of an unnamed man who was clearly Morris Ketchum Jesup. The *Times* reference to the growing strength in ethnology at the Museum was just one indication of the attention Jesup had paid from the start of his presidency to the development of the anthropological collections.

The Anthropology Department itself had been established in 1873. Whereas in museums today, scientific staff are experts trained in a particular discipline, the members of early American Museum departments could make no such claims of professionalism. The Anthropology Department was perhaps the least professional of all, having not one anthropologist or archaeologist on its staff. Moreover, the individual assigned to head this department was, of all people, Albert Bickmore. Bickmore's lack of ethnographic expertise disturbed no one, for the principal purpose of the Anthropology Department was to form a collection of artifacts for exhibition, not for scientific analysis. The Museum expected neither Bickmore nor any of the other department members to conduct any research on or write about the ethnological collections.

One type of art that appealed especially to the Museum trustees was that from the Northwest Coast. By the early 1880s many American natural history museums were looking with envy at items that had been displayed at the Philadelphia Centennial Exhibition and that now formed part of the fine collection of the Smithsonian Institution. Numerous factors contributed to what Douglas Cole (1985) refers to as the "scramble for Northwest Coast artifacts" after the 1875 Centennial Exhibition—a genuine desire on the part of museum officials to further understand the natural world to which they believed the Indian belonged; a scientific curiosity about other cultures; a competitive urge to outdo other museums which were also engaged in collecting Indian artifacts; and, perhaps unconsciously, a desire to display in a museum the remains of those barbarian cultures the United States had so recently subdued. Probably as a result of a combination of these factors, the American Museum of Natural History, which in 1880 possessed nothing from the Northwest Coast other than a group of Chinook skulls, decided that it was time to engage in serious collecting of art from this region.

Pl. 23. Painted basketry hat. H 17.5 cm, D (base) 35 cm. *Collected by Powell, 1880–85. 16/692*

Heber Bishop and Israel Powell

One of the Museum's trustees, Heber Bishop, decided in 1880 to help the American Museum of Natural History by providing funds for the acquisition of an art collection from the coast of British Columbia and Alaska. Bishop's first fortune had been made in Cuban sugar as a planter and refiner; after a period of political instability forced him to move to New York, he made another fortune in gas, iron, and railroads. This wealthy patron of the arts suggested that in addition to providing substantial support for a large scale acquisition of Northwest Coast materials, he would himself actually engage in some collecting in the course of a trip he was to take to the Pacific Northwest (Cole 1985:82–83).

To formalize the agreement between the American Museum and Heber Bishop, in May 1880, Bickmore wrote the trustee a letter detailing the institution's wish to establish a Northwest Coast art collection, referring to the necessity of "salvaging" the rapidly disappearing Indian cultures and describing the types of articles he hoped Bishop would purchase:

It has been, from the foundation of our Museum, a favorite part of the whole plan with us, to try to obtain in time an exhibition of the Ethnology and Archaeology of our own American continent on a complete and exhaustive scale and we have felt the need of making every effort to secure what now exists before it shall be destroyed by civilization. If, therefore, through your generous assistance, the existing tribes of the Northwest Coast could be represented in the Museum, it would form a department that would be particularly interesting in itself and of increasing rarity and importance. . . . We desire the dresses, implements and weapons of all kinds from each of the principal tribes as far north and including Alaska, particularly those beautifully carved pipes and ornaments in stone from the Queen Charlotte Islands. The two important points in which to secure such objects appear to be Victoria and Sitka (Bickmore to Bishop, 28 May 1880).

Shortly after receiving this correspondence, Bishop traveled to the Northwest Coast on a business trip, and purchased $155 worth of silver jewelry, canoe models, small spoons, and other tourist art. It was at this time that he met the Indian superintendent of British Columbia, Dr. Israel Wood Powell of Victoria. Powell had been informed already of Bishop's interest in Northwest Coast art. In March of 1880, Bickmore had written him to say that a "friend who is generously inclined toward the Museum" was probably going to help fund a Northwest Coast collection, and to request that someone in British Columbia be made available to help collect for the Museum. While he may have enjoyed his brief foray into Northwest Coast art collecting, Bishop was quite agreeable to allowing Powell to do the actual purchasing and trading with the Indians (Cole 1985:82–83).

Israel Wood Powell was a medical doctor from Victoria appointed by the government in 1872 as superintendent of Indian Affairs for coastal Indians in British Columbia. Having limited experience with and minimal knowledge of the Indians prior to his appointment, Powell seems to have been ill-suited for his position. Apparently, the British Columbian members of Parliament had, for political reasons, insisted upon this local physician, who carried on a medical practice while supervising all the coastal peoples out of his Victoria office (Fisher 1977:180).

It was not difficult to find fault with this Indian superintendent. At the time of Powell's appointment, Governor Douglas, who had spent years in British Columbia as a Hudson's Bay Company official, expressed concern over his lack of experience with the Indians and ignorance of their ways. Nine years later, on a trip to the Coast, Franz Boas criticized Powell's lack of knowledge (Fisher 1977:180). In a letter to his parents (2 Nov. 1886), Boas wrote: "Today I finally made my much-talked-of-visit to Dr. Powell. . . . He does not seem to know very much about Indian customs. At any rate I shall be able to do better than he. He was very gracious . . . and promised to help me in every possible way. Fortunately I shall not need his help" (Rohner 1969:51–52).

The role of the British Columbia Indian agent was rarely easy or enjoyable. Although ostensibly appointed to advise and protect the natives, in most disputes between settlers and Indians, these government officials sympathized with the settlers. In addition, their attitudes toward their charges were often paternalistic and patronizing, and it was not uncommon that an agent would speak freely of the Indians' "foolishness and ignorance." On the Northwest Coast, Indian agents actively supported the passage of the anti-potlatch law, and then spent much time and energy trying, unsuccessfully for many years, to enforce it (Fisher 1977:206–7). Although Powell himself seems to have been a humane individual, who in some disputes between Indians and whites ruled that the Indians had been the aggrieved party, his position of enforcing governmental policy usually placed him in a position of antagonism toward the natives and their traditions he so poorly understood (Fisher 1977:182–86).

Powell's ignorance of Indian ways presented no obstacle to his success as a collector of Northwest Coast art. Prior to the American Museum's request for his services, Powell had acquired some of the art that the Smithsonian Institution displayed at Philadelphia, and had purchased numerous pieces for the National Museum of Man in Ottawa. His American Museum of Natural History assignment presented Powell with only one problem, and that had to do with his being a Canadian in the employ of an American museum; in a letter to Bickmore, he stated, "I should not like to undertake another work of this kind, and when looking at [the objects] this morning, I really felt guilty of a want of patriotism in sending the collection out of the country (Wardwell 1978:24).

Despite his pangs of guilt, Powell would ultimately acquire a spectacular collection of Northwest Coast art for the American Museum. The Museum officials desired monumental and old pieces, and wrote Powell explaining their wishes. In one letter Bickmore asked Powell to "get the highest post you can possibly obtain . . . and the most impressive," to fit under a new 178-foot-high dome that would be constructed for that purpose (Bickmore to Powell, 14 Oct. 1880). In another letter, Bickmore described his interest in old but well-preserved nontourist pieces: "we seek objects that have been used and perhaps blackened with age but not chipped and broken. The bright, new, clean carvings have too much a shop-like appearance as if not made for worship or other use but only for sale" (Cole 1985:83).

The Bishop-Powell Collection

From 1880 when he received these instructions, until 1885 when his purchasing relationship with the American Museum effectively ended, Powell sent to New York 791 pieces worth a total of $2,174.09 (Cole 1985:83). Following instructions to purchase monumental sculpture, Powell sent back several Haida totem poles and house posts; although perhaps not the tallest on the coast, these became the earliest heraldic columns in the American Museum's possession. The Museum also acquired an extensive array of smaller artworks that the Northwest Coast Indians had used during their vivid ceremonies. East Coast museum-goers could now begin to get some sense of the artistic and ceremonial richness of the remote cultures of British Columbia and Alaska.

Pl. 24. Comb made from tusks of a pig. L 15.5 cm. *Collected by Powell, 1880–85. 16/902*

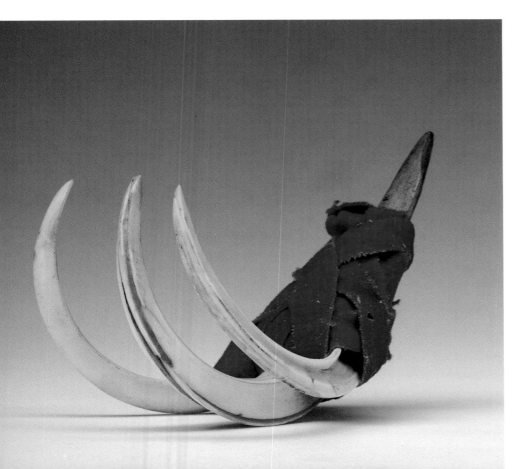

A good deal of potlatch art arrived in New York City as a result of Powell's collecting efforts. The Haida eulachon bowl (pl. 19) held the rich oil into which hosts and guests dipped dried salmon; the beaver headdress (pl. 15) decorated the forehead of a nobleman at the feast. Of considerable significance as a symbol of social rank was the conical hat made of woven spruce roots (pl. 23) decorated with the painted image of the beaver. When worn, both the spruce root hat and the wooden frontlet displayed the toothy face of the chief's crest hovering above his own face, creating a union of the living human and the mythic animal that reinforced the intimate connection of the man and his heritage.

During their celebrations, the Northwest Coast Indians performed elaborate dances accompanied by percussive music. One of the most exquisite musical instruments in the Powell-Bishop collection was a rattle collected from the Tsimshian (pl. 25). The body of this rattle represents Raven, a mischievous and powerful mythological being. Some conjecture that this bird is in the process of performing one of his most admirable acts: stealing the sun. It seems that prior to this event, a malevolent creature, unwilling to share the sun's warmth and light with humankind, kept the celestial body hidden in a box. Raven tricked this selfish being into letting him into the box, and he quickly picked up the treasure with his beak and flew away. On the rattle, a small reddish object can be seen in the raven's mouth: that is the sun which is about to be spit out into the sky to illuminate the world.

A variety of other enigmatic images appear on the instrument. On the raven's back is a frog leaping toward a reclining humanoid wolf thrusting its vivid red tongue into the frog's mouth; near its tail is a round, open-eyed face whose beaklike nose curves sharply and enters its own mouth. Carried by the elite at feasts and rituals, these raven rattles were highly prized objects of considerable aesthetic merit to the Northwest Coast Indians.

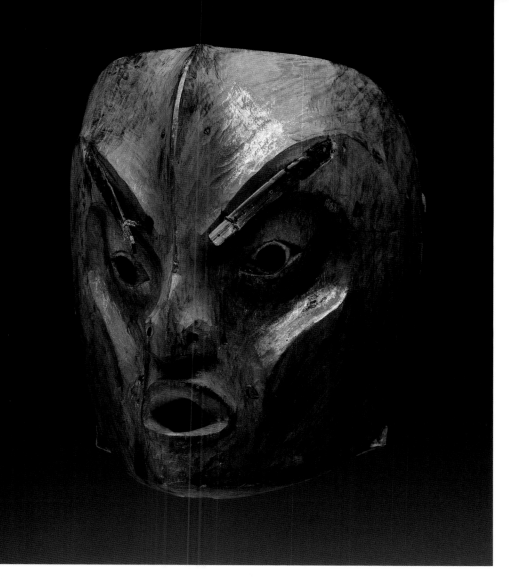

Pl. 25. Tsimshian raven rattle. L 35.6 cm.
Collected by Powell, 1880–85. 16/292

Pl. 26. Kwakiutl mask with movable eyebrows.
Heiltsuk. H. 25.5 cm, W 20.6 cm. *Collected by
Powell, 1880–85. 16/597*

Pl. 27. Tsimshian wooden mask, with shredded
cedar bark and carved wooden skulls. L 83.7 cm.
Collected by Powell, 1880–85. 16/576

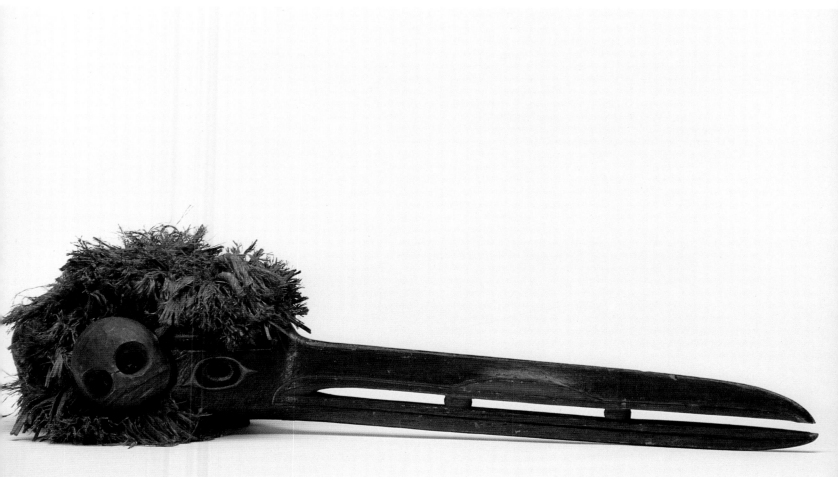

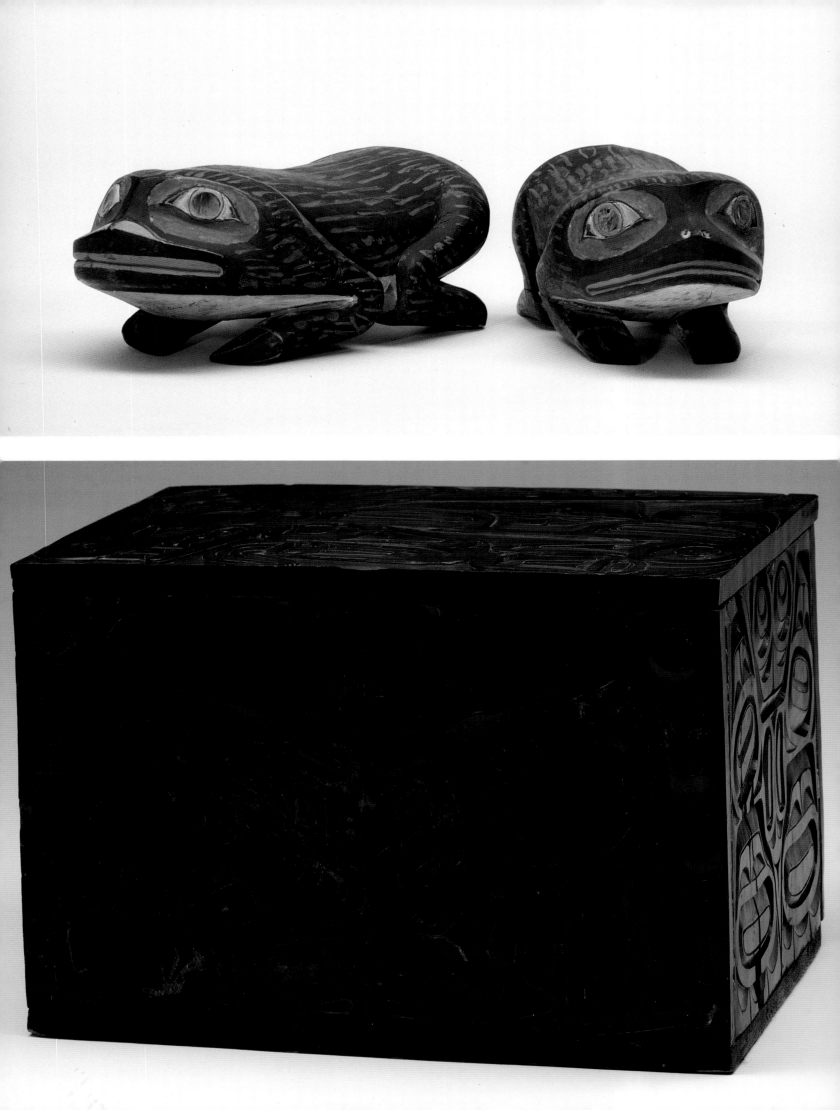

From Heber Bishop's generosity, the American Museum received artworks that constituted the beginnings of what was to become an exceptional collection of Northwest Coast masks. A Heiltsuk piece (pl. 26) has skin pulled tightly over its face, boney ridges projecting along its cheeks, eye sockets, brows, and down the middle of its forehead, an open mouth, and upraised brows lending an expression of surprise. From the Tsimshian came a mask, worn during secret society performances, depicting a long-beaked crane with skulls nestled in its shredded cedar bark "feathers" (pl. 27).

Pl. 28. Kwakiutl wood carvings of frogs representing crest beings. L 35.2 cm, H 13.6 cm. *Collected by Powell, 1880-85. 16/573*

Pl. 29. Haida argillite box. H 20.5 cm, W 19.5 cm. *Collected by Powell, 1880–85. 16/687*

Pl. 30. Haida argillite model totem pole. H 55.2 cm. *Collected by Powell, 1880–85. 16/554*

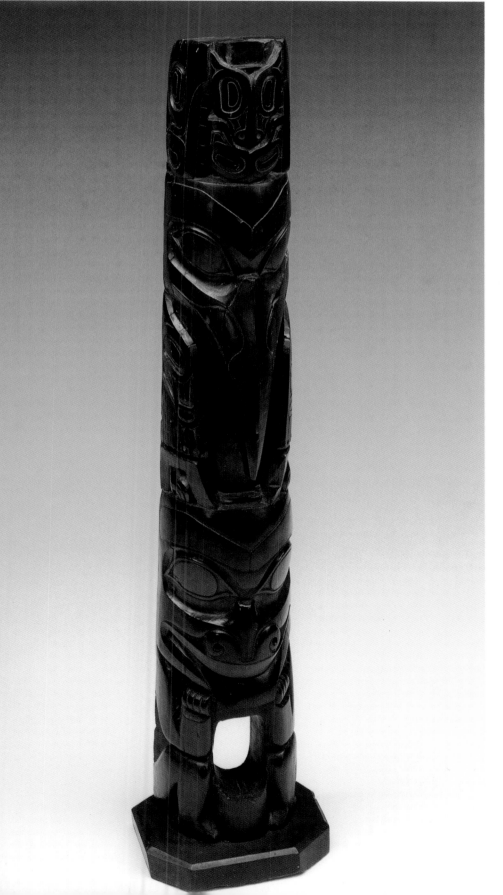

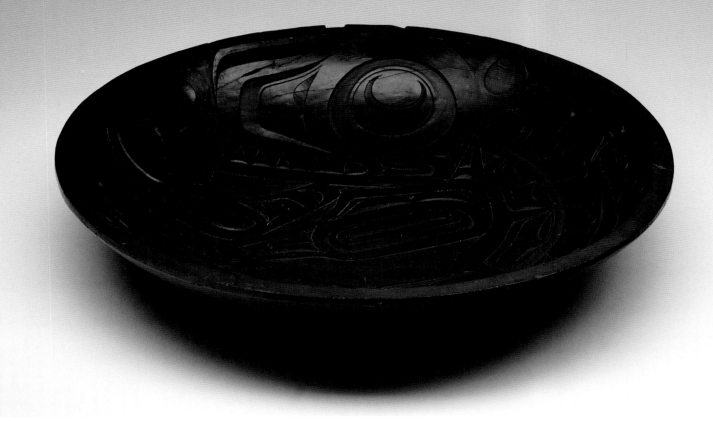

Pl. 31. Haida argillite dish, incised to depict a killer whale. D 42 cm. *Collected by Powell, 1880–85. 16/605*

WHILE the Northwest Coast artists created bowls, hats, rattles, and masks for use at their own ceremonies, carvers of the Queen Charlotte Islands made one type of art not for local consumption but for the tourist trade. Among the numerous Haida objects that arrived in New York City were several sculptures made out of argillite, a soft carbonaceous shale that hardens when exposed to air. The Haida had first begun producing argillite carvings during the early nineteenth century for sale to the white traders and sailors who wished to return home with souvenirs made by local Indians. These "curiosities"—typically imitations of functional objects—had no use and can thus be thought of as commodity-type artworks created to satisfy a market demand. At first, the Haida carvers manufactured imitations of pipes in argillite, but by the 1880s were creating miniaturized replicas of boxes, bowls, and totem poles, as well as illustrations of certain myths (Sheehan 1981; Macnair and Hoover 1984; Wright 1979, 1980, 1982, 1983, 1986).

In the American Museum's collection of argillite carvings are a stately model totem pole (pl. 30) and a circular bowl depicting a killer whale in shallow relief (pl. 31). The Haida carver usually tried to represent the entire body of whatever animal he was illustrating, even when, as is the case with the dish, the shape of the object did not easily lend itself to the shape of the animal's body. To adapt the contour of the killer whale to the dish, the artist curved its body into a nearly complete circle so that its large-eyed face almost touches its tail.

Pl. 32. Haida argillite carving of bear mother.
H 24.2 cm. *Collected by Powell, 1880–85. 16/575*

Another Haida carving that Powell purchased depicts a mythic theme that be-
came very popular and much in demand by the white consumers of argillite
sculpture, the bear mother (pl. 32). The bear-mother myth describes the adven-
tures of a high-ranking woman who, when out in the woods on a berry-picking
expedition, stepped on some bear excrement and proceeded to curse (out loud
but to no one in particular) the animal defecators and insult their cleanliness. The
bears heard all this and as they could not tolerate such insolence, decided that the
disrespectful woman had to be punished. To do this, a bear transformed himself
into a handsome man who approached the woman and seductively asked her to
follow him to his mountain home, which she did, only to become partially bear-
like herself. The products of their union turned out to be little creatures that
looked like bears but which, like their father, could metamorphose into human
form. On the argillite carving of this woman nursing her bearcub child, the bear
mother herself appears in the process of an animal-human transformation. Clad in
an elegant blanket and wearing the large shelf-like labret that connoted her high
status, the woman is indisputably Haida; however, the rough fur covering her
cheeks and the large paws emerging from beneath her drapery signify a clear af-
filiation with the animal world (Barbeau 1953, 1957).

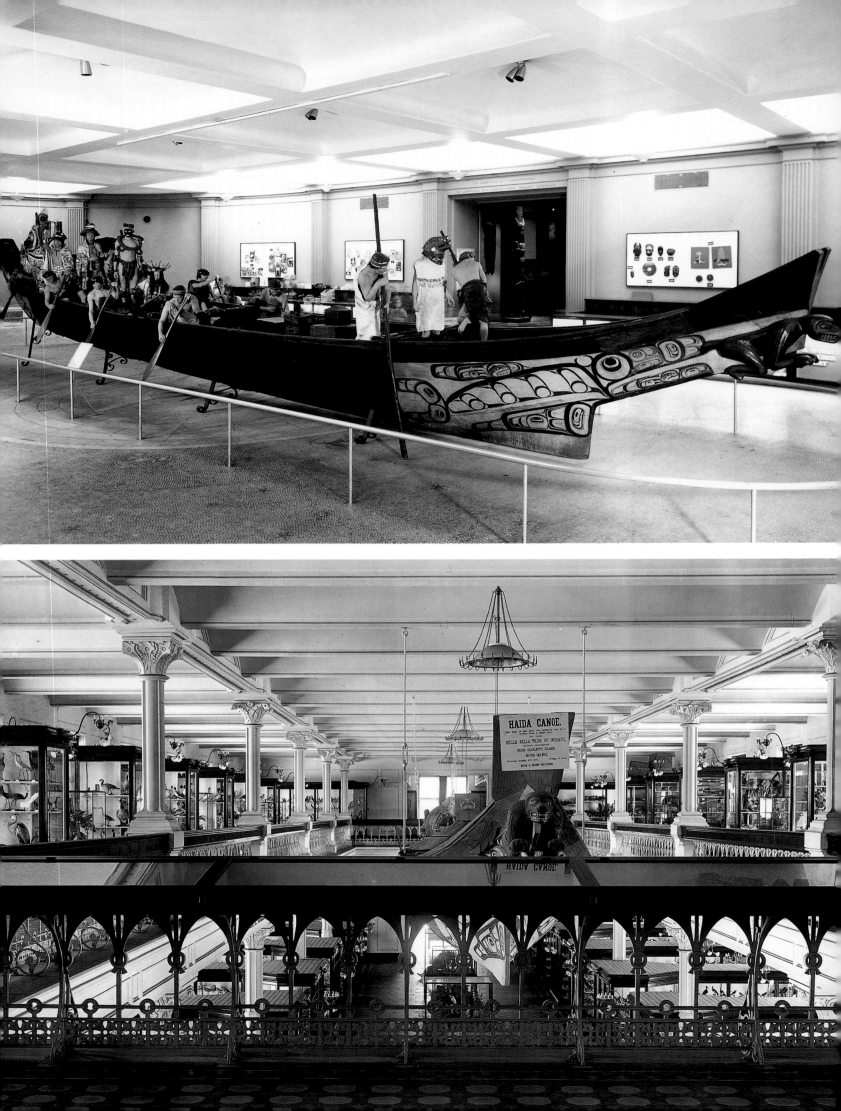

The most extraordinary item of the Powell-Bishop collection was the twenty-one-meter canoe, the largest Northwest Coast canoe in any museum and a remarkable example of Northwest Coast manufacture (fig. 21). In this region of indented shoreline, myriad islands, and steep, impenetrable forests, boats offered the easiest means of transportation. While most Northwest Coast canoes held only a few passengers, this exceptional example, sturdy enough to withstand the pounding of ocean waves, could carry more than thirty people. The carver had adzed out a hollow in a single log of red cedar, poured water into it, and added hot rocks. Softened by hot water, the log stretched wider as the carver inserted wooden thwarts.

The American Museum canoe was probably made by the Haida, who manufactured many such ocean-going canoes for themselves and for trade with other coastal peoples. After the canoe had been purchased, perhaps by a mainland group, an artist had decorated the prow and stern with delicate, calligraphic-like paintings of a killer whale and a raven, and had attached to the bow a three-dimensional carving of a crouching animal.

Before sending this enormous boat on its long trip to New York City, Powell expressed deep concern "that considerable damage may be sustained before the monster arrives in New York." After purchasing the canoe at Port Simpson, Powell hired a group of Haidas to paddle it from the Skeena River to Victoria. In that city, the canoe was loaded onto the deck of a steamer bound for San Francisco, then was moved onto a Pacific Mail steamer and shipped to Panama. To cross the isthmus without damage, and avoid being broken at turns, the canoe was placed on two flatcars and securely attached to the forward one, free to swing loosely on the greased guys of the rear car. Once on the Atlantic side of the isthmus, the canoe was placed on yet another mail steamer bound for New York City.

Fig. 21. The Northwest Coast canoe as it presently appears in the American Museum's 77th Street lobby. *328838*

Fig. 22. The Northwest Coast canoe as it appeared shortly after arriving at the American Museum in 1883. At this time, the ethnology collections were displayed in part of the gallery above the second-floor bird collection. Ethnographic materials can be seen in the cases to the right. The canoe itself is suspended from the ceiling. *489*

Fig. 23. From below, a view of the Northwest Coast canoe suspended above bird collections. *Photograph taken shortly after 1883. 487*

Although trustees and friends of the Museum, including Henry Villard of the Northern Pacific Railroad and Trenor W. Park of Pacific Mail Steamships, covered most of the expenses for this transport, the Museum had to pay the seven dollar charge for a horse-drawn dray to cart the canoe from the city docks to West 79th Street (notes on the canoe, Anthropology Department, AMNH; Cole 1985:83–84).

Suspended from the ceiling in the Museum gallery (figs. 22, 23), the great canoe became a hit with visitors. On April 1, 1883, the *New York Times* carried a story entitled, "The Museum Curiosities: Rare and Valuable Additions to the Collections," which, although misidentifying the vessel as "of Thlinkit make," commented on the canoe's "graceful outline" and declared that "it is safe to say no institution in the world contains so interesting a specimen." The article then went on to praise numerous other objects purchased by Heber Bishop, including the horn spoons which "would seem more likely to be found on a civilized table than to be used for holding blubber and the like."

After describing the skill with which the Northwest Coast artists carved and painted masks and headdresses, and complimenting the "tasteful decoration" of the argillite plate, the reporter commended the ingenuity of the raven rattle, "colored in the highest style of barbaric art." In a comparison of this display to that of other Indians of the United States, the reporter opined, "it is remarkable to note that in this distant part of the continent are a number of tribes more advanced in the ruder arts than their more southern contemporaries." Thus, unlike the Philadelphians who found little of merit in the Northwest Coast Indian art displayed at the Centennial, some New Yorkers reacted enthusiastically to these extraordinary paintings and carvings.

Photography on the Northwest Coast

Some of Israel Powell's most interesting acquisitions were the photographs taken by Edward Dossetter, a professional photographer who accompanied the Indian agent on an official inspection tour of Indian villages in 1881. Although we tend to think of masks, charms, and totem poles as the typical artifacts of ethnographic peoples, many early collectors on the Northwest Coast traded in another commodity as revelatory of Indian culture as carvings and paintings. These were the photographs of natives and their villages which white photographers sold on the curio market.

Prior to his 1881 trip with Dossetter, Powell had taken several such inspection tours accompanied by professional photographers—Richard Maynard in 1873 and 1874, and O. C. Hastings in 1879 (A. Thomas 1982:67–69). Powell, who had a great sense of history, viewed these trips as significant retracings of the great exploratory voyages of the late eighteenth-century Europeans, and often asked for photographs of the same scenes that eighty years earlier some shipboard artist had sketched. When he visited the Nootka, he wrote in his report that many people were absent, and "I was sorry not to be able to renew my acquaintance with the chief Ma'quinna, the descendent of the Ma'quinna of Cook, Mears, Quadra and Vancouver, one hundred years ago. . . . I took a photograph of the village, and, as a matter of curious comparison, I have added another taken from a sketch Vancouver, made in 1790" (A. Thomas 1982:69). To record the historic dimensions of his own trips, Powell had his photograph taken in a variety of settings, such as O. C. Hastings' print of the superintendent surrounded by the Masset Haida, standing before Chief Wiah's Monster House (see fig. 11).

The earliest photographs of Indians on the Northwest Coast were small (2" × 4") so-called *cartes de visite*, portraits taken during the 1860s in Victoria studios by professional photographers and sold as curiosities to colonists and travelers. At this time, glass plates had to be developed in the darkroom immediately after exposure. With the invention of the dry glass plate in about 1870, darkroom work could be postponed until after the photographing sessions, freeing the photographer to leave his or her studio and, on the Northwest Coast, travel to remote regions and photograph nature as well as culture, white settlements and Indian villages. A market developed for these pictures. On the one hand administrators and military personnel wanted permanent records of their charges and their lands, while on the other hand tourists wanted to adorn their Victorian mantlepieces with visual records of their trips to the glorious and fascinating Northwest. Photography became much simpler and more accessible to all, when in the 1880s George Eastman invented his Kodak, which used flexible film on roles of 100 exposures that could be sent to Rochester for developing and printing (Blackman 1981:63–64, 1982a:87–88).

On his 1881 trip with Powell, Dossetter took an impressive assortment of photographs of both people and village views. Some of the most beautiful images are those of Haida villages such as Skidegate (figs. 8, 9) and Masset (fig. 24) that show with almost magical clarity the forest of intricately carved totem poles thrusting toward the sky, proudly declaring the status of the families who lived in the large houses behind them. In addition to photographing individual buildings, such as a house from Bella Coola (fig. 25), Dossetter took pictures of structures such as the Reverend William Duncan's Metlakatla church (figs. 15, 16, 26).

Fig. 24. Haida village of Masset.
Dossetter photograph, 1881. 24422

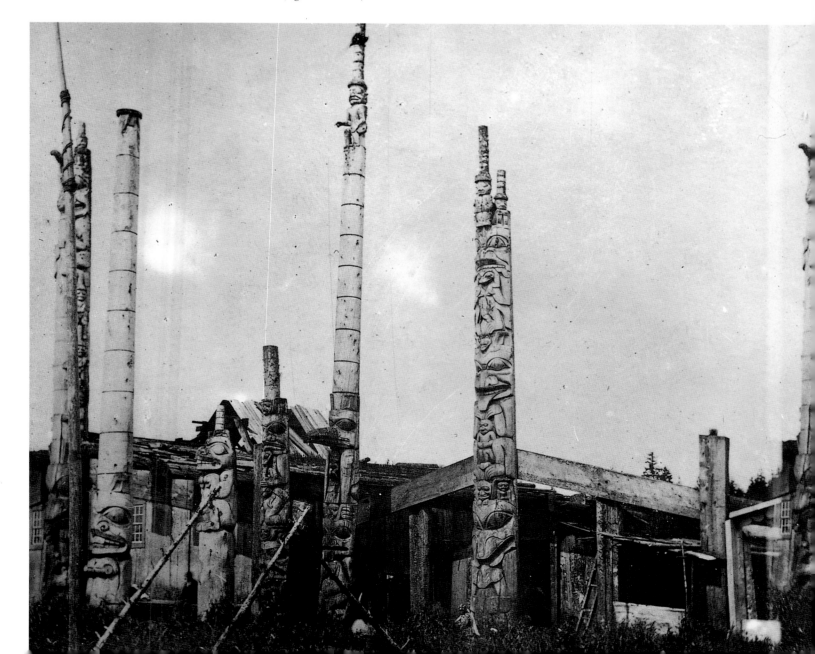

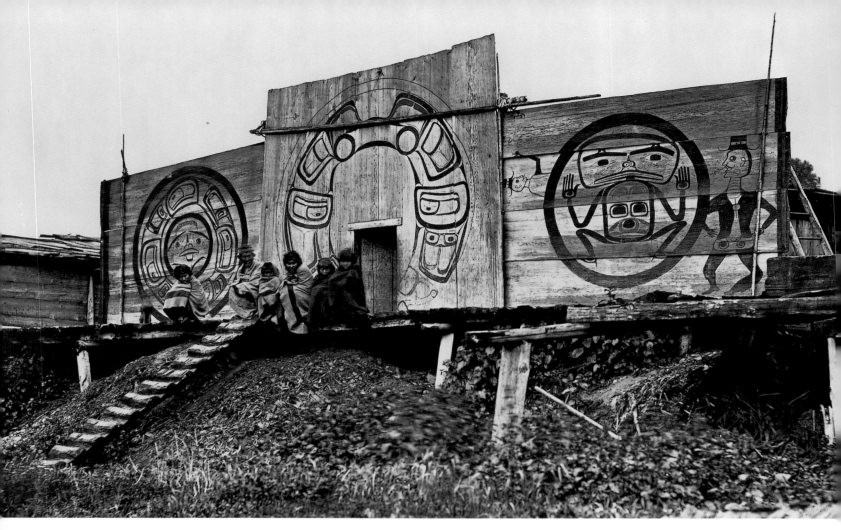

Fig. 25. Bella Coola village.
Dossetter photograph, 1881. 32951

Fig. 26. Interior of the church at Metlakatla.
Dossetter photograph, 1881. 42299

Since the natives viewed their images as marketable commodities, they often insisted upon payment before allowing Dossetter, or most other Northwest Coast photographers, to photograph them. We can assume, for example, that the four Masset "chiefs" (fig. 27) who posed in their ceremonial costumes, with one exposing his elaborate chest tatooing and two wearing masks, received handsome compensation from Dossetter for the privilege of photographing them. The same goes for the two lively eyed aristocrats from Skidegate (fig. 28), who, wearing western garb, stand before the base of a carved post, creating an intriguing portrait of the traditional and the acculturated (Blackman 1982a:94; Thomas 1982:73), and probably the sombre group of Haida from Yan (fig. 29). Not nearly so directly confrontative to the photographer was the "old Hydah woman" from Masset (fig. 30) wrapped in a Hudson's Bay blanket, who turns her face, full-lipped from the by now rare labret, away from the camera in modesty or shyness.

The Dossetter prints, along with the prints of other photographers who explored the Northwest Coast at the end of the nineteenth and the beginning of the twentieth centuries, provide a context for the magnificent artworks Powell sent back to the American Museum of Natural History. Because Powell knew so little about Indian culture, he simply crated the masks, costumes, totem poles, and canoes and sent them to New York City. These photographs, which showed costumes and masks being worn, totem poles standing before huge houses, canoes lined up on crescent-shaped beaches, restored to these museum artifacts the cultural context from which they had been so rudely separated.

Fig. 27. Haidas of Masset village. At right stands Chief Xa'na; second to left is the powerful shaman K!oda'-i; two other individuals are shamans wearing masks. *Dossetter photograph, 1881. 337179*

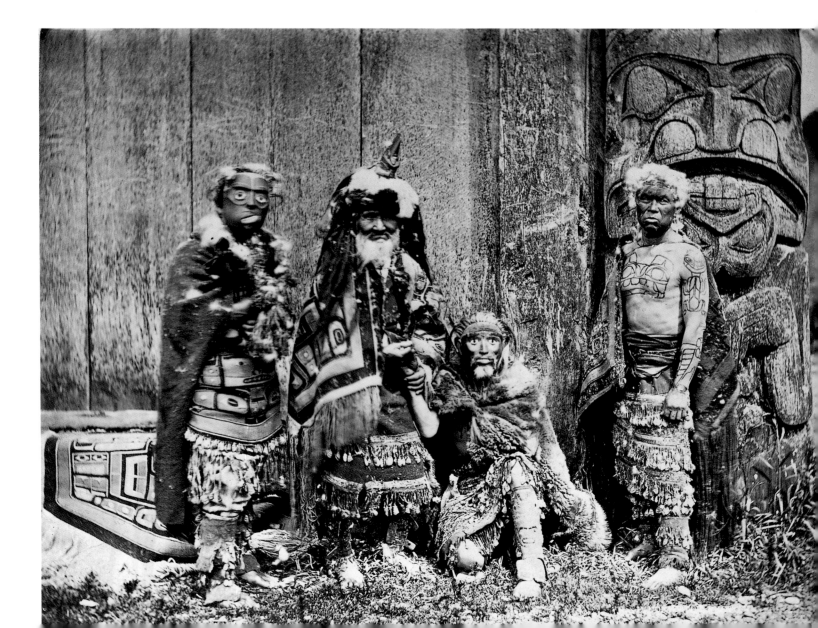

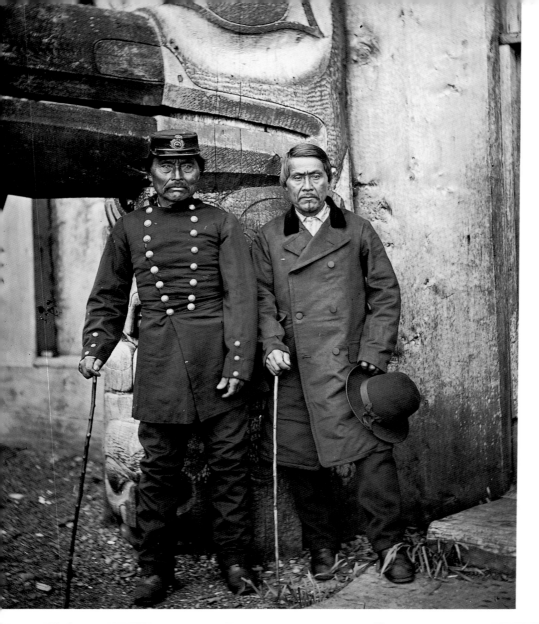

Fig. 28. Two Haida chiefs standing before the frontal carvings of one of the houses in Skidegate village. *Dossetter photograph, 1881. 42263*

Fig. 29. Haidas of Yan village. *Dossetter photograph, 1881. 44310*

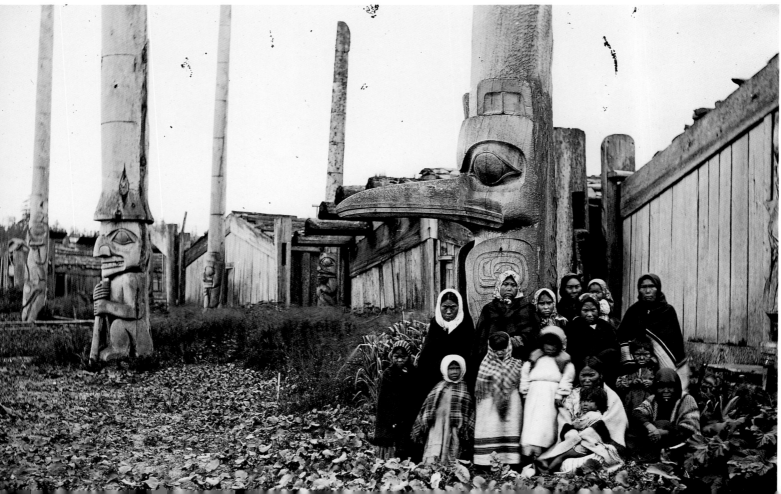

Fig. 30. Haida woman of Masset village shown wearing a labret. *Dossetter photograph, 1881. 42270*

The Emmons Collection of Tlingit Art

With the Powell collection installed in the American Museum's exhibition hall, and duly admired by the press and the public, Bickmore was moved to purchase more Northwest Coast art. An array of objects, including a Salish board carved in shallow relief with a skeletal man with a schematic face (pl. 33), were purchased in 1891 from a private collector, James Terry.

Although extensive, the Terry collection was nothing compared with the extraordinary acquisition of over four thousand pieces of Tlingit art purchased between 1888 and 1893 from naval lieutenant George Thornton Emmons (fig. 31), introduced to Bickmore by Heber Bishop. Emmons had gathered his enormous collection while stationed in Alaska. Unlike Powell, Emmons became an expert on the culture of the Indians with whom he traded, and sent detailed notes on the meaning, function, and general cultural significance of the objects he sent to New York City.

Pl. 33. Salish wooden board; relief carving
depicts human skeletal figure. H 180 cm. *Collected
by James Terry, 1882. T22193*

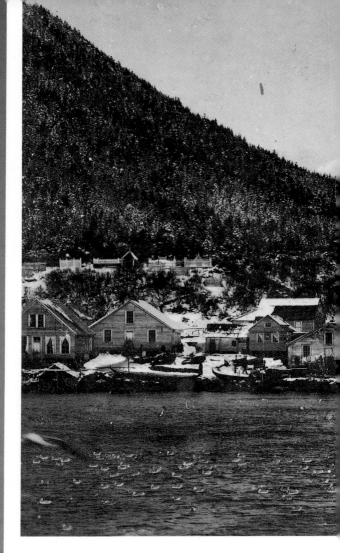

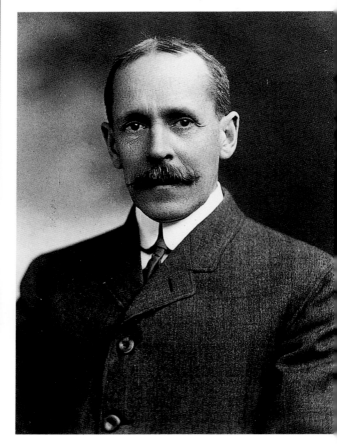

Fig. 31. Lieutenant George Thornton Emmons,
U.S.N. *328741*

Fig. 32. Sitka, Alaska, 1889. *124888*

George Thornton Emmons (1852–1945) was a remarkable man who seemed never quite able to fit comfortably into white society. His father, a long-time and successful naval officer who reached the rank of rear admiral, was a stern and practical man who set high standards for his immensely talented and highly intelligent but less than conventionally successful son. Emmons experienced a series of failures, the first of which involved his education when Annapolis rejected his application to study there. The Naval Academy only admitted him after President Grant, who was a friend of the elder Emmons, appointed the young man to the institution. Although he managed to graduate in 1874, after attending Annapolis for four years, he ranked twenty-eighth in a class of thirty, a most undistinguished record for the son of an admiral. Emmons first served on ships in the Atlantic and Mediterranean, and then in 1882 was stationed in Sitka (fig. 32) in what could not have been meant as a promotion (Low 1977:4).

Here he quickly discovered a group of people who admired him and whom he came to admire—the Tlingit Indians (fig. 33). This was certainly a most unexpected situation for a man raised in a conservative household of white Protestants, the son of a man who, after having visited the North Pacific region in the mid-nineteenth century, wrote his wife that Alaska was a place populated by "the ignorant half naked savage race" (Adm. Emmons to wife, 15 Nov. 1857.*) Emmons soon found himself spending more time with the Alaskan Indians than with his fellow white officers, who doubtlessly were perplexed by the appeal the Tlingits had for this easterner. So obsessed did Emmons become with the Tlingits that he devoted as much spare time as possible to traveling among their myriad islands and dramatic fjords, often in a Haida canoe, to speak with the Indians (in Tlingit), to learn of their traditions, to take voluminous notes on their culture, and to purchase their artworks. He made many close friends, such as Chief Coudawat, an especially powerful nobleman from Chilkat (fig. 34).

* I am indebted to Jean Low for this correspondence.

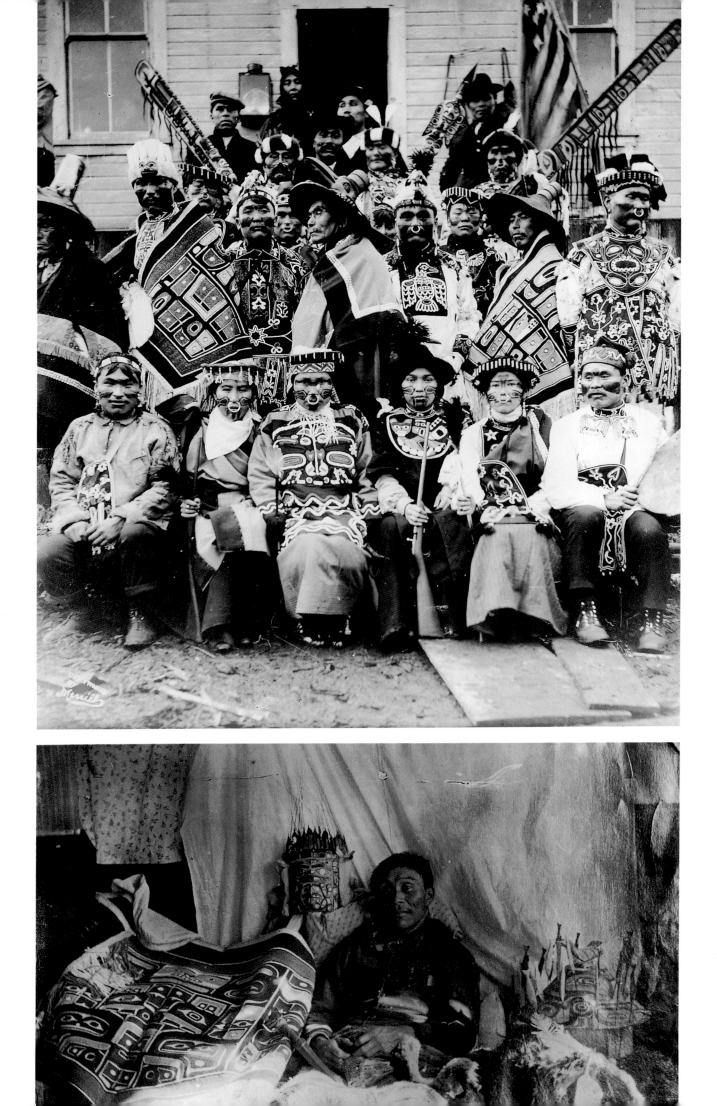

Although he had never received any anthropological training, Emmons recognized that the artworks he collected had religious and social significance, and thus regularly asked the owners of a piece he purchased to share with him as much information as possible about its use, symbolism, significance, and history. This information, which accompanied the pieces he sent to the American Museum, typically lacked two items that Emmons certainly could have easily included had he so wished: the exact geographic sources of the objects and the name of the informant who supplied explanatory data. By the time Emmons was collecting among the Alaskan Indians, other people, either employed by museums or by independent entrepreneurs, were combing the Coast, trying to purchase the tallest poles, the most complicated masks, the most beautiful charms. Thus, while Emmons provided tremendously detailed explanations of the pieces he collected, he intentionally omitted information that these competitors would have found useful, and indulged in secrecy in order to prevent their getting an edge on him.

The Indians appreciated Emmons's respect for their culture and art, and recognized that his attitudes toward them differed from those of other whites. As a consequence, many noble Tlingit families welcomed the lieutenant to their potlatches, at which he could observe firsthand the function and discover the meaning of objects he collected. He learned, for example, that the most valued artwork a chief could wear was the conical hat depicting a crest animal (such as pl. 6, a monumentally sculpted heavy piece representing a killer whale). Indicative of great wealth as well as military prowess was a headdress called the "bear's ears" (pl. 7), an imitation of the ears of a bear covered with abalone squares, each of which had a value of several dollars.

Since Emmons treated the Tlingit with respect, and displayed such genuine interest in their art and culture, these Indians were far more receptive to his interventions in their affairs than they were to other whites. Early in his stay in Alaska, Emmons was assigned to subdue a "riot" in Auk village, not far from the new Juneau gold camp. To settle this dispute, Emmons certainly could have resorted to brute force, but instead met with the chief of the village, Cow-wy-chee, and asked his assistance in devising a means to prevent bloodshed. Emmons's personal bravery, his courteous treatment of the Indians, his understanding of their customs, and his esteem for their nobility impressed Cow-wy-chee and formed the basis of what would become a long and intimate friendship (Low 1977:4).

Whites rarely comprehended the Indians' attitudes toward life and property. Emmons, who seems to have had an almost intuitive understanding of Tlingit values, on numerous occasions helped whites and Indians avoid misunderstandings. For example, in 1887, a Canadian survey party wanted to hire a group of Tlingit to pack them over the Chilkoot Pass. These Indians, very experienced at crossing these high mountains with heavy packs, would have nothing to do with the Canadian request, but refused to explain why. As they needed the Tlingits' services badly, the Canadians turned to Emmons for help. Emmons described his exchange with the Indians:

Calling the tribe together we met in a clearing in the willows. The men in many colored blankets sat in a circle, and listened in silence as I told them that it was our wish that they should assist the party instead of suffering the loss of over a thousand dollars by refusing to handle the hundred-odd packers. I asked them why they made an exception of Ogilvie when they would pack any other party. For some minutes they sat in silence with their heads down in their blankets, then the chief arose and made a fiery speech saying that King George men (Englishmen) in the days of their fathers had fired on their camp and killed three of their people and as no compensation had ever been made they refused to have any relations with them (Low 1977:6).

Fig. 33. Tlingits at a potlatch held in Sitka on December 9, 1904. *Merrill photograph, 1904. 328740*

Fig. 34. Tlingit Chief Coudowat of Klukwan surrounded by some of his crest objects. *Photograph taken 1892. 11213*

It seems that two generations back, a Hudson's Bay Company steamer had fired on some relatives of this Tlingit group, killing several people. According to the unwritten law of the Tlingit, the Hudson's Bay Company, or any other Englishmen, should have recompensed the survivors for their losses either with lives of individuals of equivalent rank, or with money. Emmons, who understood this equation of life and money, somehow managed (he never explained how) to convince the group to accept the assignment (Emmons n.d.).

The Princeton–New York Times Expedition to Alaska

In 1886, Emmons's intimate knowledge of southeast Alaska made him a valuable member of an expedition led by Lt. Frederick Schwatka and sponsored by Princeton University and the *New York Times* to climb Mount St. Elias, a peak in the Yakutat region, the northernmost section of Tlingit territory. Also on the expedition were Heywood Seton-Karr, a British alpinist, and William Libbey, a wealthy Princeton professor of physical geography who enjoyed spending his summers on expeditions to exotic and far off lands.

Sailing from Sitka on July 16, 1886, the expedition arrived in Icy Bay in the Yakutat region on a windy July 19. The surf that day was ferocious, and Schwatka, already impressed by Emmons's bravery and abilities, asked him to land the first small boat. As Schwatka said later, "Emmons was known to be a man who would take any risk within the bounds of reason to accomplish a duty he was sent to do and his experience in the surf was sufficient to justify a good knowledge of that uncertain method of landing a boat and its effects" (Low 1977:7). There were some tense moments as the men on the deck of the ship lost sight of Lt. Emmons as he disappeared several times behind violent, foamy, five- to six-foot waves. Happily, soon enough Emmons appeared on the beach and helped the others set up camp.

During the attempt to scale Mount St. Elias, someone carelessly threw away a can of baking powder half-filled with arsenic intended for use in poisoned wolf and fox bait. One of the Indians on the trip found the can and despite Libbey's warnings that the material was poison and should be discarded immediately, brought it back to Yakutat, where the arsenic made its way into some Indian bread.

Libbey discovered that the poison had not been thrown away when some women approached him with the can, asking why everyone who ate the bread made with the "baking powder" became sick. He went to their house and had them all drink coffee and instructed them on how to use a feather to induce vomiting; although most of the Indians took his advice and recovered, some felt no faith in white men's ways and instead summoned a shaman. Much to the dismay of Libbey, Seton-Karr, and others, the shaman could not cure a poisoned child by means of his spiritual incantations, and the child died (Baird 1965; de Laguna 1972:187–94).

The shaman, whose healing ministrations the expedition members were allowed to watch, displayed a collection of ritual articles which Libbey must have noticed with interest. Indeed, Libbey, who was not a mountaineer himself, intended not to scale Mount St. Elias on this trip but instead to collect specimens of Northwest Coast Indian art for Princeton's Museum of Archaeology and Geology. The Yakutat Tlingit engaged in a lively trade with whites of such items as baskets, silver jewelry, and crude carvings, which appealed to tourists but were of limited value for those, like Libbey, intent on collecting traditional artifacts of the "vanishing Indian." Although Libbey, with Emmons's help, did purchase some excellent masks and bowls from the Yakutat Tlingit, he was not fully satisfied with his activities in the region until a cache of shaman's artifacts was discovered.

One evening, Libbey was presented with an array of masks, rattles, charms, and other magical paraphernalia that had been removed, perhaps that very day, from a shaman's grave located in a remote section of the bay. It is possible that it was Emmons himself who discovered that shaman's grave and removed its contents, for over the years he had become particularly skilled at locating these extraordinary caches. The question of whether or not this removal constituted grave-robbing was delicately glossed over by Seton-Karr's description of this event:

Whenever a *shawaan* dies his charms and other articles that he has used are placed in boxes, buried with him, and left to rot unless rescued as curios, for no Indian will touch them. As no Indian even dares to approach the grave of a medicine-man, the abstractions can never be discovered or lamented. In the evening the two sacksful were spread out on the floor in the captain's cabin for inspection, and comprised, among other things, a quantity of masks of painted wood, a leather shawl ornamented with sea parrots' bill, and a crown of wild-goats' horns (Baird 1965:10).

The Tlingit may not have resented Emmons's removing the magical paraphernalia from shamans' graves, for these Indians had intense fear of the power within those objects.

Libbey could return quite happily to Princeton, now that he had acquired a rare collection of Tlingit shaman's art. The mountaineers on the expedition, unfortunately, could not claim such success, for they failed to reach the summit of Mount St. Elias (indeed, it would be Harvard University, rather than Princeton, that would ultimately be able to place a flag atop this peak). Undaunted, Lieutenant Schwatka left Alaska, only to embark on a new adventure in Africa. Seton-Karr returned to England and wrote a book, *Shores and Alps of Alaska*, which contained vivid descriptions of the healing seances of the Tlingit shamans. And George Emmons remained on the Northwest Coast, to continue observing these Indian healers in action and acquiring from graves their magical artworks (Low 1977; Baird 1965).

Tlingit Shamans

The members of the Mount St. Elias expedition, although delighted with the artworks from the shaman's grave, found little of merit in Tlingit shamans themselves. They were not, however, as vociferous in their antipathy to shamans as were the missionaries, who called shamans loathsome and contemptible and worked hard to remove them from positions of power. The missionaries had an uphill battle, for the Tlingit regarded with a combination of respect, fear, awe, and admiration these supernaturally powerful individuals whose responsibility it was to cure the sick, control the weather, accompany war parties, send spirits to spy on enemies, and ensure an abundance of fish and berries.

Albin Johnson, a missionary among the Yakutat Tlingit between 1889 and 1906, wrote a description of shamans titled "An Evil Side," which left no room for doubt about his assessment of their merit: "the status they occupied among the people was egotistic, supercilious, self-important, hated, keeping the people in a certain fear and in the deepest darkness." One of Johnson's great moments was his wife's missionary success with one particular shaman. After Mrs. Johnson spent a long time with this old man discussing "the love of Jesus," she invited him to church. Much to everyone's delight, he arrived, wearing new clothes and a short haircut. Since much of the shaman's powers resided in his long unkempt hair (fig. 35), this shaman's new coif symbolized his complete acceptance of the new faith (de Laguna 1972:722–23).

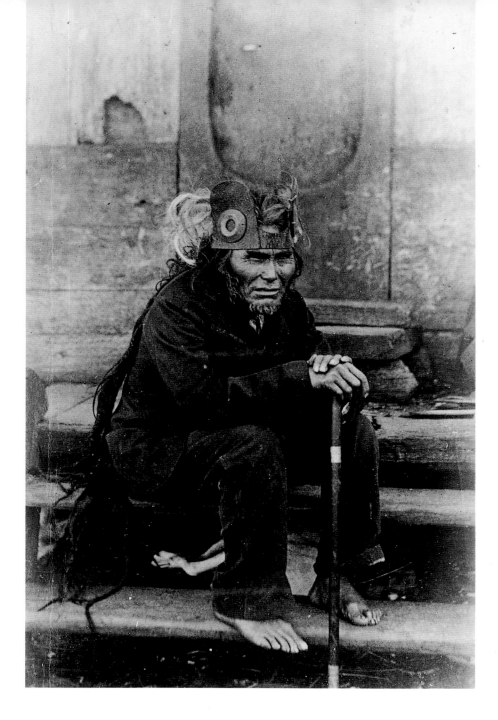

Fig. 35. Tlingit shaman Tek-'ic of Yakutat.
Photograph taken c. 1888. 41618

Not always were conversions absolute and unconditional. In 1888 one shaman held a public performance in which he cut his hair, renounced his practice, and rushed into the ocean to purify himself. Although this might have seemed genuine to most whites who observed it, Emmons had his doubts. Commenting on this performance, Emmons stated: "I believe that all of this was meant for effect, to satisfy legal conditions [the shaman it seems had been arrested for his activities], and at heart he remained a shaman, for he retained all his paraphernalia and much of the influence of his past" (Emmons n.d.).

Lay Tlingit also publicly renounced their association with shamans, only to turn to them when in despair. Naturalist John Muir, who traveled around southeast Alaska in 1879 and 1880, met many Tlingit who made convincing speeches about the depth and sincerity of their acceptance of Christianity and their denial of shamanism. At one point he met a properly converted Stikine nobleman whose son had fallen seriously ill. The chief dutifully went first to the missionary for medicine, but when his son did not immediately recover he became discouraged and consulted a shaman.

To diagnose the cause of illness, the shaman instructed his spirits to help him look through his patient's body. They informed him that a spirit had stolen the boy's soul in punishment for an inappropriate comment. It seems that the boy had made fun of a crawfish in the water by saying, "Oh, you crooked legs! You can't walk straight; you go sidewise." The Tlingit believe that animals can understand human speech and react intensely to insults. The crawfish became so infuriated at the boy's comments that it seized his soul and took it into deep water, causing an illness which would never be cured until the soul was returned to his body. The worried father asked the shaman to retrieve the stolen soul and restore it to his son's body. Since, like modern physicians, Tlingit shamans commanded considerable sums for their services, this particular shaman answered that this would be an expensive job, perhaps costing fifteen blankets (Muir 1979:236–37). Muir does not inform us of the outcome, but since this "converted" Tlingit was sufficiently wealthy to afford the fee, it is likely that he paid the shaman's price.

It was rare for any white person to find anything of value in the Tlingit shaman—except, of course, for Lieutenant Emmons whose interest in these manipulators of the supernatural was genuine. Perhaps it was his sympathetic nature that inspired so many Tlingit shamans to share their experiences with Emmons and permit him to view their performances. One Tlingit man described to Emmons the process by which spirits informed young boys that they were to become shamans. It was usually at the age of puberty that a prospective shaman received the "divine calling," by first hearing a vibrant buzzing in his ears, and then falling to the floor in a trance. While in this altered state of consciousness, the young boy saw an opening in the sky through which light streamed toward his head, transporting spirits from the heavens into his body (Emmons n.d.).

After recovering from this sensational experience, the novice, now supernaturally strengthened, had to embark on a shamanic vision quest during which he encountered animals that were to be his supernatural helpers. These animals—often land otters—walked up to the young man, stuck out their tongues at him, pivoted several times, and fell dead at his feet. As the tongue contained the animal's spiritual force and life potency, the novice excised it from the animal and wrapped it, along with other tongues, in a bundle that became the source of immense power. After this vision quest, the novice returned to the village with his newly acquired assemblage of animal-helpers and either he himself carved their images on all sorts of artworks or he commissioned a master carver to do so. He also ceased cutting his nails and hair, and soon took on an appearance distinctly different from the neatly shorn lay Tlingit (Emmons n.d.).

Although the Tlingit shaman had numerous responsibilities, healing the sick was his most important task. Any number of spirits filled the universe; they could cause sickness from mild illness to fatal disease. Sometimes an angered spirit, like the crawfish insulted by the chief's son, stole a patient's soul. At other times, malevolent spirits harmed the soul that remained in the person's body. The most serious maladies were caused by witches who were human members of the community who had allied themselves with malevolent supernaturals. Witch spirits, like shamanic spirits, could come unannounced to an individual, who could not refuse their calling. Witches were believed capable of flying and if trapped in a house, could escape through the smoke hole. Witches (who could be male or female) were feared by all, for they caused illness by performing incantations over stolen nail or hair cuttings, pieces of uneaten food, or articles of clothing from their victims (Emmons, n.d.).

If the shaman decided that a patient was the victim of witchcraft, he performed an elaborate ceremony, which Emmons had the opportunity to observe and describe. Before the shaman began his performance, he first consulted with one of his spirit helpers to determine the appropriate fee for the particular therapy required, then haggled with his client's family to assure that he would be properly recompensed.

Once an agreement over the price was concluded, the shaman entered the patient's house with eight or more members of his family who carried his paraphernalia. These people all sat in a line, and began pounding on the floor with a beating stick to summon the spirits. To the sounds of this rhythm the shaman changed into his costume, let down his long hair and covered it with bird down, donned his hide apron, crown, and necklaces, and started shaking his bird-form rattle. Attracted to the sounds of these percussive instruments, the spirits flew into their images painted and carved upon the shaman's costume and paraphernalia. And, when the shaman put on his masks, he was actually transformed into the spirit beings they depicted (fig. 36) (Emmons n.d.).

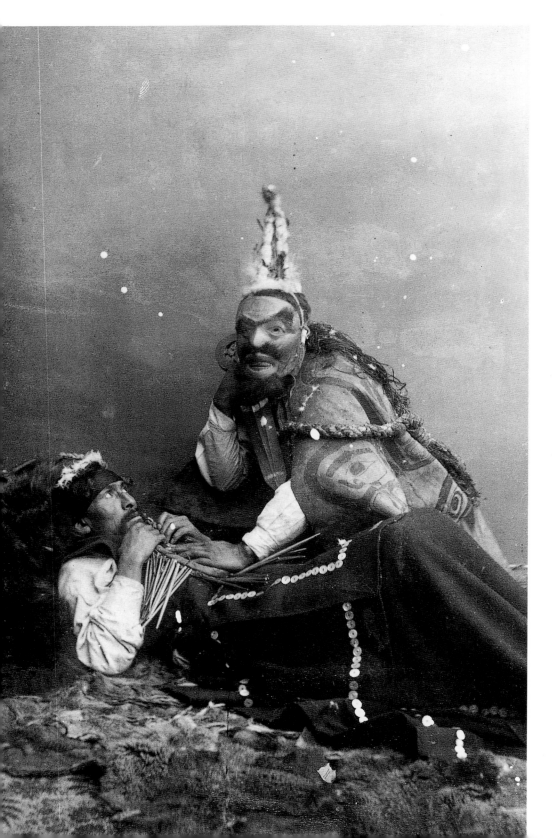

Fig. 36. Tlingit shaman wearing a mask, posed as if curing a patient. *Photograph taken c. 1889. 335775*

EMMONS collected many hundreds of supernaturally potent artworks that Tlingit shamans manipulated during their seances. Just as the lay Tlingit wore a variety of types of headgear, Tlingit shamans possessed an array of different headpieces. Plate 34 is a crown composed of plaited human hair to which is attached a maskette depicting a powerful chief flanked by four wooden guardians. Human hair, this time in a long flowing train fastened to the face of a skeletal, oppen-mouthed dead slave, appears on the piece in plate 35. On the artwork in plate 36, a circle of fluffy swan's down and eagle feathers contains in its center the image of a dead man's spirit, whose eyebrows have become wolves and on whose cheeks nestle little mice said to be "eating the secrets of the spirits and witches which they give to the shaman." Somewhat different from these maskettes is a rectangular cap made from a segment of Chilkat blanket ornamented with swan's down and a real wolf's tail and topped by a wooden image of a wolf holding a small spirit in his mouth (pl. 37).

Pl. 34. Tlingit shaman's wooden headdress with human hair, feathers, and down; the central mask depicts a very powerful chief; flanking figures are shamanic guardsmen. Chilkat. L 33.4 cm, H 14.6 cm. *Collected by Emmons, 1882–87. 19/913*

Pl. 35. Tlingit shaman's wooden headdress mask with hair, fur, and abalone. Baranoff Island. H (with hair) 151.6 cm. *Collected by Emmons, 1882–87. 19/930*

Pl. 36. Tlingit shaman's wooden headdress mask with human hair and eagle tail feathers; depicts a dead shaman's spirit whose eyebrows are wolves. Small figures on either side of the nose are mice eating the secrets of spirits and witches, which they give to the wearer. Chilkat. H 85.5 cm, W 23 cm. *Collected by Emmons, 1882–87. 19/911*

Pl. 37. Tlingit shaman's dancing headdress made of Chilkat blanket material, decorated with wool, down, and wolf fur. The design on the textile depicts the land otter spirit, and the carved head is a wolf with a small spirit in its mouth. Chilkat. L 22 cm, H 15 cm. *Collected by Emmons, 1882–87. 19/977*

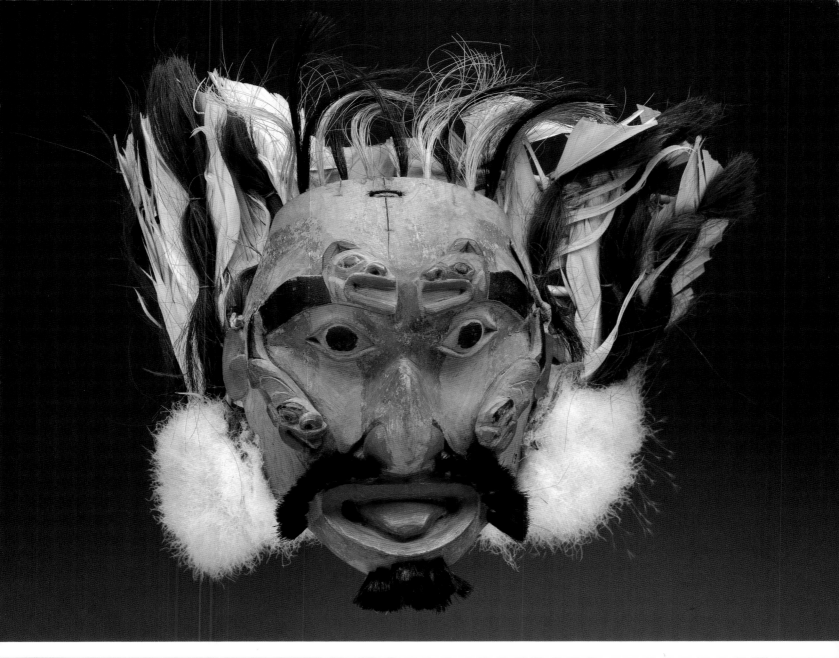

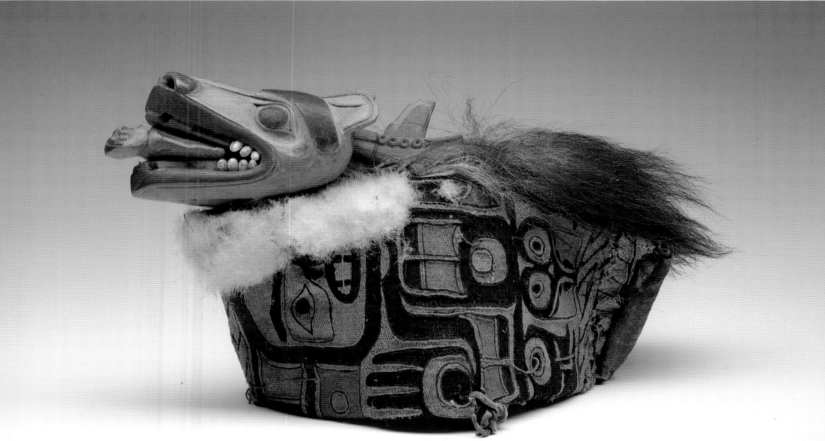

During his seance, the Tlingit shaman would wear an apron (pl. 38) painted with the image of his spirit assistants and ornamented with ivory and bone charms. These charms, as well as the deer dewclaws suspended from the apron's fringes, bumped against each other during the shaman's dances and created a rhythmic music that complemented the percussive sounds of his drums and rattles and summoned the shaman's spirit helpers into their artistic images. This music harmonized with the sounds of the shaman's rattles, which also called his spirits.

Plate 39 illustrates a shaman's rattle depicting the magical oystercatcher bird on whose back crouch three small witches in the process of planning evil activities; these malevolent creatures hold onto the tentacle of an octopus which "guards and transports the witches noiselessly through space" (Emmons n.d.).

Pl. 38. Tlingit shaman's moosehide apron; painted design covered with small ivory and bone charms; fringes hung with deer dew claws. Auk. L 91.6 cm. *Collected by Emmons, 1882–87. 19/1040*

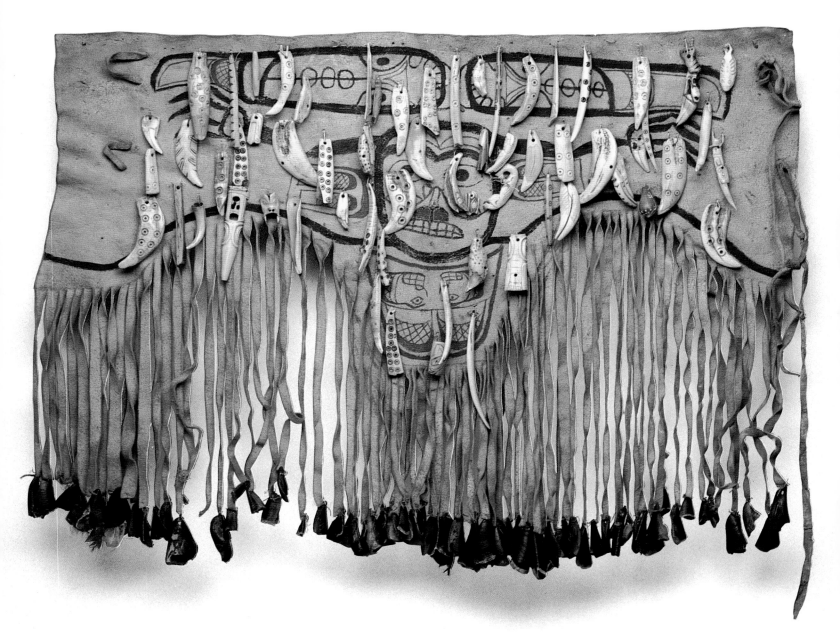

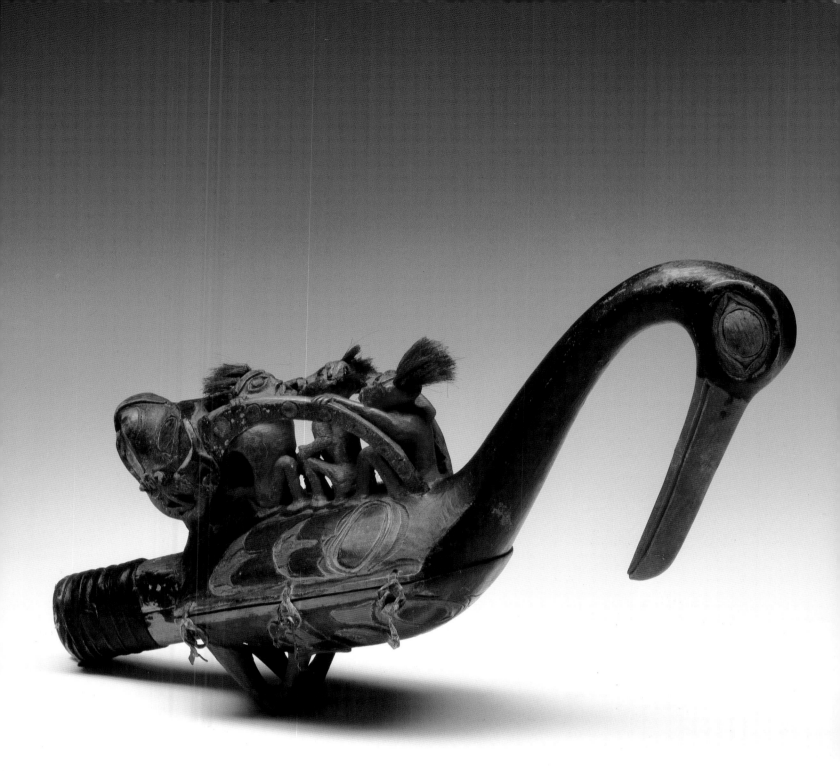

Pl. 39. Tlingit shaman's wooden rattle; depicts an oyster-catcher bird on whose back sit three small witches planning evil activities and being guarded and transported through the air by the mountain goat near the handle. Chilkat. L 37 cm, W 13 cm. *Collected by Emmons, 1888–93. E/348*

In order to defend himself and his wards against malicious supernaturals like witches, the Tlingit shaman owned a variety of batons which he used like clubs. A number of different spirits engaging in violent activities populate a baton (pl. 40), including a land otter seemingly crushed between an eerie anthropomorphic human face and a crow in whose long, sharp beak stands a naked man, his eyes opened wide as if being choked.

Among the shaman's most valuable and most highly supernaturally charged possessions were his charms. These small, jewel-like objects carved from walrus ivory or bear teeth depicted surrealistic images of the shaman's spirit helpers. One especially elegant charm (pl. 41) of a killer whale from whose mouth a naked man is about to emerge illustrates the magical process of metamorphosis, as the cetacean's dorsal fin becomes a tiny man, and its nostrils are transformed into frontal faces. The shaman sometimes wore such charms suspended on leather thongs about his neck and, when he deemed it advisable, left the magical objects with his patients as therapeutic amulets.

The other extremely powerful type of Tlingit shamanic art was the face mask, such as the frog spirit with little amphibians emerging from its mouth and crawling over its brow (pl. 42). Although most were made of wood, some were carved from the vertebrae of a whale (pl. 43). The forward thrust of the beak-nose, the wide-open mouth encircled by copper and filled with operculum teeth, the piercing copper eyes, the hair all askew, and the rough texture of the whale bone combine to create an image of unusual intensity and dynamism.

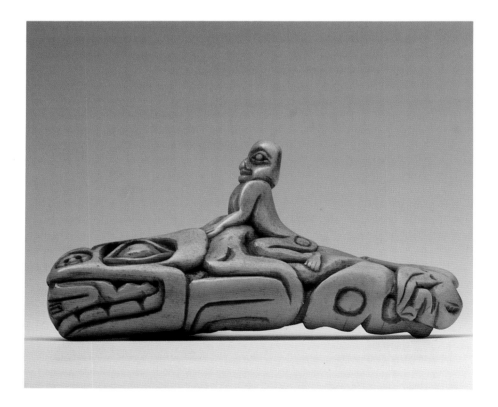

Pl. 41. Tlingit shaman's antler charm representing killer whale, with one anthropomorphic being in its mouth and another as its dorsal fin. Angoon. L 12 cm. *Collected by Emmons, 1888–93. E/2710*

Pl. 40. Tlingit shaman's wooden club; depicts a frontal face atop a land otter and a raven with a man in its mouth. Chilkat. L 68.7 cm. *Collected by Emmons, 1882–87. 19/1161*

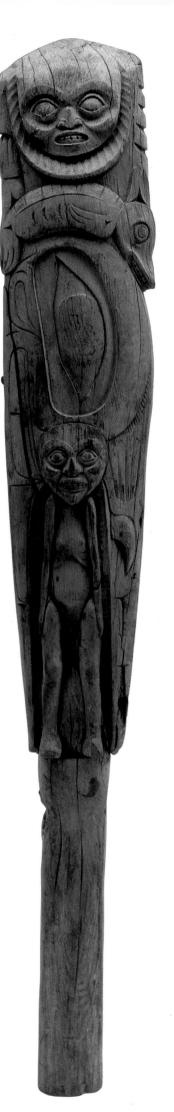

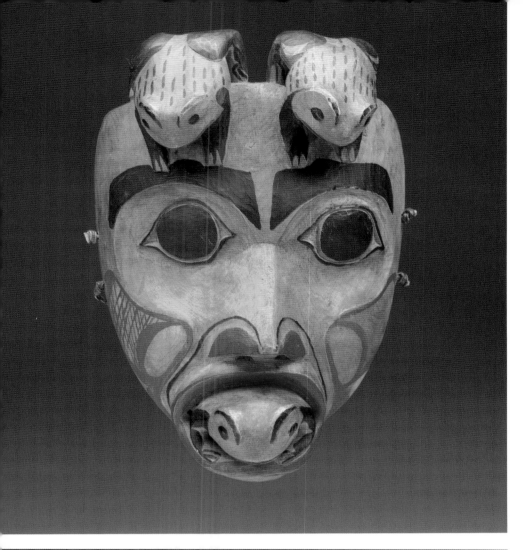

Pl. 42. Tlingit shaman's wooden mask representing a spirit with frogs crawling over the forehead and a frog emerging from the mouth. H 23.2 cm, W 15.2 cm. *Collected by Emmons, 1888–93. E/1654*

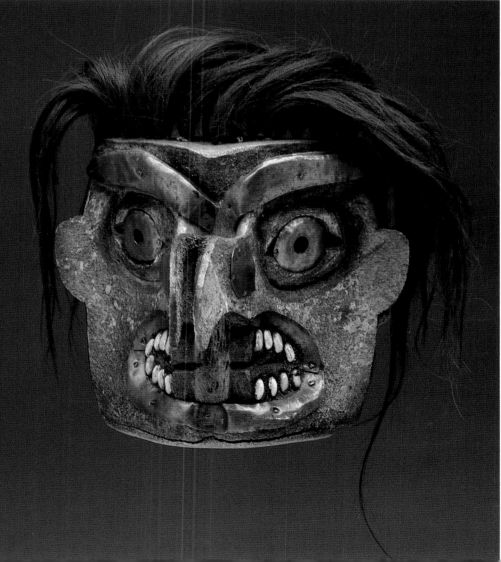

Pl. 43. Tlingit shaman's mask carved from the vertebra of a whale, ornamented with copper, operculum, and human hair; depicts a raven. H 28.5 cm, W 23 cm. *Collected by Emmons, 1888–93. E/1262*

In order to accrue the greatest strength possible, the shaman had actually to be *transformed into* his spirit-helpers by means of a masquerade. By wearing a series of masks during his seance, the shaman became a variety of animals, for example, eagles and frogs, as well as spirits of human form, such as old women and warriors. As he put on and took off his array of masks, the spirit power within him intensified, causing his dancing to become more and more frenzied and his body movements to be increasingly convulsive. Finally, he ceased entirely to be aware of his surroundings, and felt conscious only of the intensity of the spiritual forces filling his body and soul. According to Emmons:

At this point sometimes his movements are so wild that his apron falls off. The wild naked figure in all its contortions with head thrown back and half closed glazed eyes, flowing locks encircled in a cloud of down, the patient, the shadows cast by the fitfull burning logs, the confusion of sounds, the atmosphere of smoke-dried salmon and human bodies, the tense expectancy of the crowded spaces kept alive the belief in the unknown and this juggler of life (Emmons n.d.).

Sometimes the patient recovered simply as a consequence of the presence of all these spiritual powers at his house; at other times, the shaman had to leave a charm or some other magical item as a therapeutic "medicine." There were occasions, however, when such activities failed to heal the patient, and it became necessary to identify the witch and force him to confess his sorcery. To do this, the shaman first summoned his spirits and asked them to point him in the witch's direction. The shaman then had his assistants bind the hands of the so-identified witch behind his back, and torture him by beating his flesh and pulling his hair. One charm (pl. 44) depicts a crouching, bound witch undergoing torture. If the witch did not confess to causing the illness, the shaman had him bound hand and foot and left on the beach at low tide to drown slowly as the tide came in. If he confessed, he was spared this final torture (Emmons n.d.).

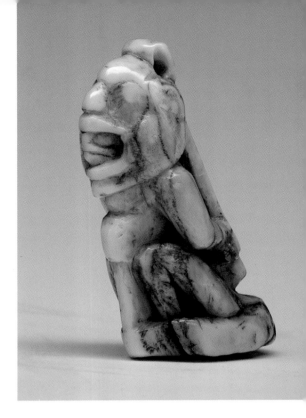

Pl. 44. Tlingit shaman's ivory charm representing a bound witch. H 7 cm. *Collected by Emmons, 1882–87. 19/455*

Fig. 37. Tlingit shaman's grave guardians positioned by a shaman's grave near Klukwan. *Emmons photograph, 1888. 336624*

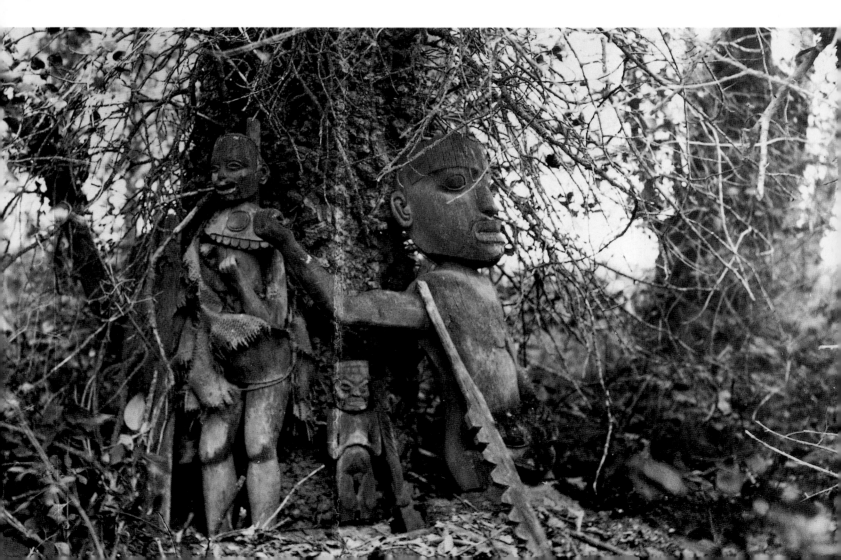

When a Tlingit shaman died, his relatives placed his corpse, along with the magical implements he had used in his practice, in remote areas far from human habitation. By doing this, the Tlingit hoped to protect themselves from the potentially lethal powers inherent in the bones and artworks. Figure 37 is a photograph of a grave not far from the village of Klukwan in a grove of cottonwood trees near the river bank. Four figures, originally painted, stood grouped about the base of a large tree, serving as sentinels to guard the nearly crumbling gravehouse from malevolent incursions by witches. The dynamic grave guardian (pl. 45) that Emmons collected from this Chilkat grave, with its open mouth, slightly crouched stance, and raised hands that once held rattles, seems quite prepared to utter a cry and protect its ward.

While many Tlingit shamans' grave guardians were as finely carved as this Chilkat example, others had a ruder and more immediate quality. For example, one guardian (pl. 46), placed near the head of the shaman's corpse, was carved from some soft chalky material. Although the roughly textured substance prohibits delicate carving, it provides the sculpted masses with a harsh energy that enhances its aggressive character. Despite the forcefulness of both this piece and its more refined Chilkat brother, the Tlingit grave guardians did little to prevent the disturbance of their wards by Lieutenant Emmons, who removed the contents of innumerable shamans' graves and sent them to Princeton University and to the American Museum of Natural History.

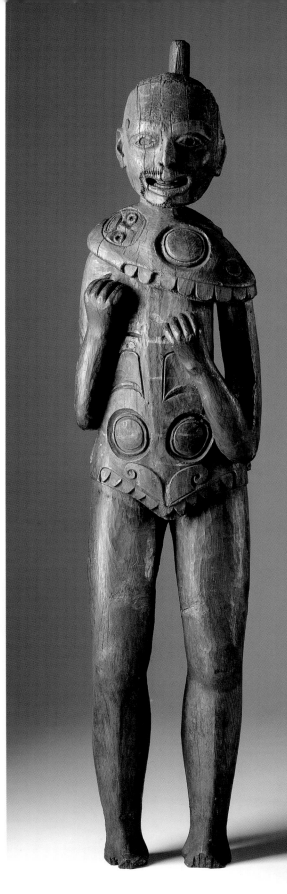

Pl. 46. Tlingit shaman's grave guardian. H 19 cm.
Collected by Emmons, 1888–93. E/1044

Pl. 45. Tlingit shaman's wooden grave guardian. Found with several other figures placed around an old tree near the grave house of a deceased shaman. Depicts a malevolent spirit that lives in the air; appears dressed as a shaman wearing over his shoulders a robe representing spirit fish; his mouth is open, as if singing, and his hands originally held rattles. See figure 37 for this statue *in situ.* Klukwan. H 156.9 cm. *Collected by Emmons, 1888–93. E/1915*

Tlingit Art at the American Museum of Natural History

In 1887, hoping to sell some of his collections to the American Museum of Natural History, Emmons sent 1,284 pieces to New York, where Bickmore had them temporarily exhibited in the cases that usually held the Bishop collection. This exhibit contained some remarkable pieces. Among the shamanic items were one small precious charm of a killer whale gnawing at a skeletal man (pl. 47), and a complicated charm depicting an owl flanked by a bear and an eagle, surrounded by ducks nibbling dead witches (pl. 48). Among the several masks in this collection was a naturalistic one of a human face with glowing abalone eyes and operculum teeth, whose pointed beak-like nose reveals the spirit's identity as an eagle (pl. 49). And, among the secular items was a large feast bowl (pl. 50) depicting a beaver out of whose ears peered small, bulbous faces.

Pl. 47. Tlingit shaman's bone charm representing killer whale, with a bear's head on its fin and a raven's head on its tail, eating a human. L 11.5 cm. *Collected by Emmons, 1882–87. 19/454*

Pl. 48. Tlingit shaman's mountain goat horn charm, inlaid with abalone. Central head represents an owl; to the left is a bear head, to the right, an eagle head; surrounding are ducks nibbling at dead witches. Chilkat. L 16 cm. *Collected by Emmons, 1882–87. 19/458*

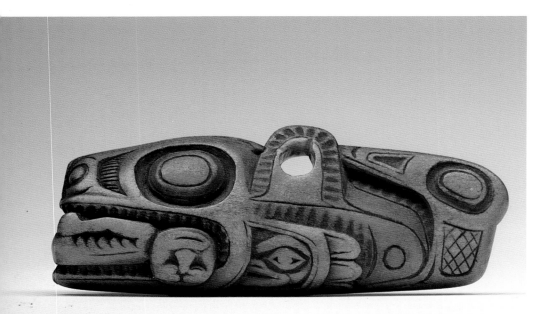

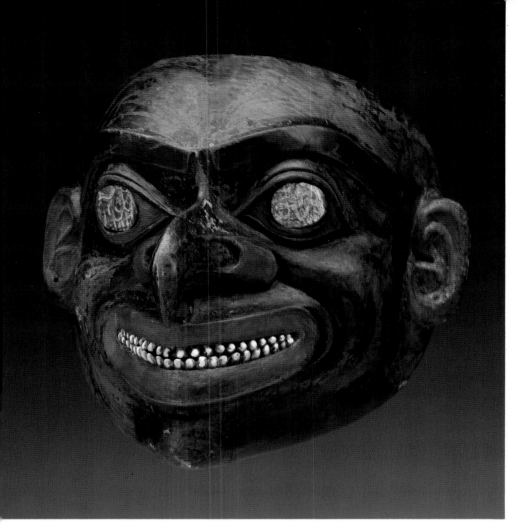

Pl. 49. Tlingit shaman's wooden mask with operculum teeth and abalone eyes; depicts an eagle spirit. Chilkoot. H 22.5 cm, W 24.2 cm. *Collected by Emmons, 1882–87. 19/852*

Pl. 50. Tlingit wooden feast dish decorated with opercula; represents a beaver. Angoon. L 115 cm, H 22 cm. *Collected by Emmons, 1882–87. 19/1257*

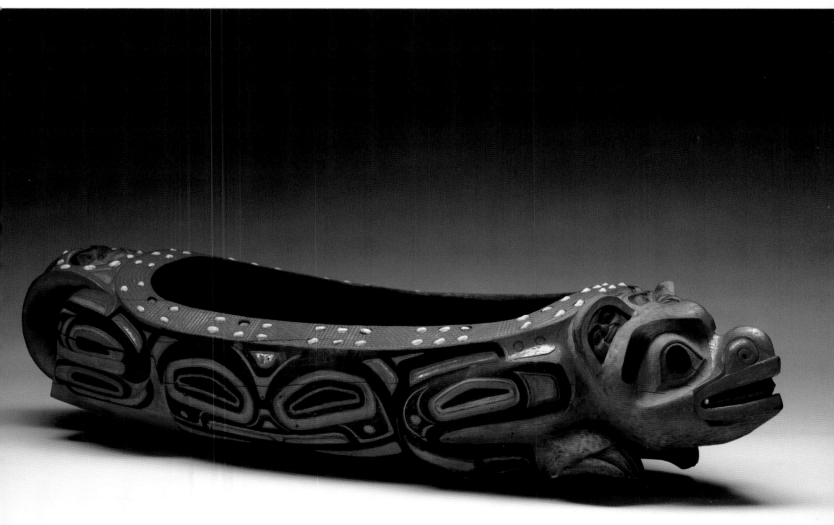

Aware that this large assortment of southeast Alaskan artworks was of exceptional quality, and anxious to supplement the American Museum's Native American holdings, Bickmore began a fund-raising campaign by sending letters to prospective donors requesting contributions for adding "this unique collection to our present means for popular education and for permanently preserving the works of the aboriginees of our land who are rapidly passing away or changing their primitive habits" (Cole 1985:88). Heber Bishop helped Bickmore raise the $12,000 purchase price by actively soliciting donations from museum trustees and others such as Collis Huntington, Cornelius Vanderbilt, John D. Rockefeller, and J. P. Morgan (Wardwell 1978:26).

Emmons, who had been granted a leave from the navy to come to New York to oversee the installation of his collection at the American Museum, badly wanted to sell these objects. Perhaps as a bargaining ploy, Emmons began to make allusions to a "substantial Chicago offer on the whole collection," which he would have to honor if the New York museum did not make up its mind speedily. Although some people at the American Museum suspected that he had invented this mysterious Chicagoan to enhance his negotiating position, the fear that the midwestern city might obtain this outstanding collection inspired Bishop and Bickmore to work even harder to raise the funds. Finally the trustees and other friends of the Museum contributed the necessary amount, and soon New York had the largest and finest collection of Tlingit art yet available.

This first sale encouraged Emmons to engage in further collecting activities. In 1888, he returned to Alaska, where he paddled six hundred miles by canoe, collecting hundreds upon hundreds of artworks, mainly of Tlingit manufacture. Although he wrote to the American Museum stating that it would have the first right of refusal for purchasing this new and larger array of Alaskan artworks, Emmons first wanted to exhibit his new collection at the 1893 Chicago World's Columbian Exposition, which was presented in the United States Government Building along with other Alaskan exhibits (Cole 1985:142).

It was not surprising that Emmons wished to display these pieces at Chicago, for among the collection were the finest pieces of Tlingit art made. An ivory charm (pl. 51) of supreme delicacy illustrates a long-beaked raven in whose mouth appear the legs and arms of a man who seems to be diving down the bird's throat. Nestling under its jaw is a small frontal face, while above it a human-faced octopus with tentacles streaming outwards seems to be rushing through the water. The collection contained as well several exceptional masks: one depicting a man slowly dying from injuries sustained in a knife fight, his eyes closing, tongue protruding, and blood flowing from gaping wounds (pl. 52); another of a very old man whose lined face ripples with intensity and energy (pl. 53); and a third, the representation of a man undergoing the most frightening experience imaginable to the Tlingit—his werewolf-like transformation into a land otter (pl. 54).

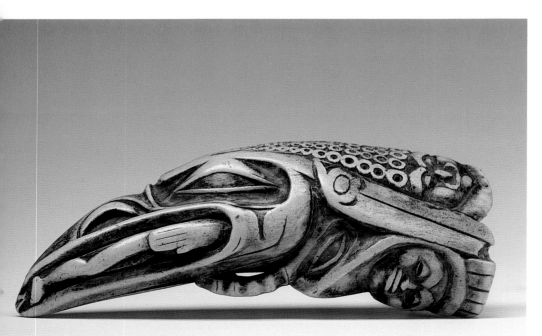

Pl. 51. Tlingit shaman's ivory charm representing a raven, with an octopus at its neck, devouring a human. Chilkat. L 15.5 cm. *Collected by Emmons, 1888–93. E/2715*

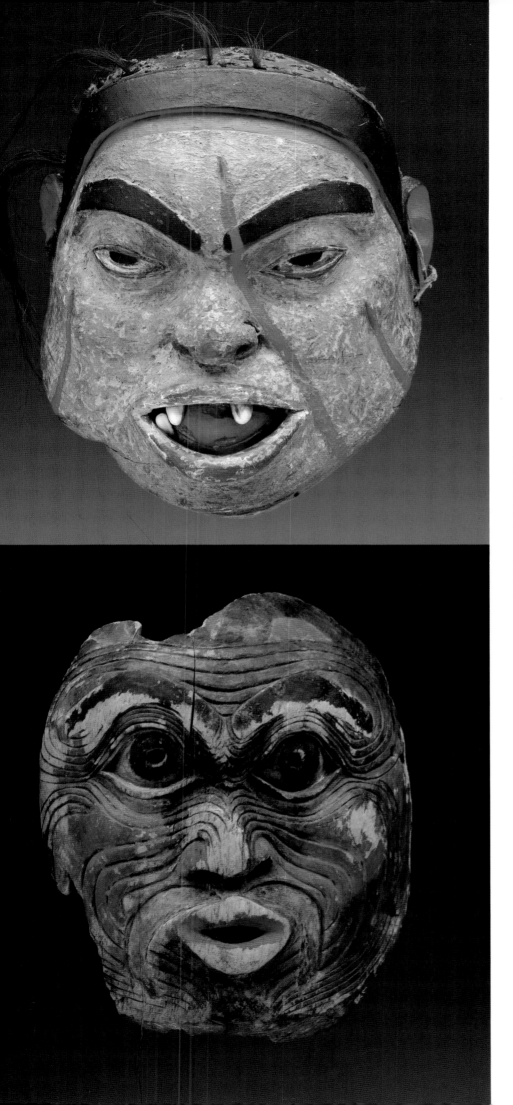

Pl. 52. Tlingit shaman's wooden mask representing a man dying from wounds received in a fight; his eyes are closing, his tongue protrudes, and blood flows from his wounds. Angoon. H 24.8 cm, W 20 cm. *Collected by Emmons, 1888–93. E/2501*

Pl. 53. Tlingit shaman's wooden mask of a very old man. Sitka. H 20.2 cm, W 16.7 cm. *Collected by Emmons, 1888–93. E/2251*

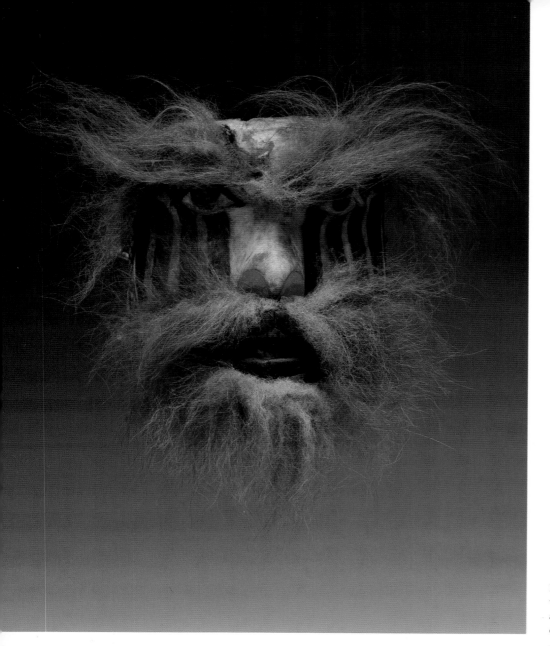

Pl. 54. Tlingit shaman's wooden mask of a man in the process of transforming into a land otter. H 24 cm. W 19 cm. *Collected by Emmons, 1888–93. E/403, E/1657*

Pl. 55. Tlingit wooden dance headdress inlaid with abalone and decorated with hair; represents a fish and a man's face; worn on top of the head during the feast that followed runs of fish. Angoon. H 15.6 cm, L 40 cm. *Collected by Emmons, 1888–93. E/1871*

Pl. 56. Tlingit wooden helmet; represents a man's face twisted as if hit with a blow or suffering paralysis. Dry Bay. H 25.1 cm. *Collected by Emmons, 1888–93. E/453*

Included in the display were a variety of secular pieces, including the brass conical hat given by Baranov to the chief of Sitka to celebrate the Russian-Tlingit peace (pl. 9). Particularly elegant was the ornamental headdress depicting a fish with a man's profile face, worn on the occasion of a feast (pl. 55). An unusual secular piece was a helmet worn to protect a warrior from his enemy's blows (pl. 56). Although such militaristic helmets were not uncommon among the Tlingit, the subject matter of this sculpture—"a man whose face is in pain as if he had been hurt by a blow"—makes it an unusual work of art. The horribly distorted visage, with its mouth and nose twisted painfully creating deep wrinkles on the right and taut stretched skin on the left, is one of the most striking examples of Northwest Coast realism.

Emmons's Chicago exhibit included 2,700 pieces, which he took three months to arrange. One review of this display described it as "one of the most interesting corners of the great Fair which one jots down mentally as 'worth seeing.' . . . Native art in its entirety: the weird spirit practice of the shaman, the rich ceremonial of death and feast, and the rude traditions going back to the legendary days of 'Yehl,' their raven creator, all are illustrated here, while the intelligent system of labeling draws one into sympathy and friendship with the wild children of the glaciers as no monograph, however well written, could do" (Field 1893:1–3).

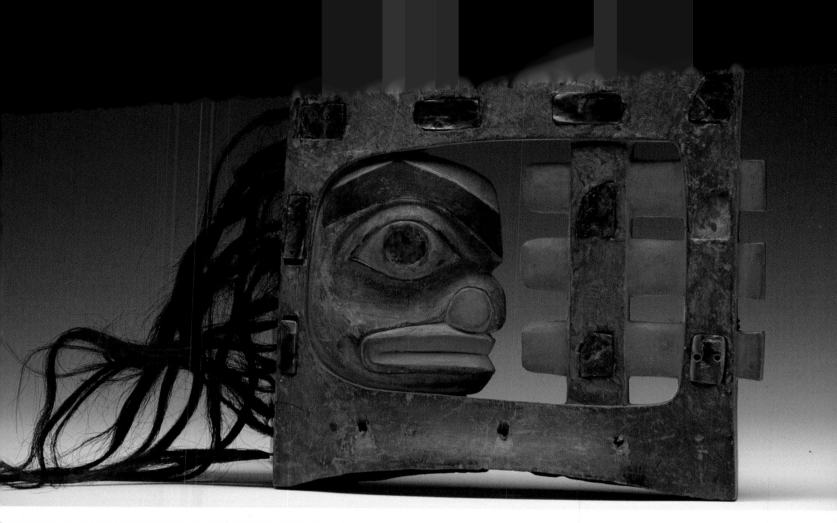

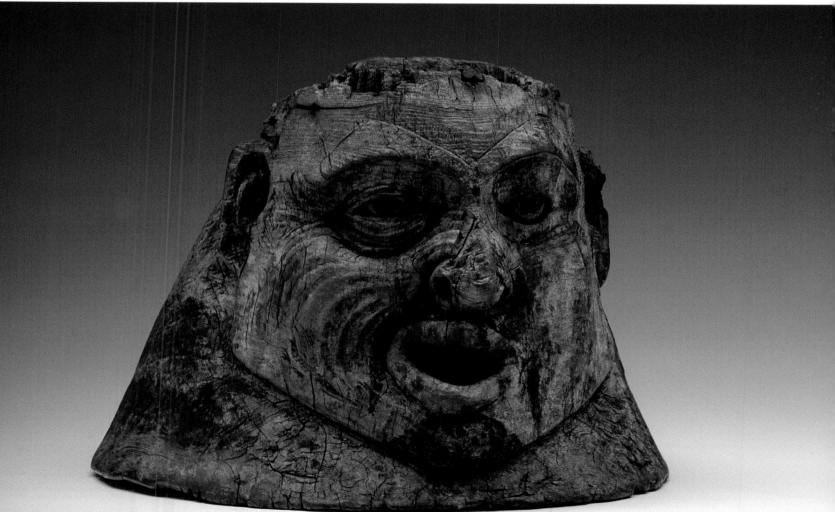

THE American Museum took note of the favorable reactions to this new collection acquired by Emmons, but found his price of over $20,000 just too high for their resources. Once again, Emmons hinted at another Chicago institution's desires for the collection. This time, the American Museum wrote a confidential letter to a friend in Chicago that said, "The collection from Alaska, owned by Lt. Emmons, has been offered by him for sale to the Museum. Other museums are *said* to be looking with a covetous eye at it; can you learn which they are, if any?" (4 Aug. 1893).

There did seem to be some truth to this rumor, for the newly established Field Museum apparently had offered Emmons money for this collection. Once again worried that Chicago might bypass New York in the race to acquire the biggest and best museum collections, the American Museum soon sent out another letter of solicitation to friends, including Joseph Choate, Collis Huntington, J. P. Morgan, Cornelius Vanderbilt, William Whitney, and Theodore Havemayer, asking for help with the purchase of a collection desired by another museum. By 1894, the Museum had signed a contract with Emmons, purchasing the 2,500 pieces for the rather incredible sum (in those days) of $25,000, to be paid over five years at 5 percent (Cole 1985:143).

Despite these apparent successes, Emmons was plagued by frustrations and feelings of rejection, which perhaps explain his increasingly negative views on the world and personal difficulties with colleagues. In 1899, poor health caused him to leave the navy. He then moved with his family to Princeton, where he carried on active correspondence with museum curators across the country to whom he tried selling, often unsuccessfully, his large store of Northwest Coast artworks. He became antagonistic to the university situated in his home town, since never did Princeton ask this highly qualified, if not formally trained, anthropologist to join its faculty. As time went on, Emmons became more and more bitter as he failed to gain public recognition for his achievements.

Although he sold two major collections to the American Museum for considerable sums of money, Emmons came to have severe problems with the Central Park West institution. One problem concerned a monograph he had promised to write about the Tlingit. Soon after the Museum had purchased its first large collection from Emmons, the lieutenant wrote Bickmore (19 Oct. 1888) announcing his preparation of a "full account of the Indians of Alaska." This was an early mention of a monograph Emmons would be writing for the American Museum nearly his entire life, struggling to finish, but never quite managing to do so.

Emmons's inability to complete this immense project greatly annoyed Franz Boas, curator in the Museum's Anthropology Department from 1895 to 1905. A productive scholar, Boas had little patience for what he viewed as Emmons's slipshod scientific methods and generally inferior intellect, and took every opportunity to criticize him. Emmons's troubles with the anthropologist had begun several years before Boas joined the American Museum staff, when he worked with Frederic Ward Putnam to set up the Ethnology Exhibition at the Chicago Columbian Exposition. At first, Emmons had wished to have his splendid Tlingit collection included in the large display of Native American culture that Boas and Putnam were installing in the Anthropology Building. The two men refused to include it in their Northwest Coast display, citing as a reason that these particular objects had already been offered for sale to a museum. Undaunted by the first of what would be a series of difficulties with these men, Emmons proceeded to have his pieces installed in the Alaska display (Cole 1985:142).

Why Boas really did not wish to include the Emmons collection in his Chicago exhibit remains obscure. However, as time went on, Boas became increasingly antagonistic toward the naval lieutenant. For example, at one point, John Swanton, an anthropologist planning to study the Tlingit in Sitka, wrote Boas asking whether it would be worth his while contacting Emmons, to which Boas replied (21 Oct. 1903): "If you tell Emmons that your work is going to be on the language,

there is no harm in consulting him, but as to other matters he is very touchy and I should not be at all surprised if his information to you would be misleading." As one of the cardinal sins in the field of science was then, as it is now, providing erroneous information, Boas's suggestion that Emmons might misdirect a colleague constituted a serious attack on the collector's character.

Perhaps the most objectionable of Emmons's failings, in Boas's eyes, was his inability to complete his monograph. In a letter to a friend (Boas to Farrand, 20 June 1903), Boas insisted that "in regard to Emmons, I feel that it would be best to have no further dealings with him, and to demand all his notes which, as I understand, belong to us." Although he realized that Emmons did have some interesting information on the history and technology of the Tlingit, he deplored his ignorance of what Boas felt to be far more significant ethnological data, namely, religion, mythology, and language.

At one point Boas complained bitterly to a Museum official about Emmons (Boas to Bumpus, 11 Nov. 1903), detailing each of the man's inadequacies. He questioned the scientific value of the collector's notes and suggested that they contained "very little that is trustworthy and useful." In addition, he asserted that the extensive documentation accompanying the collections was almost useless, that "no trustworthy information is available in regard to any of the numerous masks." Moreover, despite appearances, Emmons had engaged in some questionable dealings such as selling to the Museum pieces of inferior quality while keeping for himself the majority of the best Alaskan artworks. Some of these especially fine articles, Boas hinted, might be on their way to the Chicago Field Museum or to the Smithsonian. Believing that the Museum was duped in 1894 by having to pay the exorbitant price of $25,000 that Emmons demanded for his collection, Boas concluded, "I wish not to be compelled always that the Museum is 'being done' by Mr. Emmons."

Since time has proven that Emmons was indeed a highly competent fieldworker who acquired tremendously valuable information about the Tlingit, there is reason to question Boas's motivations in his disparaging remarks about the collector. Indeed, it is possible that another reason existed for Boas's deep animosity toward the lieutenant. Emmons, at least later in his life, was deeply anti-Semitic, as is evidenced in a letter he sent to a friend in 1910 in which he complained about "the Jews . . . coming into Ethnology through Boas" (Cole 1985:350).

Such an attitude could not have endeared this increasingly irascible man to the Jewish Boas and his liberal supporter Putnam. It is perhaps ironic that George Thornton Emmons, who had immense respect and admiration for a group of Native Americans (themselves certainly the victims of racism), became an anti-Semite. Although it may be that his anti-Jewish sentiments were deepset, they might well have been strengthened by his feelings of rejection at not being intimately involved with the major developments in the Anthropology Department at the American Museum of Natural History during the Putnam/Boas years. Indeed, as Emmons's relationships with the American Museum cooled, the institution became committed to the scientific study of the Indians of the Northwest Coast and initiated a major expedition, conceived by Boas, to the region. Intentionally excluding Lieutenant Emmons, Boas sent a team of men to various locations along the Northwest Coast to collect art and ethnographic data. Boas did ask Emmons to contribute two monographs to the Expedition publications, one on Tlingit basketry (1903), the other on the Chilkat blanket (1907), but to Emmons's chagrin, Boas edited the publication on the Chilkat blanket so heavily and added so many of his own materials, that he ended up crediting himself with a significant amount of the authorship of the volume. This would certainly not have qualified as respectful treatment of the naval lieutenant's expertise.

Fig. 38. Frederic Ward Putnam at the age of
seventy. *M. S. McN. Watts photograph, 1909.*
Peabody Museum photograph 3833, courtesy of
Peabody Museum, Harvard University.

4 / Frederic Ward Putnam
and Franz Boas

DURING the last years of the twentieth century, institutions such as museums and universities were subjected to a spirit of professionalism which valued credentials and expertise over amateurism. Thus, it should come as no surprise that Albert Bickmore's tenure as head of the American Museum's Anthropology Department had to yield to the new professionalism of the Progressive Era. His general administrative duties and frequent public lectures prevented him from devoting sufficient time and energy to the expanding ethnographic and archeological collections. Moreover, his lack of anthropological expertise surfaced when, in 1890, a visiting anthropologist informed President Jesup that certain collections under Bickmore's control were mislabeled, insect-infested, and in general disarray. Disturbed, Jesup quickly hired Frederick Starr, an eminent anthropologist, to supervise the department.

Starr soon left the American Museum, however, to join the newly established University of Chicago, and Jesup replaced him with another non-professional, James Terry, a collector of Native American art. Hired to catalog the collection he had recently sold to the Museum, Terry turned out to be inadequate to the needs of the position and soon was dismissed. Jesup finally decided it was time to appoint the best man in the field for this important post and invited Frederic Ward Putnam (fig. 38) of the Peabody Museum at Harvard to join the American Museum staff. In 1894 Putnam consented to take on this new assignment under the condition that he be permitted to retain his position in Cambridge and work in New York just one week per month. Jesup agreed, and finally the Department of Anthropology had professional direction.

Frederic Ward Putnam 1839–1915

Frederic Ward Putnam was, by all accounts, a remarkable man. In 1889, O. T. Mason of the National Museum in Washington, D.C., wrote to Putnam describing a Parisian whom he resembled:

I was reminded of you a thousand times in Paris, by Dr. Hamy, who looks like you, trots around like you, is general secretary of everything, and an indispensable man-of-affairs to the Paris Anthropologists.—In all our meetings, nothing could go on until Dr. Hamy arrived; and to keep up the comparison, once in a while he came in a *little late* (Mark 1980:53).

This energetic man, once described as "an institutional entrepreneur in an age of organizing geniuses" (Stocking 1968:278), could look back at his accomplishments with satisfaction at the end of his life; he had established anthropology departments at Harvard, Columbia, and the University of California at Berkeley; built ethnographic museums in Cambridge, Chicago, and Berkeley; and created out of Bickmore's disarray the most distinguished anthropology department in any American museum.

A member of a family that had lived in New England since 1640, Frederic Ward Putnam was certainly a man with whom Morris Ketchum Jesup could feel comfortable. Born in Salem, Massachusetts, in 1839, Putnam belonged to a lineage that included the Appletons, Fiskes, Wards, and Higginsons, all old and distinguished New England families. While not independently wealthy himself, Putnam's background gave him entry into the elite world of New York City's museum trustees and millionaire philanthropists. Likewise, Putnam's scientific training, commitment to research and education, and impressive scholarly record convinced colleagues of lesser means but major academic accomplishments of his seriousness of purpose (Mark 1980:14–15).

At the age of sixteen Putnam met Louis Agassiz, then busy establishing his Museum of Comparative Zoology. Agassiz was impressed with the young scientist who had already written several noteworthy papers on the natural history of Essex County, Massachusetts, and was working as the curator of ornithology at the Essex Institute in Salem. He soon invited Putnam to study with him at Harvard, and within a year the young man was in Cambridge, responsible for the Museum of Comparative Zoology's fish and invertebrate collection. Agassiz turned out to be a most difficult mentor, who absolutely refused his students permission to publish under their own names any work done in "his" museum; this autocratic attitude, combined with his steadfast rejection of Darwinian evolution, prompted many students to leave Cambridge. Putnam abandoned his studies in 1864, not long before another Agassiz student, Albert Bickmore, did the same (Mark 1980:15–19).

Putnam returned to Salem and was soon appointed superintendent of the Essex Institute, where he experienced his first entrepreneurial success in institution-building. Putnam had made the acquaintance of a wealthy, educationally and philanthropically oriented native of Salem, George Peabody, who endowed what became the Peabody Academy of Science. These funds transformed the provincial institute into a first class museum which still flourishes today under the name of the Peabody Museum of Salem.

Even before he had provided funds to support the Salem institution, Peabody had approached Harvard University in 1865 with an offer of $150,000 for Agassiz's museum (Hinsley 1985:49–50). Not willing to become indebted to anyone, the Swiss director refused the endowment which stipulated that the museum's name include reference to Peabody. Undaunted by this rejection, the ambitious philanthropist approached President Walker of Harvard with the suggestion that he supply funds to create an entirely new institution, the Peabody Museum of American Archaeology and Ethnology. Walker found the proposal "unusual" but decided to go ahead with it and in 1866 Harvard and Mr. Peabody had an anthropological museum. In 1875, Putnam, who over the years had become increasingly involved with archeology, became the Peabody's curator, a position he maintained until his retirement (Mark 1980:19–22).

The Chicago World's Columbian Exposition

Although he remained deeply committed to the Cambridge museum throughout his life, Putnam's drive inspired him toward ever more ambitious projects. One of his early dreams was to build a great ethnographic museum in Chicago on the grounds of the World's Columbian Exposition held in 1893. Three years before that fair opened, Putnam presented to the Exposition's organizing committees a bold plan for the creation of this museum, which he described at some length in an article in the *Chicago Daily Tribune* (30 May 1890) on "American Ethnology; an interesting suggestion for the Columbian Exposition":

. . . cannot Chicago secure and place in the Exposition a perfect ethnographical exhibition of the past and present peoples of America and thus make an important contribution to science which at the time will be appropriate, as it will be the first bringing together on a grand scale of representatives of the peoples who were living on the continent when it was discovered by Columbus, and by including as thorough a representation of prehistoric times as possible, the stages of the development of man on the American continent could be spread out as an open book from which all could read. Further than this, such a collection would form a grand beginning for a permanent ethnological museum which would grow in importance and value as time goes on (Dexter 1966a:316).

Putnam labored to convince Exposition officials of the desirability of his dreams. After one particularly successful meeting with them at which he argued his case, he wrote triumphantly to his wife: "I have carried the fort by storm. The committees have agreed to all my plans, have backed me up right through and said that I have hit the nail on the head" (Dexter 1970:18). In order to realize his dream, Putnam accepted the position as chief of the fair's Department of Archaeology and Ethnology, a task that turned out to be extremely burdensome.

Early on, Putnam encountered serious public resistance to his plans. One article carried in September 1890 by the *Chicago Tribune* cautiously stated that if Putnam's proposal were "practical it certainly would be a great attraction." A few days later, however, the same newspaper complained about the expense of Putnam's project and suggested that the Smithsonian could just as easily provide such an exhibition. Then its writer went on to state that, "if the archaeological enthusiasts think that the public has a wild, yearning desire to see skeletons from the glacial gravels or detritus from the cave floors and shell heaps, let them spend their own money. The directors have no money to waste on the man of the ice sheet . . . Prof. Putnam, like all those dried-up prehistoric specialists, mistakes the purpose of the Fair."

The *Chicago Daily Globe*, in a similarly unfriendly piece entitled "Dark Ages of America," described Putnam's plan as a "queer steed" that fair officials oddly propose to "ride . . . into a prominent place in the display of wonders of America." For most white Americans, those "wonders" consisted primarily of the products of their own civilization, and not those barbaric redmen who just a few years earlier had "massacred" Custer and his troops (Dexter 1966a:318–19).

The 1893 Chicago World's Columbian Exposition was meant to commemorate the "discovery" of the New World by Columbus four hundred years earlier and to celebrate the progress of American culture since 1492. Called the "White City" (fig. 39) because its temporary buildings, made of a combination of plaster and fibers, were painted white, the Chicago Exposition glorified what was seen as the improvement of human culture from its crude primitive beginnings to its current epitome of progress (Rydell 1984:38–71). As befitted the values of the era, progress was conceived of in material terms; Louis Sullivan's Transportation Building, for example, celebrated the development of transportation from "an emblem of the poorest method of travel," the primitive litter, to "the acme of comfort and speed," the steamships and locomotives of the modern civilized world (Bogart 1984:158). Small wonder that the Chicago press reacted negatively to Putnam's concept of devoting an entire section of the fair to the Indians, whose cultures were so obviously inferior to those of contemporary white Americans.

The fair officials, some of whom doubtless shared the views of the Chicago newspapers, needed convincing to ensure adequate funding for Putnam's project. In order to persuade these men that his scheme had merit, Putnam resorted to playing on the rivalry between Chicago and East Coast cities. According to Putnam, some easterners felt that the Columbian Exposition would simply be a large-scale carnival with no socially redeeming values (see Horowitz 1976:27). During a newspaper interview which he turned to his own purposes in 1891, Putnam stated:

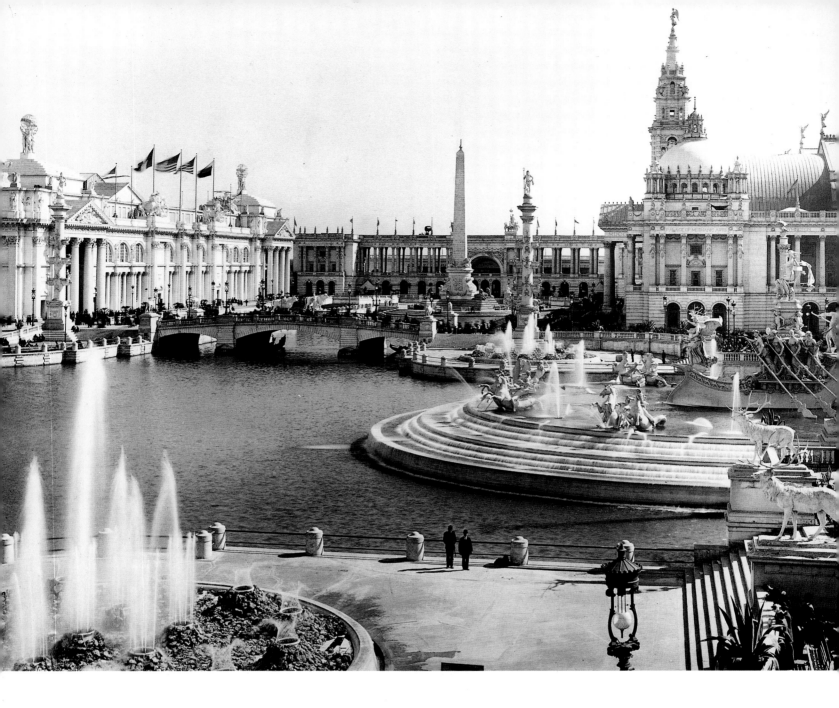

Something must be done to show that the Exposition is to be more than a gigantic cattle show and horticultural exhibition. Down East that idea largely obtains, and I have had a good many bouts with persons disposed to sneer at the Exposition. I would not give my time to getting up a mere tableau, a temporary exhibit. It wouldn't be worth the candle, but if I were asked to collect a permanent exhibit I would go into it with all my heart and soul. Chicago now has a choice to get together the material for a great scientific museum, something that will give her a permanent collection of great value to the world (Dexter 1966a:318).

Putnam also wrote to his supervisor, Director-General George Davis, that if sufficient funds were allocated to his department, he could convince these easterners that Chicago was not the crass and materialistic place they believed it to be and that indeed the city did have educational and scientific interests in mind for its fair.

The officials apparently accepted Putnam's arguments and provided the resources necessary to ensure that their fair would have exhibits of sufficient seriousness and quality to counteract the expected slurs by easterners. Before long, Putnam traveled back East and gave lectures on the scientific credibility of the anthropological exhibits to be displayed in 1893. On returning to Chicago, he could announce with pride that he had convinced the East Coast intelligentsia of the World Columbian Exposition's educational virtues (Dexter 1966a:319–20).

Fig. 39. Chicago World's Columbian Exposition. View from roof of the Manufactures and Liberal Arts Building to the Basin, 1893. *Photograph by C. D. Arnold. Chicago Historical Society photograph ICHi-02525, courtesy of the Chicago Historical Society.*

The product of Putnam's struggles was the Anthropology Building, housing an impressive collection of ethnological and archeological exhibits as well as a library. Over one hundred assistants from all over the country had helped to assemble these materials which would become the nucleus of the anthropological museum that Putnam hoped Chicago would establish at the close of the fair. Complementing but by no means competing with Putnam's displays were those of the Smithsonian Institution in the United States Government Building which included life-size statues of Indian adults and children from a variety of tribes in traditional dress, as well as Emmons's collection of Tlingit art in the Alaska exhibit (Rydell 1984:57–58). The visitor to Chicago had many opportunities to see excellent displays of Native American materials assembled by the most dedicated anthropologists and archeologists of the day.

Unfortunately, the fair-going public wanted more than museum-like exhibits. Much to Putnam's dismay, it turned out that his own work at Chicago required as much showmanship as scientific expertise. Four years earlier, the Paris Exposition had displayed the immensely popular "colonial city," in which 182 Africans and Asians lived in models of their native villages. The Chicago people wanted to reproduce this kind of "living museum" and assigned to Putnam, as chief of ethnography, control over the Midway, a mile-long strip of land containing model villages of Dahomaians, Javanese, Egyptians, Samoans, and Native Americans, interspersed with restaurants, parlors with exotic dancers, and the ferris wheel. The man assigned to install many of the live ethnographic displays at the fair, Sol Bloom of San Francisco, found it amazing that the Cambridge archeologist was responsible for this section of the fair, and many years later described how Putnam in control of the Midway was like Albert Einstein managing Barnum and Bailey's Circus (Rydell 1984:62).

Putnam made the best of this incongruity, laboring hard and successfully to prevent the Indian exhibits from becoming "wild west shows." He also tried to convince the public of the scientific merit of everything under his control, including the belly dancers on the Midway whose *Danse du ventre* caused quite a scandal. After the fair was over, Putnam wrote:

At one end of the street the old Temple of Luxor reminded us of ancient Egypt, while the architecture of the street and the Mosque at the other end told of Cairo in its splendor. Here in the playhouse of the street were gathered the dancing women, and here was to be witnessed the national Danse du ventre which not being understood was by many regarded as low and repulsive. What wonderful muscular movements did those dancers make, and how strange did this dance seem to us: but is it not probable that the waltz would seem equally strange to these dusky women of Egypt (Dexter 1966a:325).

Unfortunately few of the 27 million visitors to the Chicago fair learned this lesson in cultural relativism, for the crowds that flocked to see this display of muscular gymnastics on the Midway found most of the other native groups repulsive. One publication put out during the duration of the fair, *Midway Types: The Chicago Times Portfolio of Midway Types* (1893), described the Indians as decidedly inferior beings.

Any superfluity of sentiment is wasted on the Indian. He prefers scalps to taffy, and fire eaters to tracts. He is monotonously hungry to kill somebody, a white man if possible, another Indian if the white man is happily absent. The Indian woman, or squaw, is a shadow worse in human deviltry than the male. Mildness, docility, kindness, loveableness seem impersonated. Yet the records of massacres, for centuries, show that the squaw is the apotheosis of incarnate fiendishness. . . . They belong to no ethical societies, dress reform clubs or art cliques. . . . Savages, pure and cunning, they gave to the Midway the shadows of characters that cannot be civilized and solemnity of appearance as deceptive as the veiled claws of the tiger (Rydell 1980:119).

The theme of human progress that pervaded the Columbian Exposition found one of its most insidious expressions here, for many white visitors viewed these displays as proof of the distance their culture had progressed beyond that of these dark-skinned peoples.

Northwest Coast Indians at the Chicago Fair

Among the "living Indian" displays was a group of Kwakiutl. Putnam had assigned to Franz Boas the responsibility of organizing the recruitment of these Indians and, through the efforts of several individuals in British Columbia, of assembling an extensive collection of Northwest Coast masks, ceremonial paraphernalia, costumes, canoes, totem poles, and entire houses. With the cooperation of the Canadian Indian Affairs department, Boas arranged for fifteen adults and two children to come to Chicago in the spring of 1893. These Kwakiutl lived for the duration of the fair in a large house, elaborately painted with a thunderbird and moon images (fig. 40), transported all the way from British Columbia.

Although the stay of these Northwest Coast Indians in Chicago was for the most part uneventful, one Sun Dance-like ceremony they performed created a stir. In August 1893, some Kwakiutl cut slits in their backs through which they inserted twine. After dancing for a while to the beat of a drum, these Indians became more and more frenzied and finally started wildly thrashing about, beating each other with clubs, snarling like wild beasts, and biting the flesh of one another and of the other Kwakiutl present. The newspapers provided the following graphic description of this scene: "Around and around they ran, leaping, twisting, and diving till it seemed to the horror-stricken spectators that each instant would see the flesh torn from their bodies" (Cole 1985:129). This scene seems to have upset many of the spectators as well as the British Columbian missionaries who, after reading about it in the newspapers, insisted that Exposition officials promise not to permit the Kwakiutl to repeat the ceremony.

Fig. 40. Northwest Coast Indian exhibit at Chicago World's Columbian Exposition, 1893. *322897*

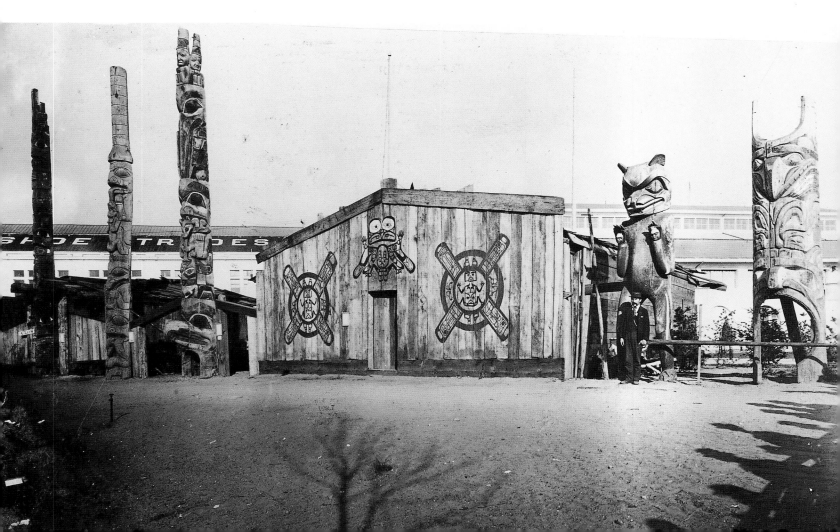

At the conclusion of the Exposition, Putnam hoped to be offered a position at the newly formed Columbian Museum of Natural History funded by Marshall Field. Although Putnam had been named as one of the incorporators of this new institution, a group of Chicagoans who disliked him used their political power to prevent him from being invited to become a trustee. The problem lay in the unwieldy dual structure of the Chicago fair which was organized and run jointly by a "commission" and an "exposition." Putnam had, from the start of the negotiations which led to his appointment as director of the anthropology sector of the fair, allied himself with the director-general of the World's Columbian *Commission,* George Davis. The word "allied" is particularly appropriate here, since Davis felt deep animosity toward H. N. Higginbotham, president of the World's Columbian *Exposition.* Higginbotham could not tolerate Putnam's loyalty to Davis, and worked to prevent the Cambridge archeologist from assuming any permanent position in Chicago (Dexter 1966a:317).

This turn of events insulted Putnam deeply, as did the appointment of Frederick J. V. Skiff, chief of the Department of Mines and Mining, to the position of director of the Museum. He felt hurt at the failure of the trustees to acknowledge his contributions to this museum, and wrote to Boas that "I am very much disgusted at the turn things have taken at the Columbian Museum, and I feel that I have been very shabbily treated by Mr. Skiff and the Trustees, after the protestations which were made by me and all the work I did for the Museum, the conception of which was mine and which would never have been accomplished had I not worked for it as I did. Such ingratitude I have never heard of before and I am very much disappointed" (Dexter 1970:21). To his friend Samuel A. Crawford, Putnam wrote that he felt that "after squeezing all the juice out of me they threw me aside as a used up orange" (Hinsley and Holm 1976:312).

Despite his own failure at the Field Museum, Putnam hoped at least to have Boas, his chief assistant at the fair, hired there as curator of ethnology. When the fair closed in October, Boas, who had found the task of managing the Indian groups quite burdensome, breathed a sigh of relief and promised "never again to play circus impressario" (Cole 1985:133), but certainly wished to continue working as a professional anthropologist in Chicago. For a while he was optimistic, for after Putnam returned to Cambridge at the end of 1893, Boas stayed on at the Field Museum, assigned to organize the vast amount of ethnographic materials that had been assembled for the fair. However, the trustees soon turned to William Henry Holmes of the Bureau of American Ethnology and asked him to become head of the Anthropology Department. Boas, indignant and upset at this turn of events, wrote to Putnam: "I immediately packed up and have left the Museum for good. . . . I am now, of course, adrift and shall appreciate whatever you may be able to do for me. You know I have nothing to fall back upon" (Mark 1980:38).

It was at about this time that Morris Ketchum Jesup contacted Frederic Ward Putnam to offer him the position of curator of the Department of Archeology and Ethnology at the American Museum of Natural History. Shortly after he accepted a half-time position with the American Museum, Putnam wrote Boas: "An interesting matter has developed in New York which may be the means of my doing something for you by and by. The Trustees of the American Museum have placed the Anthropological Department of that Museum under my charge, and for the present I am to go there one week in four with the understanding that I shall have such assistants as may be required" (Mark 1980:37). Putnam knew that he could not possibly run the American Museum's Anthropology Department adequately without additional support staff and hoped in time he could convince Morris Jesup to hire the most brilliant anthropologist of the time, Franz Boas.

Franz Boas 1858–1942

In 1886, Putnam, then forty-seven, had met the twenty-eight-year-old Franz Boas (fig. 41) at a meeting of the American Association for the Advancement of Science. Boas, who had just returned from his first field trip to the Northwest Coast and was full of enthusiasm and plans for future research on American Indian anthropology, immediately struck Putnam as a man of exceptional intelligence and unusual capabilities. This meeting would be the beginning of a long and fruitful friendship during which the patrician New Englander served as patron of this brilliant but erascible young German Jew. Soon after their fortuitous encounter, Boas secured a job as assistant editor of *Science* magazine and, as Putnam wrote to a friend, "from that time he became one of us" (Cole correspondence; Mark 1980:32).

Franz Boas was born in Prussia in 1858 to a family of freethinking Jews whose left liberal social attitudes greatly influenced his anthropological theories. Boas, who firmly believed from an early age in the equality of man, wanted to work for "equal rights for all, equal possibilities to learn and work for poor and rich alike" (Stocking 1968:149). His university days seem to have been quite wild—when he studied at both Bonn and Heidelberg he drank immoderately, fought half a dozen or more duels, and was at one point jailed for indulging in some student pranks. While at the University of Kiel, he experienced the religious prejudice that would eventually cause him to leave Germany, and left that institution with scars on his face caused by duels fought over his fellow students' anti-Semitic remarks (Cole correspondence; Kluckhohn and Prufer 1959:8).

Although Boas was to become renowned as an anthropologist, he earned his doctoral degree in 1881 from the University of Kiel with a thesis in physical science. But after he graduated, he decided to investigate the relationship between how a group of people perceive their environs and the actual topography of the region in which they live (Stocking 1968:144). In order to make such a study among as "simple" a people as possible, Boas made an expedition from 1883 to 1884 to Baffin Island in the Arctic Ocean to study the Eskimo. He spent long hours with these northern peoples, lived in their snowhouses, traveled with their dogsleds, enjoyed their generous hospitality, and soon came to realize that despite what Europeans may have said about them, the Eskimos were by no means "simple."

Boas's convictions about social equality received a substantial boost during his stay in Baffinland, for here he interacted firsthand with "primitive" peoples whom so many anthropologists and sociologists defined as culturally, ethically, and evolutionarily inferior, but whom he came to respect. After a twenty-six-hour dogsled trip, during which he and his guide got lost for an entire foggy, dark day in minus 45 degree temperatures, he wrote:

Is it not a beautiful custom among these "savages" [wilden] that they bear all deprivations in common, and also are at their happiest best—eating and drinking—when some one has brought back booty from the hunt? I often ask myself what advantages our "good society" possesses over that of the "savages" and find, the more I see of their customs, that we have no right to look down upon them . . . We have no right to blame them for their forms and superstitions which may seem ridiculous to us. We "highly educated people" are much worse, relatively speaking. The fear of traditions and old customs is deeply implanted in mankind, and in the same way as it regulates life here, it halts all progress for us. I believe it is a difficult struggle for every individual and every people to give up traditions and follow the path to truth. The Eskimo are sitting around me, their mouths filled with raw seal liver (the spot of blood on the back of the paper shows you how I joined in). I believe, if this trip has for me (as a thinking person) a valuable influence, it lies in the strengthening of the viewpoint of the relativity of all cultivation [Bildung] and that the evil as well as the value of a person lies in the cultivation of the heart [Herzensbildung] which I find or do not find here just as much as amongst us, and that all service, therefore, which a man can perform for humanity must serve to promote *truth* (Cole 1983:33).

Fig. 41. Franz Boas. *2A5161*

These words reflected Boas's admiration for the Eskimo as well as his deep dissatisfaction with European culture. Prior to this trip to the frozen north of the New World, Boas had begun to feel uncomfortable in Germany, alienated from what was becoming an opportunistic and materialistic society. He realized that his Jewish heritage, in a country that was becoming more and more anti-Semitic, and his general outspokenness on social and political matters, in an increasingly conservative climate, would certainly prevent his appointment to any university position. Among the Eskimo, Boas encountered an admirable society—so very dissimilar to his own German culture—in which all things were shared and all men were equal. These "savages" whom so many Europeans considered inferior, seemed to Boas to embody a more complete sense of humanity than their white brothers (Stocking 1968:150).

When Boas returned to Germany after his trip to Baffinland, he found Bismarck in the process of establishing an empire over the primitive peoples of New Guinea and Africa and became all the more appalled at what his country had become. A desire with which he had earlier toyed, to leave this oppressive country and move to America, now firmed into a commitment (Stocking 1979:34). Political considerations were not the only incentives to his moving to the United States. Before he had left for the Arctic, Boas had met the daughter of an emigré doctor while she was on a holiday in the Hartz Mountains. The young scientist fell in love with Marie Krackowizer and wanted to marry her, but knew that first he had to establish a career in America. Although it would be several years before Boas could actually permanently settle in the United States, his mind was made up to leave Germany, and he pursued job opportunities in America with immense zeal.

Despite his commitment to emigrate, Boas had to return to Germany after his first trip to the New World. He needed work and was pleased when Adolf Bastian of the Royal Ethnographic Museum of Berlin offered him a temporary assistantship to help prepare the newly acquired American collections for exhibition. Here he discovered a people who fascinated him and whom he wished to study further: the Indians of the Northwest Coast. Johan Adrian Jacobsen, a Norwegian in the employ of the Berlin Museum, had spent time in British Columbia, assembling an unusually large and fine collection of Northwest Coast art (Cole 1985:66). Boas was intrigued by these paintings and carvings, so totally different from the austere and simple art of the Baffinland Eskimo. Many years after this initial encounter with the baroque style of the Northwest Coast, Boas said: "My fancy was first struck by the flight of imagination exhibited in the works of art of the British Columbians as compared to the severe sobriety of the eastern Eskimo. . . . I divined what a wealth of thought lay hidden behind the grotesque masks and the elaborately decorated utensils of these tribes" (Boas 1909:307).

Adrian Jacobsen's brother, Fillip, had also traveled to British Columbia and collected some art. When in British Columbia, Fillip Jacobsen convinced a group of nine Bella Coola Indians to accompany him back to Germany for a visit, where they performed masked dances, demonstrated the use of snowshoes, and re-enacted mock potlatches (Cole 1985:66–73). Although many Germans found this troupe entertaining and pleasantly exotic, Boas was fascinated by these British Columbian Indians. When the Bella Coolas came to Berlin, Boas spent long, intense, but very pleasurable hours with them, learning their difficult language. So drawn was Boas to the Bella Coolas he had met and the art he worked with at the Berlin Museum that in 1886, he solicited contributions from relatives to finance a trip to the Northwest Coast.

Boas's First Trip to the Northwest Coast, 1886

Boas had several goals for this initial field trip to British Columbia: he wanted to collect artworks which he hoped to sell to museums, he wanted to study the linguistics of the region, and he wanted to establish himself among Americans as a creditable scholar of American Indians. Since Marie Krackowizer lived in New York City, Boas hoped his Northwest Coast anthropological activities might lead to a position at the institution where he badly wished to work: the American Museum of Natural History. Once he had a steady job, he could marry Marie and settle in his adopted country (Cole 1985:102–9).

On arriving in British Columbia, Boas stopped in Victoria, to discover Indians living in squalid slums and dressed in European fashion. He stayed a short while in that city, then took a steamer up the coast to Newitti (see back endpaper), a relatively unacculturated Kwakiutl town off northern Vancouver Island. The Newitti people were suspicious of his intentions, for they took this well-dressed man for a missionary. Boas had to explain at some length that despite his fine clothing he was *not* a cleric intent on conversion but instead a visitor from Germany anxious to learn about those very traditions missionaries were trying so hard to eradicate (Rohner 1969:32).

The very next day the Kwakiutl invited Boas to a potlatch, at which he listened to singing and speech-making, and joined in a feast of halibut stewed with fish oil. The host, to demonstrate his great importance, gave away blankets and money to all his guests, and then chopped up his new boat and burned it as if it was mere firewood. As Boas sat watching, fascinated but unable to understand the Kwakiutl language, he suddenly noticed that he himself had become the subject of their speeches; an interpreter informed Boas that the Indians still could not understand why he had come to Newitti. Since they knew he was not a missionary, they wondered if he were instead a government agent who had come to enforce the anti-potlatch law (Rohner 1969:32–33).

It seems that not long before, Dr. Powell had threatened to send a gunboat to Newitti if they continued to disregard the law and conduct potlatches. In good Indian fashion, Boas responded to their suspicions with a speech:

My country is far from yours; much further even than that of the Queen. The commands of the Queen do not affect me. I am a chief and no one may command me. I alone determine what I am to do. [Boas had been introduced as a chief when he arrived.] I am in no way concerned with what Dr. Powell says. I do not wish to interfere with your celebration. My people live far away and would like to know what people in distant lands do, and so I set out. I was in warm lands and cold lands. I saw many different people and told them at home how they live. And then they said to me, "Go and see what the people in this land do," and so I went and I came here and I saw you eat and drink, sing and dance. And I shall go back and say: "See, that is how the people there live. They were good to me and asked me to live with them" (Rohner 1969:33–34).

This speech, which Boas described to his parents as "beautiful," pleased the Indians enormously; many told Boas that "their hearts were glad." So impressive was this important man who could orate nearly as well as they, that the Kwakiutl requested from Boas a written statement promising that no more gunboats would be sent. Put on the spot, Boas explained that the Queen was "somewhat" more important than he, and quickly announced he would tell the white people "that I liked to see [the Kwakiutl] sing and dance," thus describing the potlatch in positive, favorable terms (Rohner 1969:34).

Boas very much wanted to see a dance performed, and offered to sponsor a feast if the Indians would do so. To pay for their performance, Boas hosted his own "potlatch." He had a large fire built in the center of the house, and then had some food cooked. As was typically the case during Kwakiutl potlatches, the guests did much of the entertaining and sang several songs before Boas had the food distributed. Toward the end of this meal, one of his guests, a great chief, made a speech:

This chief [pointing to Boas] has come to us from a distant land, and all our hearts are glad. He is not like the other whites who have come to us. His heart is pure and kind toward us Indians. None of the King George men [English] or the Boston men [Americans] gave us . . . festival. But his people must be good and he shows that he has the heart of a chief. Whoever of us shall meet him, will be glad and recognize him as a great chief. We are glad he came and hope he will return. My heart is friendly toward him and if he wants anything from us we shall do our best to do what he asks (Rohner 1969:37).

By respecting the Kwakiutl traditions and showing admiration for and interest in their culture, Boas had gained the confidence of these Indians who so deeply distrusted other whites. Probably conscious of this honor, Boas accepted the Newitti chief's warm speech "with proper composure," and distributed tobacco to all the men (Rohner 1969:37).

After staying for less than two weeks in Newitti, Boas left to explore other British Columbian Indian villages. His letters home describe simultaneous fascination with the natives and terrible discomforts at the traveling conditions. Although he sometimes stayed with the Indians in their large, smokey communal houses, most often he roomed with whites. Sometimes Boas had to sleep in a missionary's house if no other accommodations were available, and even when hotels existed, they were "nothing like the Hoffman House in New York or the Central Hotel in Berlin." The "hotel" in Comox was, for example, a large farmhouse with several rooms rented out to travelers. Such rooms, often ugly and filthy, offered as "beds" thin mattresses placed on hard floors which caused Boas numb hips. The food, typically beans, oatmeal, and potatoes, was as a rule awful and the late autumn weather was most often rainy and unpleasant (Rohner 1969:41).

These physical discomforts were compounded by personal difficulties. In some parts of British Columbia, the natives had become sufficiently Christianized to observe the Protestant sabbath and, to Boas's great annoyance, would not agree to work with him on Sundays. Moreover, in a world where Jews were almost unheard of, this man who did not attend Sunday church services was regarded as a great oddity. In order not to stand out so (and perhaps to make his personal interactions with the Christianized Indians easier), Boas at times did go to church.

To make matters worse for this young man, as he traveled from place to place, observed and sometimes participated in Indian ceremonies, recorded myths from natives willing to share their traditions, sketched totem poles, and purchased artworks, Boas suffered loneliness. The mail came infrequently, and he became sad when no letters from his fiancee showed up among his correspondence. At one point he met Fillip Jacobsen who now lived in British Columbia, and wrote to his parents how pleased he was to speak his native tongue again and how it was "refreshing to meet someone . . . glad to see you" (Cole correspondence; Rohner 1969:66)

Boas hoped this first field trip to the Northwest Coast would establish his credibility among the American scientific establishment as a serious enthnographer. In order to gain entree into the American Museum, and perhaps land a job there, Boas offered to sell Bickmore some Kwakiutl art. While still in the field, Boas had sent to New York a collection of masks, cedar rings, and whistles he had seen worn by the Newitti in ceremonies, along with a few other pieces he had acquired in British Columbia. When he arrived in New York on his return trip from the Coast, Boas lectured to Bickmore and several other Museum officials on the collection; although Bickmore himself liked the pieces and probably would have paid $500 for the lot, he could not persuade Bishop to provide the necessary funds. Boas made a favorable impression on the group, but no mention at all was made of any possible position for him. Deeply disappointed, Boas sold his collection to the ethnographic museum in Berlin (Cole 1985:109).

All was not lost, however, for in August, before his trip to British Columbia, Boas had met Frederic Ward Putnam at the American Association for the Advancement of Science meetings. After he returned from his travels to the Northwest Coast, as a result of Putnam's influence, Boas received his first American job—an editor of the weekly journal *Science*. Now steadily employed, Boas could marry Marie Krackowizer and settle down in his newly adopted country.

Boas's Debate with the U.S. National Museum

It did not take long for Boas to cause a stir in the American scientific community, for soon after becoming an editor of *Science* he attacked two of the country's most eminent anthropologists. In the pages of this distinguished journal, Boas engaged in a debate over the principles of museum arrangement with the curator of ethnology at the U.S. National Museum, Otis Mason, and John Wesley Powell, of the Bureau of American Ethnology (BAE).

On a visit to Washington, D.C., Boas had been distressed at the manner in which the U.S. National Museum displayed its ethnological collections. All pieces that had served the same function—musical instruments, vehicles for transportation, or tools—were displayed together in a sequence from the simplest type made in the simplest tribe, to the most complex types created by civilized groups. At the lowest end of the scale appeared archeological specimens from "stone age" peoples of the prehistoric ice ages placed alongside ethnological objects from Eskimos or Bushmen, or other "living representatives of the stone age." These scales always terminated with what the Museum displayed as the most perfect items made in the most highly developed, most sophisticated, most advanced countries in the world—the United States and the nations of western Europe.

The principles informing these displays were in part derived from the book, *Ancient Society, or Researches in the Lines of Human Progress from Savagery through Barbarism to Civilization* (1877), written by American anthropologist Lewis Henry Morgan. In this major work, Morgan proposed that mankind had evolved through a series of stages: savagery, barbarism, and civilization. Like virtually all other nineteenth-century anthropologists, Morgan assumed that every human society progressed toward the ideal currently manifested by western European culture. All races did not evolve at the same pace or progress equally as far up the evolutionary ladder; certain cultures, like those of the "living stone age," had evolved only slightly and stopped at a lower stage of social development, whereas others, like the white Americans and Europeans, had forged ahead to the apex of the evolutionary scale.

As curator of the U.S. National Museum, Mason remained absolutely committed to the usefulness of evolution as the model for the study of man. Like so many other adherents of the so-called "comparative method," he firmly believed that all peoples at the same level of socioeconomic development shared material and intellectual culture. According to this theory, societies at the "savage" stage, like Paleolithic cavemen, Eskimos, Australian aborigines, and South African Bushmen, would in many ways be virtually identical. When anthropologists discovered among two or more peoples similar myths, tools, art forms, musical instruments, vehicles of transportation, house types, or any of an immense number of cultural elements, they inevitably concluded that those groups shared a position on the evolutionary scale.

In 1887, Boas launched a vigorous attack in *Science* against the U.S. National Museum's method of exhibition based on the comparative method of evolutionary anthropology (1887a). Boas believed that by exhibiting objects from very different cultures which some anthropologists felt were on the same rung of the evolutionary ladder, the Washington museum robbed all the pieces of their historical and social contexts. Displaying a tool among many tools only demonstrated some similarity between cultures; what Boas found far more significant and relevant was the complete picture of the culture, gleaned from displaying that tool alongside musical instruments and transportation vehicles from that same culture. Boas was convinced that the sort of sweeping generalizations Mason and others made about social evolution were erroneous and suggested that sometimes groups shared cultural elements as a result of the transmission from one group to another of ideas and inventions. He even proposed the shocking notion that accidents of history led to the cultural similarities between groups (Boas 1887b). The idea that chance might have caused anything could not have been accepted easily by the late nineteenth-century mind, and was apparently simply misunderstood by Boas's opponents. The debate raged in several issues of *Science,* with both Mason and Powell presenting their reasoning for the evolutionist displays, and Boas rebutting them angrily (Cole 1985:114–18; Hinsley 1981:98–100).

While this debate may seem to us today quaint and perhaps even academic in the worst sense, at the end of the nineteenth century the sort of social Darwinism that the Smithsonian depicted in museum exhibitions had consequences beyond the study of anthropology. Jingoistic and nationalistic Americans who wanted scientific validation of their social views, which placed the Caucasian at the apex of the evolutionary pyramid, often resorted to the theories of social Darwinism. In 1894, W J McGee of the Bureau of American Ethnology and first president of the American Anthropological Association, expanded upon Morgan's phases of social development with the following words about the evolution of political systems.

Just as patriarchy gives way to hierarchy, and hierarchy to absolute monarchy, as limited monarchy is giving way to democracy of republicanism, already the foremost nation of the earth is a republic, and all other civilized nations are either republican or undergoing changes in the direction of republicanism. So according to the experience of the ages, the best nation is a republican one, and the best citizen is the individual adapted to life under republican conditions (McGee 1894:353).

McGee believed that members of this highest race had the moral responsibility to help humanity's inferior races, languishing in savagery or barbarism, transcend their limitations. In an address to the National Geographic Society in 1899 on the topic, "National Growth and National Character," McGee asserted that "the white-skinned man indeed leads the world today . . . in enlightenment [a stage even more advanced than civilization] the strong man not only carries the weak until cured or coaxed into strength, but seeks ever to lift to his own plane the world's weaklings, whether white, or yellow, or red, or black" (quoted in Haller 1971:106). Although McGee maintained a deeply optimistic view of the ultimate success of the "strong man's burden," he was conscious of all the pitfalls involved in his plan.

In another address, this time made at the Louisiana Purchase Exposition in St. Louis in 1904, McGee described how the superior races, in their attempts to elevate the inferior ones, would transcend themselves so energetically that the lower races would have difficulties keeping up with their advancements. Thus, despite the best of will, the inferior races, those "mental and moral beggars of the community . . . may not be trusted on horseback but only in the rear seat of the wagon" (quoted in Haller 1971:107).

Certainly for Franz Boas, a man from a liberal-minded family, who had discovered the intellectual prowess of the "primitive" peoples he met, these views, which gave scientific backing to a hierarchical view of humanity that placed white Europeans and Americans at the top of the social scale, must have been abhorrent. Boas found the comparative method displayed at the U.S. National Museum deeply disturbing, perhaps because he connected it, as I have done here, to the prevalent evolutionist bias of anthropology of the day.

Boas's arguments with the Washingtonians on museum displays were early manifestations of his life-long struggle to purge anthropology of its evolutionist, racist bias. After struggling for a long time with the question of why some cultures have different configurations and others seem quite similar to ours, Boas ultimately concluded that human societal variations were due not to the progress of evolution but instead to historical factors. As early as 1894, Boas asserted that the Europeans who had developed a more elaborate civilization than their African brothers did not do so because of some innate racial superiority but instead as a result of chance contacts with other peoples; "in short, historical events appear to have been much more potent in leading races to civilization than their faculty, and it follows that achievements of races do not warrant us to assume that one race is more highly gifted than the other" (Boas 1894:327). Thus Boas used history to dispute the prevalent racist notion that dark-skinned peoples had not developed technologically advanced societies as a result of evolutionary inferiority.

Associated with that notion was the belief held by most whites that "primitive" people were by nature intellectually inferior and were incapable of sustaining a logical sequence of thoughts. Boas used his own field experiences to contradict these ideas. He described how the Kwakiutl often found the questions of the white visitor uninteresting and irrelevant, and therefore mentally drifted away. If, however, the investigator touched upon a topic that interested the Indian, such as the potlatch, he would talk for hours, providing the most detailed, explicit information on the most complicated of matters. What the evolutionists interpreted as racial inferiority—lack of interest in those questions the whites thought universally fascinating—Boas explained as the effect of culture. He argued against a thesis held by most of his colleagues by identifying specific cases where it did not hold (Boas 1901).

Boas Returns to the Northwest Coast

In order to gather sufficiently extensive data on primitive culture to counter the evolutionists, Boas needed to return to the area which he believed offered the most interesting sources of information, the Northwest Coast. Indeed, he was to travel many times to British Columbia, to study the art, myth, ritual, and social organization of the Northwest Coast peoples. From his first visit in 1886 to his last in 1930, Boas remained most connected to the Kwakiutl, whose complex and sometimes even confusing culture he managed to describe in great detail in numerous publications.

Boas's second trip to the Northwest Coast, which took place in summer of 1888, was funded by the Northwest Tribes Committee of the British Association for the Advancement of Science. This was the first of five trips sponsored by that group, totalling twelve months of fieldwork (Stocking 1974:84). Boas ran into great difficulties with Horatio Hale, the head of the British Association's Northwest Coast Committee, who insisted on a general approach to fieldwork; that is, he wanted Boas simply to provide an ethnographic summary of the area without necessarily visiting all the peoples and spending much time in numerous villages. Hale wrote to Boas:

what is specially desired of you in your present mission, is not a minute account of two or three tribes or languages. We wish to learn from you a general synopsis of the ethnology of the whole of British Columbia, according to the linguistic stocks. We do not expect you to visit every part of the Province; but we think that with what you have already seen of it, and what you can learn from the natives and white residents and from books, you should be able to give an ethnological description of the whole region, from north to south, without omitting any stock (Rohner 1969:81).

Boas, always extremely thorough, found this superficial approach most unsatisfactory, for in order to obtain what he considered to be the necessary amount of detailed information on social organization, art, mythology, and religion, he needed to spend extended periods of time in a few selected villages.

In 1889, before leaving on his second trip sponsored by the British Association for the Advancement of Science, during which Hale wanted Boas to study the Nootka and Salish as well as the Kwakiutl, the young anthropologist wrote his supervisor a lengthy letter suggesting an alternative plan for his fieldwork. Boas hoped to be able to concentrate on the Kwakiutl of Alert Bay (fig. 42) near Vancouver Island and the Bella Bella on Campbell Island, close to mainland British Columbia. Having experienced intense loneliness on these trips, he also suggested that he bring his family to Victoria for about a year so he could remain longer on the Northwest Coast and obtain more information on the Indians.

Hale was very displeased with Boas's suggestion, and wrote to him disparaging the plan.

I must earnestly enjoin you to follow implicitly the instructions you received from me. If you had done it last year . . . you would have saved yourself and me a great deal of trouble, and would have produced a more satisfactory report . . . I cannot understand why you should persist in causing me an immense amount of useless trouble, as well as much annoyance, by objecting to my instructions, which you are expressly engaged to carry out. Kindly go on hereafter with your usual energy and ability, in the course of which, after much experience and careful consideration, I have marked out for you (Rohner 1969:82).

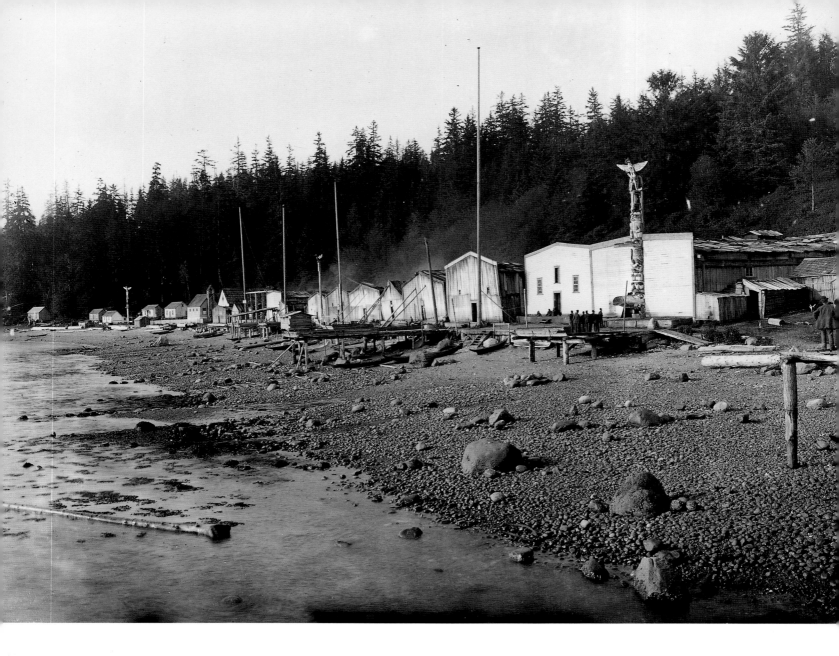

Fig. 42. Kwakiutl village of Alert Bay.
Photograph taken 1898. 411790

In a letter to his wife written in the field, Boas complained that Hale knew nothing about general ethnology and moreover created immense difficulties by his "vanity, pedantry and sensitivity." Boas nevertheless reconciled himself to this man's "useless instructions" (Rohner 1969:107, 109).

Boas's assignment was to survey the tribes of British Columbia, paying special attention to their linguistics and physical anthropology. During the late nineteenth century, especially in America, it was generally believed that racial differences could be measured by head size and that the so-called cephalic index was a permanent racial characteristic, fundamental to the classification of human races (Stocking 1968:57). Thus, research in physical anthropology consisted of taking measurements of the heads of living people, and collecting skeletons in order to measure skulls.

The supposed relationship of physical characteristics to racial qualities is evident in the works of Daniel Brinton, at one time the president of the American Association for the Advancement of Science, and professor of American linguistics and archeology at the University of Pennsylvania. Brinton, one of the most influential scientists of his day, was a firm believer in the following hierarchy of races: white, Asian, American Indian, Australian, Polynesian, and African—each of which had physical traits reflecting their relative position on the hierarchy. Particularly inferior physical characteristics were those "reversions of perpetuations of the ape-like (simian pithecoid) features of the lower animals which [were] man's immediate ancestors," and included prominence of the jaws, recession of the chin, early appearance of the wisdom teeth, and continuation of the "heart" line across the palm of the hand (Brinton 1890:40–48). While the superior races were blessed with long skulls, narrow noses, round eyes, straight jaws, and broad faces, the inferior ones had the broad skulls, broad noses, narrow eyes, projecting jaws, and narrow faces. Brinton claimed in 1896 that "the black, brown and the red races differed anatomically so much from the white, especially in their splanchnic organs, that even with equal cerebral capacity, they could never rival its results by equal efforts" (Brinton 1896:12).

Brinton's views on the physiological causes of racial differences were based on a notion prevalent at the time that corresponding to the progressive stages of human development was a progressive development of cranial capacity. W J McGee firmly believed that brain sizes corresponded very closely to culture grade. As a group evolved, the brain became larger since more advanced stages of development demanded more complex neural activities. He felt that this process of "cephalization" could be noticed in certain particularly impressive examples of human progress, as for example in the change from George Washington's "retreating" brows to the "full-forehead type of the living statesman" (McGee 1899:425).

Head-measuring was a major preoccupation of many nineteenth-century anthropologists, who believed that the hierarchy of races was manifested by the size of the head as well as the capacity of the skull. Elaborate equipment was invented for the measurement of the head of living peoples, while precise methods were developed to gauge the cranial capacity of skulls (Haller 1971:16). So fascinated were anthropologists with the potential of these technologies that they established societies for the purpose of ensuring further scientific studies of crania. The Mutual Autopsy Society of Paris, for example, was founded to secure brains for research, and the American Anthropometric Society was organized to preserve and study its members' brains. Brain surgeon Edward Spitzka, one of the founders of the American Anthropometric Society, performed one of the most extensive studies of an individual's brain on that of John Wesley Powell of the Bureau of Ethnology. At one time, Powell had made a bet with McGee that his brain was larger; and on Powell's death in 1903, Spitzka, assisted by McGee, Frank Baker, professor of anatomy at Georgetown and editor of the *American Anthropologist*, and Daniel Lamb, vice-president of the Association of American Anatomists, conducted one of the most thorough cranial analyses ever made. As one might expect, Spitzka concluded from this study of Powell's brain that a clear relationship existed between cranial capacity and intellectual superiority (Haller 1971:37–38).

DURING his field trips to the Northwest Coast, Boas dutifully performed the tasks assigned him by the British Association for the Advancement of Science, taking endless measurements of Native Americans, though certainly not to provide evidence supporting the hierarchy of races. In later years, Boas would use the data obtained on these field trips to discern specifically how, on the one hand, environment, and on the other, physical growth, affected the size and shape of one's head and body. By studying the relationships of head and body forms of groups of people, Boas would use physical anthropology to offer clues as to their history of contacts and migrations. And, as he became increasingly opposed to racialist science, Boas would use the results of his physical anthropological investigations as evidence to contradict the prevailing racist attitudes of his times. In his major book on the subject, *The Mind of Primitive Man* (1911), Boas systematically and scientifically dispelled each of the premises upon which some physical anthropologists based their hierarchical arrangement of the races.

Boas did not find it easy to obtain on the Northwest Coast the necessary data for physical anthropological research. In order to collect a sufficient number of measurements, he went to the local jails and measured Indian inmates, and referred to himself as "a mongrel dog. I look up all kinds of people without modesty or hesitation" (Rohner 1969:88). At one point Boas managed to convince the priest at a mission school to measure the heads of his male students. That priest then introduced the anthropologist to the nun who ran the girls' school, who, when learning of his desires, "almost scratched out my eyes. She said such a request was never made before and that it is outrageous for a man to want to measure girls. 'How can science dare thus to deal with the work of God,' she yelled at me" (Rohner 1969:125). This was not unlike the reaction Boas received to his attempts at measuring children in the schools of Worcester, Massachusetts, in 1891. The local press launched an all-out attack on this "alleged anthropologist . . . with visage seamed and scarred from numerous rapier slashes" who might corrupt the town's innocents (Stocking 1968:170).

It was insufficient simply to measure heads in order to obtain adequate data for an analysis of a people's physical anthropology. Needed also were skulls and skeletons, which Boas obtained on the Northwest Coast from graves. At one point Boas described in his letter diary how a photographer, O. C. Hastings, took him on a boat trip to "a place where there are Indian skulls," only to discover that someone had stolen all the skulls, leaving just a headless skeleton. "It is most unpleasant work to steal bones from a grave, but what is the use, someone has to do it. I have carefully locked the skeleton into my trunk until I can pack it away." When he went to sleep that evening, Boas had nightmares of "skulls and bones" (Rohner 1969:88). Despite his aversion to the task, Boas hoped to make a profit from these collections, since the going rate for skulls and complete skeletons was five dollars and twenty dollars, respectively (Cole 1985:120).

A few days after his skeleton nightmares, Boas had adjusted nicely to his new role as grave robber. Indeed, he was so comfortable that he could write home the following dry description of his activities:

yesterday . . . I could not do much, to my regret. So I measured and described the skulls which I had stolen and made arrangements with my photographer friend to return to the graveyard in order to obtain one or two additional skeletons. We went out there again at eight and now I have three skeletons, but without heads. . . . Before I leave I shall get two more. At ten o'clock we were back from our expedition. . . . this afternoon I cleaned the first skeleton and packed it up. They take up more room than I thought, and I shall have to acquire larger boxes. Besides having scientific value these skeletons are worth money (Rohner 1969:90).

Unfortunately for Boas, he had great difficulty selling all this skeletal material, and never realized the great profit for which he had hoped.

UNTIL 1895, when Frederic Ward Putnam managed to have him hired as a regular staff member of the American Museum, Boas did not enjoy job security for any long period of time. One year after he assumed his position at *Science,* he resigned. In 1889 he was appointed docent in anthropology at Clark University in Worcester, Massachusetts, but left in 1892, as part of a general faculty revolt against the high-handedness of President Stanley Hall on matters of academic freedom. Then he became Putnam's assistant at the Chicago Fair and hoped to be appointed full time to the Field Museum at the Exposition's end. When it turned out that the Chicago museum hired William Henry Holmes, Boas left, once more with no steady employment. He looked on with some envy at his patron's appointment at the American Museum of Natural History and hoped quite desperately that Putnam's assurances of a position for him at that distinguished institution would be realized.

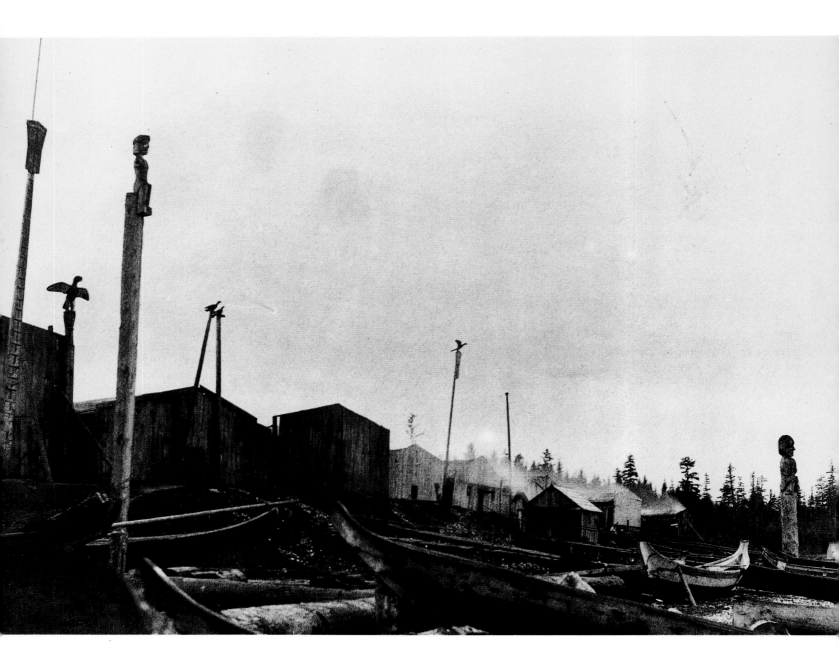

Fig. 43. Kwakiutl village of Fort Rupert. On the beach are two poles with figures seated atop; these are the "blanket poles," between which blankets were piled during potlatches. *Hastings photograph, 1894. 336057*

5 / Franz Boas and the American Museum

IN the summer of 1894, Frederic Ward Putnam wrote to his protégé Franz Boas about a temporary position that he had managed to find for him at the American Museum of Natural History: Boas would prepare a special exhibit using manikins to depict life on the Northwest Coast. Responding to Boas's question about the salary he might expect for his work, Putnam wrote, "there is little doubt in my mind that you will be employed at the compensation you have stated in order to prepare the groups. . . . So I do not see, my dear fellow, but that things look bright for you ahead, and after the cloudy days the sunshine is coming" (Dexter 1976:304).

Putnam had convinced the American Museum to join the trend already followed by a number of other natural history museums of having an extensive set of models made illustrating the lives of primitive peoples. These life-size manikins depicting people wearing costumes and engaged in some activity had been invented in Europe where they had enjoyed a great vogue for several decades. During the Chicago fair, the Smithsonian Institution had impressed audiences with displays of wax Indians living and working in their natural environments. Instead of the usual rows upon rows of primitive tools, utensils, costumes, and ceremonial paraphernalia in glass cases, here the cultural artifacts could be carried, manipulated, or worn by models of natives. Many museums, including the American Museum, saw good reason to have life groups made because of their great appeal to the public (Jacknis 1985:81–82).

Putnam arranged for Boas to supervise the installation of a Northwest Coast Indian life group. Although this would be the first ethnological exhibit of its kind at the Central Park West institution, it was not the first case of a museum collection in its natural setting. Indeed, the Museum had since the late 1860s displayed groups of stuffed animals situated in their natural environments. The first of such environmental groups was a pride of lions (1869), followed by an orangutan group (1880), a robin in her nest (1887), and a bison group (1889). Humans became subjects for such contextual displays only in 1896 when Boas completed his Northwest Coast life group (Wissler 1942–43:213).

While the Central Park West museum was negotiating with Boas about his commission to make a life group, the Smithsonian Institution was engaging in similar discussions with the anthropologist, for it too wanted him to supervise the construction of a Northwest Coast life group. To collect information and materials for these two commissions, Boas had to return to the Northwest Coast. In 1894, he took yet another trip west, this time sponsored by the Smithsonian, the American Museum, and his old funding source, the British Association for the Advancement of Science. His responsibilities for the museums involved gathering materials for his life groups; for the BAAS he was expected to take measurements of certain Indian groups and visit the Tsimshian to obtain ethnographic information.

Boas's 1894 Trip to the Northwest Coast

Boas left for the Northwest Coast in September 1894, not very enthusiastic at the prospect of leaving his family once more, and, without a permanent job, most uncertain about the future. The trip turned out to be of immense value, particularly the several weeks he spent in November among the Kwakiutl of Fort Rupert (fig. 43), a village especially appealing to Boas since Indians constituted its entire population (Rohner 1969:180). On arriving in this remote village, Boas did what he had learned was appropriate: he invited the residents to a feast. Two hundred and fifty Kwakiutl came, those of lower ranks arriving first, followed by the higher ranking groups. They welcomed him formally, and sang several songs. Then Boas made a speech, telling his audience how pleased he was to be among them, then proceeded to deprecate the significance of his food offerings which consisted of hardtack and molasses.

The Indians responded to Boas's expression of politeness (it was *de rigueur* to apologize for the meager quantities of one's food, even when enormous amounts were laid out) with an equally polite speech, which called him a great chief and claimed that no feast like his had ever been given. With the poetic hyperbole characteristic of the Kwakiutl, one high-ranking guest informed Boas that "you are the loaded canoe that has anchored in front of a mountain from which wealth is rolling down upon all the people of the whole world; you are the pillar supporting our world" (Rohner 1969:177). Although the feast cost Boas $14.50, he "gained the good will of these people and received invitations to all the feasts which are taking place here" (Rohner 1969:178, 180).

A few weeks later, Boas invited these people to another feast at which he distributed apples; Boas wrote home about the apparel of his guests: "This morning I invited everybody to an apple feast, for which they especially decked themselves out" (Rohner 1969:187). A photographer whom he had hired to take pictures in Fort Rupert, O. C. Hastings, recorded this second feast with a series of invaluable photographs of some of Boas's guests (figs. 44, 45, 46). Since at most potlatches, guests pay debts that have accrued over the past to other guests, we assume that these blanket photographs illustrate such a payment (Jacknis 1984).

The Kwakiutl accepted Boas, and invited him to all their ceremonies and even gave him a Kwakiutl name, He'iltsakuls, "the silent one," which referred to his inability to communicate in their language. Despite this deficiency, Boas tried hard to fit in among the Fort Rupert Kwakiutl. He dressed as they did at feasts, wearing "blanket and neckring" (Rohner 1969:178, 180), and ate as much of their rich and sumptuous cuisine as his stomach could tolerate. As he wrote to his wife, Boas found these feasts remarkable:

The salmon were all cooked and placed on platters. These were long flat platters like those one can see in museums. Olachen [a very greasy fish] oil was poured over them and we started eating. You should have seen me eating with wood spoon and four Indians from a platter, with blanket over my shoulders—I don't want to make a mess of my coat at these festivals and without something it is usually too cold. . . . During the whole feast a colossal fire was maintained so that the roof started to burn several times and someone went up to extinguish it. That is part of a large feast!*

* I am indebted to Douglas Cole for this translation.

Fig. 44. Kwakiutl guests at Boas's feast, Fort Rupert, November 1894. Those seated on the upper platform with cedar bark neckrings are members of the Cannibal Society. *Hastings photograph, 1894. 336121*

Fig. 45. Kwakiutl at Fort Rupert. Chief making a speech at Boas's feast, November 1894. *Hastings photograph, 1894. 336118*

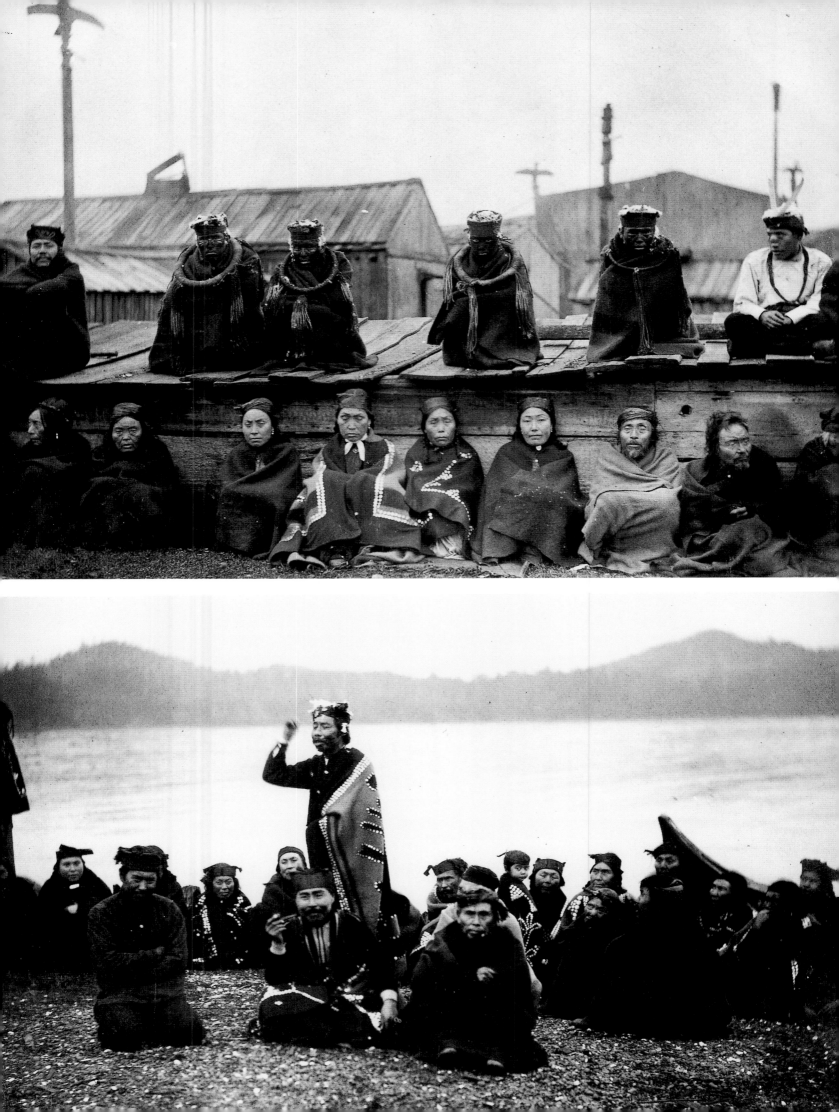

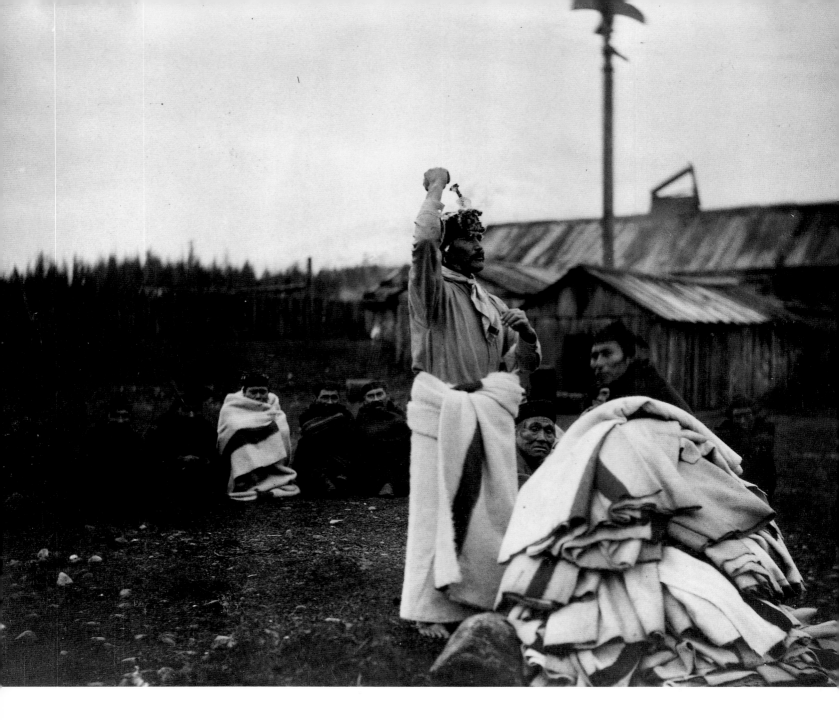

Fig. 46. Kwakiutl chief making speech near pile of blankets being distributed at Boas's feast, November 1894. *Hastings photograph, 1894. 336116*

Boas described in some detail the beauty of the carved spoons and bowls, such as that illustrated in plate 57, an almost spherical sea otter bowl which depicts the animal lying on its back, hands in mouth, looking over its rotund belly toward its flippers, which have been transformed into an eagle's head. Other bowls of the type Boas might have seen at this occasion include a large dish depicting an elegantly sculpted whale, under whose jaw crouches a small man, seemingly crushed by the dynamic cetacean's weight (pl. 58), and a double-headed wolf bowl on which two spike-toothed growling wolves extend their heads forward, each carrying in its mouth a wooden copper (pl. 59). Another bowl actually assumes the form of an immense spoon whose handle becomes the face of Dzonokwa, a mythic woman who, under the right circumstances, bestows wealth on certain select individuals (pl. 60).

In addition to praising the aesthetic nature of the utensils used at these feasts, Boas also commented upon the general pomposity of the speeches given by the participants. He did, however, note that these Kwakiutl potlatches were not entirely somber affairs. At one point the assembled guests broke into loud laughter. Sometime during the proceedings, one chief rose and, announcing in a foreign accent that he was a Haida Indian, proceeded to give a speech that all found extremely funny (Rohner 1969:178, 182).

Pl. 57. Kwakiutl wooden bowl; represents a sea otter with an eagle's head at its tail. Nak'wagdox. L 45 cm, H 23 cm. *Collected by Hunt during Jesup Expedition, 1902. 16/8963*

Pl. 58. Kwakiutl wooden bowl; represents a whale with a crouching man beneath. Koskimo. L 85 cm, H 43 cm. *Collected by Hunt during Jesup Expedition, 1899. 16/6895*

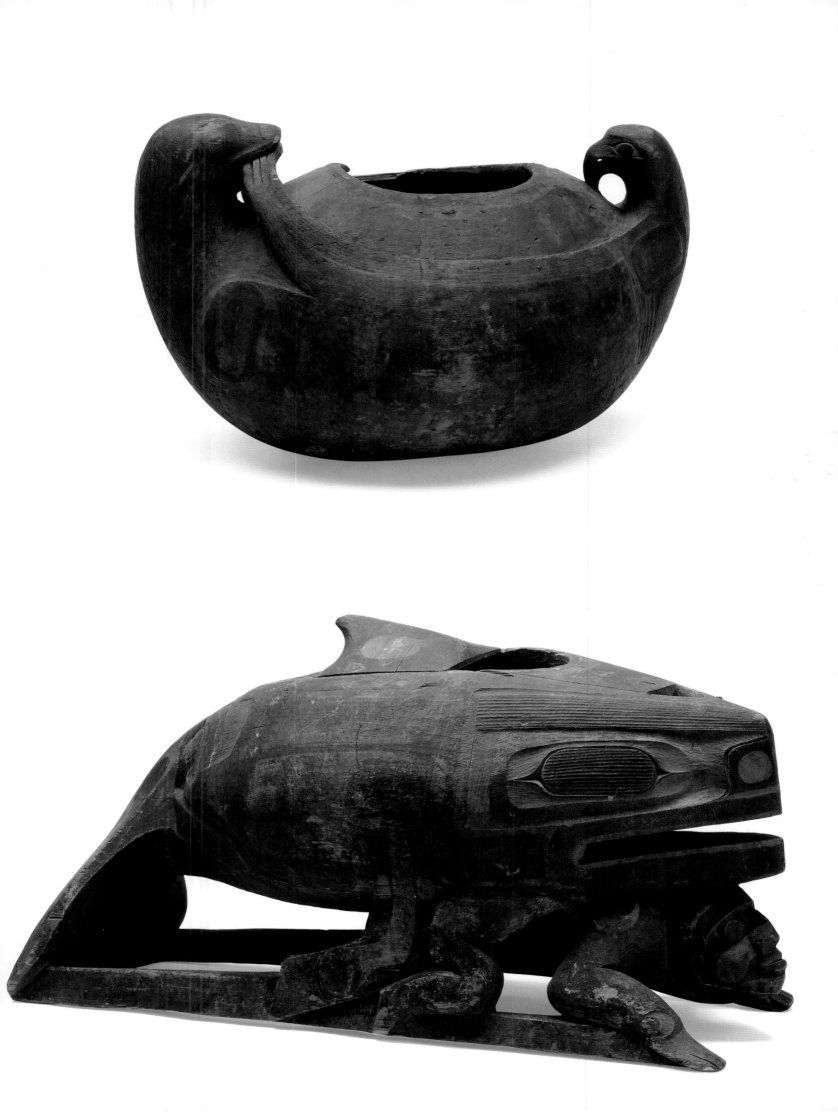

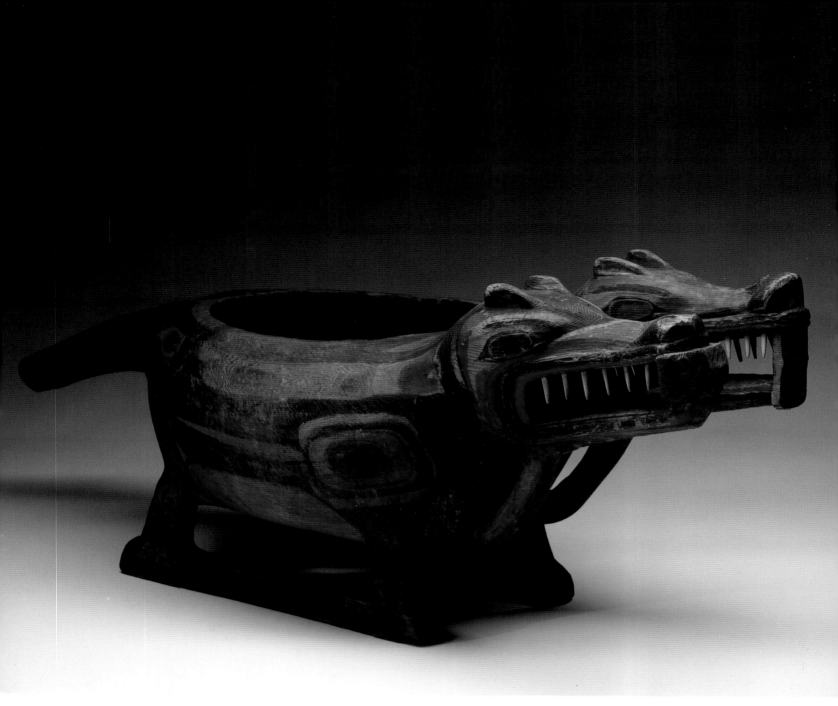

It was during this visit to Fort Rupert that Boas had the opportunity to observe one of the most fantastic of all the Northwest Coast rituals, the Kwakiutl Winter Ceremonial. This immensely complicated series of interrelated ceremonies included the initiation of young people into the secret societies, the payment of potlatch and marriage debts that had been accrued during the previous year, and almost continuous feasting. The Winter Ceremonial itself was an elaborately staged dramatic presentation of the mythic events that occur during the winter season when spirits, who in the summer live in far off regions, come to visit the Kwakiutl. The two most powerful of these spirits are the extremely tall Warrior-of-the-World, a frightening being with a black body and batlike eyes who paddles about the northern reaches of the universe, and the Cannibal-at-the-North-End-of-the-World, a man-eating monster whose large body is covered with blood-rimmed mouths anxious to feed on human flesh. When these and other spirits come to Kwakiutl territory during the winter, they are said to capture certain young men and women and imbue them with intense spirit powers, and by doing so, initiate them into what are conventionally called secret societies. During the celebration of the Winter Ceremonial, secret society members who were initiated in the past retrieve and then "tame" those kidnapped novices whose contacts with the supernatural had caused them to become uncontrollably wild.

Pl. 59. Kwakiutl wooden bowl; represents a double-headed wolf, each of which holds a copper in its mouth. Koskimo. L 116.3 cm, H 42 cm. *Collected by Hunt during Jesup Expedition.* *16/4690*

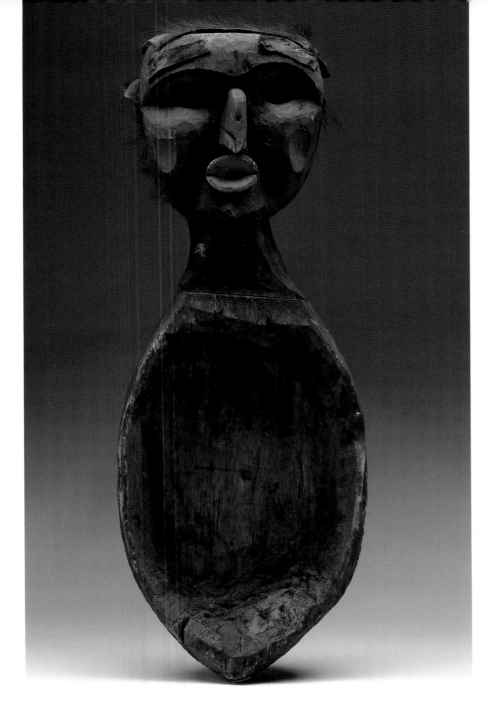

The Winter Ceremonial involved a large number of individuals engaged in a variety of different activities. Participants included those who had been initiated into secret societies and those never initiated; the initiated individuals belonged in turn to a series of grades, many of which were associated with animals. Boas describes an early feast he attended at which the various associations used animal sounds to identify themselves:

While the people were eating, the different societies uttered their cries:
"The Hens are pecking!"
"The great Seals keep on chewing."
"The food of the great Killer-Whales is sweet."
"The food of the Foolish-Boys is sweet."
"The great Sea-Lions throw their heads downwards."
The Mosmos said: "It will be awful."
When uttering these cries, the members of the societies lifted their spoons and seemed to enjoy the food. . . . They ate as quickly as they could, and all the different . . . societies vied with each other, singing all the time (Boas 1966:180).

Pl. 60. Kwakiutl wooden bowl in form of a large spoon; handle represents Dzonokwa, a mythical female being capable of both harming people and giving them great wealth. L 86 cm. *Collected by Hunt during Jesup Expedition, 1901. 16/8556*

Throughout these rituals, two groups of dancers, the Fools and the Grizzly Bears, served as ceremonial policemen. They watched to make certain that all audience members paid attention to the goings-on, were silent at the appropriate times, and observed all rules of etiquette. It was proper, for example, to eat very quickly at the feasts, and whenever the Fool or Grizzly Bear dancers noticed a guest dallying with his cuisine, they pushed and scratched him to encourage speedy eating (Boas 1966:185). The Fool dancers could be especially violent policemen, as when they threw stones at disorderly participants or killed by spearing to death those guilty of especially serious transgressions of ceremonial etiquette (Boas 1897b:468). In addition to maintaining order through violence, these remarkable creatures sometimes created tremendous disorder—they ran around like madmen, knocked innocent people down, broke whatever objects they could grab, and tore blankets off the shoulders of men and ripped the textiles to pieces (Boas 1897b:469).

Grizzly Bear dancers usually wore bear claws on their hands and sometimes dressed in full bearskins. Fool dancers usually dressed in the filthiest of costumes made of tattered cloth and cedar bark rings, such as those photographed by Hastings (fig. 47), but sometimes wore masks with long, curving noses that extended as far down as their chins. One such mask (pl. 61) accentuates that long droopy nose by red and then white bands about the nostril area, and a thin strip of copper down the center ridge. The Fool dancer who wore this red, black, and white mask could, by pulling strings hidden in its underside, lift the black and white eyebrows to reveal a thick band of copper, only to lower them and cover that shiny metal strip.

Fig. 47. Fool dancers of the Kwakiutl winter ceremony, Fort Rupert. Child second to left is Mungo Martin. *Hastings photograph, 1894. 106706*

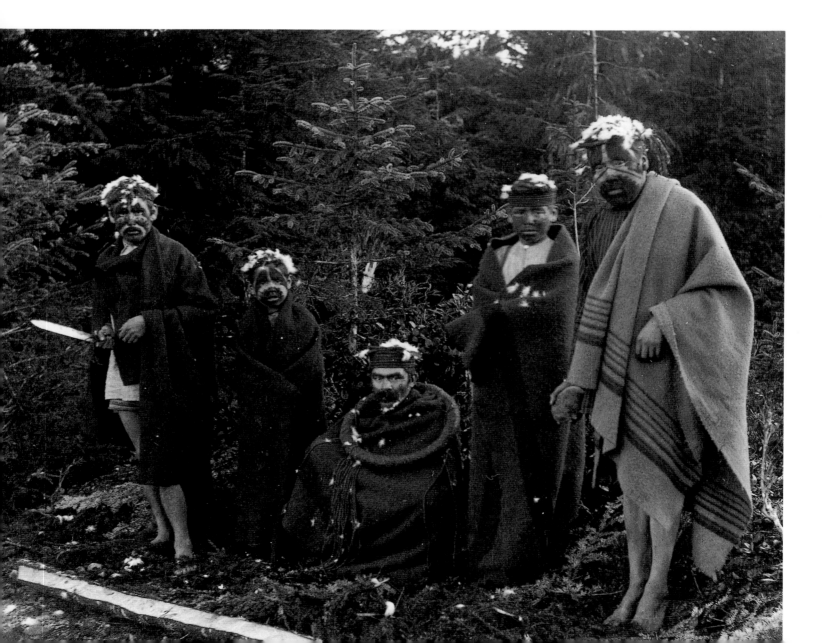

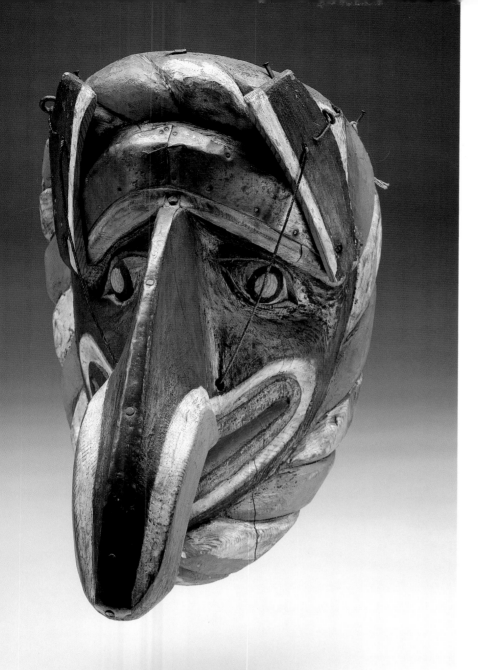

Pl. 61. Kwakiutl wooden mask of Noohlmahl, the Fool dancer of the Winter Ceremonial. Fort Rupert. H 37.1 cm, W 24.4 cm. *Collected by Hunt during Jesup Expedition, 1897. 16/2337*

The long noses on Fool dancer masks were visual allusions to the powers inherent in the mucus of the Fool dancers, who were said to have been initiated by a fabulous people called A'lasimk who had immense noses and bodies covered with mucus. These mythic people inspired the Fool dancer initiates to eat and smear their bodies with mucus (Boas 1897b:468–69). Boas observed one of the Fort Rupert Fool dancers carrying his son around, smearing his mucus all over the youth's face in order to "imbue him with the sacred madness of the Fool dancer" (Boas 1966:183).

At some point before the actual start of the Winter Ceremonial, eerie whistles in the woods announced the arrival of the various spirits, and the youths who had been selected for initiation into the secret societies disappeared into the woods. It was generally understood that these young men were now in the control of whatever spirit being was associated with their particular secret society. The most dramatic of these initiations was that for the Cannibal dancer who had supposedly been staying with the Cannibal-at-the-North-End-of-the-World and needed to be tamed of his man-eating urges. Although the novice was said to have been with the Cannibal for three to four months, he had actually been staying in the woods not far from the village.

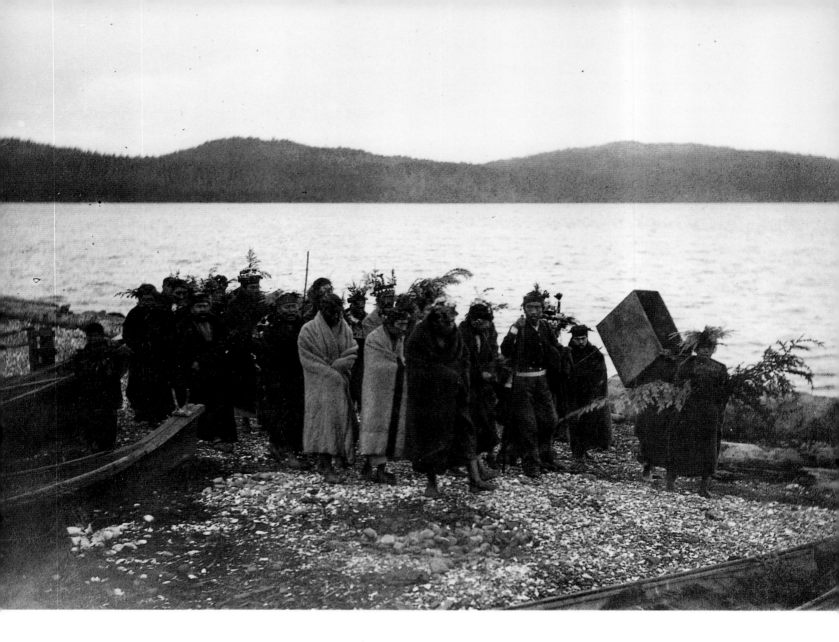

When the youth to be initiated into the Cannibal, or Hamatsa, society returned to the village after this seclusion, he was said to have inherited the Cannibal spirit's insatiable desire for human flesh (fig. 48). During the ceremony that Boas observed, one particular orator described the Cannibal dancer by saying, "you . . . saw the streaks of blood running from the corners of his mouth to the lobes of his ears. These indicate that the Cannibal-at-the-North-End of-the-World lives on nothing but blood" (Boas 1966:214). Although for part of the ceremonials the initiate remained relatively calm, when he heard the word "raven," referring to one of the avian monsters who attended the great Cannibal, he became agitated and, suffused once more with the Cannibal spirit, lunged at people, trying to bite them. He sometimes had a similar response to the sight of a masked dancer impersonating one of the Cannibal's avian attendants, such as that in figure 49. Anywhere from four to sixteen initiated members of the Cannibal society had to surround the novice to prevent his harming others during this ecstacy, but they did not always succeed.

Fig. 48. Kwakiutl at Fort Rupert. The Hamatsa initiate, carrying hemlock branches, is led from the woods to the house. *Hastings photograph, 1894. 336282*

Sometimes the Cannibal dancer became too frenzied to be restrained, and appeared to bite members of the audience. Although the Kwakiutl may have at one point in time really bitten the audience members seriously, when Boas observed the Cannibal dance, the novice pulled up the victim's skin with his teeth and sliced off a small piece with a concealed knife, only to return it after the end of the ceremony to prevent anyone from using the skin for witchcraft (Boas 1897b:440–41). These victims of his cannibalistic urges had agreed to be bitten prior to the event, and received handsome compensation for the privilege at the end of the ceremony. At one point, after a dancer bit some audience members, a man stood up and orated: "Our Cannibal dancer touched some of you . . . in his excitement and hurt you. This copper, the face of which is engraved with the design of the grizzly bear, is worth 500 blankets. It is to pay those whom our great friend has bitten" (Boas 1966:213). The orator proceeded to name the ten biting victims, giving each "fifty blankets of this copper," which probably refers to the fraction of the total value of the copper to be paid to each (Holm correspondence).

Fig. 49. Kwakiutl dancer wearing a Hokhokw mask, Hamatsa ritual, Fort Rupert. Hokhokw used its long, powerful beak to crack open humans' skulls in order to eat their brains. *Hastings photograph, 1894. 336132*

The Cannibal dancers entered the house from the woods, wearing a costume of shredded cedar bark rings and a simple dancing apron that seemed indicative of their wild non-humanness. Their attendants carried wooden rattles carved in the form of skulls to signify their violent desires (pl. 62), and wore headrings of red-dyed cedar bark to which more little wooden skulls were attached (pl. 63). After four days and nights of frenzy, the initiate was finally pacified and made a full-fledged member of the Cannibal society. His reintegration into human society was symbolized by his donning a sophisticated emblem of civilization, a button blanket or sometimes a bearskin blanket.

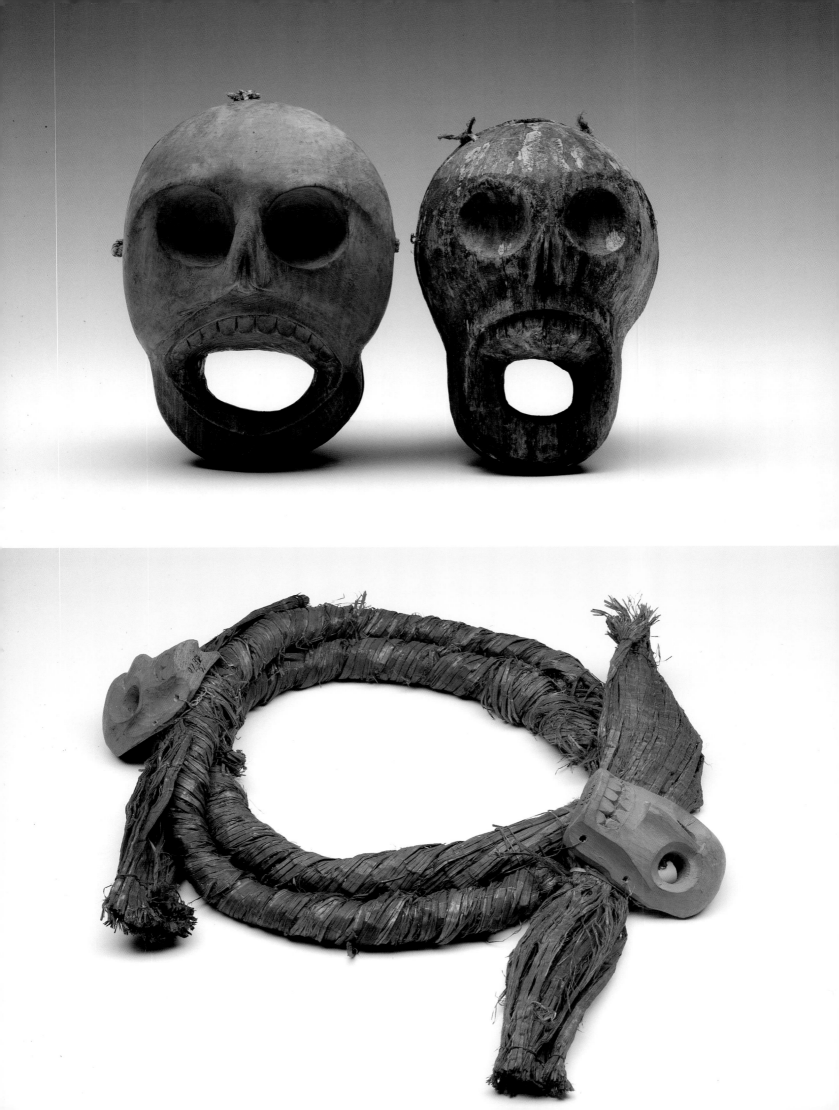

Another major society that held dramatic initiations was that of the Warrior spirit; the performances of this society, which often occurred along with Cannibal dances, were characterized by brutality, bloodiness, and sleight-of-hand tricks. One of the mythic beings associated with the Warrior was Toogwid, a female warrior who performed some of the most extraordinary tricks. Sometimes, puppets such as the family of ghosts in plate 80 were secretly manipulated to make it appear that otherworldly associates of Toogwid were actually visiting the house. Then, at one point, Toogwid herself danced about, trying to catch her supernatural power, which she seized and then threw forward; at that point, the double-headed serpent, Sisiutl, appeared flying at the rear of the house, quivering, and rapidly moving backwards and forwards (Boas 1966:234).

One especially gory act occurred when Toogwid invited the audience to kill her. As she sat near the fire, one of her attendants drove a wedge through her head, causing great amounts of blood to flow and her eyes to pop out of their sockets to dangle on thin threads. Despite the convincing nature of this particular scene, like all else during the Winter Ceremonial, it too was the product of clever stagecraft. The wooden wedge was a contraption that consisted of a wooden band covered with hair, with the point of a wedge on one side and the blunt end on the other. Bags of seal blood were attached to the band; when placed on the head, the bags broke. A pair of seal's eyes were hidden in her hair and, at the appropriate moment, fell dangling down over her eyes. After exposing her bloody self to the audience, Toogwid quickly had the "wedge" removed and then reappeared, clean and without wounds (Boas 1897b:489).

The Thrower of Sickness was another performer of the Warrior society. He entered the house wearing nothing but hemlock rings about his head, neck, waist, ankles, and wrists. After dancing he showed the group a telescope-like "magical stick" which he could lengthen and shorten at will. He tossed this object toward the crowd, and suddenly it appeared at the rear of the house, vibrating in mid-air (actually, some assistants were manipulating strings which supported a duplicate of his stick). Then he caught it and, thrusting it into his own body, collapsed in contortions. Although he appeared to bleed profusely from his mouth and chest, he actually pierced bags of blood hidden under his costume and held in his mouth. After much laboring, he vomited out the stick and miraculously recovered without a scratch. Then he threw his stick at people, hitting two young men who fell forward, seemingly dead, with blood rushing from their mouths. Within minutes, however, the Thrower or a shaman resurrected these "killed" victims (Boas 1897b:486, 1966:194–95). To prove to the crowd that they controlled life and death, the Throwers would sometimes carry a skeleton of a child into the house, toss it into the fire, and place the charred bones in a ditch from which the child would miraculously arise (Boas 1966:200).

Another dramatic performance was the Ghost Dance, a reenactment of a visit to the land of the dead. The Kwakiutl made elaborate secret preparations for this dance by digging a ditch behind the fire and laying under the floorboards tubes of kelp that led from the fire pit to outside the house. During the performance proper, a dancer called to the ghosts and, after circling four times about the fire, slowly disappeared into the ditch, appearing to sink into the underworld. After he vanished, voices emitted from the fire pit—actually men outside the house speaking into the kelp tubes—assuring the assembled group that the dancer had been taken to the land of the ghosts. Several days later, a carving depicting a ghost, carrying the dancer in its arms, emerged slowly from the pit (Boas 1897b:482–83).

Pl. 62. Kwakiutl wooden rattles representing skulls; used during Winter Ceremonial. Koskimo. *Left:* H 22 cm, W 14 cm; *right:* H 17.8 cm, W 12.1 cm. *Collected by Hunt during Jesup Expedition, 1899. 16/6896, 16/8295*

Pl. 63. Kwakiutl cedar bark headring with wooden skulls; used during Winter Ceremonial. Kwikset'enox. L 41 cm, D 34 cm. *Collected by Hunt during Jesup Expedition, 1899. 16/6860*

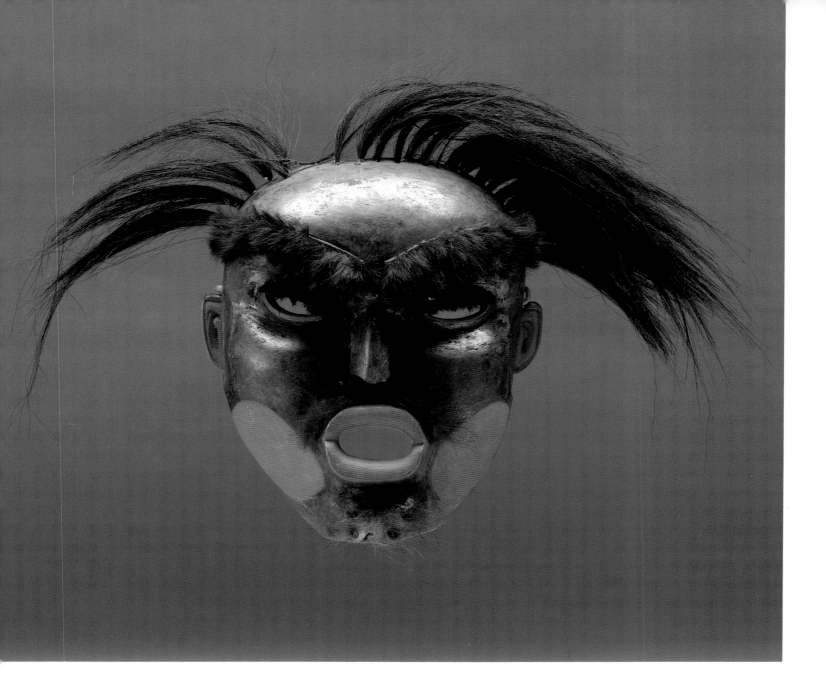

Pl. 64. Kwakiutl wooden mask of Dzonokwa,
a mythical female being. H 30 cm, W 24 cm.
Collected by Hunt during Jesup Expedition, 1899.
16/2376

Pl. 65. Kwakiutl wooden mask of Sisiutl,
a double-headed serpent, with an anthro-
pomorphic face in the center. The Sisiutl can both
harm people and give them wealth and prestige;
the serpent's tongues are retractable, and the
sections depicting serpents move back and forth.
L 239.4 cm, H 56.5 cm. *Collected by Hunt during*
Jesup Expedition, 1899. 16/6768

Throughout the days of these rituals, masked dancers representing a variety of spiritual beings entered and exited the house. One was Dzonokwa whose face appears on a large potlatch spoon (pl. 60) as well as on a dramatic mask (pl. 64). This enigmatic, multifaceted giant woman is both monstrous, for she sometimes roams the woods kidnapping and eating babies, and also beneficent, for at other times she bestows wealth on those she favors. Her open red-ringed mouth, almost sucking in victims, gives clear indication of Dzonokwa's bloodthirstiness, while her disheveled hair, flying all askew, suggests her wildness.

Sisiutl, one of the Warrior spirit's assistants, who could be ridden like a steed or rowed like a canoe, was impervious to any weapon and could turn an enemy to stone simply by gazing at him. This spirit is represented as a snake-like creature with a frontal humanoid face in its center, and, at each end, an outward-facing serpent's head with its aggressively protruding tongue (pl. 65). Masks with movable parts, like snapping bird beaks and rotating octopuses, added to the drama, as did the so-called transformation masks which at first depicted one creature and then, with the pulling of a few strings, snapped open to reveal an entirely different being hidden beneath the first spirit's visage (pls. 78, 79).

Although in the flickering smokey firelight these gory and violent scenes may have seemed convincing, they were all simulation and stagecraft. As Boas said in one letter describing one part of the cycle, "This is, of course, all make-believe" (Rohner 1969:187). Making good use of trap doors, puppets, and especially bags filled with blood placed on the body or inside the mouth to be pierced at the appropriate moments, the Kwakiutl managed to create an almost incredible spectacle. Boas ended up writing extensively about these remarkable performances, collecting large amounts of art used during them, and also creating for the Smithsonian Institution a life group depicting one of the most dramatic episodes during the ceremonials.

The Smithsonian Institution
Cannibal Ceremony Life Group

During his visit to the Fort Rupert Kwakiutl, Boas took notes for the life-size group on the Winter Ceremonial he was to prepare for the Smithsonian. He decided to recreate with manikins the moment the novice emerges, still quite wild, from the mouth of a cannibalistic spirit. After the young man had "returned" from the woods, he retreated into a room (supposedly the house of the Cannibal Spirit) which was especially set aside for him. A large screen separated that room from the rest of the house and contained the image of the open-mouth Raven, the associate of the Cannibal. When it was time for the novice to reappear in the main part of the house, he leapt through Raven's mouth, assisted by the ceremonial attendants.

When Boas went to Washington in January 1895 to oversee construction of the Cannibal Society group (fig. 50), he realized that he had no good illustrations of the scene he wished to replicate. Although he had taken extensive notes on the performance, and collected a representative sample of ceremonial artifacts that could function as models for the participants' costumes and ritual paraphernalia, he had no pictures of the dancers' and attendants' positions. Since this information was necessary if the sculptor were accurately to represent the scene, and since Boas was the only individual in the area who had actually seen a Kwakiutl Winter Ceremonial, he took it upon himself to pose for the preparator. Several photographs still exist of Franz Boas, squatting on the floor and crouching in a hoop that represents the mouth of the Raven spirit through which the dancer

Fig. 50. Figure group of Kwakiutl Hamatsa initiates emerging from a room behind a painted screen. Group designed by Boas, 1895, for the Smithsonian. *Smithsonian Institution photograph 77-10036, courtesy of the Smithsonian Institution.*

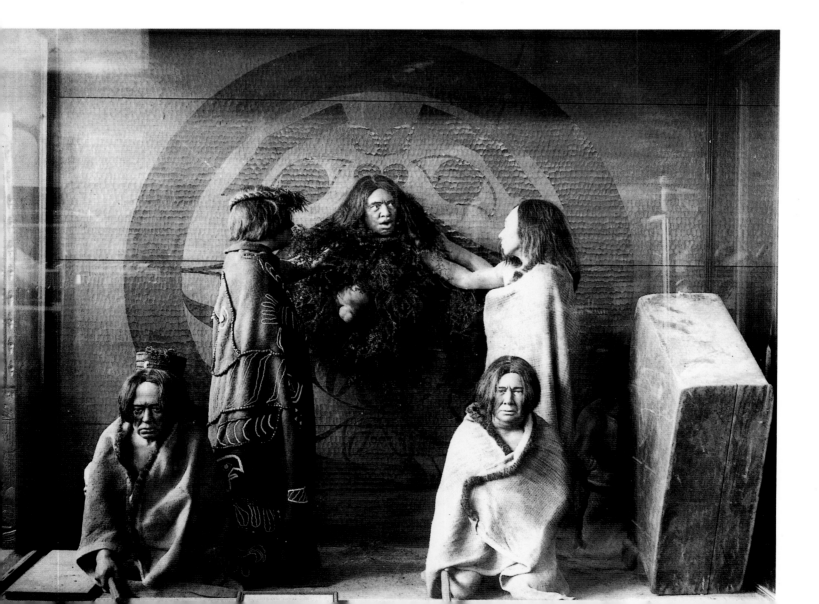

Fig. 51. Franz Boas posing for Kwakiutl Hamatsa figure group at the Smithsonian Institution, 1895. *Smithsonian Institution photograph 8300, courtesy of the Smithsonian Institution.*

emerges (fig. 51). In an attempt to imitate accurately the Hamatsa's expression during his experience of wildness, Boas rounded his lips and widened the rolled-up eyes (Hinsely and Holm 1976). The contemporary visitor to the Smithsonian Institution probably had no notion of how intimately connected this distinguished anthropologist was to the creation of what was for many years a popular feature of that museum's Northwest Coast display.

Boas and His American Museum Life Group

Boas went to the Northwest Coast in 1894 to collect information not only for the Smithsonian's life group, but also for the American Museum's. Boas and Putnam both wanted the New York City life group to be completely different from the one made for Washington. Indeed, the two groups could not have been less alike. In contrast to the Smithsonian Institution's dramatic representation of an intense ceremonial moment, the New York scene, an illustration of the use of cedar on the Northwest Coast, showed several individuals quietly going about certain everyday activities (fig. 52).

In the official guidebook to the Northwest Coast hall Boas himself described the figure group.

The importance of the yellow and red cedar is illustrated. . . . A woman is seen making a cedar-bark mat, rocking her infant which is bedded in cedar-bark, the cradle being moved by means of a cedar-bark rope attached to her toe. Another woman is shredding cedar-bark, to be used for making aprons. A man is taking red-hot stones out of the fire with tongs made of cedar-wood, and is about to place the stones in a cedar box. The Indians have no kettles or pots, but cook in boxes, heating the water by means of red-hot stones. A second man is engaged in painting a box. A young woman is drying fish over the fire (Boas 1900:3–4.)

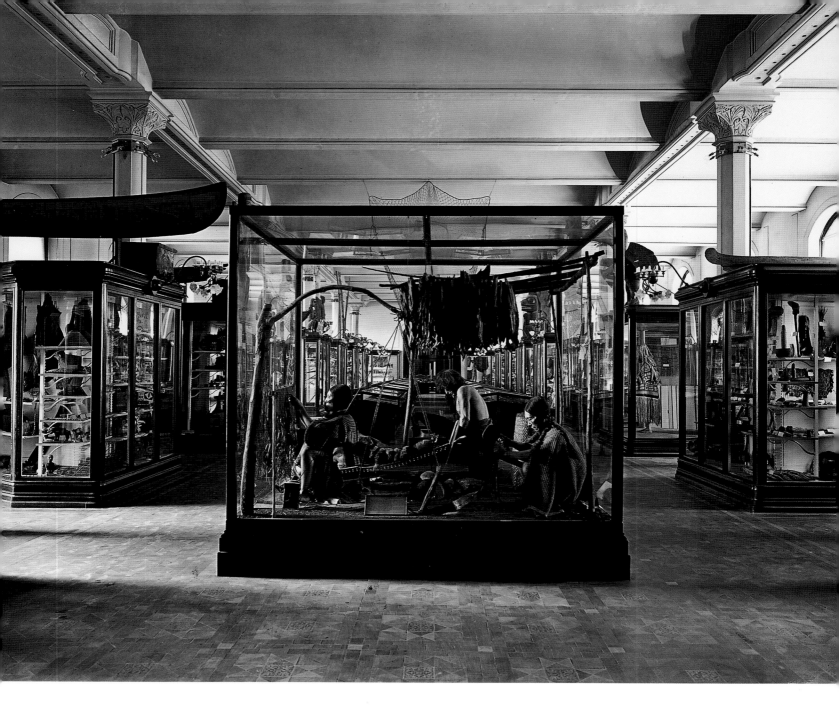

Boas did not have to resort to posing for the cedar life group, as he had done for the Smithsonian Cannibal dance group, for he had planned ahead in Fort Rupert. During his weeks in that village, Boas had asked a woman to pose for his photographer, Hastings, as she performed certain cedar-related tasks, such as shredding cedar bark and making mats and baskets. An outdoor studio was set up, and Hastings took pictures of the woman crouching upon a mat, surrounded by cedar-processing implements, and spinning while rocking her infant's cradle, which was suspended from a tree limb, by means of a string attached to her foot (fig. 53) (Jacknis 1984:33). The spinning photograph is of special interest, for behind the woman, holding up a large blanket-backdrop, are none other than Franz Boas on the left and George Hunt, his chief Kwakiutl informant, on the right.

When he returned to New York, Boas worked with the Museum staff, showing them these photographs which were to serve as the basis for his display. For the actual figures, a sculptor named Caspar Mayer made plaster manikins which he then painted. Although Mayer worked from the photographs to determine the proper positions of all the individuals in the group, he used for their heads castings from life that Boas had made in the field (Jacknis 1985:98–99).

Fig. 52. American Museum of Natural History North Pacific Hall. Life group exhibit of the "Uses of Cedar." *Photograph taken c. 1904. 351*

PUTNAM had hoped that Boas's activities at the American Museum might inspire Jesup to hire the young German full time. Unfortunately, Boas worked rather slowly on these American Museum figures, in part because he was simultaneously writing a major monograph on the Kwakiutl for the Smithsonian. This slowness disturbed Jesup, who complained in December 1895 that despite the $600 already given to Boas, nothing was yet accomplished. Confident that Jesup would finally recognize Boas's qualifications as the best anthropologist in the country, Putnam kept trying to calm the president. Since Jesup resisted the often repeated proposals to hire Boas full time, Putnam energetically pursued a series of other options. On June 15, 1895, he wrote to President Seth Low of Columbia University, suggesting that the institution hire Boas, "who unquestionably stands at the head of the physical anthropologists in America and who is also the acknowledged authority in ethnology and linguistics of the Pacific Coast tribes" (Dexter 1976:305). Putnam also quietly conducted negotiations with Boas's wealthy uncle, Abraham Jacobi, in an attempt to persuade him to contribute some portion of Boas's salary.

By the end of 1895, Putnam had finally succeeded in working out a suitable arrangement. He wrote Boas:

President Jesup at my request has appointed you special assistant in charge of the Section of Ethnology and Somatology in the Department of Anthropology for the year 1896 at a salary of $3000 with the understanding that should you receive an appointment from Columbia College the salary paid by the Museum would be at the rate of $1500 from the time you begin to receive a salary from the college (Dexter 1976:306).

By March 1896, President Low wrote to Putnam that Columbia would indeed appoint Boas as a lecturer for a salary of $1,500 per year (Mark 1980:39). This was subsidized by a secret contribution from Abraham Jacobi (Cole correspondence), and the wandering anthropologist finally had a real home.

Fig. 53. Kwakiutl at Fort Rupert demonstrating the spinning of cedar for American Museum life group. Holding backdrop at left is Franz Boas; at right is George Hunt. *Hastings photograph, 1894. 11604*

For his part, Putnam had realized his long-time dream of assembling a top-flight group of anthropologists and archeologists who together would create a truly distinguished museum anthropology department. His pleasure at this success was tinged with not a little gloating that he was now in a superior position vis-à-vis Chicago. As he wrote to his daughter in late 1895, "The new wing of the Museum is started and you know that it is to be entirely for my Department. You will understand that all this has meant hard work for me, but I have succeeded and that is all I ask. . . . I regard getting Boas as a grand thing, for Boas and myself make a pretty strong team and with Saville [Marshall H. Saville, the archeology curator], Smith and Pepper [Harlan I. Smith and George H. Pepper, two anthropology assistants] to help, you see I have the best equipment of any anthropological museum in the country and I'll show Chicago I can go them one better" (Dexter 1976:306).

Appointed special assistant in the Museum in late 1895, Boas soon became disgruntled at what he felt was the institution's backwardness in acknowledging his professional standing. Within a week of his joining the staff, the egoistic Boas decided that his title was inadequate to his status, that he did not enjoy sufficiently direct access to the president, and that he had not been consulted about plans for the department. In a letter to Putnam, Boas insisted that "I believe you can make it clear to Mr. Jesup that my position in science is such that I can demand that much as a simple matter of courtesy" (Mark 1980:38). Putnam must have made this clear, for soon Boas received the title of assistant curator, began to meet regularly with President Jesup, and assumed the leadership of the anthropology department when Putnam was in Cambridge three weeks of each month.

Often deeply dissatisfied with the conditions under which he had to work, Boas frequently complained bitterly to Putnam, especially about what he considered to be insufficient respect from the Museum administration, and their lack of enthusiasm for his projects. Putnam finally had to advise him to "go slow and don't get disturbed. Remember the old saying 'that it is the quiet pig that gets the most milk.' We will get our milk all right in the end" (Mark 1980:39). The two men worked, Putnam quietly and Boas not so quietly, to persuade President Jesup to support one particularly significant—and rather expensive—project. They did, finally, "get their milk," for the wealthy philanthropist-president of the American Museum eventually agreed to endorse what was to be the most ambitious museum expedition of the day—the Jesup North Pacific Expedition to the Northwest Coast of America and northeastern Siberia.

The Jesup North Pacific Expedition

The frontispiece of the American Museum of Natural History's 1896 *Annual Report* contained a colorful map showing the locations of the various people who lived in northeast Siberia and on the Northwest Coast of America. The *Report* had a short piece by President Jesup describing a topic of great current interest to anthropologists and other scientists. "I refer," Jesup said, "to the theory that America was populated by migratory tribes from the Asiatic continent. The opportunities favorable for solving this problem are rapidly disappearing and I would be deeply gratified to learn that some friend or friends of the Museum may feel disposed to contribute means for the prosecution of systematic investigations in the hope of securing the data necessary to demonstrate the truth or falsity of the claims set forth by various prominent men of science. A map of the localities which should be covered by such a system of research appears in this report."

Jesup had become intrigued by an ambitious project proposed by Putnam and Boas: a major expedition to the North Pacific region of both Old and New Worlds to determine, once and for all, whether the Native American peoples developed entirely in North America or whether they came from Asia via Siberia. If the former were proved to be the case, then the American Indian had evolved in isola-

tion; whereas if the latter were discovered true, then the peoples of North and South America would have had contacts with other Old World peoples at some point in their histories. Putnam and Boas felt that by sending a team of scientists to the Northwest Coast and to northeast Asia to collect data and artifacts, much could be learned about the prehistoric and historic relations between peoples on both sides of the North Pacific Ocean. The final product of this expedition would be a multi-volume series of publications that would provide the last word on this significant topic.

Morris Ketchum Jesup had always liked big ideas, such as the Jesup Collection of North American Woods that he had funded in the 1880s. Presented with an ambitious plan of obvious scientific merit, he embarked on a fund-raising drive that included the request for support in the 1896 *Annual Report*. When none of his fellow philanthropists could be persuaded to contribute to this worthy cause, Jesup himself donated the necessary funds. By the time the next *Annual Report* was published, he had committed himself to this project which would bear his name. The frontispiece contained another color map, this time with a somewhat smaller "Field of Proposed Operations" than that published the previous year, for Jesup could not afford to be extravagant with his own money. Nonetheless, the project was still to be a major one, with men to work in interior and coastal British Columbia in 1897 and 1898, in Siberia in 1898, 1899, and 1900, and in Alaska and the Aleutians in 1899, 1900, and 1901. As it turned out, the Jesup Expedition supported research in British Columbia for its entire duration, and sent men not only to Siberia, but to Washington State as well. It did not, however, have any field-workers in either Alaska or the Aleutians.

For Franz Boas, this was to be his major opportunity to disprove the then dominant cultural evolutionist theories. He claimed in a letter written to President Jesup (2 Nov. 1898) that while anthropologists were of two minds on the question of Asiatic-Amerindian relationships, most archeologists believed Native Americans had developed independently of Asia. He may have been thinking of J. W. Powell of the Bureau of American Ethnology, who at one point had written that "mankind was distributed throughout the habitable earth, in some geological period anterior to the present and . . . anterior to the development of organized speech," and thus all similarities in "arts, customs, institutions, and traditions" of different ethnic groups resulted not from any "genetic relationship" but from the process through which these groups have "progressed in a broad way by the same stages" and thus have come to share similar culture (quoted in Thoreson 1977:109). Boas, of course, found such cultural evolutionist ideas questionable and suspect, and intended to use the data collected during the Jesup Expedition to dispute their premises.

In the introduction to the first volume of the publications of the Jesup North Pacific Expedition (Boas 1898a), Boas took the opportunity to spell out his theoretical intentions. Here he outlined the history of anthropology, which had for years accepted without question certain theories that explained with perfect clarity the order behind what appeared to be superficially chaotic. For example, the logical, rational Morganian model of human developmental stages had for many years helped render comprehensible the bewildering array of human societies. But then, Boas argued, newly learned facts began to disturb that comfortable clarity, to shake one's confidence in those laws. The amount of new information about "primitive" peoples that had been increasing enormously over recent years did not support the confident assertions of the evolutionists on the progress of human society. In a prefiguring of Thomas Kuhn's *Structure of Scientific Revolutions*, Boas asserted that "the beautiful, simple order is broken, and the student stands aghast before the multitude and complexity of facts that belied the symmetry of the edifice that he had laboriously erected" (Boas 1898a:2). Now, Boas argued, it was time to abandon those obsolete and unworkable theories and replace them with other, more sophisticated interpretations of what in his view was an extremely complex array of phenomena.

While Boas agreed with his predecessors that the goal of anthropology was to discover "the laws that govern the growth of human culture, of human thought," he could not support their simplistic method of identifying similarities and "features common to all human thought." Now anthropology had to accept and acknowledge the unique qualities of individual cultures, and then identify the differences between these and other cultures which had been equally carefully scrutinized. Once the anthropologists and archeologists had studied a culture in minute detail, they could reconstruct its history by comparison with other minutely analyzed cultures. It was only after this had been done for a sufficiently large number of societies that the anthropologist could hope to identify those laws underlying the history of all mankind. Although Boas did ultimately succeed in discrediting nineteenth-century evolutionism as a viable anthropological theory, he was never to engage in synthesis and generalization; instead, he devoted his life to collecting enormous amounts of ethnographic and historical data, without which such syntheses and generalizations could never be made.

The aim of the Jesup Expedition was, according to Boas, to investigate the "history of man in a well-defined area," the Northwest Coast of America and northeastern Siberia. To do this, scientists would study the languages, the physical characteristics, the myths, and the art of the peoples of this region, with the intention of discovering their history. As Boas said, "What relation these tribes bear to each other, and particularly what influence the inhabitants of one continent may have exerted on those of the other, are problems of great magnitude. The solution must be attempted by a careful study of the natives of the coast, past and present, with a view of discovering so much of their history as may be possible." So Boas explained his goals for the Jesup North Pacific Expedition (1898a:6–7).

The Announcement

In March 1897, both the Associated Press and United Press wire services carried dispatches describing the American Museum of Natural History's Jesup North Pacific Expedition. Since Putnam's name had been associated with the project, he figured prominently in the stories that were published across the United States and Canada. In a memo to President Jesup, Putnam described with not altogether convincing modesty how he had urged the newspaper representatives not to highlight him in their stories, "but that was just what they were bound to do, owing to my prominence here and to the interest taken in my work" (Putnam to Jesup, 16 Mar. 1897). He went on to comment that President Eliot of Harvard and several other intellectual leaders in Cambridge and Boston had praised Jesup for the importance of this endeavor.

For several days the *New York Times* carried stories about this Expedition. An article dated March 12, 1897, outlined a route which took the Expedition up the Northwest Coast of America through British Columbia and Alaska, across the Bering Sea, into Siberia, down its coast to China, and then on along the Indian Ocean to Egypt. This was a rather fanciful description of the Jesup Expedition, and the very next day, the same paper ran a piece based on an interview with Franz Boas that described with far greater accuracy the actual geographic scope of the trip to the Northwest Coast and Siberia.

This article described the main objective of the Expedition as "to investigate and establish the ethnological relations between the races of America and Asia," as well as to provide a detailed analysis of the problem. Boas pointed out that no systematic study on the question of whether Indian culture had developed in the New World or Old had ever been carried out. Although this "big question" was highlighted in all of Jesup's correspondence on the Expedition, and was the focus of media attention, Boas was quite certain of the fact that indeed the Indians had migrated from the Orient at some point in the relatively recent past, and seems to

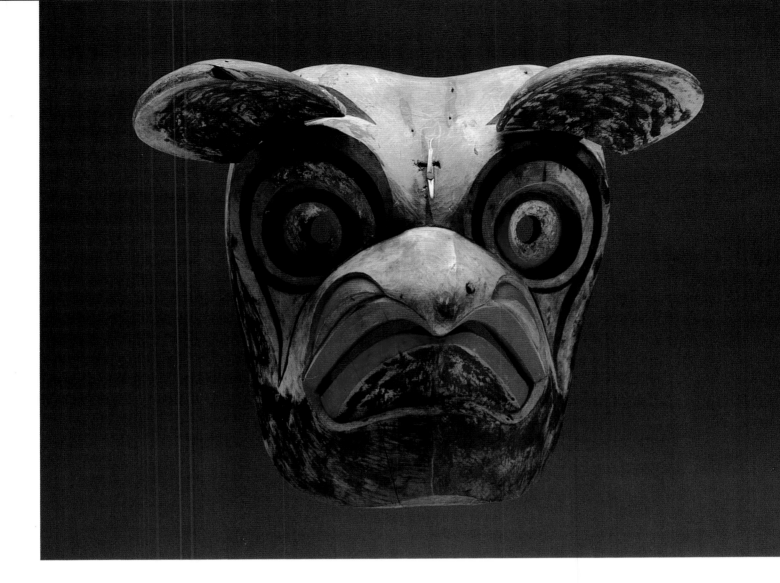

Pl. 66. Bella Coola wooden mask. H 37 cm, W 29 cm. *Purchased from S. Kirschberg, 1896. 16/1113*

have had little interest in spending much time on that issue. Instead, he went on to outline the more interesting specific problem he wished to solve: what were the racial relations between the Siberians and the Northwest Coast peoples. He pointed out that although there were many who held that the people of British Columbia were more closely related to the Asiatic race than any other North American Indians, no material from the Asiatic side had been gathered to back up this notion. He also wanted to acquire better data on the relationship of the coastal tribes to each other and to other Native American peoples. He summarized his intentions by saying that the Expedition's task was to "discover to what extent American and Asiatic ideas influenced each other."

On March 14, 1897, the *New York Times* carried an editorial on "Mr. Jesup's Explorations," praising the North Pacific Expedition as one "alive with human and historic interest." Suggesting that anyone who had looked at a map and seen the proximity of Asia and Alaska might have assumed that the Native Americans originated from west of the Bering Strait, the *Times* demurred "but anthropology, being one of the most complex and difficult, has come to be about the most cautious, of the sciences." Thus, the myths, folklore, language, culture, and physical types of the region must be minutely analyzed before any conclusions can be made on what the editor described as "about the biggest of the unsolved anthropological and ethnological problems." Complimenting the generosity and wisdom of the Expedition's patron, the piece concluded by stating that Jesup "has set a commendable example for men of wealth who are willing to employ a part of their fortunes to increase the stock of human knowledge."

NEWSPAPER stories such as those in the *New York Times* impressed many people. After reading a story about it in his local Princeton newspaper, George Thornton Emmons wrote to Boas (14 Mar. 1897) saying how deeply he desired to join the expedition, but how his other responsibilities made that quite impossible. Of course, due to his distrust and dislike of the naval lieutenant, Boas had little interest in Emmons's participation and might have felt relief at these expressions of regret to a nonexistent invitation. Although Emmons did compliment Boas himself, noting how fortunate Jesup was to have procured the "services of one so capable of doing this work, for it is more the custom in this country of Ethnologists to study people from a long distance surrounded by the comforts and warmth of a Museum office," his praise was equivocal. "It is a pity," he wrote, "that such important work could not have been conceived and carried out years ago for the present generation have little definitive knowledge of their ancestral customs and the Aleutian Islanders, a most interesting people, are so Russianized that it will be difficult to determine the truth from what is merely believed." Behind a veil of friendliness and support, Emmons suggested that it was too late to obtain the information necessary for this ambitious project to succeed.

Unlike Emmons, most Americans reading the announcement had no understanding of the real nature and significance of the Expedition; they simply found fascinating the concept of traveling with anthropologists and archeologists to far off places. Soon letters were pouring into the Museum from those who wished to join Boas: a newspaperman from Seattle, an artist from Connecticut, a boatman from Oregon, a fish warden from East Longmeadow, Massachusetts (who described himself as a fullback with no injuries who neither smoked nor drank alcohol), and a June graduate of Dartmouth, member of Delta Kappa Epsilon Pi who had written a paper on ethnology and found anthropology interesting. These applicants tried selling themselves in a variety of way. From Simcoe, Ontario, came a letter from a man of considerable speed and stamina who wrote, "I am strong and robust, and free from every taint of disease. I am able to sustain all extremes of weather and can walk fifty or sixty miles a day with ease. My daily exercises for five years have been about ten miles night and morning. In ten paperchases held last fall my average running speed was eight and one-third miles per hour." A particularly well-rounded individual described how he could do just about everything that might be needed on such an expedition: "I can cook, pack a mule, collect paleontological specimens, skin a bird or work survey instruments; I can develop and print a photograph. . . . I've been with surveys, railroads, irrigation, land and harbour. I was once a draftsman." And, moreover, he fully understood and respected discipline (Department of Anthropology archives, AMNH).

Some of these letters revealed a great deal about their writer's personal qualities. One unmarried twenty-four-year-old businessman from Massachusetts explained that "business life is distasteful to me, and as I am quite nervous, inclination and medical advice lead me to seek outdoor scientific work." Presumably to assure the Museum organizers that they were not immigrants of dubious capabilities, many letter writers made a point of describing themselves as native-born Americans. To reinforce this, one man described his cooking as "New England style" (Department of Anthropology archives, AMNH). Little did these applicants know that the real leader of the Expedition was not Frederic Ward Putnam, descendant of the Puritans, but instead, a German Jew who himself had only recently emigrated to America.

Competition with Chicago's Field Museum

In the back of both Putnam's and Boas's minds as they conceived this monumental project was doubtless a desire to best the institution which had rejected them both—the Field Columbian Museum. Although William Henry Holmes had initially been given the position at the Chicago institution that Boas craved, the arch-

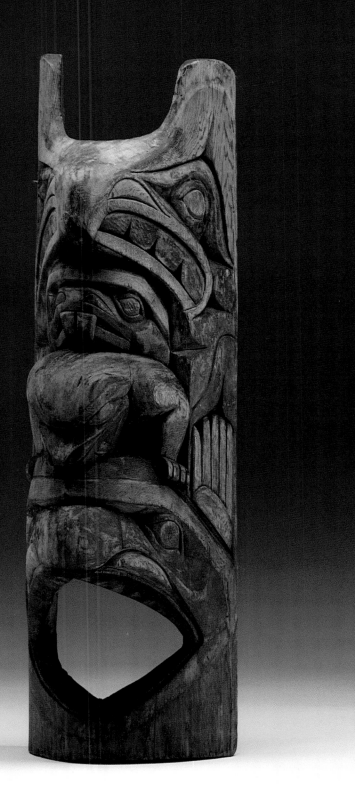

eologist did not remain long in the Midwest; in 1897, Holmes returned to Washington, D.C. The man who replaced him was George Dorsey, trained by Putnam and the recipient of Harvard's first Ph.D. in anthropology (1894).

Dorsey had a singular ambition: to create a museum in the Middle West superior in every way possible to the older institution beside Central Park. Back in New York City, Putnam, in his turn and perhaps in revenge against the museum that had so cavalierly treated him and his German protégé, had decided to make the American Museum into an institution that surpassed the Chicago Field Museum. The stage was set for an institutional struggle that would be played out during the Jesup Expedition.

Pl. 67. Bella Coola wooden totem pole model. H 54.9 cm. *Purchased from S. Kirschberg, 1896. 16/1115*

Not long after the American Museum announced its ambitious venture, the Field Museum announced its intention to launch an expedition to the Northwest Coast. In response to Boas's pique over this matter, Putnam wrote (5 May 1897):

I cannot say that I was surprised to hear of the Field Museum's expedition. . . . The fact that the New York Museum is doing something in that direction would be a strong incentive for the people in Chicago to do something also. It is one of the unfortunate results that come from making our work known before it had at least been partially accomplished. The fact that Mr. Jesup considered this work of such great importance as to carry it out, would be sufficient to induce others to enter the field, although of course honor should keep them out.

Honor aside, during 1897, the first year of the Jesup Expedition, representatives of both the American Museum of Natural History and the Chicago Field Museum were traveling up and down the Northwest Coast, competing with each other to collect as much art as they could to send back to their respective institutions.

Then, in 1899, the *Seattle Times* carried an article on George Dorsey's plan for an expedition to the Northwest Coast to study the origins of the Indians of the region. On reading this example of research-project plagiarism, Boas blew up, tore out the article, and sent it to Putnam and Jesup with the following words scribbled in the margins: "It is rather mean in Dorsey to go into our regime this way. That is Dorsey!"

It is perhaps ironic that while Boas detested Dorsey and disdained the superficiality of his scientific work, Dorsey seems to have admired Boas. On the occasion of the 1907 publication of a *Festschrift* dedicated to Boas, Dorsey wrote to Boas, praising his influence as "the greatest factor in our science today. . . . I can only come to a full realization of it when I try to conceive what we were before you came among us and what we would have been had you not come. Every worker in anthropology is indebted to you, and the amount of his success may be measured by the extent of his indebtedness. It seems to me that I can wish for nothing higher than that your students may be worthy of their master" (quoted in Hinsley 1981:272). Despite these complimentary words, it was clear that Boas never accepted Dorsey as a "worthy" student.

The First Year in the Field, 1897

None of the letters that poured into the American Museum after the press announced the Jesup North Pacific Expedition had any effect upon the composition of the Expedition team, which was staffed by individuals Boas hand-picked. During the first year of the Expedition, Boas went to British Columbia, "courtesy of the Northern Pacific Railroad," with Harlan Smith of the American Museum and Livingston Farrand of Columbia University, where they met up with a Scotsman-turned-Indian-expert, James Teit of Spences Bridge, and the son of a Tlingit woman and a Hudson's Bay Company official who had been raised as a Kwakiutl, George Hunt.

Boas, Farrand, and Smith left New York in late May 1897, and arrived in Spences Bridge, British Columbia, in early June. The settlement was at this time a small hamlet of three or four houses and a hotel next to the train station. During his 1894 trip to the Northwest Coast, Boas had been to this "little dump" in the warm, dry, and sunny interior of the province, and been offered a "dirty bed shared with a drunken workman," at which point he objected so strenuously that he was given "a 'lady's room' which was tolerable. No fresh linen, of course, because they had only two sets and the other was in the wash" (Rohner 1969:139). This next time, his accommodations were considerably better, for he stayed with Teit on his ranch not far from the village.

Smith, an archeologist, stayed in the Spences Bridge region as Boas, Teit, and Farrand took a pack train of five horses northward along the Fraser River toward the Chilcotin region. Riding along narrow Indian trails on slopes far above the wild Fraser River, these men could see the snow-peaked Coast Range a distance off to the west. Although they were traveling through the drier region of British Columbia—Boas at one point called it the "country of eternal sunshine" (Rohner 1969:204)—the Expedition encountered heavy rains, which made camping particularly unpleasant. Moreover, the mosquitos tormented everyone.

A few months before Boas left New York for British Columbia, he had written to Teit, whose responsibility it was to outfit the team. In this letter of 16 April 1897, Boas wrote that he did not wish to carry a tent unless it were absolutely necessary, and wanted "to get along the way I always used to do, either camping without cover or at best, using a sheet of canvas that we can put up improvised." Camping outfits were "rather expensive and unnecessarily elaborate," and Boas wanted to travel as lightly as possible. Teit, far more familiar both with camping and with the region itself, wrote back reassuring Boas that he would be supplying all the necessities, except blankets which the New Yorkers should themselves bring (29 April 1897). He did point out in that letter that there was a need for protection in the evening "against mosquitos and flies which are bad in some parts of the country through which we will pass." Doubtless Boas now appreciated the tent, which not only kept him free of these tormenting creatures, but dry as well.

The group split up when they reached the Chilcotin region, where Farrand was left to study the Athapaskan Chilcotin Indians for a month. Boas and Teit then embarked on the final and most difficult part of their westward journey to the coast, the traverse of a desolate 1,200 meter high plateau. The stunted pines that grew in some parts of the plateau had overgrown the trail and badly scratched the travelers as they pushed their way through the dense stands. Areas of few or no trees provided no respite from the discomforts of the forests, for these clearings turned out to be swamps filled with hidden pits of soft mushy peat and mud. Boas and his team labored long hours to free the several horses that sank into deep mucky bogs. Throughout all this, the rain persisted and the mosquitos continued to feast (Rohner 1969:212–15).

The group finally arrived at the western end of this seemingly endless plateau, and began the last leg of the trip, a crossing of the Coast Range mountains themselves. Boas, who had periodically described the beauties of the region in letters to his parents and wife, found this portion of his trip exceptional.

The trail ascends higher and higher until, at a height of five thousand feet, the summit is reached. Here a few small snow-fields have to be crossed, and the trail suddenly emerges on the north side of the Bella Coola River. The river is seen almost five thousand feet below; and on the opposite side of its deep and narrow valley rises the high peak Nuskulst, which plays a most important part in the mythology of the Bella Coola. Enormous glaciers flank its sides, and a little farther down the river appear other snow-clad mountains of beautiful form (Stocking 1974:114).

It took the party just a few hours to descend from these spectacular heights, and soon they found themselves in the warm and humid climate of the coast, so completely different from that of the interior.

In order for the party to cross the deep and swift Bella Coola River, the Indian guide had to float on a quickly constructed raft to the far shore in order to retrieve a canoe they saw beached there. While the men and the packs crossed in this canoe, the horses had to swim across, encouraged with sticks and shouting. A ride along the river led them to the Bella Coola village, where Boas was delighted by the cuisine, "salmon, an agreeable change from beans and bacon," the luxury of sleeping in a bed which felt "wonderful to stretch out on in the evening," and the clean laundry, which made him "feel like a new man" (Rohner 1969:214–15).

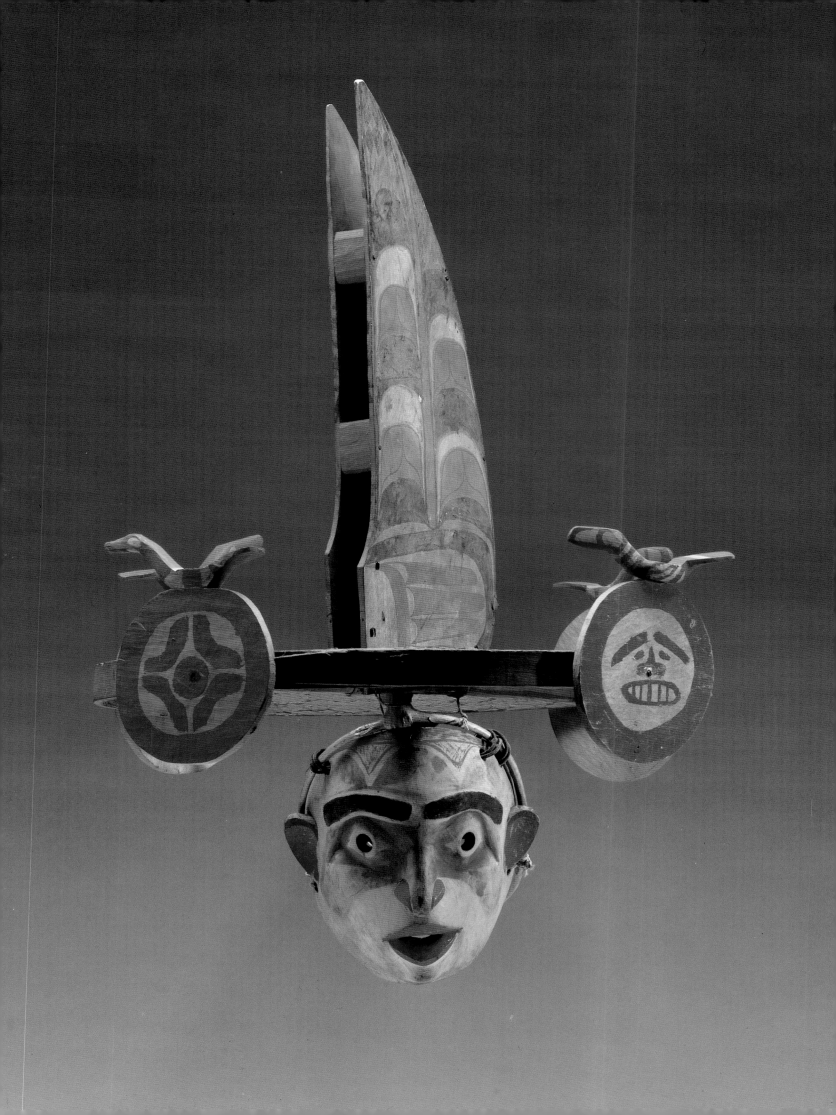

It was in Bella Coola that the party met up with George Hunt, who was in the process of collecting a good many myths, as well as a splendid assortment of artworks. Among the latter were a mask of the sun whose spherical face is surrounded by four oval faces each of which is flanked by upraised hands (pl. 69), and a complicated mask that includes a softly modeled naturalistic face mask surmounted by a circular band decorated with three wooden circles surmounted in turn by small stylized birds (pl. 68). The band supports a pair of wing-like painted objects. In addition to the masks, Hunt and Boas sent back to the Museum a remarkable sculpture called a "death bringer" (pl. 70). Used during the winter dance, this carving depicts a monster with a broad nose, bulging forehead, deep-set eyes, wildly disarrayed hair, and hands actually made of the paws of some mammal, cloaked in several different kinds of fur.

After studying the Bella Coola for a few weeks, Boas took a steamer north toward Tsimshian territory. As he waited at the steamer dock, to his chagrin he encountered Dorsey who was traveling south. Although outwardly friendly, Boas seethed after the brief visit, and wrote to his wife:

This trip of Dorsey's annoys me very much. More than I can tell you. . . . What makes me so furious is that these Chicago people simply adopt my plans and then try to beat me to it. Well, little Dorsey won't have achieved much with the help of that old ass, Deans [a collector he employed]. . . . When I was in Chicago they assured me that Dorsey would not be here at the same time as I. I don't really think his trip will interfere with my work, but this treacherous way of acting makes me awfully angry (Rohner 1969:221).

He then went on to speculate on his own scientific generosity, describing how he was more than willing to work with men like Smith and Farrand; "It seems to me, though, that everyone who is serious should seek and take my advice and not just run out here at random" (Rohner 1969:221).

Boas disdained Dorsey's slipshod and decidedly unscientific method of collecting, which entailed a rapid tour of villages, buying this and that, never settling down long enough to acquire any useful data. Dorsey was also guilty of something Boas tried to avoid at all costs: insulting the Indians. In particular, Dorsey showed gross insensitivity to the Indians' feelings about a matter that concerned them greatly: the bones of their ancestors. During this whirlwind tour of the Northwest Coast, Dorsey's osteological activities on the Queen Charlottes brought forth an angry protest from the Anglican missionary at Masset, the Reverend J. H. Keen, who wrote, "they tell me that bones and other things have been removed wholesale and that the perpetrators had not even the grace to cover up their excavations. . . . that fellow Dorsey must have handled the graves most unmercifully." During these plunders, Dorsey dug up almost every grave in large areas of the Queen Charlottes, leaving strewn about items he did not desire: "some hair, recognized as having belonged to an Indian doctor, and a box which had contained a body, were found floating in the sea" (Cole 1985:175). Probably gratified at this outcry, Boas wrote Putnam, "I am sorry Dorsey was so indiscreet in the matter; but you well know his insatiate desire for bones" (11 Nov. 1897).

Anxious to complete his fieldwork and return home, Boas could not dwell long on his antagonisms with the Field Museum people and soon after encountering Dorsey at Namu, he continued his trip northwards. He joined Smith on the Skeena River where they collected information on Haida art and measured and photographed Tsimshians and Haidas. Later, they met up with Farrand among the Kwakiutl group called the Bella Bella.

The party finally broke up in mid-September, when Boas and Farrand returned to New York, and Hunt went home to Fort Rupert. Smith did not travel east at this time but went instead to southern British Columbia where he pursued his archeological studies of the region by investigating shell-heaps at the mouth of the Fraser River and prehistoric stone monuments on southern Vancouver Island (Boas 1898a:11).

Pl. 68. Bella Coola wooden mask; depicts Yulatimot, one of four brothers who live in an elevated room in the rear of the House of Myths (house of the gods). They carve and paint, and are said to have given man his arts. H 40.7 cm, W 21.7 cm. *Collected by Hunt during Jesup Expedition, 1897. 16/1411*

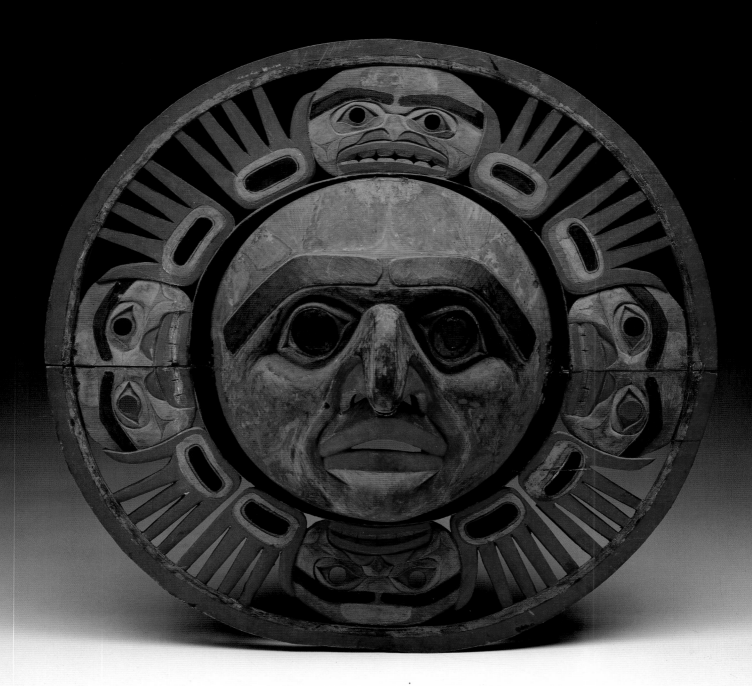

Pl. 69. Bella Coola wooden sun mask. D 63 cm.
Collected by Hunt and Boas during Jesup Expedition,
1897. 16/1507

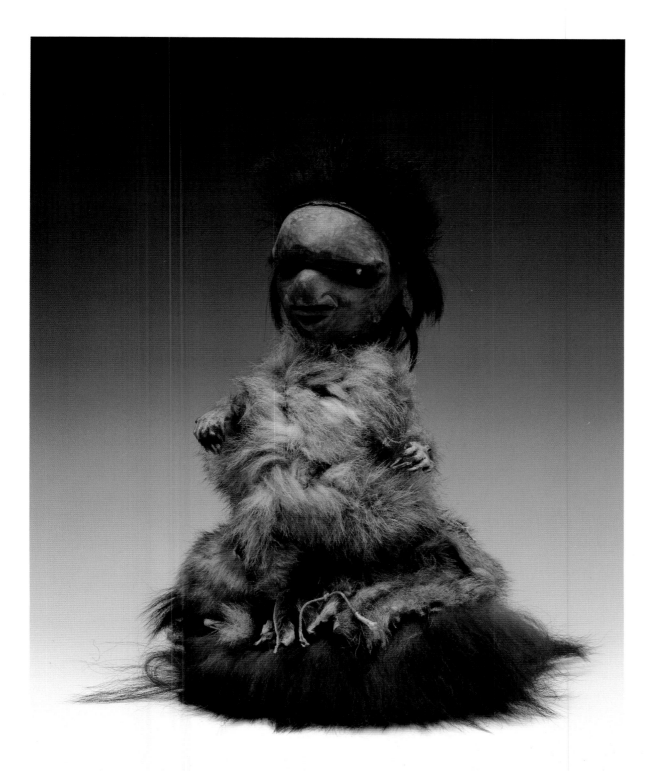

Pl. 70. Bella Coola wooden figure covered with
fur; represents the "death bringer" and is used in
Winter Ceremonial dances. H 48 cm. *Collected by
Hunt during Jesup Expedition, 1897. 16/1488*

The First Jesup Expedition Collections

The American Museum of Natural History's Northwest Coast collections grew considerably as a result of the Jesup North Pacific Expedition. Numerous artworks from the Thompson River Indians, the Chilcotin, the Bella Coola, and the Kwaki-utl were sent to the American Museum in the course of the first year's fieldwork. These were augmented by Nootka pieces obtained by Fillip Jacobsen, who was helping the Expedition collect pieces. Jacobsen sent the Museum a geometric wolf mask (pl. 71), and an intriguing rattle composed of wooden fish suspended in a cagelike construction (pl. 72). In addition to artworks, the members of the Expedition sent back to New York numerous bones, skeletons, and plaster face casts they had acquired. These pieces did not have an easy or simple voyage to New York City, for an unpredictable difficulty arose at the Canada–United States border.

In a letter dated 10 November 1897, the customs collector at the Port of Og-densberg, New York, a Mr. Peters, informed Mr. Winser, the secretary of the Museum, that the auditor of the Treasury Department had returned an entry of "one box of plaster casts, one Indian ladder, thirteen boxes of Anthropologica" which had been falsely or erroneously classified by the senders as "natural history." "In the opinion of this officer," Peters wrote, "the term 'specimens of natural history' applies only to natural objects and does not apply to any artificial product or man-ufacture," and insisted that since plaster casts and ladders are clearly *not* natural, they would require the payment of duty. Then Peters went on to question the contents of the "Anthropologica" boxes, which upon inspection, turned out to be bones.

Since the affidavit described all the materials as "ethnological," Peters con-cluded they were not duty free and had properly to be classified under paragraph 702, New Tariff, as "a collection in illustration of the progress of the arts, sciences, or manufacturers" because in his judgment, "ethnology is a science, viz.: the sci-ence which treats the division of mankind into races, their origin, distribution and relations, and the peculiarities which distinguish them." One can imagine Mr. Pe-ters, a government official at a remote border post, confused at all these bones and plaster casts of faces, consulting a dictionary to be certain of the correct defi-nition of ethnology.

Winser quickly wrote back to Peters, explaining the nature of the American Mu-seum of Natural History, and by mid-November, the New York customs officer had relented and allowed the boxes in duty free as "collections in illustrations of arts and sciences made by the Curator of the American Museum of Natural His-tory in New York City in the Scientific Research in Fieldwork, and imported by said Society for exhibition in the City of New York at the American Museum of Natural History, an Institution in the City of New York duly established by the Encouragement of Arts and Sciences, and for Educational purposes" (13 Dec. 1897).

But by May of the next year the problem had arisen again, when Peters once more wrote Winser (24 May 1898) to inform him this time that the United States auditor had returned an entry of two boxes, with a document stating that "there is no provision in the tariff for ethnological specimens . . . and you are requested to state under what paragraph these specimens are claimed to be exempt from duty; also whether the American Museum of Natural History in New York is a public institution or was established for individual profit." Understandably apologetic for this bureaucratic hindrance, Peters suggested that Winser satisfy the auditor by sending the "usual affidavit" showing the character and incorporation of the Mu-seum, and descriptions of the objects themselves with information demonstrating that these collections, by illustrating "the progress of arts, sciences or manufac-ture," can be covered by paragraph 702, New Tariff.

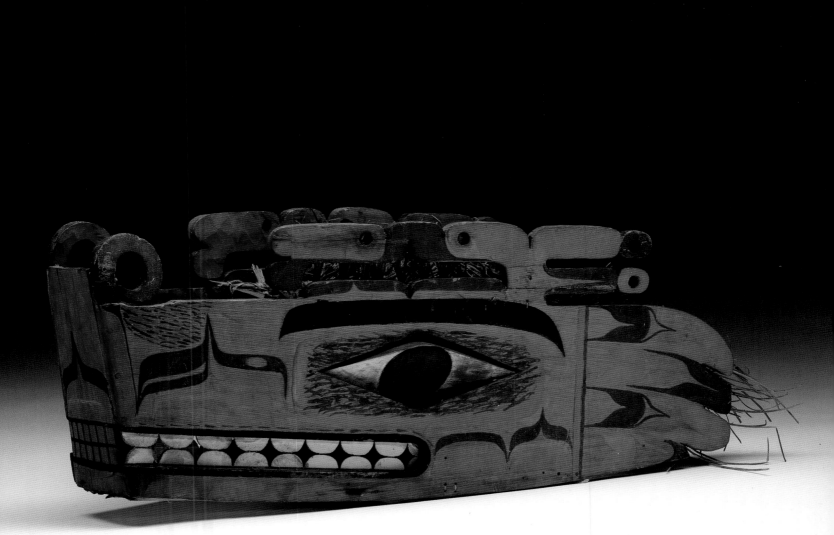

In November of 1898, a Mr. Oliver, the shipping agent of the Canadian Pacific Railroad, hoping to avoid such obstacles at the border, tried to arrange a direct shipment to New York City from British Columbia. He requested that the American Consulate in Huntington Junction provide him with papers that would enable the pieces to proceed across the border without being stopped. The consul was most agreeable, and sent Oliver the necessary forms. He returned them, properly filled out, but the consul nevertheless failed to provide the appropriate waiver of customs inspection. Apparently those forms had "gone astray" somewhere, so to prevent further delay, Oliver just sent the shipments on to the border, hoping they would eventually arrive at their destination.

Winser finally had had enough, so in January 1899, he wrote directly to Lyman Gage, secretary of the Treasury. With not a little pique, he described how the American Museum collected specimens from all over the world, including British Columbia, "in illustration of the Arts and Sciences." Although these specimens had little or no commercial value, he complained, the collector of customs of the Port of Ogdensberg, acting under instructions from the auditor of the Treasury Department, insisted that they post bond under paragraph 702 of the Tariff Act.

Pl. 71. Nootka wooden mask representing a wolf; used in the Wolf Dance. Clayoquath. L 71.4 cm, H 25.4 cm. *Collected by Jacobsen during Jesup Expedition, 1897. 16/1898*

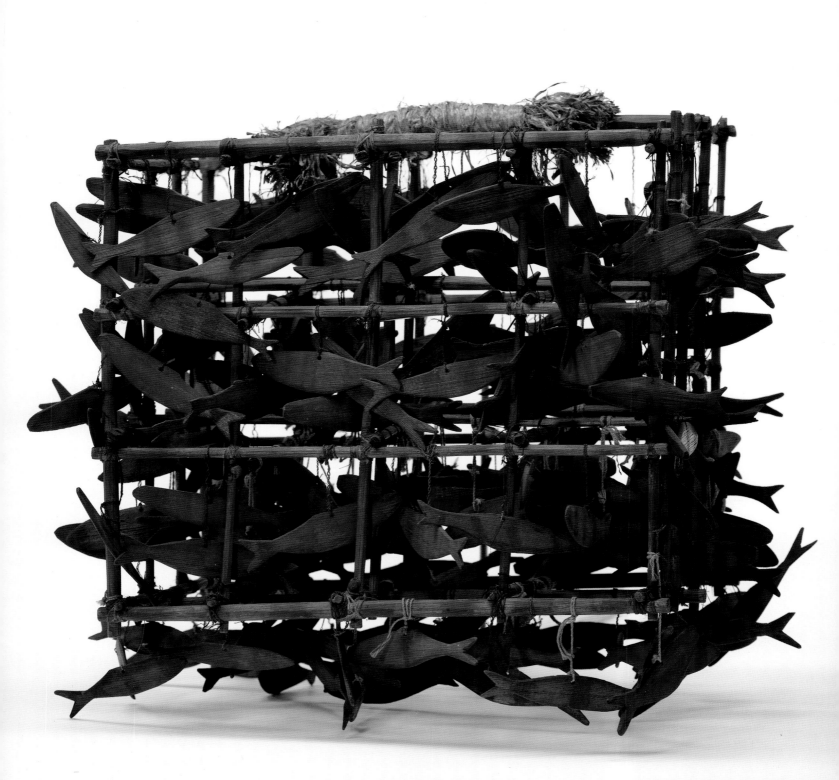

Could not the Treasury Department authorize the importation of such pieces duty free? Secretary Lyman acted quickly, and by March of 1899, Peters wrote Winser, "I enclose a copy of the letter from the [Treasury] Department authorizing the acceptance of a bond without sureties, for your importation at this port. . . . I regret the inconvenience to which you have been put in this matter, but it seems to have been unavoidable" (17 Mar. 1899). Although Winser, Boas, and the others might well have argued with this official over the avoidability of the actions of the customs officers, they were doubtless pleased that now shipments of "Anthropologica" could arrive from the Northwest Coast unhindered.

Pl. 72. Nootka wooden rattle, consisting of small wooden fish suspended in a grid of wooden dowels. Clayoquath. H 36 cm, W 35.2 cm. *Collected by Jacobsen during Jesup Expedition, 1897. 16/1966*

SHORTLY after Franz Boas returned to New York City, he granted an interview to the *New York Herald*. The paper subsequently carried a story on the Kwakiutl that offended him deeply. Entitled "Fierce Kwakiutls, Who Practise Cannibalism in North America, As Seen by Dr. Boas," and subtitled, "Maneating Savages Who Practise Inhuman Tortures in North America" (31 Oct. 1897), the article began:

You don't have to go to the heart of Africa or to the wilds of Borneo to find cannibals. They may be found on the North American continent, in the territory of Her Majesty the Queen of Great Britain and Empress of India, and almost within our own borders.

Dr. Franz Boas, of the American Museum of Natural History, has just returned from an expedition along the extreme western coast of British Columbia, close to Alaska, where dwell the Kwakiutl, a race of anthropophagi, man eating savages, who, uninfluenced by the encroachments of civilization and isolated from the rest of the world, still practice the blood-thirsty customs and weird ceremonies instituted when America was unknown to the Old World. They are fond of festivals, and devote a large portion of their time to weird dances and feasts and orgies of the wildest sort, during which terrible tortures are imposed on members of the tribe.

The *Herald* claimed that Dr. Boas had supplied the reporter with information on the Kwakiutl; if so, the paper twisted Boas's material in a grotesque fashion. As a result of his extensive measuring of British Columbian Indian heads, Boas had reached the conclusion that compared with their neighbors, the Kwakiutl had relatively large heads, high noses, long bodies, and short limbs. The reporter used these data to describe the Kwakiutl as "a strangely built race," with "enormous" faces and "abnormally high" noses. A group of Indians whom Boas had spent long hours scientifically measuring had suddenly become a race of physical monstrosities.

The article then went on in like fashion to distort other information Boas had provided the reporter, resulting in an odd mix of fact, opinion, and fiction. Interspersed with pejorative judgments of Kwakiutl culture—the author describes "weird dances," accompanied by "hideous screaming," performed by men with "hideously painted" bodies—many of the actual descriptions of that culture were accurate. In describing the Cannibal Ceremony, for example, the author correctly describes the transformation of the village from secular to sacred status at the beginning of the winter season, the mythologies associated with the various secret societies, and the ingenious theatrical tricks resorted to when producing these dramatic masked ceremonies.

Despite the relative accuracy in reporting an especially dramatic Kwakiutl ritual of the War Dancers, the readers of the *New York Herald* must have been impressed by the following colorful description of initiatory torture.

One of their customs . . . is to suspend a native from the rafters of the ceremonial hut by a thong passed through strips of flesh cut in his back for this purpose. Beneath him stand members of the society wearing hideous masks and with sharp lances upraised. If the victim falls he is impaled on the lances, and the cannibalistic etiquette among these people permits that he shall be eaten by the rest of the party.

Franz Boas, who by this point was committed to using anthropology to prove the equality of races, must have been dismayed at such misuse of his information in an article describing the Kwakiutl as decidedly subhuman. Later he would employ museum exhibits to educate the public about Northwest Coast culture and thus counteract the sort of sensationalism that appealed to the readers of the *New York Herald*.

Fig. 54. George Hunt. *11854*

6 / The Men in the Field

THE first year of the Jesup North Pacific Expedition, 1897, was to be the only time that the project took on the appearance of a classic "expedition," with men traveling together and exploring new territories. During the Expedition years, Boas himself returned to the Northwest Coast only once again, in 1900, for a two-month stay among the Kwakiutl of Alert Bay where he worked with George Hunt.

For most of the six-year duration of the Expedition, Boas remained in New York, carrying on active correspondence with the various people working in several different regions. In 1898 and 1899, Smith continued his archeological explorations on Vancouver Island and the Fraser River delta. Farrand worked on the west coast of Washington in 1898 and among the Quileute in 1900. Throughout the period, Teit traveled over much of the interior of British Columbia to collect materials from and information on the inland Indians, while George Hunt continued to work among the Kwakiutl. In 1898, Roland Dixon was hired to take photographs and casts of heads among the natives of Washington and southern British Columbia, and in 1900 and 1901, a recent Harvard graduate, John Swanton, spent several months among the Haida of Queen Charlotte Islands. In addition to these men in British Columbia, the American Museum employed several Russians who worked among a variety of Siberian tribes (AMNH Annual Reports for 1898–1902; Freed, Freed, and Williamson 1988). As these fieldworkers were more or less independent of one another, the story of the Jesup North Pacific Expedition becomes a series of narratives describing each man's experiences.

George Hunt 1854–1933

In many ways, George Hunt (fig. 54), Franz Boas's most valued Kwakiutl informant, was also his most prized ethnological assistant. Born in Fort Rupert in 1854, the son of a Tlingit woman and an English Hudson's Bay Company employee, Hunt functioned as a Kwakiutl. Several anthropologists and collectors who had worked on northern Vancouver Island before the Jesup Expedition, sought out this intelligent, bilingual man with intimate knowledge of Kwakiutl culture; in 1879 Hunt worked for Israel Powell, and in 1881 and 1885 he helped Johan Adrian Jacobsen collect for the Berlin Royal Ethnographic Museum. By the time Hunt met Boas during the latter's 1888 field trip, he was accustomed to dealing with acquisitive whites.

Although Boas and Hunt had brief interactions at this time, it was in 1891, when they collaborated for the Chicago Columbian Exposition, that their relationship solidified. Putnam had assigned Boas the responsibility for assembling a variety of "living" ethnological exhibits, including a group of Kwakiutl. Boas, in turn, met with Hunt in Victoria in August 1891 (Cole correspondence), asking him to engage the services of several villagers who would be agreeable to spending several months in Chicago. In addition, he asked Hunt to acquire as many artworks as possible to display in the Ethnology Hall; within a year, Hunt had assembled ceremonial paraphernalia and canoes, as well as an entire house. In the spring of 1893, seventeen Kwakiutl, including George Hunt, arrived in Chicago to spend the summer living in their house and demonstrating their customs and rituals, including the infamous "Warrior Dance." During this time Boas trained Hunt in ethnographic field methods, which Hunt learned extremely well (Jacknis n.d.).

Despite his high regard for Hunt's abilities, Boas had occasional difficulties with him. Although Hunt was indispensable to Boas during his 1894 winter field trip to the Northwest Coast, the anthropologist complained to his wife that Hunt was sometimes less than cooperative.

I wish I were away from here. George Hunt is so hard to get along with. He acts exactly as he did in Chicago. He is too lazy to think, and that makes it disagreeable for me. I cannot change this, though, and have to make the best of it. He left at noon with some excuse and returned only after several hours. He knows exactly how dependent I am upon him (Rohner 1969:183).

Despite these complaints, George Hunt was a valuable assistant, so valuable in fact that others tried to engage his services. To Boas, the most galling examples of this were the several attempts by the Chicago crew to seduce Hunt into their collecting camp. During the first year of the Expedition when Boas ran into Dorsey and his assistant, James Deans, in Namu, they asked if he knew of Hunt's whereabouts. Boas lied, saying he had no idea where they might find Hunt, and immediately wrote to his informant, instructing him "not to do anything" for Dorsey and Deans, should they find him (Rohner 1969:222). Then, in 1899, Field Museum people stooped to deceptiveness in their pursuit of Hunt. One day, a man who claimed to represent the American Museum approached Hunt in Alert Bay, to inform him that since the trip from New York City was so expensive, Franz Boas would no longer be able to visit the Kwakiutl. In order to maintain contacts with Hunt, the Museum had sent this newcomer in Boas's place. Although this stranger refused to identify himself, he may very well have been none other than George Dorsey (Jacknis n.d.).

A final provocation occurred in 1903 when Hunt received an invitation to come to Chicago to help arrange the Field Museum's collections; this so infuriated Boas that he quickly wrote a letter to Dr. Charles Newcombe, a physician from Newcastle who had settled in Victoria and was then in the employ of the Chicago institution, claiming that since Hunt was still working for him, the action "on the part of Dorsey [is] an interference with my work" (28 Dec. 1903). Newcombe wrote a propitiating reply stating that he had hoped Boas could spare Hunt long enough on his trip to or from New York City to supply some information on Kwakiutl poles at the Field (5 Jan. 1904). The Chicago museum would have happily paid partial expenses for Hunt's entire trip from British Columbia; "there was absolutely no hint of anything farther than this, nor has any other idea with regard to Hunt ever entered my head," Newcombe claimed, and added, "I shall, of course, drop the matter."

IN the early months of the Jesup Expedition, Boas had sent Hunt a letter that he was first to translate into Kwakiutl, and then to read to the assembled village at a feast for which Boas would pay. In this letter, Boas described the intent of his project, and assured the Kwakiutl that he would try to show "to the white men in Victoria that your feasts and your potlatches are good. . . . that your ways are not bad ways" (Cole 1985:157). He regretted that so many young Kwakiutl no longer celebrated their traditions.

It is good that you should have a box in which your laws and your stories are kept. My friend, George Hunt, will show you a box in which some of your stories will be kept. It is a book that I have written on what I saw and heard when I was with you two years ago. It is a good book, for in it are your laws and stories. Now they will not be forgotten. Friends, it would be good if my friend, George Hunt, would become the storage box of your laws and of your stories (14 Apr. 1897).

Hunt then presumably showed the Kwakiutl Boas's 425-page book, *The Social Organization and the Secret Societies of the Kwakiutl Indians*, and perhaps even shared with them a translation of Boas's acknowledgment in the Preface: "The great body of facts presented here were observed and recorded by Mr. George Hunt of Fort Rupert, British Columbia, who takes deep interest in everything pertaining to the ethnology of the Kwakiutl Indians and to whom I am under great obligations" (Boas 1897b:315).

In 1900 the Kwakiutl of Alert Bay held a winter ceremony to which they invited Hunt, an initiated Hamatsa. To their dismay, the Canadian government officials raided the ceremony and arrested several individuals, including Hunt. It seems that the Indian Agent, R. H. Pidcock, accused Hunt of "assisting in the mutilation of a dead human body," the corpse of a woman who had died several years earlier. To defend himself, Hunt claimed to be obtaining information for the agent to act upon, an argument Pidcock correctly did not buy (Pidcock to A. W. Vowell, 7 Mar. 1900.)*

Shortly after his arrest, Hunt was in contact with Boas: "I am writing to let you know that I am in trouble. I am taken Prisoner in Alert Bay for going to see *Lawitses* tribe winter Dance, a *Hamatsa* eating Daid corps and I was sent to Vancouver to be tried. But I got a lawyer and he sent me Home to get some more witnesses and I am to be tryed on the 13th of next month and I am depending on Mr. Spencer for Money for I am Poor" (15 Mar. 1900; Cannizzo 1983:51).

In a letter to Dr. Newcombe (29 Mar. 1900), Boas expressed indignation at such wrong-headed interference with "nearly extinct" rituals. Then he mentioned his intention of sending the court one of his books acknowledging Hunt: "It would seem to me that to any sensible judge or jury it will make all the difference in the world why a man should take part in affairs of that sort." In the end, a conviction was not obtained, and Hunt was acquitted of all charges (Cannizzo 1983:52).

Hunt collected voluminous texts (for $.50 a page) that he copublished with Boas as volumes in the Jesup Expedition Memoirs series (Boas and Hunt 1902–5, 1906), and purchased around 2,500 artworks for the American Museum, many of which are its most precious examples of Kwakiutl art. Boas insisted that Hunt collect old and complicated pieces with good documentation on associated myths and inheritance rights. So punctilious was he in fulfilling his obligations, that Hunt described a set of masks as being full of "fine worm Holes, so you see that they must be old" (Jacknis n.d.).

During the Jesup Expedition, Hunt collected an impressive array of Kwakiutl art that expanded the American Museum's holdings considerably, and greatly increased the New York public's understanding of British Columbian Indian ceremonials. When, during a potlatch, a Kwakiutl chief wished to add a dramatic touch to the festivities, he directed his guest's attention to the wooden statues that were either set up outside atop tall poles or erected within the communal house (figs. 55, 56). These figures, which could depict the chief himself, his speaker, his rival, or members of his rival's family, enhanced the chief's position at the expense of his rival by insults and mockeries. For example, the illustrated sculpture in plate 73, an unusually explicit representation of a twisted-faced woman exposing her genitalia, was made by one chief to ridicule his rival whose daughter had become a prostitute in Victoria. Another example, the figure of a chief's rival, was placed before the fire and then offered some grease from a ladle. After pretending to listen to what the statue said, the chief's attendant smiled and announced publicly, "I thought so. He came to warm himself at our chief's fire, because he is cold in his house and has never tasted grease." The attendant then covered the artwork with grease (Boas 1966:343–46). To accuse his rival of insufficient food and grease was a terrible insult; to throw grease away was an indication of the chief's immense wealth. Chiefs insulted in this fashion typically retaliated energetically and with equal aggressiveness, often by displaying their own statues mocking their rivals.

* I am indebted to Douglas Cole for this reference.

Fig. 55. Kwakiutl village of Fort Rupert. Post depicts a killer whale, the crest of one of the La'alaxsent'aio clan. *Hastings photograph, 1894. 336065*

Fig. 56. Kwakiutl village of Fort Rupert. *Hastings photograph, 1894. 336062*

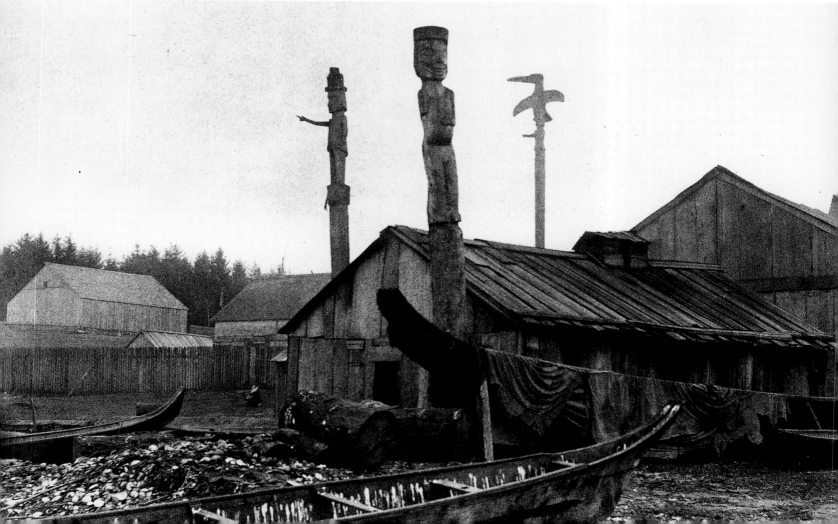

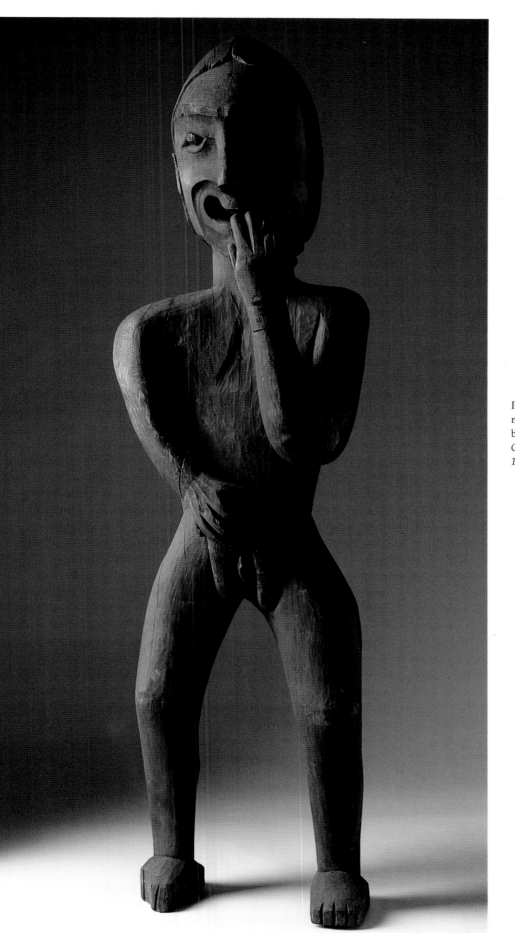

Pl. 73. Kwakiutl wooden figure of a woman, made to ridicule her family because she had become a prostitute. Kwikset'enox. H 158 cm. *Collected by Hunt during Jesup Expedition, 1901. 16/8381*

In addition to art used in a secular context, Hunt sent to the American Museum a collection of pieces, including masks, used during the Winter Ceremonial. These face masks depict a wide variety of beings and include a boldly painted anthropomorphic face with shaggy hair and eyes that seem to gaze upward, as if in a trance (pl. 74), a wasp whose facial features are decorated with bands of copper that must have shone brilliantly in the firelight (pl. 75), and an octopus with rows of suckers in sharp relief on its cheeks and a small octopus face hovering, open-mouthed, above its forehead (pl. 76). By means of pulling strings that the dimmed light must have concealed, this octopus's tentacles could pulsate, and its mouth open and snap shut.

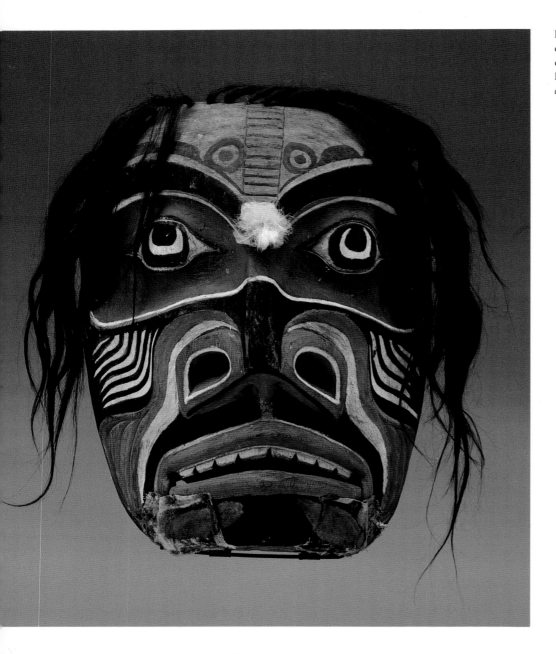

Pl. 74. Kwakiutl wooden mask with hair and down; a laughing mask used during Lao'laxa, a dance acquired from the Northern Kwakiutl. Fort Rupert. H 43.2 cm, W 35 cm. *Collected by Hunt during Jesup Expedition, 1897. 16/2375*

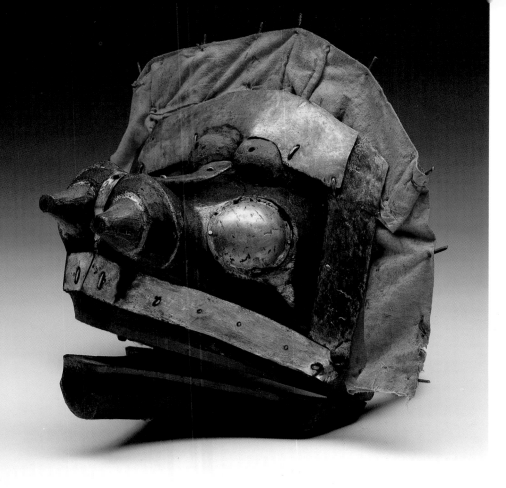

Pl. 75. Kwakiutl wooden mask with copper plates, said to belong to the Qa'wadekegala; depicts Wasp. H 54.2 cm, W 41.1 cm. *Collected by Hunt during Jesup Expedition, 1901. 16/8534*

Pl. 76. Kwakiutl wooden octopus mask; tentacles pulsate, mouths open and shut. Gilford Island. Mask: H 30.6 cm, W 27.5 cm. *Collected by Hunt during Jesup Expedition, 1899. 16/6874*

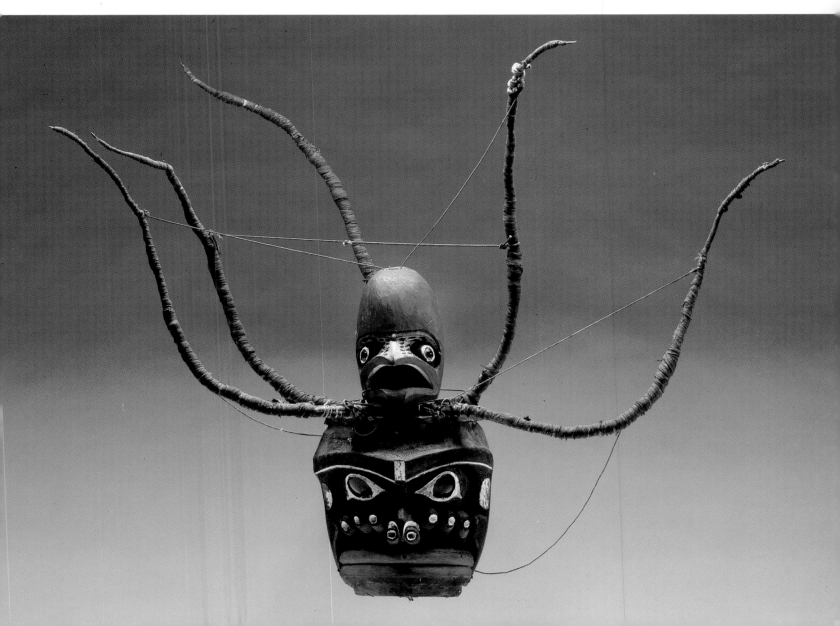

Other Kwakiutl masks in this collection were cleverly animated, such as that depicting the avian attendants of Cannibal-at-the-North-End-of-the-World, Ho'xuhok, and two ravens, surrounding what seems to be the face of the Cannibal himself (pl. 77). By pulling strings, the dancer could open and shut the beaks of these birds in syncopated beat, creating a "musical" mask.

Even more dramatic were the transformation masks that revealed two, sometimes more, faces in succession. When shut, one such mask (pl. 78) was a simple and elegant depiction of Raven; snapped open, the mask revealed Raven of the Sea, surrounded by four brilliantly colored sections painted with images of sharp-toothed creatures facing inwards. Another transformation mask (pl. 79) is perhaps the most remarkable piece in the Hunt collection, for it is a triple transformation mask, illustrating when shut a smiling bull head, when first opened a sea raven, and finally when fully opened, an exquisitely and sensitively modeled white human face accentuated with red nostrils and mouth. In addition to these masks, there were other articulated pieces, such as the family of ghosts (No'tEmg.ila) with articulated limbs that were used as puppets during the performances of these dramatic rituals (pl. 80).

Pl. 77. Kwakiutl wooden mask with cooper and cedar bark; depicts Ho'xuhok, a fabulous being said to be similar to the crane, and two ravens. Knight Inlet. H 68.6 cm, W 67.6 cm. *Collected by Hunt, 1904. 16/9586*

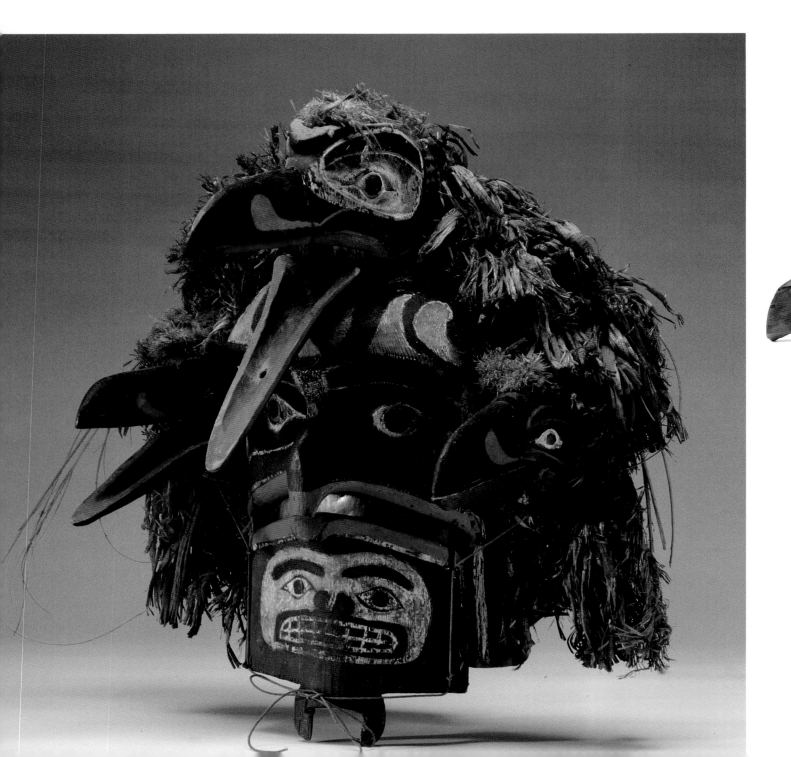

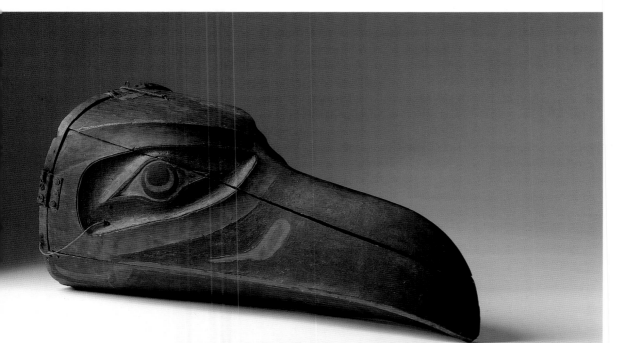

Pl. 78. Kwakiutl wooden mask depicting Raven as well as raven of the sea; snaps open and shut to reveal two entirely different beings. Drury Inlet. L 83 cm, H 38.2 cm. *Collected by Hunt during Jesup Expedition, 1901. 16/8529*

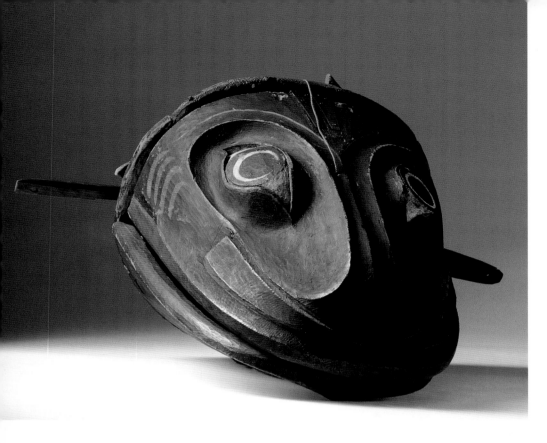

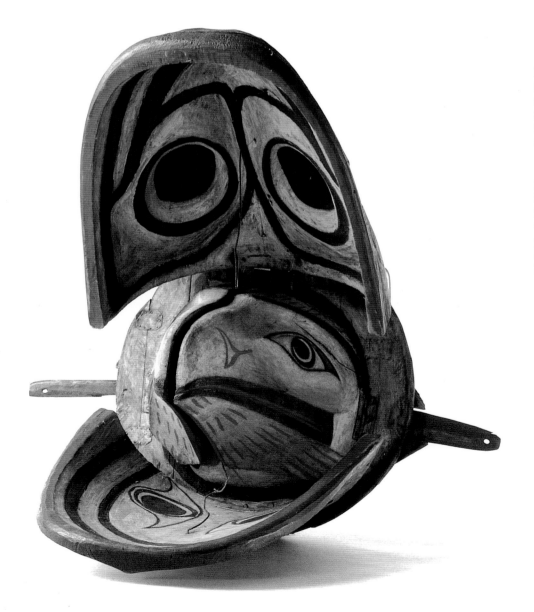

Pl. 79. Kwakiutl wooden mask depicting man inside a sea raven inside a bull head; snaps open and shut to reveal three entirely different beings. See page 5 for a view of the mask fully opened. Drury Inlet. L 61.5 cm, W 54.4 cm. *Collected by Hunt during Jesup Expedition, 1902. 16/8942*

Pl. 80. Kwakiutl wooden figures with hair and leather costume; depicts No'tEmg.ila ghost and its two children, beings who participate in the warrior dance and involve Toogwid; used as puppets. Kingcome Inlet. H 120 cm. *Collected by Hunt during Jesup Expedition, 1901. 16/8427, 16/8428a,b*

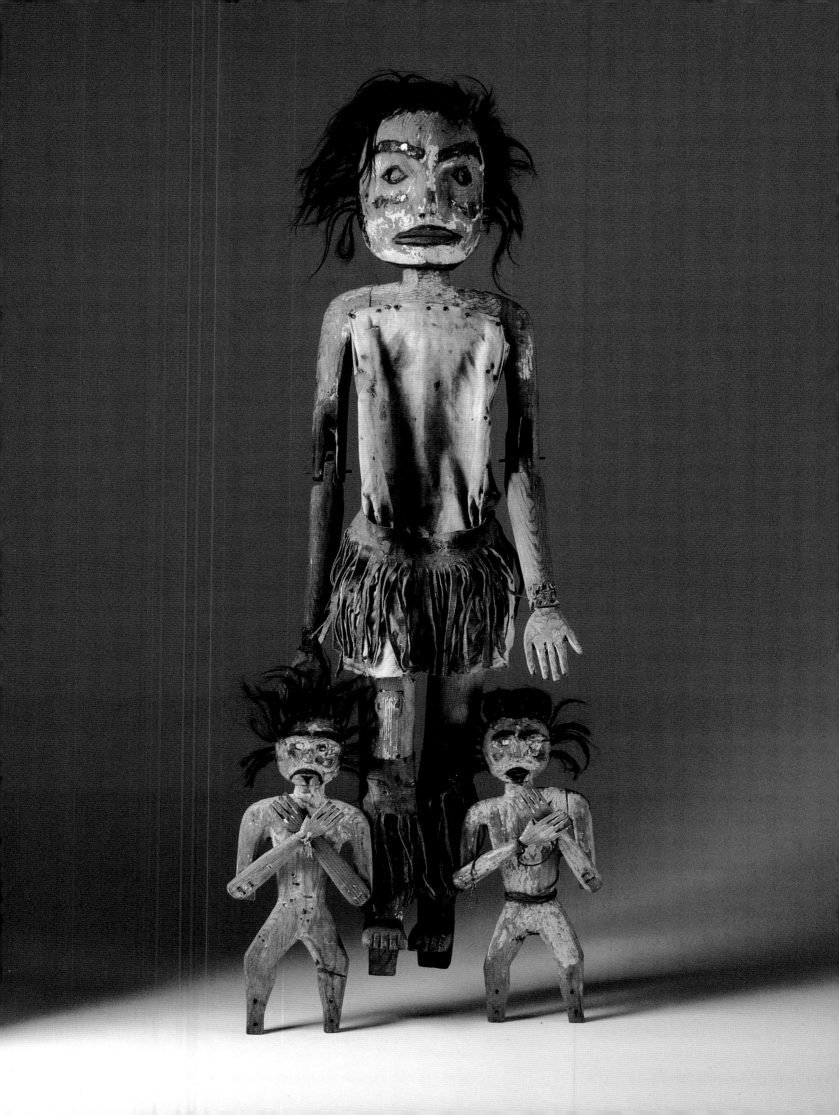

Although Boas was by and large extremely pleased with the objects Hunt sent back to the Museum during the years of the Jesup Expedition, he occasionally questioned the judgment of his Kwakiutl collector. One such occasion concerned the purchase of the great Dzonokwa bowl (pl. 81), now considered one of the Museum's treasures. This remarkable two-meter-long dish represents the child-eater Dzonokwa who is also known to bestow immense wealth on families who receive coppers from her. The artwork is a celebration of cavities for holding food: Dzonokwa's belly constitutes the principal bowl, while her naval and breasts are little dishes. One can even remove her aggressively carved masks to reveal yet another bowl hidden under her face.

Boas was most unhappy with Hunt about this purchase. On learning of the $65.00 bill for this carving, Boas wrote Hunt, "the price that you had to pay for the Dzonoq'wa dish is very high; and although I presume you were very much interested in this specimen, I do not think the purchase was a very good one" (17 June 1902). Hunt responded by explaining that the owner had refused another collector's offer of $100 for the same or a very similar bowl, and wrote, "the owner would not sell it for that Price so I thought I got it very cheap for if we write about the ways the Indians Handle it in the large feast I think you would like it" (4 July 1902).

ALTHOUGH the Jesup North Pacific Expedition came to an official end in 1902, Hunt continued to collect for the American Museum and, in 1904, acquired one of its most treasured collections, the Nootka Whalers' Washing Shrine from Friendly Cove on Vancouver Island (fig. 57). This was actually a complex of figures erected in an open shed, in which certain privileged individuals, usually chiefs, prayed and purified themselves in order to attract beached whales (Drucker 1951:173). The shrine was located on an island in a freshwater lake not far from the village. The chief would go to the shrine and bathe in the water by rubbing his body with hemlock boughs.

The Whalers' Washing Shrine was a great treasure of the Nootka people who told Hunt the legend behind the shrine's origin. According to this story, many generations ago, a man imbued with intense shamanistic powers, Tsaxwasap, had inherited from his grandfather a shrine which consisted of four human skulls and some hemlock branches. Tsaxwasap knew that if he added certain items to the shrine he could increase its magical potency, which could then guarantee a constant supply of whales.

Once when Tsaxwasap was out in the woods with his wife, she defecated. Her husband, somehow intuiting that his wife's feces actually contained the spirits of several men, insisted on picking them up with some cedar twigs and bringing them to his purifying house. This intensely magical excrement attracted four whales. Shortly thereafter, the shaman kidnapped ten newly born infants in their cradles and brought them to his shrine so that their cries would lure even more cetaceans. No one suspected Tsaxwasap of this appalling deed, and soon he was engaging in further activities aimed at enhancing the strength of his shrine. He began removing from graves the skulls of men who had been long dead and then placed forty skulls on the righthand side of the shrine, forty skulls on the lefthand side, eight skulls atop sticks on the right side, eight skulls atop sticks on the left, and four in front of the house to serve as watchmen. Then Tsaxwasap found twelve dried up corpses of people and placed them in two rows in the center of the structure facing the door. After this, he kidnapped one hundred and twenty more infants and placed them, in their cradles, in his house. This magical house served its purpose well, for many, many whales came to Tsaxwasap.

Pl. 81. Kwakiutl wooden bowl representing Dzonokwa, with small bowls for breasts and navel; open-mouthed face carving can be removed to create another receptacle for food. L 270.8 cm, H 59.8 cm. *Collected by Hunt during Jesup Expedition, 1902. 16/9013*

Over the passage of time, the corpses and children's cradles rotted away. Tsaxwasap's descendant no longer could easily kidnap babies nor rob graves, and had to resort to replacing the decaying pieces with cedar carvings of children and corpses. He could, however, keep the skulls from the original shrine which remained almost "as if new." These were the contents of the Whalers' Washing Shrine Hunt thought might be worth trying to acquire for the American Museum (Boas 1930).

Hunt sent Boas a photograph of the shrine to solicit his advice on whether it was advisable to pursue its acquisition. It had not been especially easy for Hunt to get access to this shrine to take the photo, for when the Nootka chief learned of his interest in the shrine, he asked Hunt if he were a shaman. Hunt responded that he was, "for they say that I could not go to see the Whalers Praying House unless I was [a shaman]." To test whether Hunt really did have healing powers, the chief brought him a sick man to cure; luckily, the patient recovered and Hunt was brought to the shrine.

In January 1904, Boas wrote Hunt giving him permission "to attempt to purchase the whaling-house of which you sent me a photograph." Boas then requested that Hunt take as many photographs of the house as possible, so that they could reconstruct the whole structure when it arrived in New York. In his letter to Hunt, he described his plan "to build a whole house just like the one in which the carvings are, in one of our halls, and to put trees and vines and bushes made of wax around it, so as to make the whole thing look just as it looks now" (26 Jan. 1904).

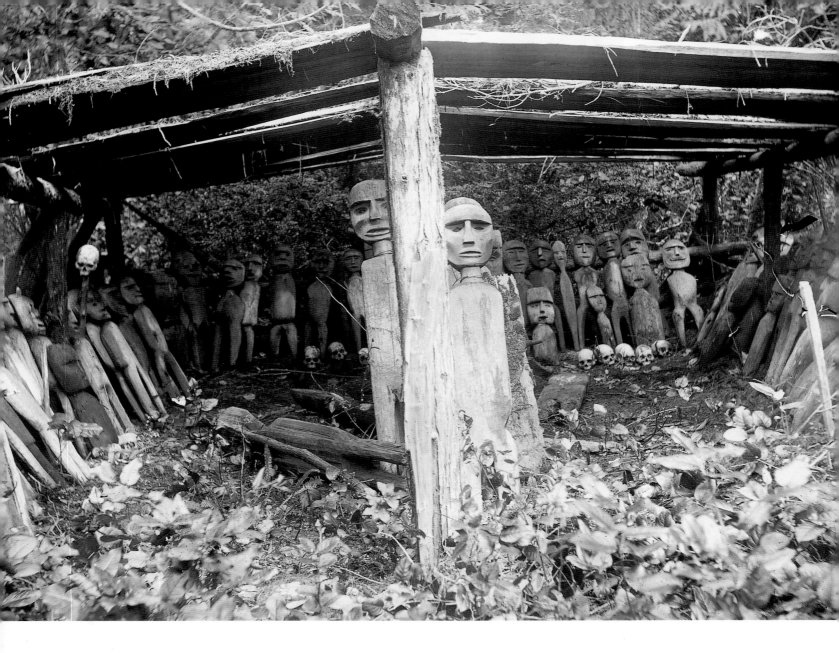

On June 9, 1904, Hunt described to Boas how he had encountered "trouble" in buying the Whalers' Washing Shrine—a true understatement, it turned out. First of all, two different high-caste men claimed ownership of the assemblage. One threatened that if Hunt tried to buy it from the other he would file a charge for selling stolen property, while the other asserted that if he did not get his proper share he would "bring trouble among his people." These men not only wanted dollars, and a good many of them, they also wanted some of Hunt's Kwakiutl Cannibal Society songs. Although one of these men did finally agree to sell the shrine for five hundred dollars and ten Hamatsa songs, he reversed his decision the very next day. He had become frightened by his people's warnings that they would die soon if he sold the shrine.

Despite these obstacles, on June 22, Hunt finally reported that he had managed to bring the two vying chiefs together on friendly terms, and get each to agree to take $250. They in turn made Hunt promise not to touch the house until all the people left the area, and to bring it to the steamer at night. On July 27, Hunt wrote proudly to Boas that the shrine was "the best thing that I ever bought from the Indians." Unfortunately, the shrine was never erected as Boas had envisioned. Properly set up in a tree-covered, open-air shrine, the eighty-odd wooden figures and the sixteen human skulls and the four wooden whales would simply have taken up too much space in the Museum; instead, in the Northwest Coast Hall is a small model of the Nootka Whalers' Washing Shrine while all the contents still remain in storage (pl. 82).

Fig. 57. Nootka Whalers' Washing Shrine near Friendly Cove. *Hunt photograph, c. 1903. 104478*

Pl. 82. Nootka wooden image from Whalers' Washing Shrine. H 160 cm. *Collected by Hunt, 1904. 16/9902*

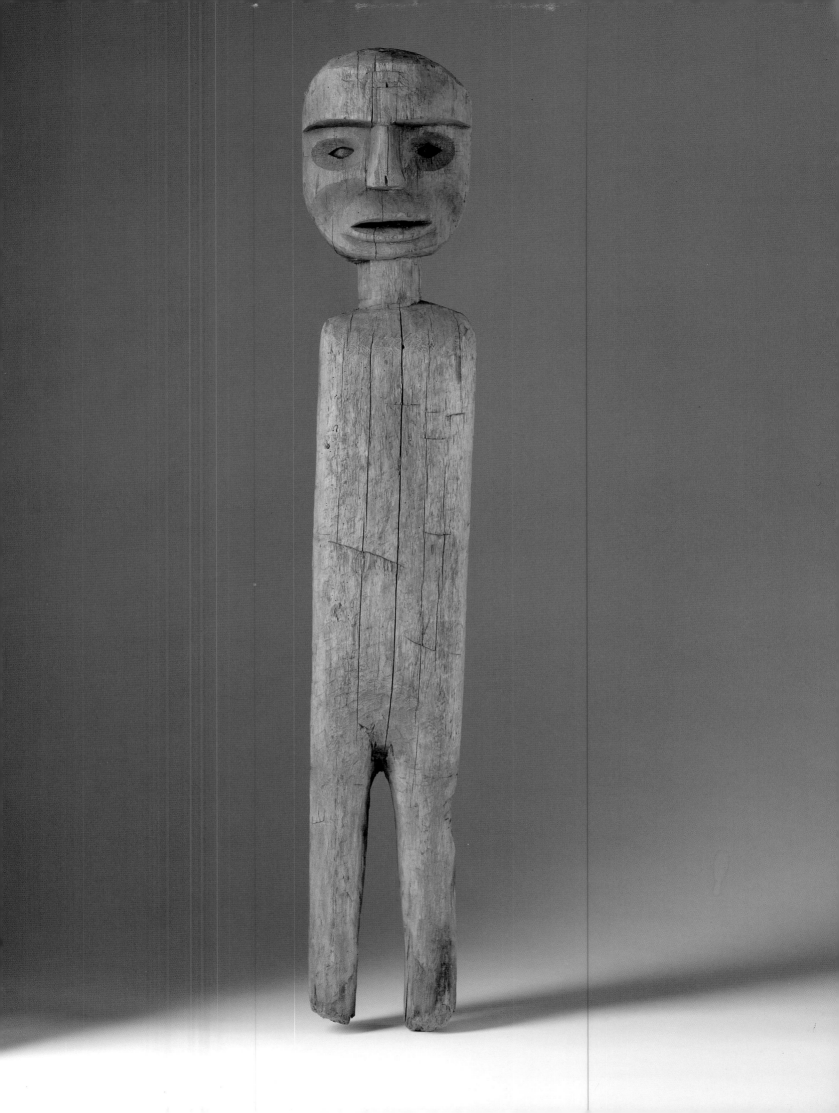

James Teit 1864–1922

When in 1894, Franz Boas arrived in Spences Bridge, a village he described as a "little dump," he was told of a white man who lived with his Indian wife three miles up a mountain road. After Boas visited this person, he wrote his wife: "The young man, James Teit, is a treasure! He knows a great deal about the tribes. I engaged him right away" (Rohner 1969:139) (fig. 58). Boas would soon become very dependent upon this kind and intelligent man for information on the interior Salish tribes in whose dialects Teit was remarkably fluent and free of accent. Even the natives found him impressive, and said that in a darkened room, "you couldn't tell him from an Indian speaking" (Banks 1970:96). Teit worked for Boas every year of the Jesup Expedition, gathering voluminous materials on the natives of interior British Columbia (fig. 59).

Teit's linguistic abilities were even more impressive when one realizes he had arrived in British Columbia only eleven years before he met Boas. The eldest male in his Scottish family, Teit forfeited his rightful inheritance when he left the Shetland Islands and emigrated to Canada in 1883, to settle ultimately among the Thompson Indians. Fascinated by these people, he learned their traditions and married one of their women, Lucy Artko, who provided him with an effective entree into this Salishan society (Banks 1970).

Fig. 58. James Teit and his wife, Lucy Artko. *Photograph taken c. 1896.*

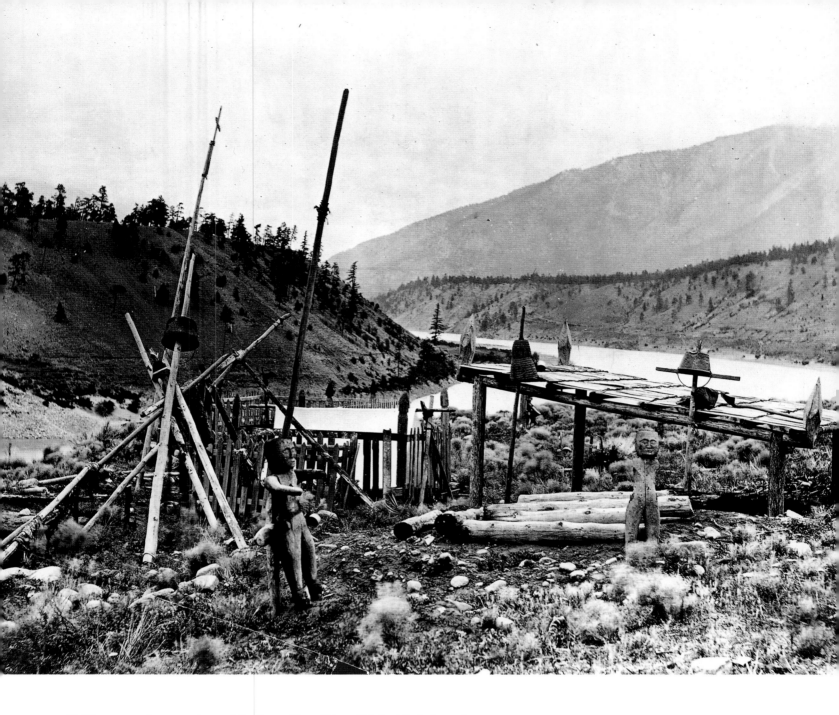

Fig. 59. Salish graveyard near Lytton. *328737*

Unlike some other members of the Jesup Expedition, Teit had little formal schooling and no real "career." At different times, he served as the clerk of the Spences Bridge store, grew apples, tended cattle, managed a fruit ranch, and packed supplies to a copper mine. His years among the Indians had made him so expert at tracking caribou, mountain sheep, mountain goat, fox, and deer, that numerous British and American hunters engaged him as their guide. After he met Boas in 1894, Teit began working part time at another job—gathering information on the customs and legends of the Thompson Indians, collecting whatever artifacts he could, and making head casts of those Indians from whom he could get permission. Teit's energy and all-around competence is reflected in a letter he wrote to Boas in the autumn of 1902, in which he described his plans: first, guiding several different hunting expeditions, then helping some neighbors build an irrigation dam, and finally assisting some other friends tear down a store and build a cottage in the same place. "During my spare time," Teit reassured Boas, "I will write off the balance of the Shuswap myths and all the Thompson and Nicola ones." Which he did.

Teit tried hard to follow Boas's directives on proper methods of ethnological fieldwork and devoted much energy to satisfying his wishes. He became obsessed with obtaining sound information, and often expressed sadness that acculturative processes were destroying some elements of traditional cultures. He described his deep regret that he had not begun his fieldwork earlier when he learned of the death, five years before, of the last individual capable of correctly speaking an obscure dialect (12 Mar. 1895). Knowing that Boas wanted bones, Teit wrote, "during a recent Chinook [a sudden warm wind that melts snows and sometimes produces flooding] a slide occurred near an ancient burial ground on the riverbank and exposed part of several skeletons. I want to procure them without being noticed and will endeavor to go there on some moonlit night" (18 Dec. 1896).

Sometimes the cultural differences between New York and the remote regions of interior British Columbia created interesting problems. In early 1904, after the Jesup Expedition proper was over, but when Teit was still collecting for Boas, the American Museum initiated a new accounting system in which each item purchased, and all travel expenses, had to be accompanied by a voucher signed by the seller. Teit wrote Boas explaining his difficulties with these vouchers (10 Mar. 1904). Those Indians who knew him usually agreed, although reluctantly, to put an "X" on the voucher when they sold him some artifact, but strangers frequently refused. Teit explained that "to them, 'touching the pen' is a very serious and solemn matter requiring much deliberation and explanation—as for instance when they make an agreement with the government."

These vouchers created other problems. "It is also very unhandy in open camps, in all kinds of weather (raining or blowing) or perhaps pestered with mosquitos, or blinded with smoke, to make the Indians mark a voucher for some little specimen I have purchased from him. Understanding the Indian's mind about the thing as I do, it seems to me in the nature of a joke. I know it is *business*, but up to date New York City methods do not always work out in the wilds of British Columbia." A sensible man, Teit went on to point out that it was quite impossible for the Museum to check these vouchers; since not one man in two hundred could actually sign his name, anyone—even Teit himself—could forge the "X's," "and no one would know whether they are genuine or not." Finally, Teit noted with some embarrassment how unusual it was for a waitress to be expected to sign a $.25 voucher for lunch. As soon as he received this letter, Boas wrote back to Teit (17 Mar. 1904) that the vouchers were simply conveniences. He agreed that "there is of course no sense in getting signatures from Indians who cannot read and write, and in all such cases, as well as in cases of single meals, etc., we are fully satisfied with your statement."

Teit sent to the American Museum some exceptionally fine Salish artworks, including the Swaixwe mask from the Lower Fraser River (pl. 83) that depicted a supernatural that lived in a lake. Only certain select Coast Salish families were permitted ownership of these wooden masks with cylindrical eyes, a bird-nose, extended tongue, protruding flanges for ears, and a headdress composed of wooden animal heads and a variety of feathers. The primary significance of these masks was social, for, worn at potlatches, marriages, or receptions for visitors, the Swaixwe mask served both to purify the individuals receiving names or being married, and to heighten the prestige of those families who possessed them (Wingert 1949:15; Suttles 1982).

It was clear to Boas from the time they met that Teit had a wealth of information that merited publication. In 1896, he saw to it that the *Bulletin of the American Museum of Natural History* published Teit's article on a rock painting of the Thompson River Indians; after the title were the words, "edited, from notes of the collector, by Franz Boas." Teit authored several of the Jesup North Pacific Expedition Memoirs—*The Thompson Indians of British Columbia* (1900), *The Lillooet Indians* (1906), and *The Mythology of the Thompson Indians* (1910). Although Teit received full credit as author of the Thompson Indian monograph, in the introduction was a note that this publication, based on two manuscripts prepared by James Teit, included a section on art and a conclusion written by the series editor, Franz Boas.

Pl. 83. Salish wooden mask with feathers; represents Swaixwe, mythical protector of certain families. Lower Fraser River. H 81.6 cm, W 49.9 cm. *Collected by Teit, 1903. 16/9222*

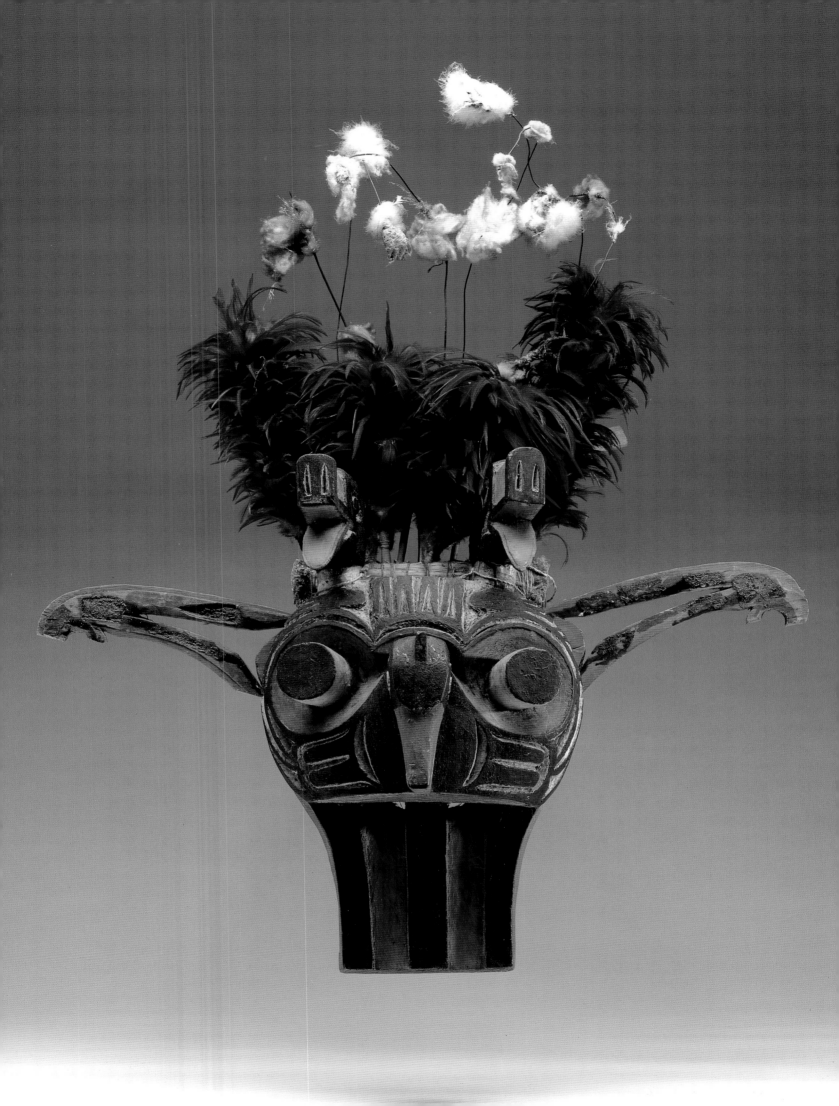

Teit's writings on Indian culture were scientifically accurate, thorough, and extremely informative. The Thompson Indian monograph, for example, contained detailed descriptions of houses, costumes, subsistence activities, travel, transport, games, pastimes, social organization, arts, industries, burial customs, and religion. It also contained something not always found at the time in such ethnographies: deep, sincere affection for the people themselves. Noting how heavily decimated the population had become as a result of measles, flu, and consumption epidemics, Teit suggested that the Indian Department supply a resident physician who might "materially improve Indian conditions." He also lamented the natives' perception of the bleakness of their future: "the belief they are doomed to extinction seems to have a depressing effect on some of the Indians. At almost every gathering, where chiefs or leading men speak, this sad, haunting belief is sure to be referred to" (Teit 1900:177–78).

Teit revealed much of himself in his letters to New York, particularly his insecurity about his work for Boas. He expressed deep pleasure at finally receiving some correspondence from Boas after a long period of silence. He wondered if he had said or done something that had offended the anthropologist. "If I have it has been done quite unintentionally and I hope you will forgive me. At one time I thought something must have happened to you or that you were dead, and consequently I was very glad when I saw your handwriting on the papers you sent me." In a letter dated 7 March 1899, Teit wrote, "it is with great sorrow that I acquaint you with the death of my wife, which took place here on the second of pneumonia. As she was a good wife to me and we lived happily together for over twelve years I naturally took her demise as a great blow." To Harlan Smith he wrote, "I feel greatly cut up about it and it will take me a long time to get over the loss" (12 Mar. 1899). His sorrow was not to persist indefinitely, however, for in 1904 Teit wrote Boas an apologetic letter (10 Mar. 1904) explaining why he had both not written for some time and failed to complete some assigned work: he had been "very busy courting," and was soon to marry. In March 1904, James Teit married Leonie Morens, the daughter of a Spences Bridge cattle rancher, converting to Catholicism in the process.

His marriage into Spences Bridge society did not end his participation in Indian affairs; indeed, during the first decade of the twentieth century, Teit labored actively on behalf of Indian rights in Canada. The British Columbian natives had immense respect and admiration for, and trust in, this man, whom they asked to accompany them to meetings with government officials. At such occasions, both in Victoria and Ottawa, Teit served as translator, sometimes working simultaneously in four or five different languages if chiefs from several areas were present. Teit wore native costume on these missions, and on one such trip to the capital, met a stranger who commented that he did not know Indians had blue eyes; Teit, always one for a good joke, responded with great seriousness that he belonged to "a different tribe" (Banks 1970:65).

Livingston Farrand 1867–1939

Another member of the Jesup North Pacific Expedition was Livingston Farrand, professor of psychology at Columbia University (fig. 60). Described by Franz Boas as "a nice traveling companion, unassuming and gay" (Rohner 1969:206), Farrand was very much a member of the eastern elite establishment. After his adventures on the Northwest Coast during the Jesup Expedition, Farrand assumed a series of philanthropic posts, among them, executive secretary of the National Association for the Study and Prevention of Tuberculosis in 1908, and chairman of the American Red Cross executive committee in 1921. He also made a career in academic administration, becoming president of the University of Colorado, Boulder, in 1915, and president of Cornell in the 1920s.

Fig. 60. Livingston Farrand. *Department of Manuscripts and University Archives, Cornell University; photograph courtesy of Cornell University.*

Farrand accompanied Boas on their 1897 adventure on horseback through the interior of British Columbia as far as the Chilcotin, where he remained for a month, collecting ethnographic information and trying to measure heads. He had limited success at the latter task, as some chiefs "flatly refused" to allow their men to be measured, while others insisted on handsome payment for the privilege. Later, he described how his stay at Chilcotin was disappointing, in that he could measure only ten heads and recorded just a few interesting stories (22 Aug. 1897).

In the summer of 1898, Farrand spent time in Washington State between Gray's Harbor and Cape Flattery, among the Quileute, and the Quinault, where he encountered more difficulties. At Quileute he became discouraged because almost all the people had left for the salmon fisheries and would not return until October. As he wrote to Boas (5 July 1898), "It was a complete knock out blow for I had been led to believe that I could catch them but it is hopeless." The only person around who could speak both English and Quileute was dying of tuberculosis, but became Farrand's chief informant in this depopulated village. Farrand wrote with regret how slowly this man could supply linguistic data.

Throughout his field adventures and despite his setbacks, Farrand maintained an optimistic perspective on his activities; indeed, his letters reveal a cheerful man who simply enjoyed new and different experiences. Although he was not at all successful with his linguistic research among the Quileute, he wrote a delighted letter to Boas (1 July 1898) describing how pleasant his living conditions were, how the Indian agent with whom he stayed was a "capital" man, how the weather was superb, and how it practically never rained. "You see," he gently chided Boas, "you frightened me last winter with your prognostications [of bad weather] for nothing. However the surprise is so pleasant, I forgive you."

When he got to the Quinault, he had more troubles. Here he spent some time doing relatively productive linguistic studies on the Salish language, which he described as "ungodly," but having little success at acquiring ethnographic information on Quinault traditions. The problem apparently was the almost universal conversion of the village he stayed in to Shakerism, "that bastard religion . . . which discontenances (sic) old ceremonials, etc. and regards them as sinful. Consequently they regard their past habits as a disgrace and are not at all proud to tell them" (Farrand to Boas, 1 Aug. 1898). Farrand discovered, however, that money could persuade these Indians to supply him with some information, even if it was not as detailed as he would have liked.

Trained in the field of psychology, and committed to a career that did not include anthropological research, Farrand produced few publications as a result of his participation in the Jesup Expedition. His only contributions to the Jesup Memoirs were three relatively slim volumes, one on Quinault traditions (1902), another on Chilcotin traditions (1900b), and a third on Salish basketry (1900a). His contributions were by no means central to the Expedition, and his involvement can best be considered peripheral. He was, however, responsible for the acquisition of some outstanding artworks, including a Quinault shaman's wand (pl. 84) used during a healing performance that involved a journey to the land of the dead to retrieve a lost soul (Wingert 1949:10–11), and a Nootka mask (pl. 85) found among the Quileutes that depicts a decoratively painted human face surmounted by a geometric wolf mask, worn by participants in the Winter Ceremonial during which initiates are carried off by wolf spirits who then bestow upon them privileges they can display on their return (Ernst 1952; Drucker 1951:168).

Pl. 84. Quinault wooden figure representing a shaman's spirit helper; used during shamanic rituals. H 50 cm. *Collected by Farrand during Jesup Expedition, 1898. 16/4921*

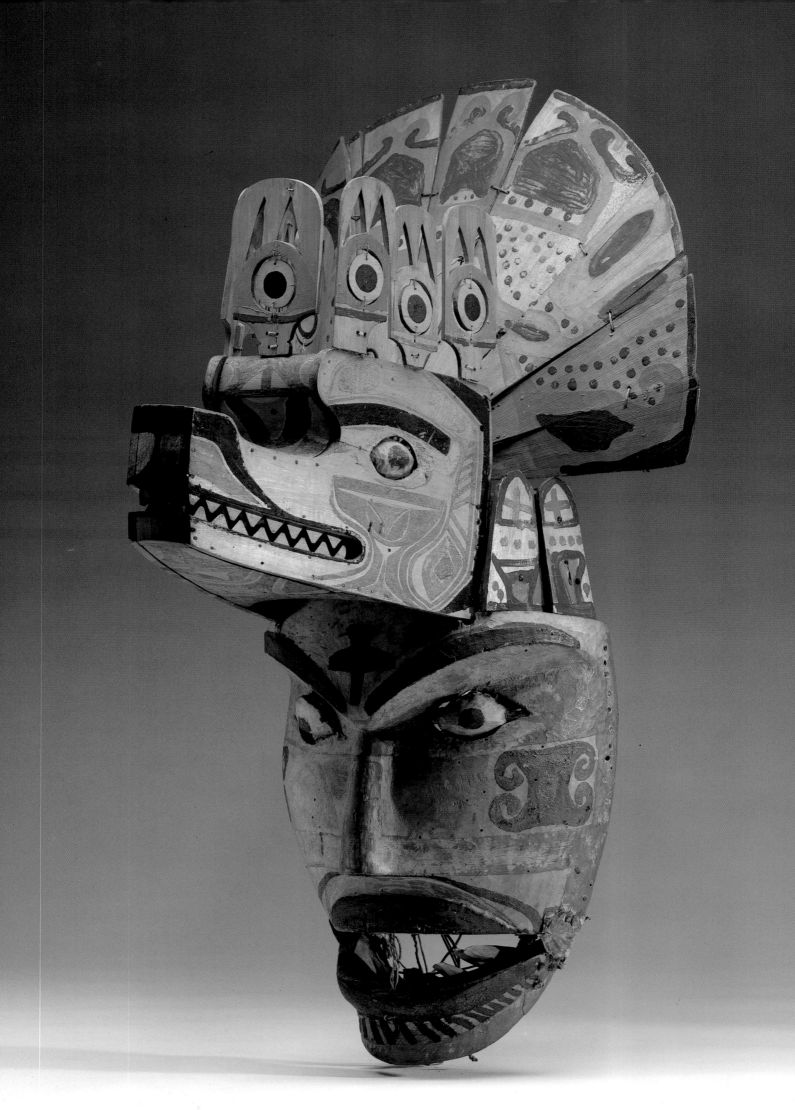

Harlan Smith 1872–1940

A man most central to the Jesup Expedition was Harlan Smith, a young self-trained archeologist who was only twenty-five years old in 1897 when he accompanied Boas and the others on their explorations of British Columbia (fig. 61). In 1898 he spent some time in Washington State; in 1899, did archeological work on the coast and in the interior of British Columbia, and traveled to northern Vancouver Island and the islands off the Washington coast. Smith collected many small archeological pieces as well as several magnificent poles that stand today in the American Museum's North Pacific Hall (figs. 62, 63).

Born in East Saginaw, Michigan, Smith began doing archeology as a boy and attracted the attention of Frederic Ward Putnam who hired him to assist the well-known archeologist Charles Metz in exploring some ancient sites in Ohio as part of the Columbian Exposition's Native American collecting project. This led to his appointment as curator of the archeological collections of the University of Michigan from 1891 to 1893. Putnam hired Smith as a staff member of the American Museum in 1895, where he remained until 1911 (Wintemberg 1940).

Boas liked Smith, but had little regard for his intellectual capabilities. During their 1897 trip together through British Columbia, Boas described the young man in a letter (15 Aug. 1897) to his parents as a reliable person whose limited education had many gaps; "I do not think he will ever become a great scientist, but this is not necessary so long as he is successful in some direction" (Rohner 1969:227). Several days later he wrote a stronger letter to his wife (21 Aug. 1897), severely criticizing Smith's theoretical simplemindedness: "he does not have the mind to spur him on and help him try to fill the [educational] gaps. . . . He is clever and resourceful, etc., but where theoretical work is involved, he lags behind. His attitude in all possible fields is very naive, and frequently the questions he asks are unbelievably simple. I often tell him to think it over himself and then give me the answers to his own questions" (Rohner 1969:229).

Another problem Boas had with this young man was his "stupid" decision, apparently made while both were in the field in 1897, to get married. Smith had been engaged for many years to a woman whom he now wished to marry, despite his extremely low salary of $60 per month. Boas tried hard to persuade Smith to wait until he had more job security as well as a living wage, and wrote several highly critical letters home about this subject. Despite his attempts to change Smith's mind, Boas could not convince him to wait and in November 1897, the young archeologist married his long-time fiancee, Helena Elizabeth Oaks. This decision, so different from the one Boas had made as a young man who waited until he had a steady job before getting married, certainly strengthened Boas's assessment of Smith's intellectual qualities (Rohner 1966:225, 229).

On the other hand, Boas would certainly not have disapproved of Smith's handling of George Dorsey of the Field Museum. Like Boas, Smith was distressed at the invasion of the Northwest Coast by the Chicago curator. Early in his stay in British Columbia during the first year of the Jesup Expedition, Smith wrote Winser that Dorsey had been in Victoria and also on the Queen Charlottes. "He seems to have struck people here very favorably by his free use of money and fine hotels. It looks as if he were doing his best to get ahead of us. He has James Deans as a guide, and Deans knows every inch of this region but is a swindler in my opinion" (30 July 1897). Dorsey, unaware of the young archeologist's attitude toward him, tried to woo Smith away from the American Museum, much as he had Hunt. In 1899, Dorsey described to Smith the large department he was building in Chicago with seven staff members, and wondered whether $1,500 would tempt him away from New York to become assistant curator. Not only did Smith turn down the offer, but he wrote Boas of their conversation (16 Sept. 1899).

Fig. 61. Harlan Smith. *2A5229*

Pl. 85. Nootka wooden mask, used in the Wolf Dance, a ceremony during which a wolf spirit abducts novices; found among the Quileute. H 89 cm, W 51 cm. *Collected by Farrand during Jesup Expedition, 1898. 16/5976*

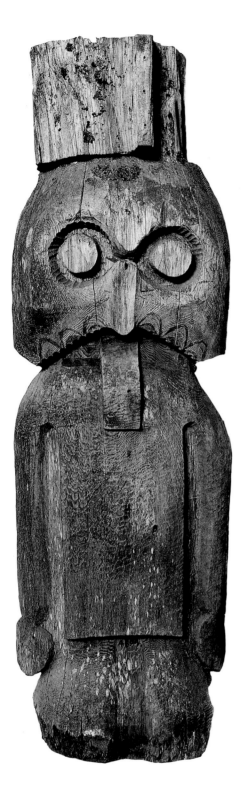

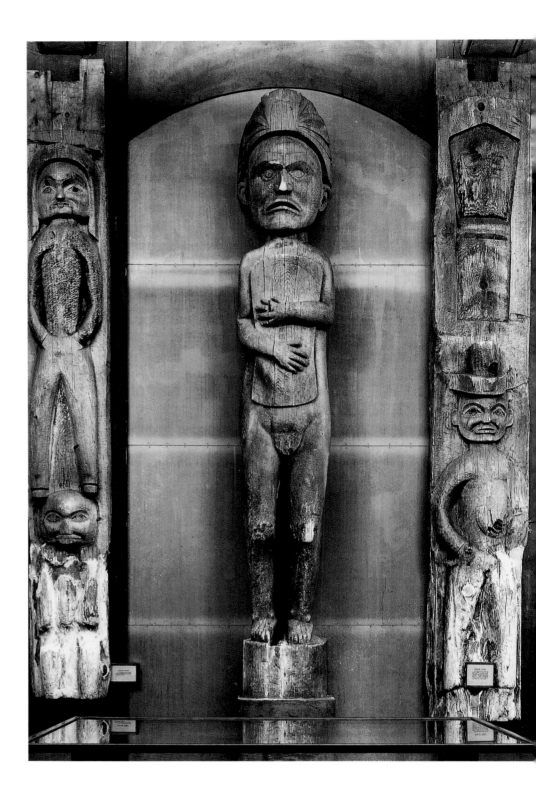

Fig. 62. Salish grave post, Comox. *Collected by Harlan Smith during Jesup Expedition, 1898. 16/4694, 31606*

Fig. 63. Three posts on display at the American Museum of Natural History. *Left and right house posts (16/4701, 16/4702) collected at Comox by Harlan Smith during Jesup Expedition, 1898. Central pole (16.1/553) collected by Smith in 1909 at Friendly Cove, Nootka. Smith paid one dollar per foot for this thirteen-foot pole. 120697*

Perhaps because of his youth and inexperience, Smith ran into conflicts with a variety of people while in the field. One of the first such problems came to Boas's attention when James Deans of Oakvale—Dorsey's guide whom Smith viewed as a "swindler"—sent him a letter (1 May 1898) complaining that the previous autumn, someone who could only have been Smith had trespassed upon private lands and dug pits and holes as part of an archeological survey of the area, leaving them uncovered. Deans proudly reported to Boas that of course *he* always filled in every hole he excavated, since open pits presented dangers to the cattle and sheep pastured in these fields. As the charge of trespassing and leaving a site in bad condition was serious, Boas forwarded Dean's letter to Smith, who wrote back with great indignity, "I have written to Deans that he is mistaken and I have written to the B. C. Market Company [owners of the land under question] telling them that I worked on their land but took particular pains to fill all the holes, having noticed the sheep. I think I know who made the holes, although I have said nothing about it."

In the summer of 1898, Roland B. Dixon, a recent Harvard graduate, worked with Smith and, at least according to Smith, was a disaster in the field. Not long after Dixon had arrived, Smith wrote to Boas requesting that he never be sent again and complaining that "Mr. Dixon does not carry out my requests in regard to the work and is impertinent to me. His example is demoralizing to some of the good men" (13 June 1898). Shortly thereafter, Smith wrote to Putnam with a different kind of complaint: "my time is taken up with the regular work of the expedition and I find that looking after instructing a young scientist seriously interferes with systematic work, besides being an extra expense on the expedition. For work in such a region as this, I need frontiersmen or common laborers who are not afraid to soil their fingers" (18 June 1898). Before long, Smith wrote Boas annoucing that he hadn't spoken for some time to the insolent youth, and added to his list of grievances the manner in which Dixon spent money (22 June 1898). Right through the period of this silent treatment, Dixon continued to write cheerful letters to Putnam saying how much he enjoyed the work and how much experience he was gaining, mentioning nothing about any difficulties with Smith.

Concerned about these indications of friction, Boas wrote Farrand asking for his views on Smith's relationship to Dixon. Farrand responded on 27 July 1898 that Dixon had confided in him about Smith's behavior. According to Dixon, no open friction existed, but he felt a "continued undercurrent of dissatisfaction." Although Farrand wrote that both men were partially to blame for the difficulties, it was clear that his sympathies lay with Dixon, whom he described as a real gentleman with an impressive intellect. Farrand ascribed the problem to the decidedly different personalities of the two men. Smith tended toward a pessimistic world view and vacillated over every decision, and, when in a position of authority, displayed arbitrary and inconsiderate behavior toward subordinates. Dixon, in contrast, was "energetic, self-reliant and hopeful," one who never said anything unkind or malicious and could get along with anyone.

Early in 1899, Boas received another letter of complaint about Smith's behavior, this time from George Hunt. Late in 1898, Smith and his wife had stayed with Hunt's sister. Hunt first claimed that the Smiths had borrowed from his family a canoe that was returned in damaged condition without proper compensation. Boas offered to pay whatever Hunt and his relatives thought would be sufficient. The other complaint was far more serious: shortly after the Smiths had left the Kwakiutl, a story highly critical of these Indians, which Hunt's people attributed to Mrs. Smith, appeared in a Victoria newspaper. So outraged was Hunt's sister over this that she refused to talk to her brother and to make matters worse angrily informed the Kwakiutl that Smith had robbed native graves, an accusation that exacerbated another problem developing at the same time (Cole 1985:158).

Not long before this moment, one of the Fort Rupert chiefs, Hemasaka, had traveled down to Victoria, to be told by someone that Boas had recently made a speech describing improvements occurring all over the world, except in Kwakiutl territory, where cannibalism still existed. The Kwakiutl, apparently furious at both this rumor and Hunt's sister's accusations of Smith's grave robbing, summoned Hunt to inform him they would allow neither him nor Boas to attend any of their ceremonies again. Hunt described the entire affair in a rather nervous letter to Boas in which he said, "I have know (sic) friend even Mr. Spencer [the white owner of the cannery and his brother-in-law] and sisters are against me now, the only thing I am wishing for is for my life Be spared" (Cole 1985:158).

Boas responded quickly to the problem, first reassuring Hunt of Smith and his wife's friendly attitudes toward all the Hunts. He suggested that the Victoria newspapers had twisted their story in order to write an article that would particularly interest their readership. Recalling his own difficulties with the yellow press (specifically, the *New York Herald* article describing the Kwakiutl as barbaric cannibals), Boas reminded Hunt of "the nasty figures and horrible description of the dance that was in one of the newspapers, said to be written by me, but which was simply made up, and stolen out of my book" (Stocking 1974:126). In order to sooth his other Kwakiutl friends, Boas requested that Hunt invite all the chiefs to a feast for which he would assume all costs, and to read portions of one of his Kwakiutl books which described these Indians in favorable of terms, as well as the following passionate letter he wrote directly to Chief Hemasaka:

I have learned that somebody told you of a speech that I made: that I have been all around the world, and seen everything changed for the best, except the Kwakiutl tribe; that they are still living on dead people. I think, Chief, that you do not believe this. I never made a speech of that kind. I do not say what is not true. I want to tell you what I said. I send you as a present a book that I made. That book contains my speech. Let one of the young chiefs, or one of your friends, read it to you, and you will see that what I say is true. The Kwakiutl have no better friend than I. Whenever I can, I speak for you. You see in this book that what I say is true, therefore you will not believe the foolish talk that you may hear about me. I have told to the chiefs in Ottawa and to the chiefs in England many times, that the potlatch and the dance are not bad. You well see my speech in the book. I wait for a letter from you, Chief, in which you will say that I am the best friend of your great tribe—the four great tribes of Tsaxis (Stocking 1974:127).

Although Boas managed to sooth the Kwakiutl's feelings about this particular episode, he had to continue curbing Smith's impulsive and sometimes destructive tendencies. Smith had been told by Boas early on not to forget the "public." In 1898, Smith wrote an article for *Popular Science News* describing the Jesup Expedition, which Boas promptly vetoed as being insufficiently serious (Boas to Smith, 22 June 1898) and forced to be withdrawn at the last minute.

Smith's obsession with self-aggrandizement continued, even after the Expedition had drawn to a close. On May 10, 1903, Smith wrote to a Museum official, H. C. Bumpus, that he was sending to New York two photographs and information for a "yellow Sunday half page." The pictures showed an ancient Indian quarry which Smith claimed he had discovered completely by himself as he explored this rattlesnake-infested region on his "little mountain climbing horse." Later on that month, Smith wrote again to Bumpus (30 May 1903), urging him to solicit public coverage of his exploits by sending a release to the newspapers that begins "American Museum of Natural History Expedition discovers pictures cut in the rocks." Apparently Smith had found some petroglyphs in a canyon seven miles northeast of the Yakima River which he claimed were the first such rock carvings found in the area.

Years after Smith left the American Museum to work for the National Museum of Canada, his personality had not much changed. In 1923, Dr. Charles F. Newcombe wrote the curator at the American Museum of Natural History, Pliny Goddard, complaining of Smith's arrogance. "H. I. Smith did himself proud in the way of publicity on his return from the north and after depicting the pushful ways of reporters yielded to their importunities so far as to grant them certain favors such as photographs of himself extracting information from admiring natives and of the rock carvings which he had risked his life to obtain in woods infested by the deadly Grizzly" (22 Dec. 1923).

John Swanton 1873–1958

John Swanton (fig. 64) was a far more sympathetic man than Harlan Smith. Born in Gardiner, Maine, Swanton received his B.A. from Harvard in 1896 and his M.A. in 1897. Although he spent two years with Boas at Columbia studying ethnology and linguistics, his Ph.D., received in 1900, was from Harvard. Described by his colleagues in Washington as "a kind and gentle man, a man of high ideals with a deep sense of social justice and fairness . . . modest to the point of shyness, yet courageous and determined in opposing any form of intolerance, aggression, or injustice" (Collins 1968:439), Swanton was certainly the kind of man toward whom Boas could have felt an affinity. Their correspondence was consistently warm, with the younger New Englander showing great deference to the established immigrant, and not infrequently writing statements highly supportive of Boas's attempts to shed anthropology of its evolutionist bias. Swanton's 1917 retiring address as president of the Anthropological Society of Washington was an intelligent, well-argued critique of evolutionism (Swanton 1917).

Before Swanton could be placed in the field as a member of the Jesup Expedition, the American Museum and Boas had to deal with some difficulties caused by the federal bureacracy. After he received his Ph.D. from Harvard, Swanton intended to join the staff of the Bureau of American Ethnology (BAE) where he would remain until retirement in 1944. Through a cooperative arrangement with the BAE and the American Museum, Swanton was to work from 1900 to 1901 on the Queen Charlotte Islands among the Haida, about whom he wrote a major ethnography (Swanton 1905).

In order for Swanton to work for the BAE, he had to pass a competitive civil service test designed to rank all those wishing to be considered for the position of assistant ethnologist. In his case, this involved being examined on his knowledge of the language of the Sioux Indians, a subject he had studied thoroughly in graduate school. Boas had worked out an arrangement with W J McGee of the BAE that Swanton would be sent to the Queen Charlottes as soon as he passed his exam. The BAE would pay Swanton's salary and receive all linguistic materials collected in the field, while the American Museum would pay all expenses and receive all ethnological materials (McGee to Boas, 29 Sept. 1900).

Boas hoped to place Swanton on the Northwest Coast by September 1900, and thus was most anxious that the examination be out of the way as speedily as possible. When in June 1900, he pressed McGee about the exact date that the test would be given, the Washingtonian answered from experience, "any action connected with the Civil Service Commission moves slowly," but he hoped the exam would take place in mid-June. It was not until July 24 and 25, however, that Swanton finally sat down, pencil in hand, to prove his expertise on Siouan language to the government so that he might depart for British Columbia. Later on, he wrote to Boas that while much of the examination had been easy, the last question, a translation of the Ten Commandments into Dakota Sioux, threw him. "I doubt," Swanton said, "whether any such Ten Commandments were ever before heard of as the ones I gave them. I still did fill the sheet" (5 Aug. 1900).

Fig. 64. John Swanton. *Smithsonian Institution photograph 45,200, courtesy of the Smithsonian Institution.*

Neither Boas nor Swanton could afford to wait as long for the results of the test as they had for its administration. While everyone hoped that the Civil Service might grade the exam before Swanton left for the Queen Charlottes, it was not until late September, when he was already well underway with his fieldwork among the Haida, that McGee was notified that he had indeed passed the examination for assistant ethnologist.

As soon as Swanton arrived in the village of Skidegate, he encountered the fieldworker's perennial problem of where to live. Two white families who lived in the area offered to put him up, the Freemans and the Tennants. In his letters to Boas, Swanton described the great animosity these families felt toward one another, and admitted that he found neither especially sympathetic; the Tennants were "hard and exacting employers who can make the air blue at will," while the Freemans were at the same time narrow-minded, excessively religious, and lacking in scruples. Although the Indians favored the Freemans who sold them supplies from Victoria far more cheaply than did their enemies, Swanton decided to stay with the Tennants, despite their charging the steep rent of $40 per month. Apparently on his arrival in Skidegate, one of the Freemans had begun to "show an interest in the welfare of [Swanton's] soul," and to avoid the oppressive missionary atmosphere of the Freemans, he stayed at the more expensive, but more comfortable home of the Tennants (30 Sept. 1900).

Swanton clearly did not find much merit in any missionaries in the area and blamed them for much of the social disruption he saw about him. He wrote letters to Boas sadly describing how the entire Haida population was now down to about seven hundred, with three hundred living in Skidegate. Unlike the relatively pristine Kwakiutl villages like Alert Bay, these Haida towns had changed considerably over the last several decades. The great old houses, photographed so eloquently twenty years earlier by Dossetter and others, no longer stood, and only immense beams remained to remind the visitor that once this had been a spectacularly impressive village. Swanton pointed an accusing finger at the missionaries, who had suppressed all the old dances and had been instrumental in having the old houses destroyed; they had, he asserted, ruined "everything . . . that makes life worth living" (30 Sept. 1900).

Swanton immersed himself completely in the work of collecting linguistic materials. By the middle of November, he reported to Boas that he had become so familiar with Haida phonetics that he could take down forty-five pages of texts per day (19 Nov. 1900). By early December, his manuscript had reached 1,000 pages, and was nowhere near completion (4 Dec. 1900). By mid-January it had grown to 1,300 pages, and by early March, to 1,700. Swanton's labors collecting texts had an obsessive quality; he wrote at one point that "it would break my heart to feel there was a story left that I had failed to gather. . . . I have found it impossible to resist the temptation to get any new-old story I hear about, and text taking has consequently monopolized 99 hundredths of my time" (12 May 1901).

While Swanton was collecting linguistic texts for the BAE, he was also supposed to have been collecting ethnographic materials for the American Museum. Shortly after he arrived, he wrote to Boas to tell him that everything on the Island was for sale; for $10 one could purchase a totem pole model, whereas for an expenditure of from $25 to $60 a totem pole would be delivered to the wharf. Much cheaper crayon drawings were available for $.10 to $.20. Swanton observed that Dr. Charles Newcombe, was among the most active whites engaged in trading with the Haida for their art, and even though the physician was "dredging the place" before his eyes, he was a likeable and "enthusiastic collector . . . [who] aspires to do real scientific work." He tried, Swanton argued, to record as accurate and complete information as possible on the items he collected (30 Sept. 1900).

Even though it was part of his responsibilities, Swanton had little interest in collecting, and seems to have actually disliked it. He wrote to Boas proposing that the Museum hire Newcombe. At first, Boas resisted, claiming that Newcombe did not have Swanton's scientific training and could not obtain the kind of detailed information he as an anthropologist needed (14 Oct. and 15 Nov. 1900). Finally he acquiesed, perhaps recognizing the seriousness of Swanton's antipathy to the collecting process, and in December of 1900 wrote a letter saying that Newcombe could collect for Swanton.

Soon Newcombe was traveling to the abandoned villages of Cumshewa, Skedans, and Tanu where he collected pieces such as boxes and monumental artworks including mortuary poles, house posts, and large totem poles (figs. 65, 66). One particularly excellent piece was Chief Skedans' "coffin box" (pl. 86), carved twenty years earlier for funerary purposes but ultimately used by his descendants as a storage receptacle for precious possessions like blankets (Newcombe to Boas, 9 May 1901). This exquisite piece consists of an elegant and colorful two-dimensional decoration spread out on both sides of a gracefully modeled three-dimensional head featuring a mountain goat on one side and the moon on the other.

Fig. 65. Haida village of Cumshewa. Gable-roofed mortuary house has a pole depicting killer whale at top and a supernatural snag at bottom, *Collected and photographed in 1901 for the American Museum by Charles Newcombe (16/8685a). British Columbia Provincial Museum photograph E31, courtesy of the British Columbia Provincial Museum.*

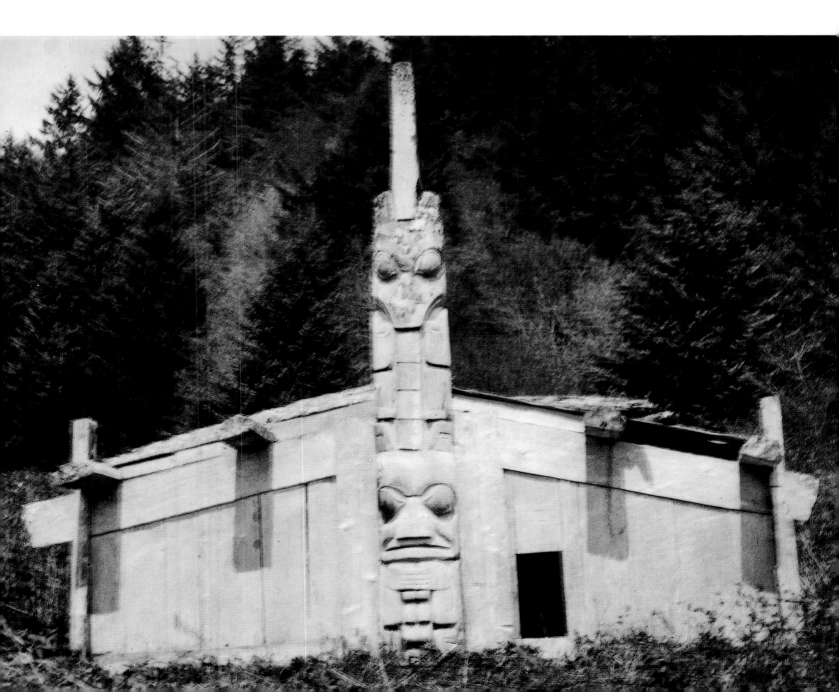

Although Swanton was probably delighted at first that Boas agreed to his request to be relieved of the collecting, by mid-January he seems to have settled more comfortably into his role as a collector of all kinds of ethnographic materials, including art. He wrote Boas that "if I had known how things were to be I should not perhaps have cared so much for assistance. I have succeeded in bargaining satisfactorily with one woman here whom Dr. Newcombe had failed to manage. I do not mean this as a boast" (16 Jan. 1901). Perhaps as proof of his humility, Swanton then proceeded to compliment Newcombe's knowledge of the local botany, of totem poles, and of "anatomical materials." In other words, the physician knew where to find graves that could easily be excavated without the Haidas' knowledge.

Like many other ethnographers who spend lengthy periods in alien cultures, Swanton experienced deep loneliness and craved interactions with people of his own culture. Although by the end of the winter, he had collected an immense amount of linguistic materials as well as a small array of artworks, he knew that much more work needed to be done among the Haida, as well as among the Tlingit. As compulsive as ever, he worried about being able to do the necessary studies, for "I am afraid that I should find trouble in getting through another winter of isolation, especially on the Alaskan coast."

Fig. 66. Haida village of Cumshewa. Third pole from left is a frontal pole for Frog House. From top to bottom, images depict horned owl, eagle, supernatural snag in human form, frog, thunderbird, and killer whale. In 1909 this pole was cut in three pieces in order to be displayed in the North Pacific Hall of the American Museum. *Collected and photographed in 1901 for the American Museum by Charles Newcombe (16/8684a, b, c). British Columbia Provincial Museum photograph E27, courtesy of the British Columbia Provincial Museum.*

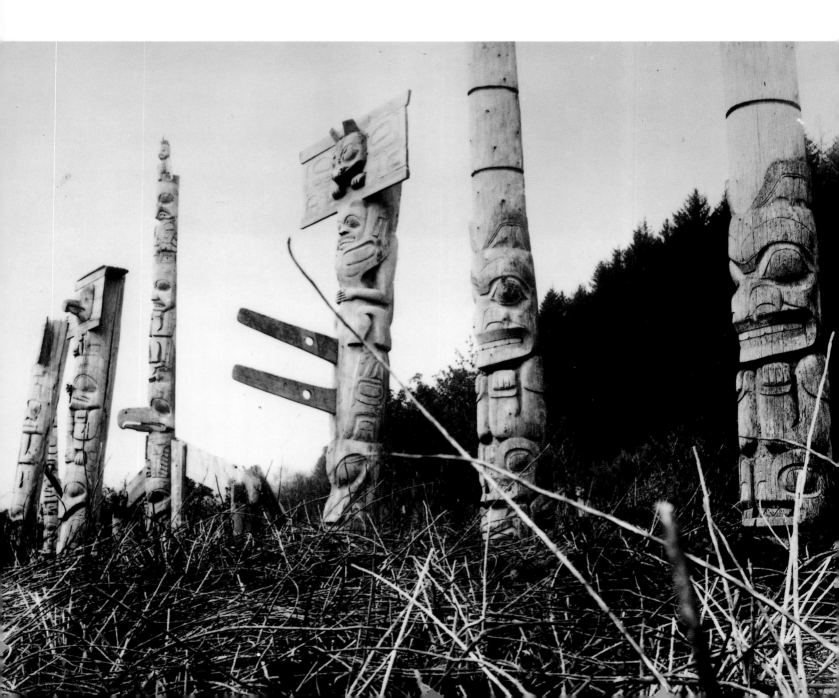

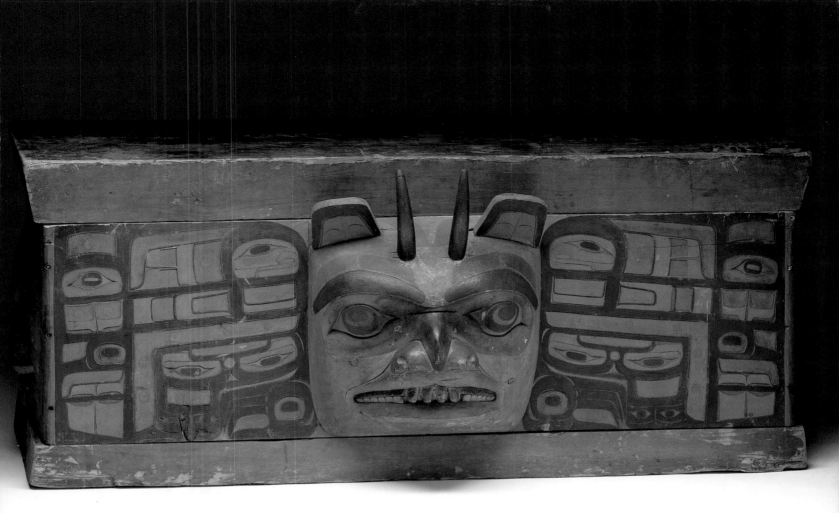

As planned, he traveled to Masset in March, where he hoped to encounter some Tlingit. On May 12, 1901, he wrote that he realized he needed to "round out" his work in Alaska, but felt his mind had finally struck a "dead centre" and could no longer perform serious studies until he had the opportunity to engage in the kinds of intellectual conversations not possible in the remote regions of the Queen Charlottes. Despite these feelings, Swanton did travel briefly to Alaska, in mid-summer before he returned East to assume his fulltime position as assistant curator at the BAE.

Pl. 86. Haida wooden box; originally made as a coffin for Chief Skedans, but used as a receptacle for blankets. Skedans. L 160 cm, H 67 cm. *Collected by Newcombe during Jesup Expedition, 1901. 16/8802*

Charles Edenshaw 1839–1920

When Swanton arrived in the Queen Charlottes in 1900, he met Henry Edenshaw, the nephew of one of the principal chiefs of the northern Haida, who impressed him both with his literacy and with his knowledge of traditional culture. In March of 1901, he stayed with Edenshaw who was then employed as a teacher in Masset. Swanton soon met Henry's relative Charles Edenshaw (fig. 67), whom he described as "the best carver here," and commissioned him to carve some totem poles, a model house, and a model canoe, and make a series of drawings of totem poles and two dimensional designs for a Jesup Expedition Memoir on the Haida. The most highly regarded Haida artist of his time, Edenshaw is still considered a major name in all Northwest Coast art; Bill Holm recently described his work as that of an "imaginative artist with absolute mastery of the tradition in which he worked, and who had developed a very personal version of that tradition" (1981:182).

When Charles Edenshaw became bedridden in 1853 at the age of fourteen, he learned to carve model totem poles out of argillite (Blackman 1982b:72). His skills developed and before long he was a mastercarver of both argillite and wood (see plate 93), as well as a talented gold- and silversmith. He also became a superb painter, as is evidenced in the small oval mats (pl. 87) woven from split spruce root and painted with elegantly rendered images of a lozenge-shaped halibut and a gracefully curved sea lion (Hoover 1983; Thomas 1967).

Although the Haida purchased such of his pieces as full-sized totem poles, masks, and rattles for their own use, many whites, recognizing his exceptional talent, sometimes commissioned art from him. When Boas went to Port Essington during his 1897 Jesup Expedition trip to British Columbia, he sought out Edenshaw for information on Northwest Coast art, and asked him to do several crayon drawings which he ultimately used as illustrations in his Northwest Coast art publications. A drawing of Wasco (fig. 68), printed in Boas's *Primitive Art* (1927), depicts the sea monster with a wolf's body wrapping its whiplike tail around one skeletal whale, and carrying another whale between its long ears.

Edenshaw belonged to a noble Haida family. His mother's brother, Albert Edward Edenshaw, had been a great chief who owned much property, sponsored no fewer than seven splendid potlatches, and lived in a huge house in Masset. During his younger years, Chief Albert Edenshaw had owned large houses in three different villages—Hiellan, Kung, and Kiusta—but had had to abandon them all in the 1870s to move to Masset.** When he traveled about, Chief Albert rode in a magnificently painted seventy-foot long canoe, manned by several of his twenty-odd slaves. On consenting to be baptized in 1884, this proud leader assumed the English name most appropriate to his position—that of Queen Victoria's husband (Blackman 1982b:66).

** The necessity of this move and the events thereafter are discussed in Chapter 1.

Fig. 67. Charles Edenshaw displaying his argillite carvings. *National Museum of Canada, Museum of Civilization photograph 88926, courtesy of the National Museums of Canada.*

Pl. 87. Haida split spruce root mats; depict a sea lion and a halibut. Painted by Charles Edenshaw, Skidegate. L 22 cm, W 18 cm. *Purchased from Emmons, 1912. 16.1/1195b,e*

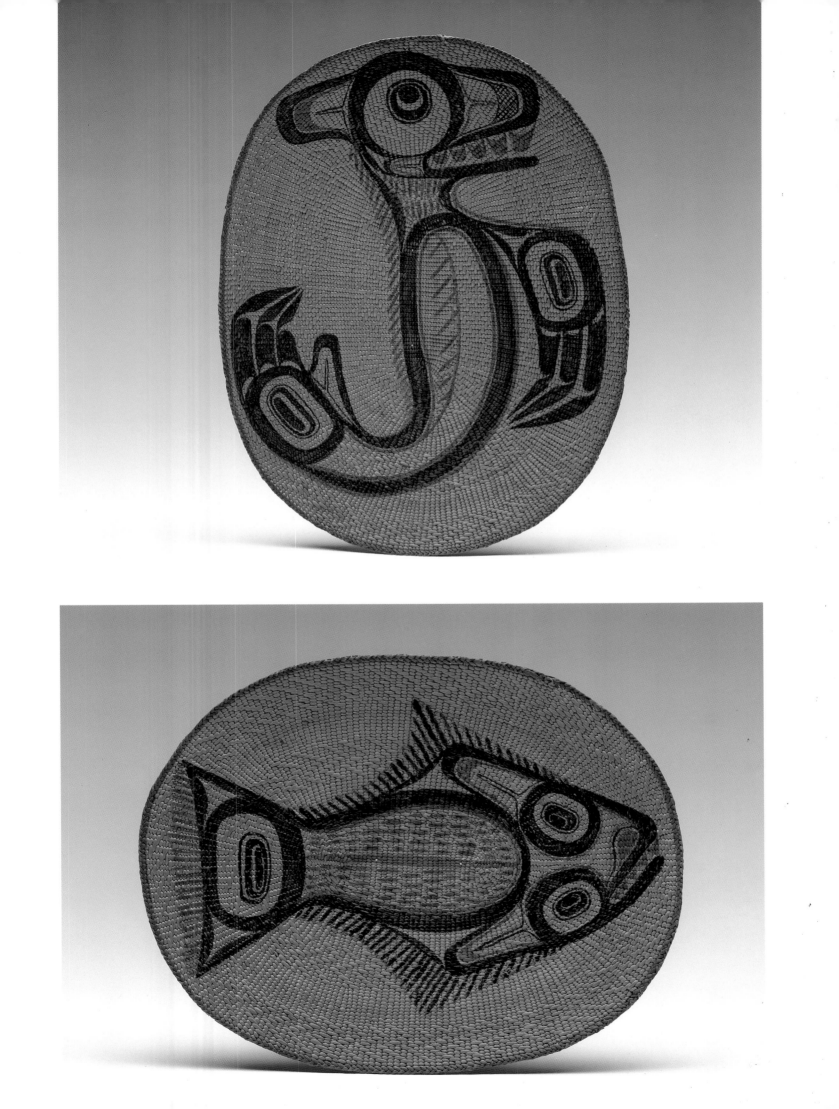

Fig. 68. Edenshaw drawing of Wasco. *Drawn on a piece of American Museum of National History stationery. 6830*

Swanton met Chief Edenshaw's artist-nephew more than twenty-five years after the great chief burned his totem poles in front of Chief Wiah of Masset, and asked him to carve models of poles and houses that once had stood at Masset and other northern Haida villages. Charles Edenshaw made for Swanton one such model of the house his uncle had built mid-century in Kiusta, prior to the abandonment of that village (pl. 88). Said to have been conceived by Albert Edenshaw in a dream, the completion of this structure, called Myth House, was celebrated with a great potlatch to which all the Haida from Graham Island, North Island, and the Kaigani area were invited (MacDonald 1983a:189).

The house model illustrates on its central pole the "lazy son-in-law" story (Swanton 1909:106), which describes the revenge of a young man accused of laziness by his mother-in-law. Assisted by a mythic being called the bird-in-the-air, this man lured a lake monster known as Su-san to the surface of the water using young children as bait. The man captured, killed, and flayed this creature, known for its particular skill at catching black whales. He then wore its skin to catch huge quantities of fish, which he secretly placed outside his mother-in-law's house. This apparently magical appearance of fish led the woman to believe she had become a shaman, something she proceeded to brag about publicly; when her son-in-law revealed to her the truth, she was so shamed that she died.

The central pole that illustrates this story depicts, from top to bottom, children used as bait (and depicted as watchmen), the man wearing Su-san's skin, the bird-in-the-air, the man's mother-in-law as a shaman, Su-san, and the black whale upon which Su-san preyed. The corner-posts on the facade, also from top to bottom, illustrate the raven, the bullhead, and a grizzly bear (MacDonald 1983a:190).

Edenshaw carved many other house and totem pole models which provided the American Museum and other institutions with replicas of the artistic masterpieces of what had once been an aesthetically sophisticated society. Some critics today write that Edenshaw suffused his art with a sadness expressive of his great culture's decline.

Peter Macnair, curator at the British Columbia Provincial Museum, has said, "if all the faces [on the artwork] are studied carefully, each can be seen to have an innate character—a vigour and personality seldom found [on art] made by most other artists. This depth of expression perhaps reflects the dilemma and tragedy Edenshaw must have faced. . . . The onerous task of leaving a testimony to the past and a legacy for the future surely weighed heavily on him" (Macnair, Hoover, and Neary 1980:70). The great Haida artist lived to see his people reduced in numbers from about six thousand at the time of his birth to a low of about six hundred; he saw them converted, moved out of communal houses, and banned from celebrating their potlatches. Perhaps the American Museum's house model conveys such a melancholy sense of loss; certainly a clear difference exists between the Masset village of 1881, with its grand houses and tall totem poles proudly declaring the prestige of great lineages, and this isolated, miniaturized model, torn from its context and devoid of meaning and life.

Pl. 88. Haida wooden house model; represents Chief Albert Edenshaw's Myth House of Kiusta. Large pole: H 91.8 cm; small poles: H 53.4 cm. *Collected by Swanton during Jesup Expedition, 1901. 16/8771*

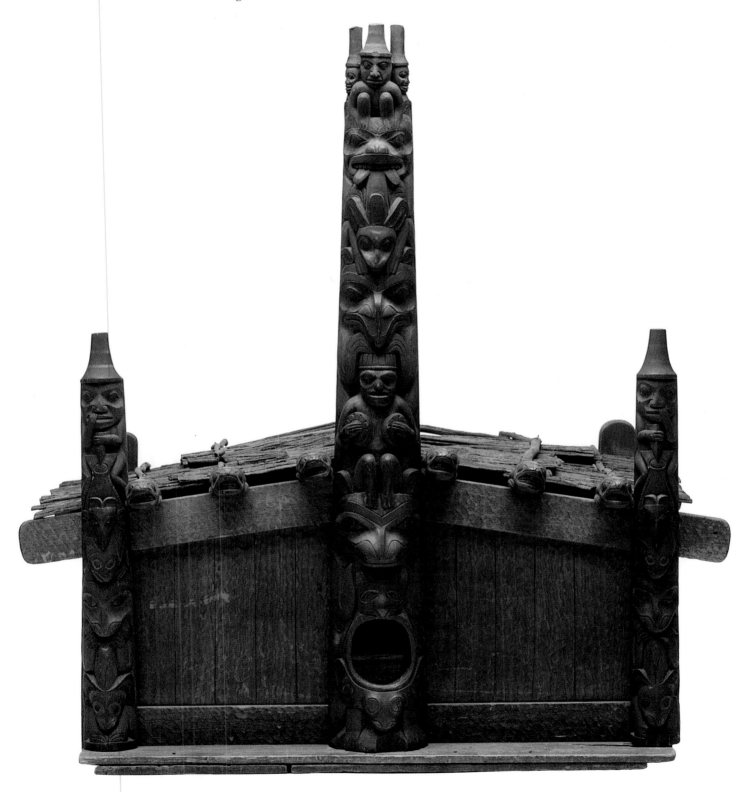

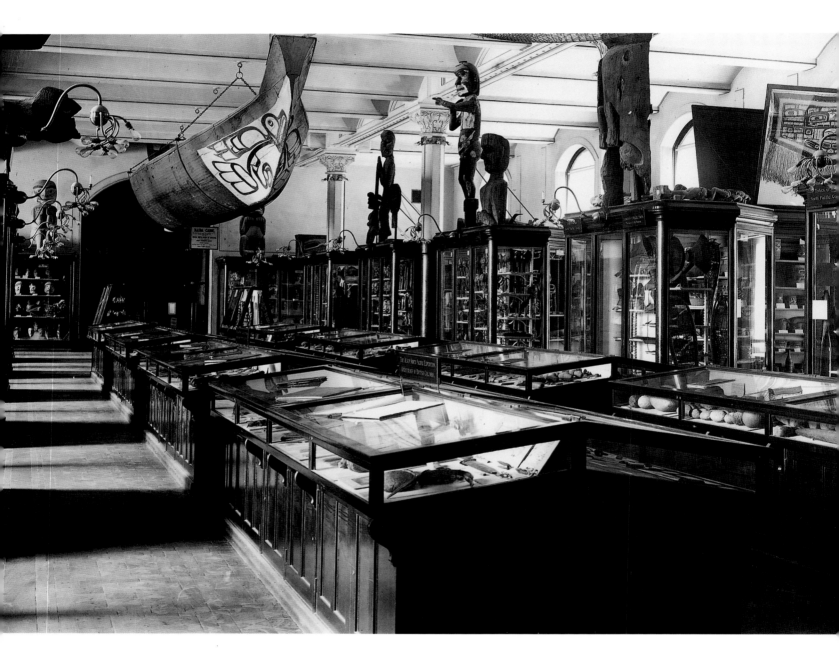

Fig. 69. American Museum of Natural History
North Pacific Hall, c. 1902. *12633*

7 / The End of the Jesup Expedition

I N 1899, A. B. Meyer, director of the Royal Zoological, Anthropological, and Ethnological Museum in Dresden, toured the eastern United States to study the natural history museums. Although he found much to compliment in the institutions he visited, in his final report to the Dresden Museum, he lavished particular praise on the exhibits at the American Museum of Natural History in New York, especially Franz Boas's North Pacific Hall (fig. 69). "The room devoted to Northwestern American culture (Pacific Coast)," Meyer wrote, "in its comprehensiveness and richness, makes a notable impression. The exhibition is instructive because it is arranged not only in geographical, but also in systematic series, the latter particularly with regard to ornament and development of style in the artistic manifestations of the Indian tribes. . . . The collection is important for an understanding of the artistic style of the Indians, particularly on account of the already well-explained objects from the North Pacific Coast" (1903:335–36).

The Northwest Coast Indian Displays at the American Museum

Before the Jesup North Pacific Expedition had begun, the first floor Ethnology Hall housed not only the Bishop and Emmons material but also Eskimo, Mexican, and Pacific items. The Northwest Coast pieces that members of the Jesup Expedition sent to the Museum were squeezed into the same exhibition space as art from half the globe, a situation that both Boas and Putnam agreed was becoming increasingly unacceptable. In 1899, the curators removed the non-Northwest Coast pieces to other exhibition spaces, and the ethnology hall became the Hall of the North Pacific Peoples (Weitzner n.d.).

A particular concept had informed the arrangement of the pieces Boas assembled in the new Northwest Coast hall. Believing that the American Museum had to realize its educational mission, he designed displays that would, he hoped, educate the casual as well as the serious visitor. For the visitor interested in discovering just a little about the region, he offered a snapshot view of the Northwest Coast cultures in a series of general or "synoptic" cases at the entrance to the hall, which provided an overview of the Northwest Coast peoples' technologies, house-furnishings, clothing, economics, travel, weapons, musical instruments, social organization, and visual arts. Then, for the visitor interested in learning more about any of the individual cultures of the region, were separate alcoves of vitrines containing materials from the coast tribes from the Tlingit to the Salish (fig. 70) (Jacknis 1985).

Although there was a central aisle in the hall, it was not easy to walk from one side to the other. At one end of that center aisle a large glass case protected the cedar life group, at the other was a diorama of a Kwakiutl village, modeled after a photograph of Newitti. Lined up in a row down that central aisle were low cases containing archeological materials that demonstrated the antiquities of the region, and thus provided visual documentation on its history. Boas placed these cases, as well as the life group and model village, in the central aisle on purpose in order to prevent the visitor from taking a speedy, and thus superficial, walk through the hall. As Boas had written to Jesup, "When the main aisle is located in the center of the Hall, visitors will wander from right to left without order and it is impossible to compel them to see the collections in such a manner that they will have the

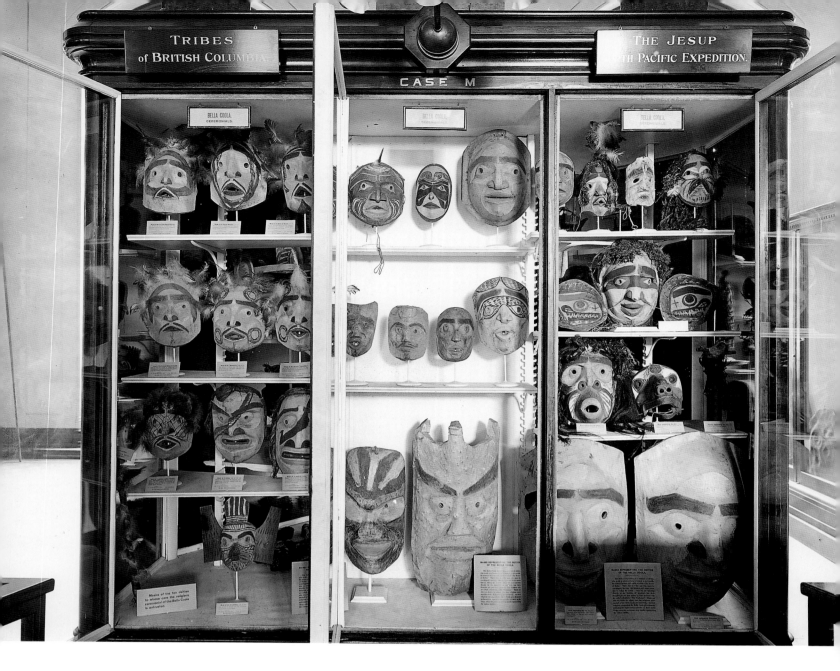

Fig. 70. American Museum of Natural History
North Pacific Hall. Case of Bella Colla masks,
c. 1905. *Weber photograph, 1905. 386*

greatest possible benefit from a short visit" (11 Jan. 1897). Filling that central aisle
with roadblocks was one way to ensure that the visitor paid at least some attention
to the exhibitions.

All the cases had identifying numbers and letters keyed to sections of a guide
booklet written by Boas himself, which explained briefly the contents of the gen-
eral or synoptic cases, as well as the more detailed cases describing individual
groups. As the Jesup Expedition monographs were published, copies of the rele-
vant studies were attached to the cases (except for the especially heavy publica-
tions, such as John Swanton's hefty *Contributions to the Ethnology of the Haida*
[1905], which were available in the bookstore or the library). Sometimes the pieces
within the cases were arranged according to the organization of illustrations in the
book, so that a visitor could look at a page of masks, look up at a case full of the
same masks, and return to the text to learn their meaning and function.

Attached to the synoptic case containing art was a copy of Boas's "The Deco-
rative Art of the Indians of the North Pacific Coast" (1897a), which, by explaining
stylistic characteristics, offered the observer a way of looking at as well as inter-
preting this unfamiliar style. Although meant as a detailed guidebook to the col-
lection, this analysis of Northwest Coast art was, like so many of Boas's other
writings on primitive culture, intended to dispute cultural Darwinism by offering
an alternative to the then-prevalent theory of artistic evolutionism.

Boas on Northwest Coast Art

By the end of the nineteenth century, almost every person who wrote on primitive art other than Boas assumed that all art styles went through an evolutionary process, with the artworks of primitive peoples being examples of early phases of the process and the art of civilized peoples representing advanced stages. Terms such as "progress," "development," and "improvement" filled the pages of evolutionary texts, sometimes in order to imply and sometimes to assert that the art of civilized peoples was superior in all ways to that of the "savages." Like similar anthropological theories at the time, this process was seen as entirely internal, for evolutionary art history allowed no external influences upon a people's art.

Although the evolutionists could not arrive at a consensus as to what kind of art was associated with which developmental period, all agreed that art evolved in a unilinear progression from one stage to another. Some hypothesized that art progressed from naturalistic representations of the real world that then became increasingly stylized, while for others, the earliest artistic forms were simplified abstractions of ideas and images that developed over time into naturalistic portrayals of reality. Certain art historians argued that the earliest art served to depict the spiritual world envisioned by early shamans, but then deteriorated into abstract non-objectivity; others asserted that art started when people copied the meaningless patterns of weaving and basketry, creating designs to which later generations applied meaning.

Boas's method for disputing evolutionist art history was to take each theory and identify at least one case that disproved its premises. He also offered several alternatives to evolutionism, but stressed that under no circumstances was a group's art style ever the product of single causes, nor did it ever evolve in cultural isolation. Particularly significant among Boas's "multiplicity of causes" were technological factors and historical interchanges between cultures.

One of Boas's principal points about Northwest Coast art concerned the wide range of stylistic options available to the artist. As the Tlingit helmet (pl. 56) depicting an old man suffering facial paralysis clearly shows, the Northwest Coast artist was capable of making very realistic representations. In contrast to this naturalism, some artworks, such as the killer whale painted on the Haida canoe (fig. 21), depicted an animal in a stylized but still identifiable fashion, while other pieces, like the Chilkat blanket (pl. 16), diverged so far from realism that without additional information on the identity of the imagery, even Indians could not interpret them. By pointing out that the Northwest Coast artist could at one moment create a realistic portrayal, and then at another paint an image of extreme abstraction, Boas provided evidence to dispute those evolutionists who theorized that the conventionalized mode antedated the realistic style, and others who claimed that naturalism came before stylization. Both styles, Boas showed, coexist simultaneously on the Northwest Coast and thus one could not with any certainty be said to predate the other.

In order to explain such wide stylistic variation without resorting to an evolutionistic developmental scheme, Boas proposed that the Northwest Coast artist's vocabulary consisted of certain conventionalized symbols that identified those specific animals that occurred over and over again in the art. It was the representation of these symbols, not an accurate depiction of the animal as it appears in nature, that was the artist's highest priority when decorating an object. The shape of that object, Boas argued, determined the level of naturalism or stylization of the image that appeared on it. When the decorative field permitted, the subject could be rendered naturalistically, but, when necessary to fit the animal and its symbols into the decorative field, the artist adjusted (often by distorting) the animal's form, a process that often led to extremely abstract images.

To explain how this was done, Boas first provided a key to the conventional symbols of animals. A beaver, perched elegantly on the Heber Bishop frontlet (pl. 15), has large incisors, a large and rounded nose, a scaley tail, and holds a stick in its forepaws that it chews. This contrasts with the image of the raven, like that on a Tlingit dagger (pl. 8), whose beak is relatively broad but straight. The killer whale, such as that posed upon a wooden hat collected by Emmons (pl. 6), has a large and long head, elongated large nostrils, a large mouth set with teeth, and a large dorsal fin which includes the depiction of a blowhole. The bear, squatting at the base of a Haida argillite totem pole (pl. 30), has large paws, large mouth with a protruding tongue, and a large, round nose. The sea monster (fig. 68) has a bear's head, bear's paws with flippers attached, and the body of a killer whale, with several dorsal fins. Frogs, such as a pair of carved frogs collected for Heber Bishop (pl. 28), have wide, toothless mouths, flat noses, and no tails (Boas 1927:202). The wolf, seen on a Tlingit shaman's hat (pl. 37), has an elevated nose, large mouth with teeth that are longer and narrower than the bear's. The sea lion depicted on a spruce mat (pl. 87) has clawed flippers, large mouth with teeth, and a short tail.

Boas explained the variations in naturalism evident in Northwest Coast art as a result of an artist's attempting to include the necessary symbols of an animal on the object he decorated. When the artist had no constraints as to the shape of his carving, as is the case of a human sculpture such as a Tlingit shaman statue (pl. 45), he could create sculpture of tremendous naturalism. Rarely, however, did he have such freedom, particularly when so much of his work was for the decoration of functional objects. For example, bowls often take the form of an animal whose hollowed-out back or belly serves as a container for food or grease. To create a sufficiently wide cavity for holding grease, the carver of the bowl in plate 19 had to extend the sea lion's width, creating as a consequence an animal of inordinate breadth compared to its length. In addition, in order to fit into the tapering area at the tail end of the bowl, the animal's rear flippers were diminished in size, compared with the larger side flippers situated on the roomier side of the bowl. For a similar example of distorting an animal to fit the shape of the object it is decorating, note the beaver on a Tlingit bowl (pl. 50), which is far longer than any biological beaver.

The problems of representing all the significant elements of an animal become increasingly difficult when the object being decorated has a shape unlike that of the biological animal, such as the circular argillite bowl depicting a killer whale (pl. 31). To adapt this cetacean's form to the circular shape of the dish, the artist bent its backbone into an almost complete circle, nestled the head between the flukes of the tail, made the two dorsal fins extremely narrow and positioned them along the rim of the dish, and greatly enlarged the flipper which then filled the center of the dish.

The Northwest Coast artist always tried to show all the necessary identifying motifs of any animal he depicted. This presented little problem when he did three-dimensional works, for all the viewer had to do to see every component of a sculpted animal, such as the long-tongued bear on the model totem pole (pl. 30), was to rotate the art object in space. From the front, the viewer could see the bear's face, tongue, and paws, and from the sides, its ears and flanks.

Depicting all the identifying parts of an animal became more difficult, however, when the images appeared on a two-dimensional surface. Unwilling to apply the technique of perspective drawing in which some important part of the animal would necessarily be "hidden" behind another part, the Northwest Coast artist resorted to an ingenious artistic device. To portray all the symbolic elements of the three-dimensional animal image on a two-dimensional surface, the artist split the creature down its middle, and positioned each profile half confronting the other on the flat surface. Such a rendering of the body, called the split representation, resulted in the simultaneous depiction of a creature both frontally and in profile (see pl. 91). By doing this, the artist depicted on a flat surface the same clearly rendered characteristic body parts as those seen when a three-dimensional artwork was rotated in space.

The artist's desire to depict all the body parts of his subject led to the remarkable organization of forms on the Chilkat blanket (pl. 16). The composition of elements on these blankets, which were the most stylized and abstracted artworks on the Northwest Coast, follow strict rules. The fundamental design principle of the Chilkat blanket is not unlike that of cubism, for the depicted animal's body is dissected and its parts rearranged on the textile. In the central panel, the animal's face, torso, tail, and legs often appear frontally, while in the side panels are profile depictions of limbs, feet, and feathers (when appropriate). So schematically are these body parts rendered that they become virtually impossible to identify without information from the blanket's owner.

Attached to the vitrines containing pieces that were illustrated in its pages, Boas's monograph on Northwest Coast art was not merely an explanation of those artworks but also a profound statement criticizing evolutionism. By offering technical reasons for stylistic characteristics, and historical explanations for tribal differences, Boas provided evidence contradicting the theories that connected style to stages in human evolution. This was, of course, part of his larger effort to promote the intellectual equality of primitive man with western man.

A N article in the *Illustrated Magazine* of the *New York Times* on "Kwakiutls of North America" (13 Aug. 1899) was clearly the result of an interview with Franz Boas, who took this opportunity to express his views on primitive mentality. In this piece, the author, Charles de Kay, stressed the level of intelligence of the Northwest Coast Indians whose artifacts could be seen at the American Museum of Natural History. After a brief discussion of the practice of flattening the heads of Kwakiutl infants with pieces of wood in order to extend the forehead, de Kay asserts that "there is general agreement that [the practice] has no effect upon the intelligence of the people to whom it is applied. They are much more intelligent than the passing traveler would imagine." And, further on, after describing Kwakiutl art, de Kay states, "It can hardly be maintained that tribes which are so clever at boatbuilding, mask carving, and the production of totem poles are devoid of brains."

The author of this article also took pains to compare Kwakiutl customs to those of the West. Certainly, it was relatively simple to relate the Northwest Coast Indians' use of art to proclaim lineage and prestige to similar usages of heraldry among the peoples of the Middle Ages. Not so easy was de Kay's analysis of the "very disgusting" practices of the cannibal ceremony, which, he found,

readily recall the loathsome messes which have always formed part of the witch and wizard outfit in Europe down to the present century, like the objects that go to make the hell-broth of the Witches in "Macbeth." The purpose seems to be the same, namely to frighten the unsophisticated by showing a daring in the handling of disgusting objects which proves the superiority of the professional and the power of his or her guardian spirits to protect the shaman or medicine man from what would be injurious to the ordinary person.

The North Pacific hall opened to the public in late 1899, with considerable media attention. The *New York Times* on the first of December carried an article praising the exhibition, beginning, "The frequently expressed reproach that the finest collections of Alaskan and British Columbian antiquities and ethnological specimens are in Europe is no longer justified." The author then went on to describe the outstanding and unique displays of Northwest Coast art on Central Park West; made special mention of the "most conspicuous object," the immense canoe suspended from the ceiling; and claimed that most visitors were particularly intrigued by the life group, portraying "the Alaskan craftsman painting on cedar wood boxes those incredible monsters called for by the traditions of the tribes."

The author of this article apparently viewed himself as something of a scholar as well as a reporter, and suggested that certain similarities between the secret society and shamanic masks on display with masks from Japan "will doubtless be noted and commented on by ethnographers and will be regarded as further proof of the Oriental origins of the Tlingits and other tribes." Then he ventured a piece of art criticism: "the carved and painted chests from Alaska will also be a revelation of a fact that has been overlooked hitherto—that the natives occasionally produced work which is not only picturesque through its grotesqueness, but is actually beautiful in itself." How pleased Boas must have been that his exhibit inspired both intelligent speculation about Asian-American contacts and highly positive evaluations on the aesthetic qualities of this art.

End of the Expedition

Like any director of an important project, Boas hoped that the Jesup Expedition would continue indefinitely, and that the American Museum's Northwest Coast art collection would keep on expanding. In an interview in the *New York Times* (13 Nov. 1897), he optimistically stated that "Jesup has set no limit on the time . . . and has declared his intention of seeing the matter through no matter what cost or length of time are involved." Unfortunately for the anthropologist, after six years, Jesup and Boas could not agree on what "seeing the matter through" really meant. Although Boas wanted very badly to continue the project, Jesup controlled the Expedition's finances, and decided when enough work had been done. Thus, in 1902, the American Museum's *Annual Report* announced the official termination of the Jesup Expedition and informed the Museum trustees that its initial aim, to collect information on the North Pacific tribes of North America and Siberia, had been realized. Now all that remained was an analysis of the voluminous materials collected by Expedition members. The *Report* noted that preliminary analyses of the customs and traditions of the northeast Asians and Northwest Coast Indians revealed that both must be regarded as of one group, "a conclusion of great significance for the wider problem of the origin and development of the civilizations of the two continents" (p. 19).

Even if Jesup might have originally been sympathetic to the idea of extending the Expedition, by the end of six years, he had become disillusioned with Boas's ability to "get things done." Several times he had demanded from Boas some major summarizing statement giving absolute proof of man's migrations from Asia to the New World. Never one to reach hasty conclusions, Boas felt unready to produce such a final document, and committed himself only to the statement that "intimate relations" existed between the Siberians and the Northwest Coast peoples. Moreover, he argued, the material Jesup wanted would be contained in the "Summary and Final Results of the Jesup Expedition," the projected twelfth volume of the Jesup Expedition Memoirs, only two volumes of which, in 1902, had as yet been published.

Several times in 1902, Boas wrote Jesup impassioned pleas for continuation of his support of the project, and urgent appeals for more money to send men back to the field, to no avail. Then, in 1903, Boas was devastated to learn that Jesup would no longer fund the publication of the Expedition Memoirs; Boas wrote a near desperate and defensive letter to Jesup protesting this decision (20 Feb. 1903):

I beg to ask you to remember that for six years I have given up all my own scientific work and aspirations on behalf of your expedition and I have devoted all my energies to making this work a success, and that all my own work has been at a standstill. Therefore, my whole scientific reputation is at stake in carrying the work to a successful end. Perhaps you do

not care for the opinion of the scientific world, but I cannot afford to have an enterprise for which I have the responsibility, fail. In 1897 when I was asked if I would accept a Professorship in Vienna, you told me that I must see you through with your expedition. I have done my share and now I must beg of you to see me through, that I may come with honor out of the undertaking.

These arguments convinced Jesup, who agreed to continue supporting the publications.

ALTHOUGH Boas was unprepared at that time to complete a summary volume—he would never be able to do so—he could, when asked, provide some interesting conclusions from the data thus far collected and analyzed. In an address given after Jesup's death in 1908, Boas announced that the Expedition bearing the late president's name had found clear indications of cultural borrowings and could provide evidence for the reconstruction of the migrations of ideas and peoples. He claimed that the North Pacific tribes, all the way down to California, constituted an ancient type of American culture distinct from other American Indian cultures, particularly those that grew maize. These tribes, according to Boas, had close relations with those from eastern Siberia, as can be seen in their myths, in art, in languages, and physical characteristics (Boas n.d.).

Boas used certain conclusions derived from the data collected during the Jesup Expedition to contradict the theories of the evolutionists. In a summary statement, he wrote:

The tribes of the North Pacific Coast no longer appear to us as stable units, lacking any historical development, but we see their cultures in constant flux, each people influenced by its nearer and more distant neighbors in space and in time. We recognize that, from an historical point of view, these tribes are far from primitive, and that their beliefs and their ways of thinking must not be considered those of the human race in its infancy, which can be classified unreservedly in an evolutionary series, but that their origin is to be sought in the complicated ethnic relations between the tribes (Boas n.d.).

With these words, Boas insisted upon a transvaluation of the entire field of anthropology, and hinted at its development into the most humane of the human sciences. His great goal for the Jesup North Pacific Expedition, to assemble sufficient quantities of ethnographic materials that, by a variety of means, would prove the intellectual equality of primitive man with his "civilized" brothers, was close to being realized.

Franz Boas's Last Years at the American Museum

The termination of the Jesup North Pacific Expedition signaled the beginning of some serious problems Franz Boas was to experience with the American Museum administration. Early in his tenure at the Museum, Boas had interacted directly with the president. He had approached every curatorial assignment with intensity, worrying as much about lighting and security in the halls as about the theoretical significance of the data being collected by Jesup Expedition members. He shared with the president his views on a wide range of topics, from updates on the status of the Anthropology Department's research projects to evaluations of the most effective brands of poison for killing the insects that infested wood carvings and textiles.

Unfortunately, this intimate association with Jesup was not to last forever, for by 1902, the Museum president's health had begun to fail and in order to lessen his administrative burdens he appointed as Museum director an ichthyologist from Brown University by the name of Hermon Carey Bumpus. This man soon became an obstacle to Boas's free access to the president. And, in his agenda for the Museum, Bumpus positioned himself diametrically opposite to Boas, who placed serious scholarly research in first place and public education second. Although the new director seems to have acted in an especially abrasive manner to the easily offended Boas, it is more than likely that Boas would have come into conflict over the question of the Museum's public role with any administrator during this particular period, for Bumpus arrived at a time when the institution was reassessing its educational mission, encouraged in part by the officials of New York City.

Dr. Meyer of the Dresden Royal Zoological, Anthropological, and Ethnographical Museum had noted in his report how devoted the American Museum was to education. Indeed, he commented that of the twelve departments of the institution, "the department of public education stands at the head of the list, a circumstance which indicates the main object of the museum" (1903:327). Although the American Museum had always had an interest in education—its charter specified its dual mission of research and education—by the end of the century, the institution had revived its previously rather morose education department in order to respond to what many perceived as a growing public need. This was to become a considerable burden for Boas. When he did concern himself with education, as in his design of the North Pacific hall, he not surprisingly tried to teach his audience about Indian culture. His supervisors had somewhat more in mind when they thought of the educational function of the Museum, for at the turn of the century, to educate meant to socialize.

By this time, the city's political and economic leaders recognized that a new wave of immigrants from southern and eastern Europe pouring through Ellis Island needed to be both inculcated with proper American values and assimilated into American society. While before 1890, the majority of immigrants into the United States had come from western and northern Europe, during the last decade of the nineteenth century, Slavs, Mediterraneans, and Jews from the Austro-Hungarian and Russian empires began arriving in ever increasing numbers. By the first decade of the twentieth century, well over six million of these southern and eastern Europeans had come to America to live in the dark and dirty slums of areas like the Lower East Side (Higham 1971).

One major means of civilizing these strange looking and sometimes politically radical newcomers was through education, the panacea of many social ills during the Progressive Age. In response to the perceived threats by these immigrants to the American way, New York City school officials reorganized their curriculum to ensure the socialization of their children into a working class with the desirable traits of cooperativeness, obedience to authority, and loyalty to this society. Adult immigrants were offered evening courses where they could learn cleanliness, industriousness, and diligence, and emulate the mythic model of the American dream: a rural, white, Protestant citizen.

To provide continuing education for those out of school, philanthropists increased their support of educational institutions like libraries and museums. Although it was a matter of debate among educators and psychologists at the turn of the century whether these southern and eastern European immigrants were *truly capable* of intellectual improvement, almost everyone believed these new citizens could be molded into compliant and obedient workers (Cohen and Lazerson 1977:380–82; Carnoy 1974:245–46; Tyack 1977:200–11).

It was at this moment that the American Museum of Natural History built a new auditorium seating twelve hundred for public lectures to improve the quality of its educational enterprises. Several speakers at the celebration of the auditorium opening on October 30, 1900, praised the efforts made by the American Museum to elevate the intellectual level of the masses. Bird S. Coler, the New York City controller, addressed the Board of Trustees and other guests on the subject of free education. This city, he explained, with its population of over three and one-half million people, spends fully 19 percent of its budget—twenty million dollars—on education. In an unveiled attack on the free higher education provided by City College, Coler asserted that the city should not be expected to assume the expense of educating all children past fifteen, the age at which nine out of ten students leave school. Institutions like the American Museum provide an invaluable service to society by ensuring that those with "no particular ability for higher education," who have properly joined the labor force, be able to continue their education. The Museum's lecture series, he believed, contributed significantly toward giving "the great 90% a chance to get ahead and make something of themselves in the world" (AMNH Annual Report for 1900:40).

Dr. H. M. Leipziger, supervisor of lectures of the Board of Education followed Coler at the podium with a poetic speech about the value of museum education as a means of furthering the spread of scientific knowledge. In addition, he asserted that museums offer wholesome recreation, "antidotes against life's sorrow and a strengthening against temptation," praised the significant contributions the Museum's lectures made to the culture of the city, and stressed the necessity for such intellectual enhancements in so cosmopolitan a metropolis as New York. Alluding to the superiority of America over that nation of Iberians it had recently defeated in the Spanish-American war, Leipziger went on, "the character of our pleasure is an index of our culture and our civilization. A nation whose favorite pastime is the bull fight is hardly on a plane with one that finds pleasure in the lyceum hall" (AMNH Annual Report for 1900:40–42).

W HEN H. C. Bumpus arrived at the Museum two years after the official opening of the auditorium, he enthusiastically championed these attitudes so characteristic of the progressivist era. Believing it incumbent upon the Museum to enhance the education of young children, Bumpus began working toward better integration of the Museum and the public schools. He revived the Department of Public Education, which sent public schools transportable exhibits called "nature cabinets" to instruct all New York City schoolchildren, including the slum dwellers, on the world beyond the busy streets and tenements. As for the permanent exhibits in the Museum itself, the director decided that all displays should be aimed at a fairly low intellectual level; "what is good enough for the twelve-year old," Bumpus at one point stated, "is more than good enough for the adult." As a result, he encouraged the construction of more and more habitats and dioramas that appealed to a younger and less sophisticated audience (Wissler 1942–43:121–22).

Clearly, the new director and Franz Boas stood on opposite sides of the fence vis-à-vis the role of the Museum. Although Boas did believe the institution had some responsibility to the New York City public, he was far more interested in scientific pursuits, and found appalling Bumpus's attempts to popularize everything. Bumpus, for his part, disapproved of Boas's methods of museum administration and began challenging the anthropologist's professional decisions. In 1903, Bumpus criticized Boas for being insufficiently attentive to his exhibit installations. Bumpus, and Jesup as well, had become annoyed at Boas's practice of postponing labeling the exhibits, often for extensive periods of time, until the corresponding monograph on them had been published. In a memorandum to Boas, Bumpus showed his pique: "I cannot help feeling that I may have made a fundamental mistake in yielding to the urgent appeals for purchases and continued field work and the general enlargement of our collections, rather than to have first cared for the proper installation of the material actually on hand" (18 Dec. 1903).

By late 1904, probably largely as a result of his increasingly tense exchanges with Bumpus, Boas asked to be relieved of his administrative duties but allowed to continue his research. This would enable him to increase his involvement with the Columbia University anthropology department: "my own scientific interests and the efficiency of my own scientific work, would be best served by a reduction of my work at the Museum, and by a concentration of my work at the University" (Boas to Jesup, 3 Jan. 1905). Although Boas bowed to the combined pressure from Jesup and Bumpus who urged him to remain in his position, he would soon encounter the ultimate affront to his authority when Bumpus began to make decisions involving the Anthropology Department without consulting its curator.

In April 1905, Bumpus bypassed Boas entirely when he directed Clark Wissler to renovate the Blackfoot Indian display so that it could be more "intelligible, instructive, orderly and attractive" (28 Apr. 1905). Then, under orders from the president, Bumpus began to work with Adolphe Bandelier, the collector of an extensive array of Peruvian archeologica, in designing the Peruvian Hall. To Boas's horror, Bumpus arranged the Peruvian collection as the Smithsonian had in the 1880s, not geographically and historically, but grouped according to object and material type. Utterly rejecting the ideal of displaying together all objects from the same culture, Bumpus embraced the evolutionist model Boas had worked so hard to discredit (Jacknis 1985:106–8).

This usurpation of authority created such ill will between Boas and Bumpus that on May 17, 1905, the president summoned them both for an interview, hoping to alleviate the increasingly serious hostilities. Unfortunately, Boas and Bumpus ended up talking past each other, and the conference served no useful function; if anything, it exacerbated the difficulties. It was at this interview that Jesup first publicly supported his director's position on the need for popular education, and in so doing, opposed the position of his anthropology curator.

As soon as the meeting began, Boas expounded his views on museum displays, insisting that all collections should communicate the intellectual equality of man with displays of the highly developed industries of primitive peoples and the "rare beauty" of their "objects [made] with their simple instruments." Tacitly attacking Bumpus's arrangement of the Peruvian Hall, he reasserted the significance of history, and pointed out how *he* had always assiduously avoided designing displays of artifacts in series that the public might erroneously interpret as evolutionist sequences. Bumpus cared nothing for these carefully thought out arguments that Boas had been developing for years, and dismissed them as irrelevant. Presenting himself as the champion of public education, Bumpus accused the anthropologist of being overly interested in scientific research. Reiterating his firm belief that displays should be understood by the preadolescent mind, Bumpus criticized the confusing nature of Boas's museum installations, complaining that he could not understand the anthropologist's principles of organization until they were verbally explained. To this, Boas retorted that if one makes up one's mind not to understand, then one will not understand. Bumpus, he challenged, saw but one museum for the relatively uneducated, whereas he envisioned several museums with different missions under the same roof (notes on the interview, AMNH archives).

Boas of course hoped that the president would support him during this unpleasant interchange. At first expressing a sentiment sympathetic toward Boas's point of view, Jesup stated that he wished to see "an illustration of the beautiful basketry made by a primitive tribe, and accompanied by a statement and illustrative facts showing how primitive and crude is the life of the people, and how they were able to make the most beautiful things with the simplest means." But then the president revealed his true beliefs on the social significance of such an exhibit, which would be "contrasted with condition of work in civilized communities. . . . a series of this kind would show that if civilized man would only use all the facilities at his disposal, he could do so much better than he actually does" (notes on the interview, AMNH archives).

At this time, science museums were seen as centers for the education of all elements of the population; these American Museum displays could serve as visual object lessons cajoling toward self-improvement those who needed it, such as the lower classes. If Indians and other barbarians could create an environment about them with efficiency and aesthetics, then certainly so could the immigrant. Jesup then proceeded to make an evolutionist point that must have pained Boas, as he expressed the desire to see "a series illustrating the advances of mankind from the most primitive forms to the most complex forms of life." The president finally insisted that science and education could and should work together in a museum exhibition, and ended the meeting with a declaration of support for his director (notes on the interview, AMNH archives).

Three days after this interview, Boas wrote Jesup a letter (20 May 1905) reiterating his complaints about Bumpus and concluding, "my impression, notwithstanding your kindly words, was therefore that the director wanted a rupture." So distressed was he at Bumpus's challenging his authority, meddling into his administrative affairs, and, especially, disagreeing with his cherished views on proper anthropological displays in museums, that on May 23, 1905, Boas resigned from his position at the American Museum, "on account of fundamental differences of opinion relating to administration between the director and myself." The American Museum officials doubtless felt some relief at the resignation of this difficult individual.

An era was over, both for Boas, who would now devote himself full time to teaching and research at Columbia University, and for the American Museum of Natural History, which would soon experience a change in administration from the presidency of Morris Jesup who favored the Anthropology Department, to Henry Fairfield Osborn, who disdained the subject of anthropology. Although some pieces of art from British Columbia and Alaska would find their way to Central Park West, the great age of collecting Northwest Coast art at the American Museum was now over.

The Osborn Administration and Anthropology

Henry Fairfield Osborn, the man chosen to succeed Morris Ketchum Jesup in 1908 as president of the American Museum and to determine its direction for the next two and a half decades, was a scientist whose views on race were in diametric opposition to those of Franz Boas. In 1891, Osborn, a vertebrate paleontologist, left his teaching job at Princeton University to build a mammalian paleontology department at the American Museum and also chair Columbia University's new zoology department. This tall, handsome, and wealthy nephew of J. Pierpont Morgan (Kennedy 1968:160), with a Princeton undergraduate degree and graduate training at Oxford, fit nicely into the world of Jesup and the other trustees, and soon became one of the president's principal scientific advisors, serving for a while as assistant to the president before the arrival of Hermon Bumpus (Kennedy 1968:114). A gracious gentleman by breeding, Osborn could, when necessary, be assertive and domineering; one of his colleagues once described the paleontologist as a man who entered meetings like a war horse champing at the bit (Porter 1983:26).

Whereas Boas had challenged the ideas of the purity of races and of the potential disaster of racial mixtures in the United States, in 1921, Osborn reported to the Museum's trustees that "our own race is threatened with submergence by the influx of other races." A firm believer in eugenics, Osborn feared that "racial deterioration" was pervading the entire world, and urged that "the purest New England stock . . . which laid the foundations of the republican institutions of this coun-

try" be preserved and its virtues extolled (Porter 1983:27–28). In an explicit attack against anti-evolutionist scientists, Osborn wrote in 1922 to a young zoologist and one-time chair of the American Museum's Mammalogy Department, William Gregory: "You will observe that racial evolution and distinctions are being challenged on every side. . . . THEY ARE ALL WRONG, and I wish it were my privilege, as it will be yours, to prove it" (Porter 1983:27). Of course, a leader of the "they" to whom Osborn referred would have been one of his Museum's ex-curators, Franz Boas.

Henry Fairfield Osborn was another who felt that one of his Museum's primary responsibilities was educating the public, particularly the immigrants. In a letter to a friend, President Osborn referred to an eminent American who shared his views: "Theodore Roosevelt told me recently that he thinks the most important task before us is to properly educate these new Americans. He considers the Museum a vital agent in this work" (Kennedy 1968:169). Osborn energetically promoted the development of outreach programs, such as those created by Bumpus, to more actively instruct the children of New York. In 1909 he wrote to his close friend Madison Grant, the president of the New York Zoological Society, that he wished to make the Museum a "positive engine [for] the propagation of socially desirable views" (Kennedy 1968:154), such as assimilation into American society, adherence to the social mores as well as the laws of the country, and rejection of any ethnic identity.

Osborn, a distinguished scientist himself, selectively encouraged scientific research at the Museum. During his administration, he fostered the development of vertebrate paleontology while he curbed expenditures by the Anthropology Department. He saw the study of evolutionary theory as one of the most important tasks of science, and wrote that his own Vertebrate Paleontology Department was "the most important in the Museum since the evidence and great questions of evolution are most plainly studied" (Kennedy 1968:162). In contrast, with regard to anthropology he wrote, "much anthropology is merely opinion, or the gossip of the natives. It is many years away from being a science. Mr. Jesup and the Museum spent far too much money on anthropology" (Kennedy 1968:163).

Despite his contempt for anthropology, Osborn recognized the need to finish the installations of the various ethnological and archeological halls, and encouraged Curator Wissler to do so in a manner as economical but as scientifically accurate as possible. On July 19, 1910, Osborn wrote to Wissler that he looked forward to the Anthropology Department devising an "ideal arrangement [of objects] that would stand the test of criticism for all time," and would never have to be tampered with. Wissler responded to this charge with the following statement: "It is because of the universal feeling that association of ideas and their diffusion is the chief factor in the origin and distribution of cultures, that museum plans are projected on a geographical basis with confidence that such plans need never be materially revised to meet future requirements" (30 July 1910). Thus Wissler supported his mentor's theories on museum arrangement and judged as incorrect the application of a biologically based evolutionism favored by many contemporary anthropologists.

Wissler had been a schoolteacher before he studied anthropology with Boas, and thus had some sense of the content of an educationally successful museum installation. One thing was certain to Wissler—the hall that Boas had literally stuffed with artworks large and small had to become less cluttered. As soon as he took over the curatorship of the Anthropology Department, Wissler began to rearrange some of his predecessor's exhibits; around 1908 he removed the low central cases that had held archeological specimens and replaced them with the Haida canoe that had previously hung from the ceiling.

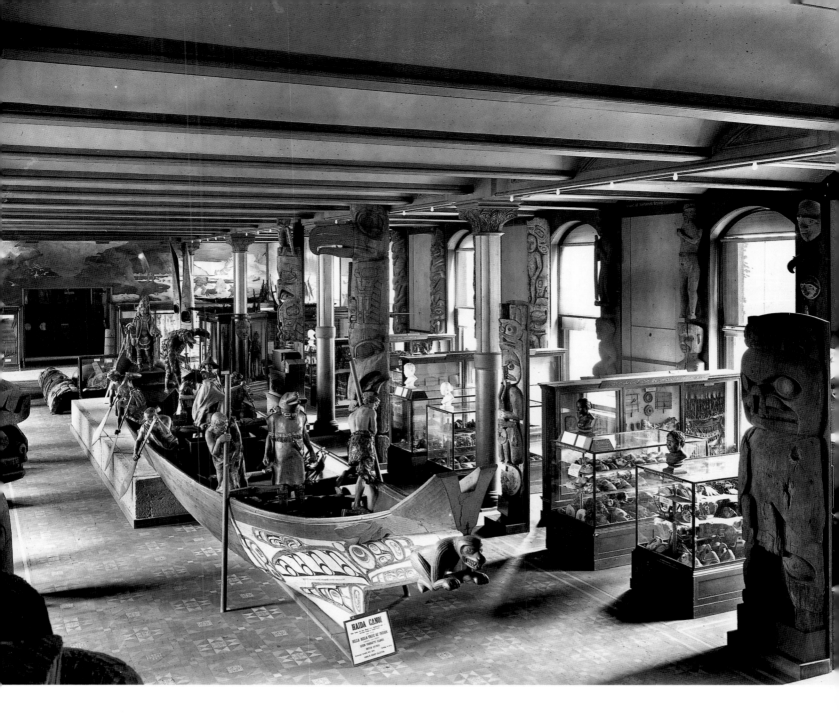

In 1910, Bumpus conceived of filling the canoe with a group of Indian figures, "representative in physique, garb, and action of the tribes of the North Pacific Coast," and thus creating a "great open exhibition case" that would be a very popular instructional tool. It must certainly have goaded Boas to learn that the consultant whom Bumpus engaged to work on this project was none other than Lieutenant Emmons, once again in the good graces of the Museum, who was assigned responsibility for supervising all the scientific details.

Emmons decided the canoe group should depict an entourage of Chilkat Indians, a chief and his followers, coming to a potlatch (Lucas to Goddard, 21 Aug. 1911). The canoe has just reached the surf at the beach and its paddlers—slaves who represent a variety of Northwest Coast ethnic groups—are holding the boat still while the Chilkats exchange songs and ceremonial greetings with another group waiting for them on the shore (fig. 71).

Fig. 71. American Museum of Natural History, North Pacific Hall, c. 1910. Note that lowermost third of pole illustrated in figure 66 appears in the center of this photograph, uppermost third appears to the left of that pole. *33003*

Sculptor Sigurd Neandross had been asked by Bumpus to make the figures for this ceremonial group of Northwest Coast Indians. To ensure the ethnological accuracy of his work, Neandross used many of the head casts collected during the Jesup Expedition to make the figures' heads, and borrowed examples from the collections of Tlingit art to copy on his models. At first he tried using a paraffin spraying machine (which Bumpus had discovered in Europe) to cover the models with wax before plaster casting; that technique proved inadequate, and for most of the models Neandross applied wax with a brush. To create the illusion of clothing on these figures, he dipped burlap in glue and draped the wet cloth over the plaster manikins. After it dried, he covered the burlap with more glue and wet plaster, and then painted it with the appropriate Northwest Coast imagery (Neandross 1910; Dickerson 1910). In figure 72, the sculptor makes a plaster manikin wearing a Chilkat tunic copied from a tunic in the Museum's textile collection.

For some reason Wissler disliked the canoe group intensely, and after Bumpus had left the Museum, wrote to Sherwood, the acting director, that "the really courageous thing to do is to admit that the group has failed; dismantle it, swing the boat up to the ceiling as it used to be, take the group of figures in the stern for a dancing group to be placed in a case in the middle of the hall, or, as an alternative, construct a model canoe two thirds the size for which the water line shall be near the floor" (20 Sept. 1913). Despite these protests, the canoe group remained, much to the delight of countless Museum visitors.

Fig. 72. Sigurd Neandross posing with one of his figures made for the Northwest Coast canoe group, c. 1910. The Chilkat tunic served as a model for the garment being worn by the manikin. *33008*

Such life groups that enhanced the popular appeal of the hall were extremely costly to make. Since President Osborn was unenthusiastic about spending large amounts on the Northwest Coast Indian installations, a cheaper means of putting "life" into the displays had to be identified, and the Anthropology Department decided to commission a series of murals illustrating the cultures of British Columbia and Alaska. In the summer of 1909, the Museum sent both the artist hired to paint these murals, Will S. Taylor, and Harlan Smith on a trip to British Columbia and Alaska to collect art, sketch the Northwest Coast scenery, and obtain ideas for the murals (Fassett, 1911). Figure 73 is a photograph of the artist seated on the banks of the Stikine River, sketching the mountains and glacier.

Taylor found the region magnificent, especially the Queen Charlotte Islands. At the end of September, in a letter to Harlan Smith who was by that time back in New York, the artist wrote, "of all the villages we have visited this summer none can be compared with the wonderful town of Masset. The old townsite across the Inlet is most wonderful in its marvelous carved totems which number about thirty-four in all, including some few house posts. I saw a few we can have at $1.00 per foot which I think is quite reasonable." Smith recommended purchase of these poles (4 Oct. 1909).

As Taylor traveled throughout the Northwest, he identified particular scenes at different villages as subjects for his murals. One of the first paintings he wished to make illustrated the weaving of the Chilkat blanket, that extraordinary abstract tapestry bordered with long fringes that swayed elegantly while worn by a dancing nobleman. At Klukwan he observed "two old women, seated in their peculiar fashion on their heels . . . creating a blanket, stripping the cedar bark for warp and spinning the wood from the crude wool of the mountain goat" (Taylor 1910:44). Then he went to Masset to learn the process of manufacturing the Haida canoe. From the Queen Charlottes, Taylor moved on to the Nass River Tsimshian to observe the techniques for processing eulachon fish oil: the small, sardine-like fish were put into water with hot stones and cooked until all their fat was rendered.

Fig. 73. Artist Will Taylor sketching Wrangell Glacier, c. 1909.

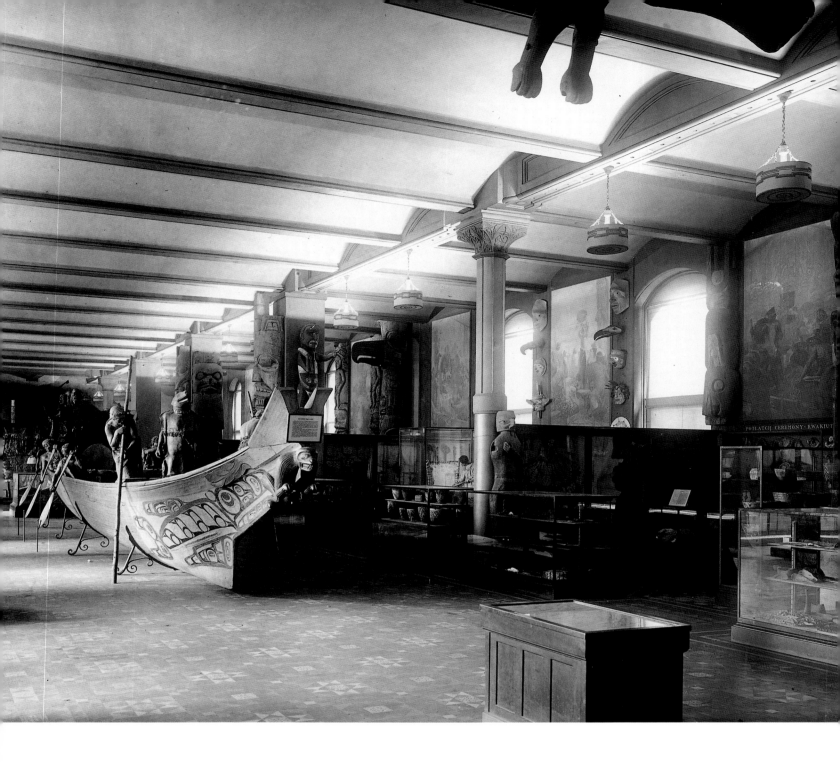

Fig. 74. American Museum of Natural History, North Pacific Hall, c. 1919. Several of Will Taylor's murals are installed along the wall. At far right is the mural of the "Potlatch Ceremony—Kwakiutl" illustrated in figure 75. *37672*

After stopping among the Bella Coola to observe their processing the cambium of hemlock or spruce with skunk cabbage to make a tasty bread-like product, the artist went to Nootka to "secure the locality, color and facts for a whaling picture—on the . . . sandy beach the whalers had returned from a successful hunt, while the inhabitants of the village welcomed a dignified old chief in his ceremonial costume" (Taylor 1910:49).

Taylor designed his paintings, which were executed between 1910 and 1926, in consultation with Emmons. Although the artist did travel to the Northwest Coast, he could not have actually seen many of the scenes he ended up painting, for by 1909, all Indians wore "white" clothing, and most lived in modern, "Christian" structures. Taylor's paintings of traditionally clad Indians in front of communal plank houses must therefore be thought of as competent reconstructions, based partially on scenes the artist actually observed, on old archival photographs, on information from library texts, and on artifacts from the American Museum collection.

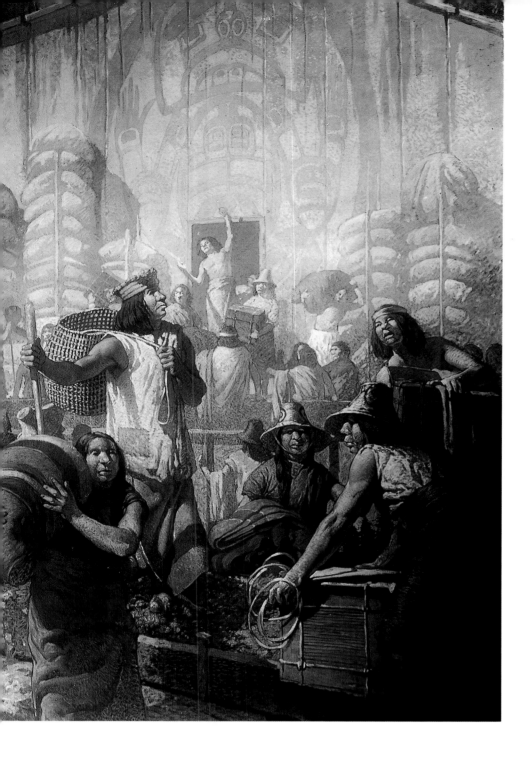

Fig. 75. American Museum of Natural History, North Pacific Hall. Will Taylor mural of "Potlatch Ceremony—Kwakiutl." *36079*

It is sometimes possible to identify the sources of Taylor's murals, such as the painting of a Kwakiutl potlatch (fig. 75) in which a half-naked man stands gesturing before the door of an elaborately painted housefront. Taylor modeled the orator after an Indian who posed (presumably for the artist himself) before a blanket suspended between two trees (fig. 76), and copied the facade design from the photographs of Newitti, taken thirty years before by Dossetter (see back endpaper). For his Chilkat blanket painting (fig. 77), Taylor photographed a Klukwan woman (fig. 78) squatting on the ground weaving onto her blanket the pattern painted on a board; he removed her western-style clothing and cotton kerchief and replaced them with a fringed doeskin dress and beaded hair ornament similar to one in the collection (pl. 89). To the Chilkat blanket-maker's right, Taylor painted another woman wearing the long-abandoned shelf-like labret about which he would have read in the late eighteenth-century descriptions of the northern Northwest Coast.

Fig. 76. Northwest Coast Indian posing for Taylor. *Taylor or Smith photograph, 1909. 46291*

Fig. 78. Tlingit woman of Klukwan weaving a Chilkat blanket, copying image on a wooden pattern board. *Smith photograph, 1909. 32467*

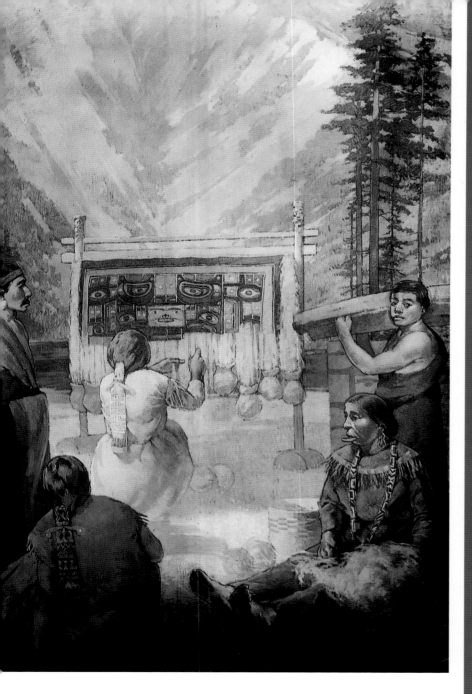

Fig. 77. American Museum of Natural History, North Pacific Hall. Will Taylor mural of "Weaving a Blanket—Tlingit." *120421*

Pl. 89. Tlingit beaded hair ornament. L 54 cm, W 12 cm. *Purchased from Emmons, 1904. 16/8389*

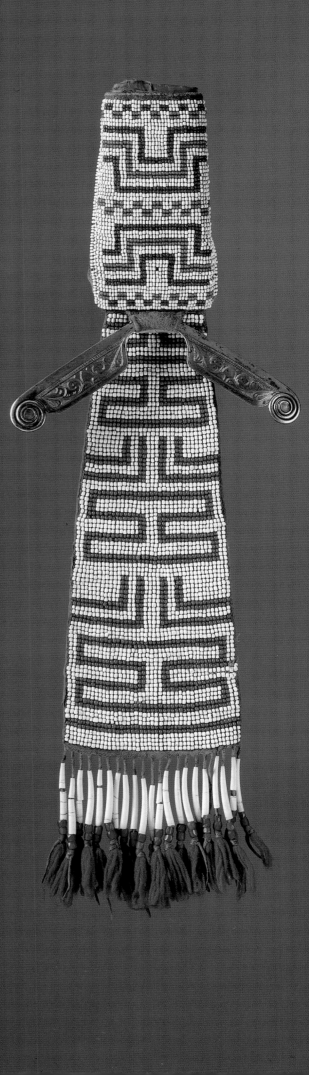

Harlan Smith accompanied Taylor on this exploration of the Northwest Coast, taking photographs, such as the one of the artist sketching on the bank of the Stikine River, as well as several of poles *in situ* (figs. 79, 80), and collecting some artifacts. While in Klukwan, he purchased a Chilkat pattern board (pl. 90), intended as a model for an apron similar to one already in the Museum's collection, a Tlingit shaman's apron purchased years earlier by Emmons (pl. 91).

One of Smith's charges was to purchase as many totem poles as he could. Unfortunately, when he arrived in British Columbia, he discovered how scarce totem poles had become and wrote from Prince Rupert to both Bumpus and Wissler on the difficulties of collecting good pieces: "poles are now practically wiped off the Earth in many localities where they were numerous twelve years ago when I had the buying fever" (6 Aug. 1909). Despite this, during his 1909 trip, Smith managed to acquire some poles for the price of a dollar a foot (e.g., fig. 81).

Fig. 79. Bella Coola village. *The poles illustrated were purchased by Harlan Smith for the American Museum (16.1/438, 16.1/554). The figures atop both poles were not included in these purchases. Smith photograph, 1909. 46083*

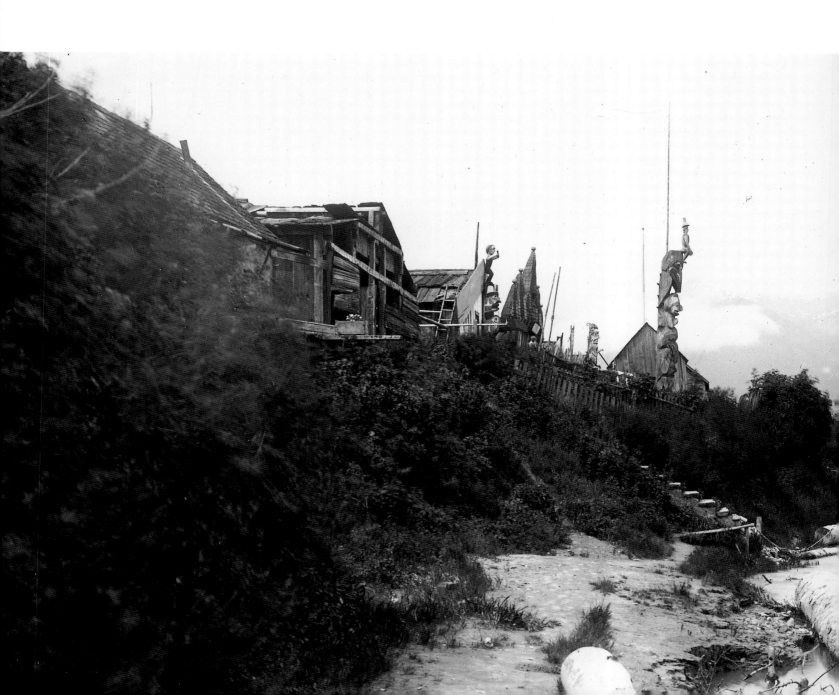

When he returned to New York in late September, Smith gave an interview to *The Sun* (19 Oct. 1909) describing his activities in British Columbia and Alaska. Pointing out that "one of the chief purposes of the expedition is related to the work of the [American] museum in entertaining and instructing the public," Smith, true to his character, described his central role in the designing of the North Pacific hall. The newspaper stated that he was in charge of rearranging that hall and, morever, had planned its arrangement of tribes from the Columbia River to Mount McKinley. Franz Boas, who years before had conceived the general ethnological organization of this hall, and Clark Wissler, who was really in charge of its arrangement, were virtually ignored.

A s Taylor worked on these large-scale murals depicting life on the Northwest Coast, the Museum purchased occasional pieces, some of which were impressive works of art. These included several particularly fine masks from the Kwakiutl (pl. 92), the Haida (pl. 93), and the Tsimshian (pl. 94). The Museum also purchased several additional artworks from Lieutenant Emmons—a delicately incised Haida copper (pl. 21) as well as two exceptional Nootka wall boards (pl. 95) that illustrate the thunderbird carrying away the killer whale, in view of the lightning snake and wolf.

Fig. 80. American Museum of Natural History North Pacific Hall. The Bella Coola pole (*16.1/554b*) photographed *in situ* in figure 79 is here shown displayed in the hall, minus the figure that originally sat on the uppermost bird's head. In front of this pole is a Haida crest figure of a beaver from Skedans that served as a coffin support (*collected by Newcombe, 1901*).

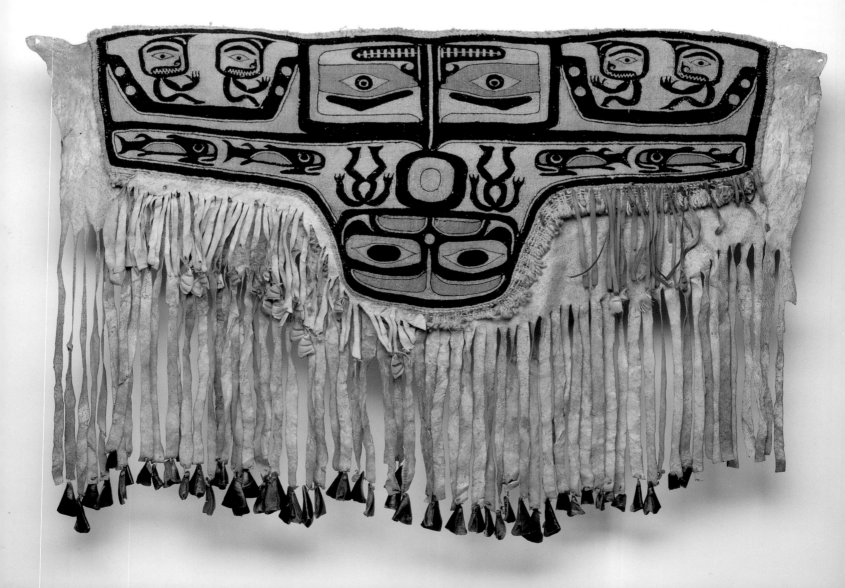

These pieces were to take their places in the hall that President Osborn wished would finally be completed. To "finish" the hall, the curators decided to line the pillars with a forest of totem poles and house posts. During his 1909 trip to the Northwest Coast, Harlan Smith had purchased several poles, but more than ten years later, the American Museum still did not have enough of these large sculptures. To rectify this, in 1922, Pliny Goddard, the anthropologist who had assumed responsibility for the Northwest Coast hall, traveled to British Columbia where he met George Hunt and requested four more house posts. In a letter to Goddard of June 23, 1923, Hunt reported that the only available pieces were outrageously priced, but suggested that the man who had carved these posts, Arthur Shaughnessy, might be willing to make four new ones expressly for the Museum—once he was out of jail. Shaughnessy had been arrested for participating in a potlatch and, as Hunt wrote to Goddard, "I don't [know] what he will say after he comes out of jail for I see that all these poor Indians are now frightened to do anything."

Although some Northwest Coast potlatchers had been arrested in earlier years, it was during the 1920s that the Canadian government began mercilessly harassing the Kwakiutl for participating in potlatches. Although the potlatch law had been passed in 1884 to take effect in 1885, Canadian officials did not strictly enforce it until about thirty years later when they began actively prosecuting any Northwest Coast Indian participating in a feast or a secret society ceremony. Especially energetic in pursuit of potlatch law violators was the Indian agent of Alert Bay, William Halliday, who was under strong orders from Ottawa to guarantee the extinction of these feasts.

The ultimate challenge to Halliday occurred in December 1921, when the Kwakiutl chief Daniel Cranmer hosted a six-day long potlatch, the most splendid ever held on the Coast. The feast was held on Village Island, a location far from Halliday's station, and attended by three to four hundred people. As Cranmer said to Helen Codere, an anthropologist who interviewed him years after the event:

I gave [the chief of Cape Mudge] a gas boat and $50 cash. . . . The same day I gave Hudson's Bay blankets. I started giving out the property. First the canoes. Two pool tables were given to two chiefs. It hurt them. They said it was the same as breaking a copper. The pool tables were worth $350 apiece. Then bracelets, gas lights, violins, and guitars were given to the more important people. Then twenty-four canoes, some of them big ones, and four gas boats.

Cranmer also distributed articles of clothing, oak trunks, sewing machines, basins ("maybe a thousand of them"), glasses, washtubs, gramophones, bedsteads, bureaus, sugar, and 1,000 sacks of flour worth three dollars a sack (Codere 1966:116–17).

It did not take long for Halliday to discover this flagrant violation of the law. So enraged was the Indian agent that he presented Cranmer and the other Kwakiutl with an ultimatum: go to jail or relinquish forever their potlatch masks and ceremonial paraphernalia. Most of them did the latter, expecting at least some reimbursement for their precious possessions, some of which Halliday sold to George Heye for his Museum of the American Indian. Halliday's superior, Duncan Campbell Scott, transferred other pieces to the National Museum of Man in Ottawa (Holm correspondence). Many Kwakiutl ended up feeling deeply deceived by the Canadian officials, for many claimed not to have received any compensation for their heirlooms, and those who did receive some payment complained that the amounts were grossly insufficient for these precious artworks (Cole 1985:250–53).

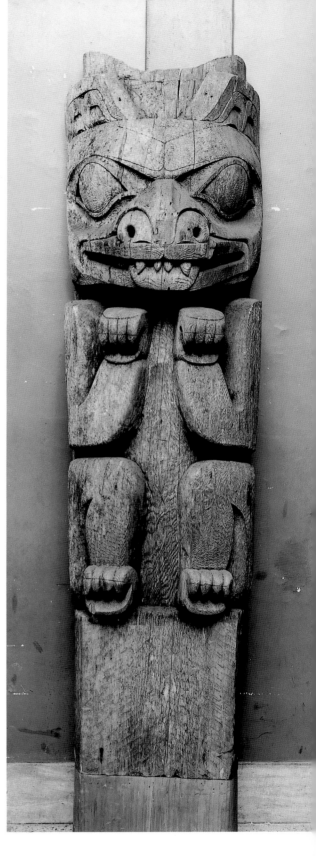

Fig. 81. Haida house post. *Collected by Smith, 1909. 16.1/981a, 325314*

Pl. 90. Tlingit wooden pattern board for apron. Klukwan. L 102.5 cm, H 47.5 cm. *Collected by Smith, 1909. 16.1/427*

Pl. 91. Tlingit shaman's Chilkat weave apron. Klukwan. Central upside-down faces demonstrate Boas's idea of split representation. L 105 cm, W 63.5 cm. *Collected by Emmons, 1888–93. E/2602*

Pl. 92. Kwakiutl wooden mask with abalone inlay. Fort Rupert. H 41.6 cm, W 30.5 cm. *Acquired from Emmons, 1929. 16.1/1872*

Pl. 93. Haida wooden mask, made by Charles Edenshaw. H 30 cm, W 21 cm. *Purchased from Henry Edenshaw, 1905. 16.1/128*

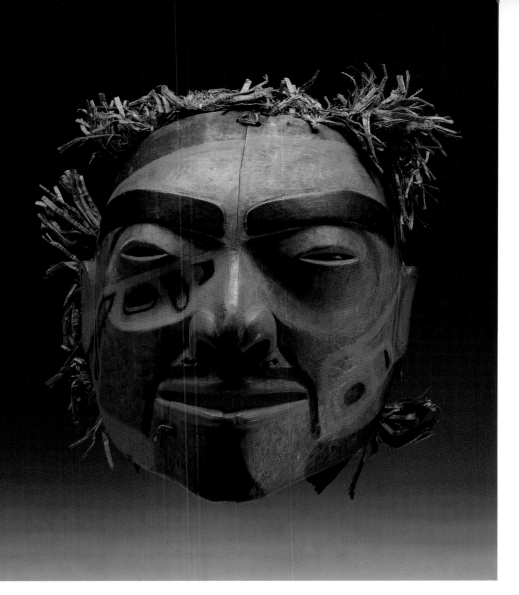

Pl. 94. Tsimshian wooden mask with shredded cedar bark. Kitikshan, upper Skeena River. H 29 cm, W 24.5 cm. *Purchased from Emmons, 1911. 16.1/590*

Halliday's response to Cranmer's potlatch had a chilling effect on all the Kwakiutl, who were about the only Northwest Coast Indians who had continued celebrating traditional rituals into the twentieth century. Now they too ceased most public potlatches, and became increasingly suspicious of any whites who expressed interest in their traditions. For example, when Goddard sent C. F. Newcombe a request in 1924 for some information on a copper in the Museum's collections, the physician replied:

I will send the print [of a Kwakiutl copper] to Alert Bay and try to learn something about it, although I have rather lost faith in some of my informants who are demoralized by their treatment under the Potlatch regulations and think that they have been cheated by the whites. I had not heard particulars as to the loot taken from the Kwakiutl and shipped to Ottawa. The Indian "Superintendent" here has just been promoted for his part in the proceedings and is more inflated than ever with a sense of his importance (Newcombe to Goddard, 11 Jan. 1924).

This was the situation among the Kwakiutl when Goddard sent his request to Hunt for the carving of four house posts. With a cynical assessment of the role of Canadian officials who prohibited traditional ceremonies for which art had been created but collected the best old pieces for their museums, Hunt sadly said, "yet the governments is buying there [sic] totem poles" (23 June 1923).

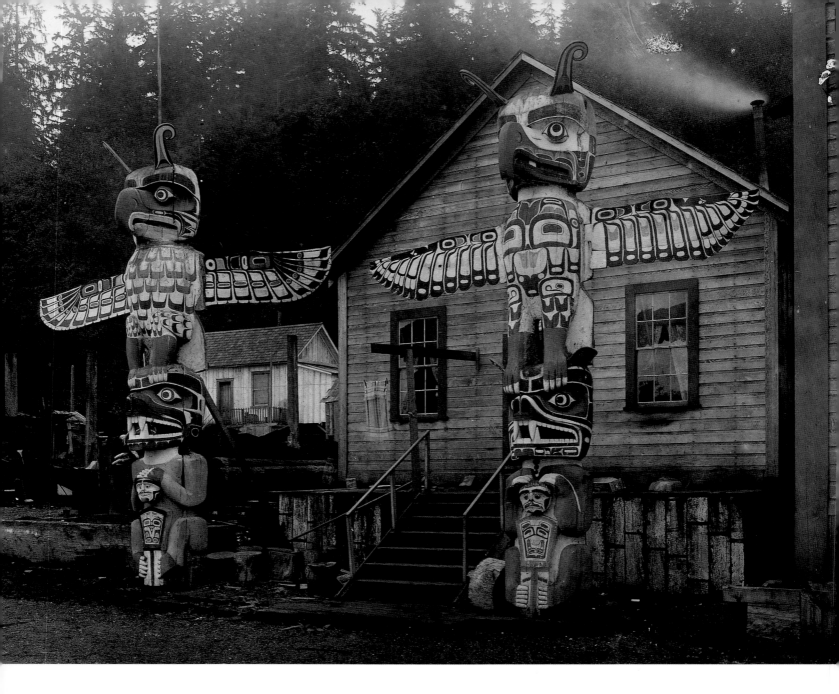

After Shaughnessy was released from jail for his participation in a potlatch, he completed the four posts for the Northwest Coast hall. Shortly thereafter, Hunt wrote to Goddard expressing his dissatisfaction with the way Shaughnessy had carved some of the hands on the posts, and assured the curator that before he sent them along, he would correct these mistakes and even redo the hands himself (30 June 1924). Hunt, now quite an expert in Northwest Coast art, had become an artist. These posts, with their hands "corrected," were erected near the entrance to the Northwest Coast hall, the first four of the "forest of poles" that line the pillars (fig. 84).

President Osborn, Curators Wissler and Goddard, and all the American Museum trustees could finally look at the American Museum's North Pacific hall with deep satisfaction. Here was the finest collection anywhere in the world of art from Alaska and British Columbia. The finely adzed bears smiling on totem poles, the crouching animal leaping forth from the prow of the canoe, the tiny ravens and land otters ingesting each other on abalone-inlaid charms, would all become part of the New York City culture, so physically far from the foggy mountains and spectacular fjords of the Pacific Northwest.

Fig. 82. Kwakiutl village of Alert Bay. House with frontal pole, the lowermost being of which is a thunderbird whose mouth opened to serve as an entrance during festive occasions. *Smith photograph, 1909. 46014*

Fig. 83. Kwakiutl village of Alert Bay. A pair of poles in front of the house of one of the village chiefs. *Smith photograph, 1909. 46027*

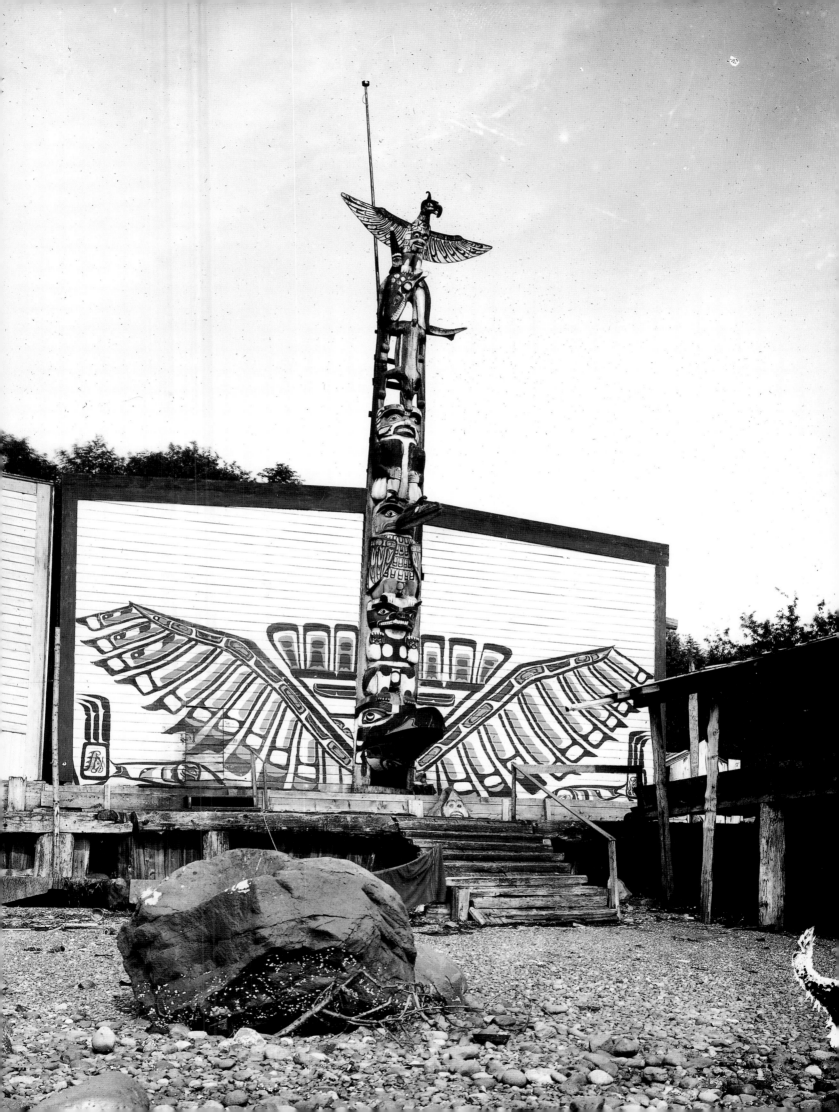

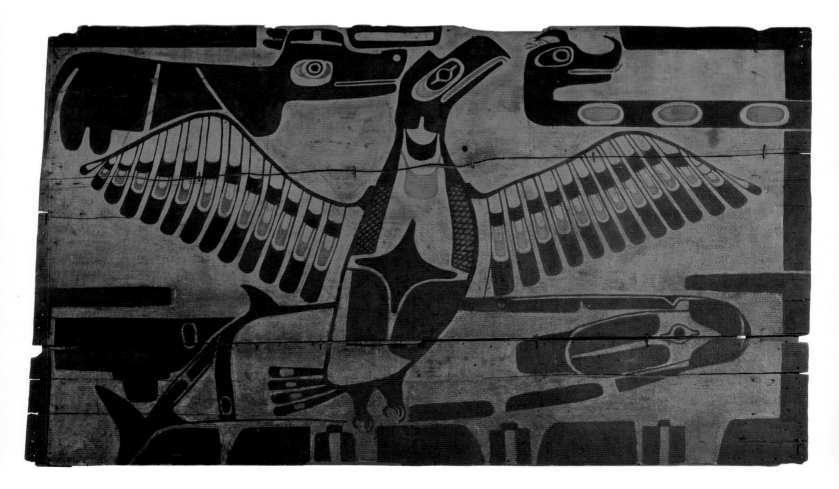

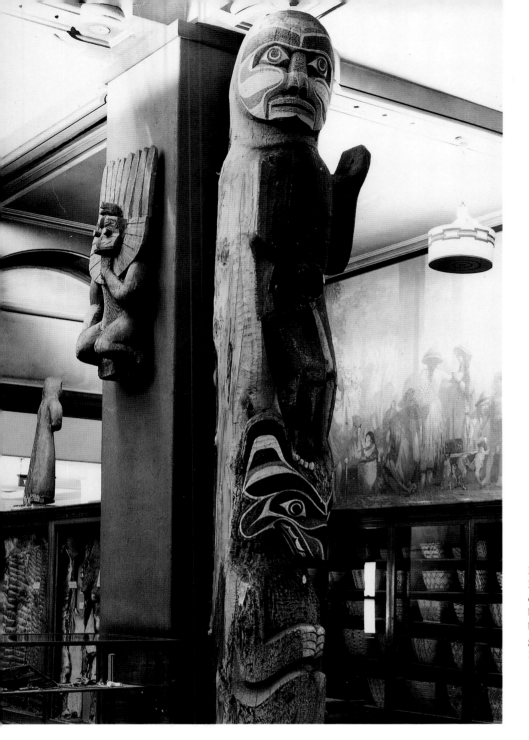

Fig. 84. American Museum of Natural History, North Pacific Hall. At right side of pilaster is one of four Kwakiutl poles (*16.1/1815*) commissioned by Hunt in 1924. At top is a human figure; at bottom, a bear. At left side of pilaster is a Salish grave figure from Lillooet (*16/7075, collected in 1899 by Harlan Smith*). *120698*

Pl. 95. Nootka painted wooden house board depicting thunderbird, lightning snake, wolf, and killer whale. L 298.5 cm, W 173.1 cm. *Purchased from Emmons, 1929. 16.1/1892*

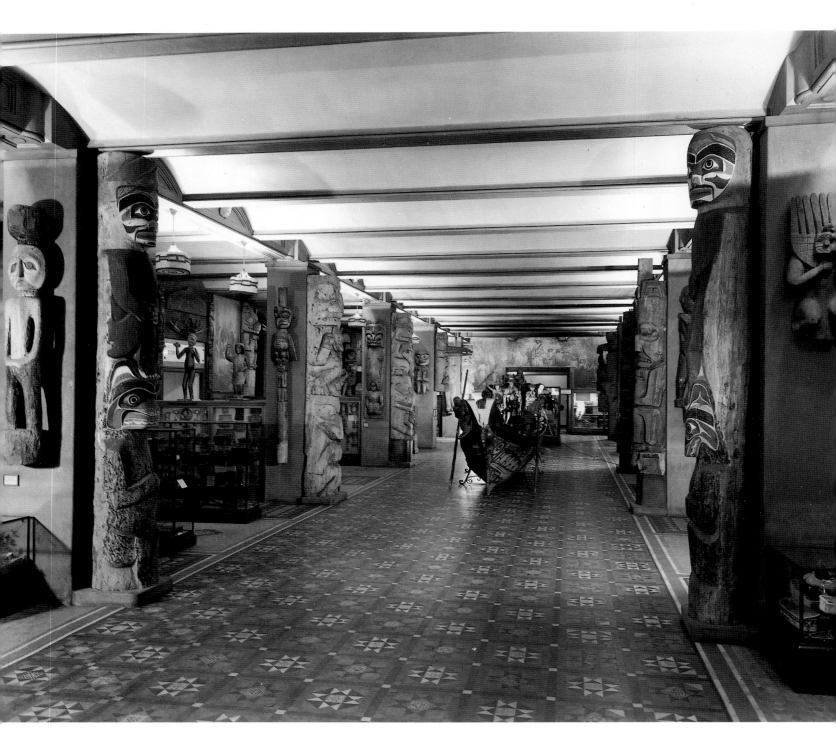

Fig. 85. American Museum of Natural History,
North Pacific Hall, 1943. *318931*

8 / The Rediscovery of Northwest Coast Art

DURING the 1920s and 1930s, it was the rare visitor who regarded the American Museum of Natural History's collection of Northwest Coast sculpture and painting as material appropriate for exhibition at an "art" museum. Despite Franz Boas's endeavors to demonstrate that primitive peoples had an aesthetic sense similar to that of "civilized" peoples, and that primitive art had significant aesthetic value, most New Yorkers at this time would have made a clear value distinction between the products of dark-skinned peoples exhibited among the dinosaurs and stuffed birds on Central Park West and the creations of whites displayed at the Metropolitan Museum. A few, surely, admired the artistry of the exquisite totem poles and delicate shaman's charms in the Northwest Coast hall, but most regarded these as "crafts" created for use by primitive peoples rather than high art made for aesthetic contemplation. These attitudes of the New York museum-going public would begin to change in the late 1930s and early 1940s with what is now considered the "discovery" of Indian art by the New York art world.

The Museum of Modern Art Exhibition

One of the first steps in this process of finally establishing Northwest Coast as a great art style was a spectacular exhibit of Indian art at the Museum of Modern Art in 1941. Two years earlier, Frederic Douglas, the curator of Indian Art at the Denver Art Museum (one of the rare art museums at the time with a creditable Native American collection), and Rene d'Harnoncourt, general manager of the Indian Arts and Crafts Board of the United States Department of the Interior, had collaborated on an exhibition of Indian art at the San Francisco International Exposition. These men then convinced the Museum of Modern Art in New York to exhibit this show in 1941 and, for the first time, a major New York City art museum displayed Indian art including several magnificent Northwest Coast carvings and paintings (Douglas and d'Harnoncourt 1941).

There was more behind the Museum of Modern Art exhibit than simply the entrepreneurship of Douglas and d'Harnoncourt, for this show was intended to support a new initiative of the federal government to publicly recognize the contributions Native Americans had made to the United States. The political ramifications of the Museum of Modern Art exhibition were indicated by the foreword to the catalogue written by Eleanor Roosevelt:

. . . this book and the exhibit on which it is based open up to us age-old sources of ideas and forms that have never been fully appreciated. In appraising the Indian's past and present achievements, we realize not only that his heritage constitutes part of the artistic and spiritual wealth of this country, but also that the Indian people of today have a contribution to make towards the America of the future (Douglas and d'Harnoncourt 1941:8)

From the time of Theodore Roosevelt's administration to the beginnings of the New Deal, the United States government had followed a policy of stifling all manifestations of tribalism. Based on the premise that Native Americans' traditional lifestyles were at odds with values of the American way—democracy, liberalism, and, especially individualism—the government encouraged Indians to assimilate white culture and abandon their traditions, especially their tribal affiliations.

By the time of the Great Depression, however, the government had begun altering its position toward Indians, and Congress passed laws preventing interference with native religious practices and encouraging tribalism (Berkhofer 1978). Douglas and d'Harnoncourt, in their introduction to the Museum of Modern Art catalog, specifically praised the federal government for having realized that the earlier assimilationist policy was "not merely a violation of intrinsic human rights, but was actually destroying values which could never be replaced" (Douglas and d'Harnoncourt 1941:9).

The Museum of Modern Art show included several special pieces from the American Museum collection that had long been on display on Central Park West. Especially impressive to the audience were the naturalistic Tlingit helmet of a man with partial facial paralysis collected by Emmons (pl. 56), and the magnificent Nootka screen of the thunderbird carrying a whale flanked by the lightning snake and the wolf (pl. 95). After museum visitors enjoyed the aesthetic pleasures of these and other Northwest Coast artworks, they could read the catalog, which expressed an attitude toward the Indians considerably different from that of Indian agent Halliday:

The old customs and crafts were discouraged by the intolerant attitudes of most of the early white settlers toward all manifestations of Indian culture. In spite of these unfavorable conditions the arts of the Northwest Coast still survive and show signs of fresh vigor. A new recognition of their value by the authorities and the public has released their dormant strength and produced work of excellent quality (Douglas and d'Harnoncourt 1941:147).

This kind of overt acceptance of the aesthetic merits of Northwest Coast art, coupled with the display of pieces owned by the American Museum of Natural History, was to signify a change in attitude toward the collections in the Central Park West institution. Now that the Museum of Modern Art, an institution clearly central to the art establishment, had accepted Northwest Coast artworks as "art," visitors could view the pieces at the American Museum with new appreciation.

Surrealists, Abstract Expressionists, and Northwest Coast Art

As the United States government promoted a more liberal and sympathetic attitude toward American Indians, and as the public grew more receptive to their art, in Europe a group of intellectuals was independently "discovering" Native American art. These were the Surrealists who, anxious to explore the inner workings of the subconscious mind behind the facade of the flesh, believed that primitive man had long been making the kind of elemental "real" art they themselves wished to create. Although they admired primitive man, the Surrealists held to an evolutionistic view of his mentality which they believed was myth-oriented, harmonious with nature, one with the spiritual domain, and psychologically closer to the earliest humans. Freud, one of their intellectual patrons, had this to say about "primitive mentality":

There are men still living who, as we believe, stand very near to primitive [i.e., prehistoric] man, far nearer than we do, and whom we therefore regard as his direct heirs and representatives . . . The savage's mental life must have a particular interest for us if we are right in seeing in it a well-preserved picture of an early age of our own development (quoted in Maurer 1984:543–44).

Because the Surrealists placed a higher value upon "primitive" mentality than on the modern mind, their version of psychological Darwinism did not have the same pejorative connotations as the social Darwinism of the cultural evolutionists. Nonetheless, they still promoted an anti-Boasian notion that primitive man was qualitatively and quantitatively different from western, civilized man.

The "primitive" peoples to whom the Surrealists looked for artistic inspiration were not the Africans who had produced the cool, monocromatic, abstracted forms so appealing to earlier generations of artists such as Picasso, but instead the Pacific Islanders and natives of North America, especially those from the Northwest Coast, who created exciting colorful and expressionistic images. In the late 1930s, a Surrealist painter, Wolfgang Paalen, went to the Northwest Coast and, smitten by the indigenous art, ended up writing an article on the subject in a special Amerindian edition of his Mexico City-based Surrealist journal, *Dyn*. Paalen wrote glowing praises of the beauty of these artworks, and interpreted them in a Surrealist fashion (Paalen 1943).

For Paalen, as for most Surrealists, primitive art was the creation of the child-like, "pre-rational" primitive mind where no dichotomy between objective and subjective reality existed, causing the individual to feel as one with the surrounding cosmos. Paalen universalized his explanation of the totem pole to include all venerated posts found throughout the world, with his suggestion that the pole is a bisexual image, "that by its very erection . . . expressed the male principle, and by its material (wood symbolizes the maternal element) the female principle. This corresponds to the archaic *complementary concept* . . . which in many religions is expressed through divinities morally ambivalent and physically hermaphrodite" (Paalen 1943:28). Paalen easily moved from bisexual imagery (which does not appear in Northwest Coast art, although he didn't mention that) to animal-human imagery (which does), implying that it, too, conveys that "archaic complementarity." In this essay, Paalen unintentionally misrepresented the meaning of Northwest Coast art in order to place it in a context, so central to the Surrealist's own artistic agenda, of a universal, collective mythology.

Paalen arrived in the New World in 1939, shortly before the outbreak of World War II, and was joined in 1941 by other important members of the Surrealist circle: André Masson, André Breton, Yves Tanguy, Kurt Seligmann, Georges Duthuit, Robert Lebel, and Max Ernst. These refugees had become acquainted with Northwest Coast art through their visits to the few Paris galleries that carried some British Columbian pieces, as well as to the Musée de l'Homme with its small collection of these artworks. Now they could see the abundant and spectacular Northwest Coast art display at the American Museum (Cowling 1978:493). Max Ernst in particular found totem poles at the American Museum fascinating, and included images of some in his totemically inspired paintings. Ernst, Breton, and others also loved to frequent the Julius Carlbach gallery on Madison Avenue, where they could purchase examples of Northwest Coast art for their private collections (Maurer correspondence).

New York City in the 1940s was an exciting artistic center for these refugee Europeans as well as for the young American artists such as David Smith, Mark Tobey, Adolph Gottlieb, Mark Rothko, and Barnett Newman, who shared the Surrealists' appreciation of Northwest Coast art. These young Abstract Expressionists found the timelessness and psychological complexity of the art from Alaska and British Columbia at the American Museum so compelling that in 1946 they persuaded Betty Parsons, the owner of an avant-garde gallery, to display a show of two-dimensional art.

Barnett Newman wrote the introductory essay to this "Northwest Coast Indian Painting" show in 1946 that included four pieces from Max Ernst's private collection, as well as sixteen from the American Museum. It is both interesting and telling that Newman chose the largely stylized and abstract two-dimensional art, rather than the more naturalistic sculptures for this exhibit. He explicitly wanted to shift the focus of appreciation of Northwest Coast art from the well-known totem pole to the "little known" painting that constitutes "one of the most exten-

sive, certainly the most impressive, treasuries of primitive painting that has come down to us from any part of the globe." Himself a painter of mystic abstractions, Newman praised the abstract yet effective portrayal in Northwest Coast art of "mythological gods and totemic monsters." He made a case for his kind of art:

There is an answer in these works to all those who assume that modern abstract art is the esoteric exercise of a snobbish elite, for among these peoples, abstract art was the normal, well-understood, dominant tradition. Shall we say that modern man has lost the ability to think on so high a level? Does not this work rather illuminate the work of those of our modern American abstract artists who, working with the pure plastic language we call abstract, are infusing it with intellectual and emotional content and who, without any imitation of primitive symbols, are creating a living myth for us in our time? (Newman 1946).

If Indians could understand an art of abstraction, why could not the citizens of the civilized western world appreciate an art analogous in style and similar in motivation created by Newman and his associates (Varnedoe 1984; Weiss 1983).

Claude Lévi-Strauss

The Surrealists and the early Abstract Expressionists interpreted the art they saw at the American Museum of Natural History according to their own artistic ideology, praising those qualities they saw in it that they strived to incorporate into their own art. There was another European who lived as a refugee in New York City during the war and shared with his artist friends an attraction for Northwest Coast art, but differed from them by appreciating the works for what they meant to the Indians, not for how they reinforced the values of modern artists. This individual, Claude Lévi-Strauss, was to become the most influential anthropologist of the mid-twentieth century.

If anyone was the intellectual successor to Franz Boas in terms of his activities on behalf of the equality of the races, it was Claude Lévi-Strauss. Born in Belgium in 1908, Lévi-Strauss was the son of an agnostic Jewish artist who brought his son up to be skeptical about religion. Although he studied law at the University of Paris, Claude Lévi-Strauss found geology far more fascinating, a parallel perhaps, to Boas's early interest in the physical sciences. Both Boas and Lévi-Strauss shared a progressive, leftist political ideology, for Boas had been a member of the Socialist party, while Lévi-Strauss maintained a sympathy for Marxism. And, when in 1937 Lévi-Strauss had the opportunity to spend five months among the natives of Brazil (he was a professor of sociology at the University of Saõ Paulo from 1934 to 1938), he discovered, as had Boas among the Eskimos, an intellectual maturity among these Indians whom he soon came to consider his peers. As a result, one theme that pervades many of Lévi-Strauss's works, and forms the centerpiece of his *The Savage Mind,* is the mental equality of all humans (Leach 1970).

Lévi-Strauss intended to prove in his writings that primitive people think in as sophisticated a manner and have as elaborate thought processes as civilized men. He did this by illustrating the universals underlying the structures with which all humans classify the component parts of the world about them and invent models to interpret reality. Humans, according to Lévi-Strauss, have invented a wide range of means to classify and understand their universe, including the creation of art. For him, the process of art production is one method of thinking, abstractly and philosophically, about the world.

When he came to New York City during the Second World War, Claude Lévi-Strauss had the opportunity to see in abundance a style of art that had tremendous intellectual depth. So utterly captivated was he by the American Museum's collections of British Columbian and Alaskan art that in 1943 he published an article in *Gazette des Beaux-Arts* on "The Art of the Northwest Coast at the American Museum of Natural History," which began:

There is in New York a magic place where all the dreams of childhood hold a rendezvous, where century old tree trunks sing or speak, where indefinable objects lie in wait for the visitor with an anxious stare; where animals of superhuman gentleness press their uplifted little paws, clasped in prayer for the privilege of constructing for the chosen one the palace of the beaver, or guiding him into the realm of the seals, or of teaching him, with a mystic kiss, the language of the frog and kingfisher (1943:175).

He goes on to praise the old-fashioned yet successful display itself in which "disused but singularly effective museographic methods grant the supplementary prestige of the *clair-obscur* of caves and of the crumbling heap of lost treasure" (Lévi-Strauss 1943:175)(fig. 85).

Lévi-Strauss simply loved Northwest Coast art, and equated it with the art of the Ancient Near East, medieval Europe, and even that of Picasso. With the sensitivity of an artist, the anthropologist suggested that the Kwakiutl masks—such as the octopus mask, with its pulleys, strings, and hinged parts—synthesize the

contemplative serenity of the statues of Chartres and the Egyptian tombs with the gnashing artifices of Hallowe'en. These two traditions of equal grandeur and parallel authenticity, of which the stands of the amusement parks and the cathedrals today dispute the dismembered shreds, reign here in their primitive and undisturbed unity. This dithyrambic gift of synthesis, the almost monstrous faculty to perceive as similar what all other men have conceived as different undoubtedly constitutes the exceptional feature of the art of British Columbia (Lévi-Strauss 1943:180).

In the middle of his poetic musings, Lévi-Strauss returns to his scholarly role and refers the reader to the Jesup Expedition publications by Boas and Swanton. Revealing great admiration for Boas, Lévi-Strauss states that "the great Franz Boas, who died a few months ago, has applied the inexhaustible resources of his analytical genius to the interpretation of the labyrinth of themes, rules and conventions of the art of the Northwest Coast," and recommends Boas's works on art to the reader (Lévi-Strauss 1943:181). It is not surprising that these two greatest anthropologists of the twentieth century would meet, so to speak, in the magnificent hall of the North Pacific Coast which the elder built and the younger one admired.

The Revival of Northwest Coast Art

When Franz Boas paid his final visit to Vancouver Island in 1930, he wrote with great sadness to his son Ernst, "I had a council with the Indians, who are really suffering because of the stupid persecution of their customs by the government. . . . It goes so far that the children in school are not allowed to draw in the traditional style of their people, but according to prescribed models" (Rohner 1969:291–92). Boas learned that despite this oppression, some remote groups had not entirely lost their old values and traditions, and indeed, continued to commission carvings to be used at furtive potlatches and winter ceremonies. During the 1940s, as European and American artists were rediscovering Northwest Coast art, some Kwakiutls living in British Columbia were becoming more open about their continued artistic productivity.

One British Columbia native who made art well into the middle of the twentieth century was Kwakiutl Mungo Martin, born in 1881 to a noble Fort Rupert family. During his 1894 visit to British Columbia, Franz Boas met this young man, who posed for his now famous photograph of the Fool dancers (fig. 47). The youthful Martin stands second to the left, his face painted with designs appropriate to the Fool dancers society.

Despite the general decline in art production in the twentieth century that resulted from the laws prohibiting rituals at which art was used and displayed, Mungo Martin had become apprenticed to his artist stepfather, Charlie James. Although Martin soon developed into an artist of some note, his carving skills could not support him and he had to work as a commercial fisherman. Few whites recognized his talents until the 1940s, when, in response to a general awakening to the aesthetic value of Indian art, several museum curators and academics realized how eminently qualified he was to restore traditional Northwest Coast art that had begun to decay. In 1947, when he was sixty-six, the University of British Columbia invited him to Vancouver to work on a totem pole restoration project and to carve some new poles for the institution's three-acre Totem Park (Duff 1981).

So successful was this project that in 1952, the British Columbia Provincial Museum brought Martin to Victoria to do similar work in Thunderbird Park. Martin's remarkable carving skill and charming personality impressed many people, and he soon became a major tourist attraction, adding considerably to the ever-increasing interest in Northwest Coast art. A local newspaper carried a story describing Martin in warm terms, and praising his artistry:

For the next three years, Victoria will probably be the only spot in North America where one can see the practise of an art that was old when Columbus discovered the continent. Moreover, it is being done in the same manner, with the same instruments, by the descendants of some of the original practitioners. Captain Vancouver may have gazed at practically the same sight that tourists are taking pictures of, this summer (Nuytten 1982:86).

In addition to his work on totem poles, Mungo Martin built a type of traditional structure that had not been erected for many decades—the large, communal house sometimes dramatically painted with crest images. On its facade, Martin painted a broad frontal face of the supernatural sea creature, Tsee'akis, whose grinning mouth swallows up all who enter and spits out all those who leave.

Mungo Martin had strong ties to the family of George Hunt. His first wife was George Hunt's granddaughter. After she died, Martin married her mother, Abayah, who was, in addition, George Hunt's daughter-in-law, Martin's son David's grandmother, and Martin's own mother-in-law. Martin's apprentice was Henry Hunt, George Hunt's grandson, and the husband of Abayah's granddaughter, who had been raised by Mungo and Abayah.* Family traditions run strong among the Northwest Coast Indian artists.

Mungo Martin's communal house was inaugurated in 1953 by the first public potlatch held on the Northwest Coast in decades. In 1951, the Canadian government had revised its Indian Act, quietly dropping from the law the prohibition against potlatching and dancing. Despite this official action, many of the older Kwakiutl invited to Martin's house-building celebration were understandably nervous, remembering friends and relatives who not long before had been jailed for participating in their traditional rituals. Some feared that the artist, by taking this bold step toward reasserting Kwakiutl pride and autonomy, had overstepped his limits with the white community. Most of these fears were allayed when on December 14, 1953, a great potlatch, attended by Indians and a few especially sympathetic whites—by invitation only—signaled the reviving of ceremonialism on the Northwest Coast.

This affair was, by all accounts, a splended integration of the traditional and the modern. Masked dancers impersonated the animals of the forest as well as the various monstrous creatures that attended the Cannibal-at-the-North-End-of-the-World, while a young Kwakiutl, dressed in red bathing trunks and fringes of shredded cedar bark, dashed about in the mad frenzy of the Hamatsa initiate. A Toogwid dancer wearing a button blanket and hemlock branch crown, after much agitated dancing, crouched and, by means of the classic Kwakiutl technique of sleight-of-hand, appeared to give birth to a large wooden frog. Speeches were made, songs sung, and a copper was displayed.

* I am indebted to Bill Holm for this information.

Although the songs, dances, and Kwakiutl speeches were all traditional, the food and the method of paying the visitors were very 1953. Since Martin's newly built house did not have cooking facilities, everyone had to go across the street to the Crystal Garden Restaurant where they feasted not on smoked salmon and fish oil, but beef stew, white rolls, apple pie, and coffee. And, instead of blankets, the guests received bags of newly minted half-dollar pieces and bright Mandarin oranges (Nuytten 1982:90–98).

After this special affair held principally for the Indians, the Provincial Museum sponsored a public opening of the house. A measure of the new fascination with Indian art and ceremonialism was the attendance; although the house held only three hundred people, two thousand whites interested in participating in this historical moment formed a line outside its doors. One of the people who did get in, James Nesbitt, later wrote: "Sitting in that big house, warmed by the open fire, the smoke in our eyes, it seemed impossible to believe it was 1953 and we were in the heart of busy Victoria. It was easier to imagine that house on some lonely beach far up the coast—one of the long, curving beaches washed by the swells of the Pacific, a beach with Indian dug-outs drawn up" (Nuytten 1982:100). Franz Boas would have been pleased with this renewed interest in the art he so admired, and how proud he would have been to see his young Fool dancer become one of the most famous Kwakiutl of the twentieth century.

Fortunately, Mungo trained his son-in-law Henry Hunt to both carve and dance, and when the Kwakiutl master died in 1962, Henry Hunt succeeded him as chief carver at the British Columbia Provincial Museum. With his oldest son, Tony, who worked with him as assistant carver, Henry Hunt continued his father-in-law's efforts to create traditional Northwest Coast artworks. Probably the most significant work by this talented father and son team was a twelve-meter totem pole carved in 1970–71 and erected in Alert Bay as a memorial to Mungo Martin. Both Indians and whites came from near and far to witness the first pole-raising celebrated in that village in almost forty years, and to sing songs and make speeches honoring a man who had done so very much to keep a splendid artistic tradition alive (Macnair, Hoover, and Neary 1980:183).

THREE years before the historic raising of Mungo Martin's memorial totem pole in Alert Bay, Willie Seaweed, another major Kwakiutl carver died. Perhaps the finest artist of his generation, this man of noble rank had been born in 1873, eleven years before the passage of the anti-potlatch bill. His name, "Seaweed," is an anglicization of the Kwakiutl "siwid," which literally translates as "paddling owner," "recipient of paddling," or "paddled to," all metaphors for a great chief to whose potlatches guests come from miles away. A profoundly conservative man who married a succession of daughters of chiefs, following the Kwakiutl tradition of enhancing one's prerogatives and consequent status through proper marriages, Seaweed raised his children in traditional fashion; he kept his son out of school and tried to arrange (unsuccessfully) the marriage of his grandson (Holm 1983).

While the Kwakiutl recognized Seaweed as a great carver, before the revival of interest in Northwest Coast art in the late 1940s, only a few whites who lived on the Northwest Coast either knew of or cared much about this artistic genius producing art under technically illegal circumstances for the entire first half of the twentieth century. One white man, however, did seek out Seaweed as part of a personal artistic quest.

In Seattle lived a young artist fascinated by the art of the British Columbia and Alaska Indians. Since his youth, Bill Holm had practically lived at the Washington State Museum (later known as the Thomas Burke Memorial Washington State Museum) on the University of Washington campus, becoming in the process an expert on Northwest Coast art. So familiar was he with the style and meaning of these complex artworks that when he was in the ninth grade, he was asked to serve as technical advisor to the seventh-graders who were producing a Northwest Coast Indian play. The Burke Museum staff was impressed by this young

man who convinced them to lend the adolescent ethnodramatists real artworks for use in their play, and who was to become the curator of Northwest Coast art at that very museum and professor of art history at the University of Washington.

Holm loved these artworks, and soon became obsessed with learning how he could create carvings and paintings similar to those he saw in glass cases and storage cabinets. How, he wondered, did the Indians create such complex and elegant designs? What were the aesthetic rules these artists followed? How could he make new artworks—not imitations of existing ones—in the traditional style? Holm studied artworks in museums, began carving in the Northwest Coast style, and learned about the ceremonial context in which these pieces were used by attending rituals from one of Franz Boas's former students, Professor Erna Gunther of the University of Washington. Understanding that this great tradition had been passed on from generation to generation by master carvers, Holm also sought out the Kwakiutl men still tenaciously holding on to their artistic legacy.

In 1953 Holm met Mungo Martin, and in 1959, traveled to the remote village of Blunden Harbour, the home of the eighty-year-old Willie Seaweed, to spend some time with this exceptionally talented man. Holm arrived in Blunden Harbour on a purse seiner with a party led by Chief Henry Speck who intended to invite the members of this village to a great feast. When they reached their destination, Speck turned off the engine and opened the door on an earlier era; with the booming voice of an experienced orator, he invited the villagers to a winter ceremony by announcing: "I have been paddling all around the world to reach the tribes for this, my purpose." As Holm then described it:

A small man stepped forward from the cluster of figures at the shore end of the rickety float. He wore a brown sweater and a cap cocked on his head. His answer to Udzi'stalis's [Chief Speck's Kwakiutl name] invitation was delivered in the same forceful style, in such a strong and resonant voice that I was surprised. He did not look the eighty-some years he was said to be. In his speech he thanked the invitors (he referred to them as warriors) for the invitation and called us into his house for refreshment, welcoming speeches, dances, and payment. This man was Willie Seaweed (Holm 1983:7).

Holm spent much time among the Kwakiutl, learning their language, practicing their dances, and studying their art.

As intrigued by the complex two-dimensional art of the northern Northwest Coast as he was by the boldly sculptural forms of the Kwakiutl, Holm then began to seek out Haida, Tsimshian, or Tlingit artists who could inform him of the proper methods of making the "northern style" art. Sadly, the northern Northwest Coast Indians had been unable to cling with equal tenacity to their artistic traditions and resist the onslaught of missionary and governmental opposition to the creation of art, and Holm found no equivalent in the north of a Mungo Martin or a Willie Seaweed.

Although Holm gave Franz Boas's writings on northern Northwest Coast art close reading, he knew, as an artist, that the German anthropologist's reconstruction of the creative process was inadequate for his purposes. Boas had provided invaluable information on how the Northwest Coast artist represented a killer whale on a circular dish, but gave no indication of the formal principles that governed the kinds of lines used, the colors applied, and the manner of organizing the numerous decorative elements in a two-dimensional design. Unable to identify a traditionally trained artist from the northern Northwest Coast region who might have been willing to educate him on these principles, Holm took it upon himself to reconstruct the formal rules of Northwest Coast art.

In 1965, Holm published his now-classic *Northwest Coast Indian Art: An Analysis of Form*, which remains the best explanation of the formal rules that govern the creation of two-dimensional Northwest Coast art. Holm's analysis of the northern two-dimensional design begins with a discussion of one of the most characteristic features of northern Northwest Coast art, the formline, an often bold and sweeping formal element much like a band that widens and narrows, that defines the constituent parts of a composition and forms the basis upon which the entire de-

sign is constructed. As Holm himself says, "to call it line only would be to minimize its importance as a formal element. The constantly varying width of the formline gives the design a calligraphic character" (1965:35). An excellent example of a formline defining an image is the Edenshaw painting of a sea lion (pl. 87).

The most frequent design unit within these formline compositions is the ovoid, a form that has been defined as either a rectangle with curved corners or a squared-off oval. Two ovoids appear in the Edenshaw sea lion, each connecting the animal's body to its flippers. Although it may be tempting to imagine the Indian artist composing his elegant formline design with its ovoid components freehand with a brush, much like the Oriental artist some compare him to, the Northwest Coast artist rarely allowed himself such freedom and instead often outlined the ovoid formlines by filling in the spaces between the ovoids with a porcupine-bristle paint brush.

Three colors, composed of pigment mixed with saliva and chewed dried salmon eggs, appear most often in two-dimensional designs: black, red, and blue or blue-green. Black, made with lignite, graphite, magnetite, or charcoal, usually dominates most artworks, and forms the primary formline that defines the major elements of the composition and forms a continuous, interconnecting web. Only the inner ovoids of joints and eye designs stand apart from this unifying grid formed by these black formlines.

Red, derived in prehistoric times from ochre and in postcontact times from Chinese vermillion, usually appears in formline designs of secondary importance, such as cheeks, hands, torso, and other body parts. Although in many examples red and black are the only colors used, sometimes blue, originally from iron minerals, perhaps celadonite (an iron silicate) (Holm, personal communication) and later from laundry bluing, is used for tertiary forms such as eye sockets, spaces between primary and secondary designs in ears, teeth, feathers, and various other fillers.

Although the ovoid is the most basic design unit in these formline compositions, other units appear with regularity as well, and include the so-called "salmon trout's head," an ovoid variant, U forms, split-U forms, S forms, as well as anatomical features such as eyes with pinched corners, brows, cheek designs, ears, tongues, hands, mammal feet, bird claws, tails, wings, and feathers. The Northwest Coast artist had to work within the constraints imposed upon him by the rules dictating the proper organization of these formlines and design units, but not infrequently displayed some individual creativity by a subtle bending of these rules, as, for example, using red for a primary formline and black for the secondary formline. One of the greatest masters of originality within traditional constraints was Swanton's and Boas's artistic informant, Charlie Edenshaw.

Another of Bill Holm's contributions to Northwest Coast art scholarship was his careful analysis of regional three-dimensional carving styles. In his reconstruction of the artistic history of the area, Franz Boas touched on the differences among the arts of the various ethnic groups on the Coast, but he did not go into this topic deeply. Bill Holm then took up the challenge to identify the formal characteristics of each tribe's sculpture of the anthropomorphic face (Holm 1972).

Perhaps the most easily distinguishable style from the entire Northwest coast is that of the Salish groups, for this southern art is typically simpler in form and less baroque in decoration than the art from more northerly peoples. The Salish face (pl. 33) tends to be a flat oval with planes defining the brow and occasionally the cheeks. Facial features include small round eyes, thin flat nose, and a mouth that does not protrude. When painted decorations on Salish art exist, they tend to have a geometric character and only infrequently exhibit the complex two-dimensional elements described above. Nootka faces (pl. 85) consist of two planes converging upon a median central line defining the nose; the facial form is often described as prism-like. The eyes on these masks are larger than those on Salish examples, and the pronounced eyebrows more clearly defined with a downward slope pointing to the central median line. Although prior to 1800, Nootkan artists used on their sculptures geometric decorations that resembled those of the Salish,

during the early nineteenth century, these painters began to use formline designs as a result of artistic influence exerted by the groups living to the north.

As one proceeds north into the area of the Southern Kwakiutl and Bella Coola, a striking change occurs in the representation of the human face. Instead of the two converging planes that define the Nootkan facial form, the Southern Kwakiutl face (pl. 74) consists essentially of a deep half-cylinder. Even more distinctive is the difference in the treatment of the eyes, which among the Nootka are simply painted or carved onto the plane defining the cheek, but which among the Kwakiutl are constructed on a bulge or an orb that is clearly separated from the facial plane by a sharp linear intersection. The facial planes around the mouth area are strongly defined as well. The Kwakiutl flamboyantly decorated these sculptures with free and exuberant applications of formline designs in colors somewhat more vivid than those used farther north. While many artworks of the Bella Coola are somewhat similar to those of their close Kwakiutl neighbors who influenced them in many regards, certain masks, such as the sun mask in plate 69, are distinctive, with a hemispherical shape, strongly sculpted, almost bulbous features, and extensive use of intense blue paint.

The sculpture of the Kwakiutl and Bella Coola tends to be painted with a more intense palette and carved with sharper transitions between planes than that of the three northernmost groups, the Tsimshian, Tlingit, and Haida. Of all the Northwest Coast tribes, the artworks of these latter three peoples are usually difficult to differentiate, for their defining characteristics tend to be extremely subtle. Tsimshian art (see, for example, pl. 94) has often been described as "classic," "refined," "elegant," and "sensitive." The transition between facial planes is smooth and rounded rather than harsh and abrupt, creating the impression of taut skin pulled over muscles and bones. The cheek area appears to be almost a truncated pyramid composed of the intersecting planes of the upper cheek, forehead, and cheek. Tlingit art (see pl. 45) has rounded faces, with indistinctly defined eye-socket area, relatively small nose, broad, open mouth with lips composed of a continuous flat band, and frequently uses a pale, greenish blue. Haida pieces, perhaps the most difficult to identify, tend to have eyesockets composed of concave ovoids, eyelids with distinct edges, and very broad brows (see pl. 93).

The Modern Northwest Coast Indian Renaissance

In the 1960s and 1970s, while Native Americans throughout the United States and Canada were experiencing a resurgence of pride in their own traditions, many young Indians on the Northwest Coast began reviving their artistic traditions, informed in part by the writings of Bill Holm. One cannot underestimate the impact these sensitive writings had on the Indian community, and on the entire renaissance of Northwest Coast art. Indeed, Holm's *Northwest Coast Indian Art: An Analysis of Form* (1965), became, in the words of one scholar, "a manual of Northwest Coast style for native artists learning the traditions of their ancestors" (Blackman 1985:36).

One of the young artists who found Holm's writings of interest was the great grandson of Charles Edenshaw, Robert Davidson of Masset. Born in 1946, this descendant of one of the greatest Northwest Coast artists had little opportunity on the Queen Charlottes to study the art of his ancestors. On these foggy islands, mention was rarely made of the past artistic triumphs of the Haida people, despite the legacy of men like Charlie Edenshaw. Most of their carvings, from spoons and boxes to the immense totem poles, had been sold years earlier to museums hundreds and even thousands of miles away. Whatever poles still stood were rotten and worm-eaten, poor indications of their prior glory. The great communal houses were forgotten. The tragic disappearance of a great tradition, lamented half a century earlier by John Swanton, was now virtually complete.

Ironically, a museum that had purchased a good many Haida treasures inspired a tentative revival of traditional art production on the Queen Charlottes. In 1953, the National Museum of Canada had published a monograph written by a curator, Marius Barbeau, entitled *Haida Myths Illustrated in Argillite Carvings*, followed four years later by *Haida Carvers in Argillite* (1957). These books made their way to the Haida villages, where many of the older men began examining with great interest the photographs of sculptures by the Skidegate and Masset masters, including Charlie Edenshaw. A resurgence of interest in their traditional art flowered among the Haida, who began coyping in argillite the illustrations in Barbeau's monographs. Unfortunately, the poorly printed, blurry photographs from which these men worked did not reveal the delicacy and details that characterized the finest argillite pieces, and their carvings, skillful as they were, could not reproduce the high quality of their models.

Robert Davidson's father urged him to work with these old men. The young man from an aristocratic family began carving argillite into model totem poles, and discovered deep pleasure in the artistic process. Like his mentors, Davidson had to work from Barbeau's published photographs, so he was taken by surprise when a resident of Masset showed him one of the few early twentieth-century sculptures still on the Queen Charlottes. Holding in his hands this old masterpiece, he could for the first time begin to understand the subtleties of his people's art. Now he began to pursue an artistic career in earnest.

In 1965, Davidson was sent to Vancouver to finish grade twelve. At the Vancouver Museum, with its displays of traditional Haida art, the youthful artist could compare his small wood and argillite totem poles to the masterful sculptures of his ancestors. Within a year after he arrived in Vancouver, Davidson had become known by several connoisseurs as an artist of note, and was asked by Eatons, a major department store, to hold public demonstrations of argillite totem pole carving. Several people, intrigued by the process and impressed by the young man's talent, placed orders for his work. They paid him eight dollars an inch, a price reminiscent of the dollar per foot paid by earlier Northwest Coast collectors of totem poles (Stewart 1979:17). At about that time Davidson met and soon became apprenticed to Haida artist Bill Reid, who was familiar with the formal vocabulary of traditional Northwest Coast art from studying art in museums.

Reid was a man of many talents. The son of a Skidegate woman, Reid had little to do with his traditional Haida culture until the 1950s, when he was in his thirties. It was at this time that Reid saw some Edenshaw carvings, and, as he later said, "the world was not the same after that" (Shadbolt 1986). Independent of Bill Holm, Reid analyzed the formal rules of artistry of his Haida ancestors, particularly Edenshaw, and created his own gold and silver jewelry and smallscale carvings. After some stimulating collaborative work with Mungo Martin on monumental sculptures, he also carved some impressive totem poles. Reid was more than ready in 1966, when he met the young Robert Davidson, to share the artistic knowledge he had been acquiring for a decade, and the two Haidas became master and apprentice.

Like his mentor, Davidson was intrigued by the silver bracelets designed by his great grandfather, Charlie Edenshaw. Fascinated by their sensitivity and fineness, Davidson soon engaged in an extensive study of the art of his ancestor, who became his artistic as well as spiritual idol. That nineteenth-century master, while working within a time-honored artistic tradition, often suffused his creations with a freshness, when he interpreted a line in a new fashion, created an unusual plastic form, or invented a slightly different animal image. As Davidson strives to incorporate original visions within the basic aesthetic vocabulary of Northwest Coast form, he thinks of his eminent ancestor: "I still marvel at all the freedom and all the creativity he has; by looking at Edenshaw's artworks I've learned to loosen up and be creative within the art form. I've learned that the only limitation I have to creativity is my own fear." The originality of a nineteenth-century artist working within a dying tradition has thus inspired a twentieth-century artist, helping revive that tradition yet freeing the artist from a too-literal adherence to formal rules.

Davidson created art for both whites and Indians; while he sold, and continues to sell, many of his prints in urban galleries to a white market, in 1969 he carved for the people of Masset the first wooden totem pole on the Queen Charlotte Islands in about ninety years. Then, in 1976, the federal agency Parks Canada commissioned Davidson to create a house front as a monument to Charles Edenshaw. Inspired by Edenshaw's carving of a chief's seat, currently in the British Columbia Provincial Museum, Davidson carved and painted an elaborate frog design on the facade. Following tradition, once the painting was complete, Davidson hosted a potlatch to fête all those who had assisted in the project (Stewart 1979:34).

In 1981, this magnificent structure was burned to the ground by the same troubled arsonist who destroyed a church, a community hall, and several vacant buildings. In his distress, and to mourn the destruction of this monument, Davidson sang a traditional Haida "crying song." As he was singing, two visions appeared to him, one of a black frog mask that symbolized the now-burnt frog painted upon the house facade; the other, of a dance to be performed by someone wearing that mask. Listening to the voice that inspired these visions, Davidson asked his brother, Reg, to carve a black frog mask with which he would dance at a public ceremony. Davidson was also inspired by the image of another mask— a brilliantly painted red mask of the Eagle Spirit—which he carved, and then hid away for months.

Although the arson attack caused Davidson to reflect on his role as a native artist in a modern community, and to withdraw temporarily from publicity, he could not be kept inactive and out of the public eye for long. One thing that had long been worrying him was the lack of relevance his art seemed to have to most Haidas, who appeared to feel little connection to their past and have little interest in reviving their traditions. Hoping to suffuse his art with communally accepted meaning, in late 1981, Davidson sponsored a great potlatch to celebrate both the bestowal upon his children of traditional Haida names and the adoption of Westcoast (Nootka) artist Joe David as his brother. Here, before over four hundred people, Davidson, his family, and friends sang, danced, orated, distributed gifts, and displayed masks, costumes, and ritual artworks that had been made expressly for this purpose (Seltzer 1984). Just as art had helped bring Robert Davidson back to his roots, so he hoped this integration of art and ritual might help revive Haida traditions for his people.

At this celebration, Davidson wore his black frog mask, and Joe David wore the bright red Eagle Spirit mask that Davidson had placed in hiding but now felt ready to display. The black frog mask, which represented the burned frog from the Edenshaw house, was visually and symbolically complemented by the dramatic Eagle Spirit, which signified to its carver "the strength we're gaining as a people, taking our rightful place in the world." After these public performances, Davidson burned the black frog mask at a private ceremony, bringing to con-

clusion the process of mourning the splendid Charles Edenshaw monument (Blackman 1985:28).

Davidson hopes to "expand the boundaries" of his culture by making public art for those peoples who live beyond the Northwest Coast. In 1986, he carved three poles—the largest being over twelve meters tall with an almost two meter base—illustrating stories of the killer whale to be erected in the PepsiCo sculpture park in Purchase, a suburb of New York City. In recent years, Davidson has created a bronze sculpture illustrating "Raven bringing light to the world," for the new National Museum of Man in Ottawa, and erected three totem poles in the atrium of the MacClean Hunter Building in downtown Toronto. In the era of the institutional collecting, wealthy philanthropists sponsored expeditions to the Northwest Coast to purchase from Indians artworks that could be sent to museums. In the 1980s, multinational corporations have joined these institutions in commissioning native artists to create new art for display in places far removed from the damp and mountainous shores of the North Pacific coast.

Robert Davidson has become an internationally renowned artist whose prints and sculptures are critically acclaimed by an audience which now fully appreciates the value of Indian art. The artist has never forgotten his roots, both cultural and artistic, and finds deep pleasure in wandering along the misty beaches of the Queen Charlottes and visiting the masterpieces of his ancestors in museums. On looking at the multitude of Haida masks on display in the cases of the North Pacific Hall at the American Museum of Natural History, Davidson is inspired to create new songs, new dances, and new artworks which will have meaning both for the modern Haida and for those people, in the artist's words, who live "beyond our boundaries."

D AVIDSON is joined by many contemporary Northwest Coast artists in reviving their traditions and discovering a welcoming marketplace for their creations. The economic value of modern Northwest Coast art is now so significant that Davidson, Bill Reid, Tony Hunt, and others were featured in an article in the *Wall Street Journal,* entitled "Northwest Indians Find Their Roots—Way Above Ground: A Totem-Pole Revival Brings Money, Pride; 'Why Let Our Culture Disappear?' " (22 Aug. 1983). After explaining the symbolic significance of these monumental carvings, the *Journal* reported that museums and corporations commission as many as ten totem poles a year from the several dozen carvers skilled at this traditional art, sometimes paying as much as $1,000 per foot. Noting that not all consumers of these magnificent sculptures understand their cultural signficance, the article quoted Tony Hunt: "Once someone wanted an actor's face carved on a totem pole. Of course, I refused. I only carve crests, and then only those I'm entitled to."

The story of Indian and white relations, begun so long ago when the first Europeans offered metal for sea otter furs, has reached a new stage of friendship and mutual respect. Corporations and private collectors acquire the creations of the new Northwest Coast artists, without questioning their aesthetic merit. And the art that for so long languished in museums is being studied with the new, appreciative eyes of an audience becoming increasingly educated on the glories of this tradition. Franz Boas would doubtless be pleased.

IN 1985, another modern Northwest Coast artist, Tsimshian Norman Tait, visited the American Museum of Natural History for several weeks while on a tour of museums that held the art of his ancestors. Although struck by many of the treasures held in the Central Park West institution, Tait found the great canoe especially impressive. Several years previously he had carved an elegant but rather small dugout canoe that proved to be highly seaworthy and now he wanted to make a really large one, like that at the American Museum. To discover how the carvers had created this immense and beautiful vessel, Tait needed to take accurate measurements and analyze in detail all its carvings, requiring that he actually enter the canoe.

Tait requested and received special permission from the Museum, and on one summer morning before the Museum officially opened, he climbed into the canoe, now in the 77th Street lobby, and wandered among the plaster manikins made seventy years earlier by Neandross under the supervision of Lieutenant Emmons. As he was measuring with scientific exactitude each dimension of the vessel, and speaking into a tape machine to record his reactions to every section of this masterpiece of artist and shipwright, two Museum janitors strolled by. Not believing what they saw, one said to the other, "Look—there's a real Indian in with those statue Indians in the big boat!" This nineteenth-century boat, one of the first acquisitions of the American Museum of Natural History from the Northwest Coast, was now the model for a contemporary Tsimshian Indian carving a new, twentieth-century canoe. After Tait returned to British Columbia on a widebody jet, carrying accurate metric measurements and a tape-recorded monologue, he retreated into his studio and began to recreate the technology and the beauty of an earlier era which was, almost magically, of this era as well and, above all, forever.

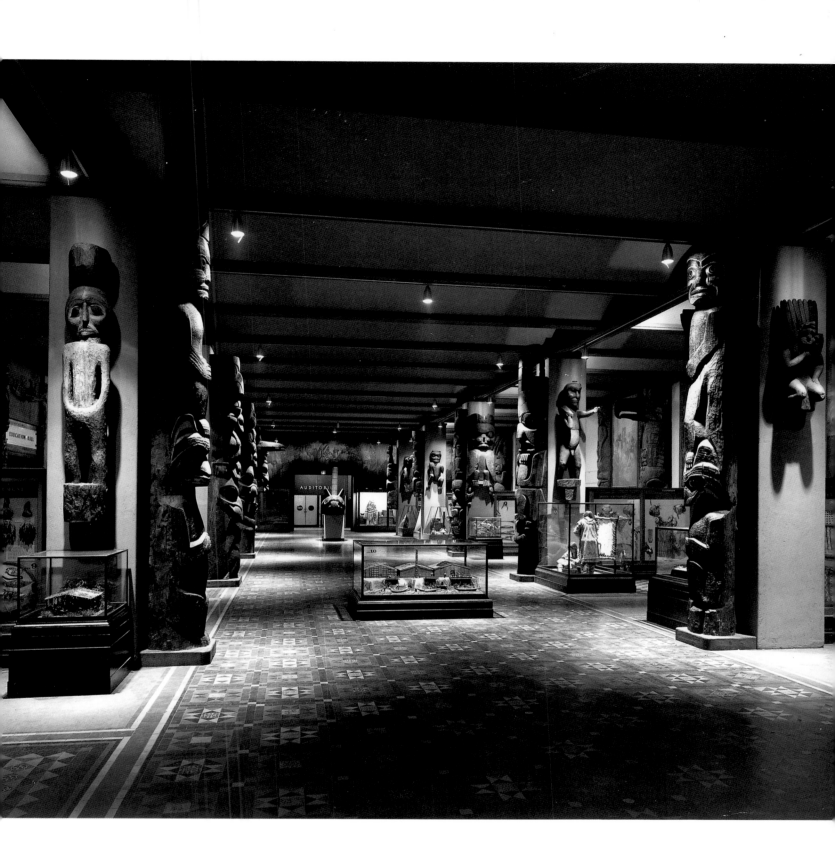

Fig. 86. American Museum of Natural History, North Pacific Hall, 1962. *328715*

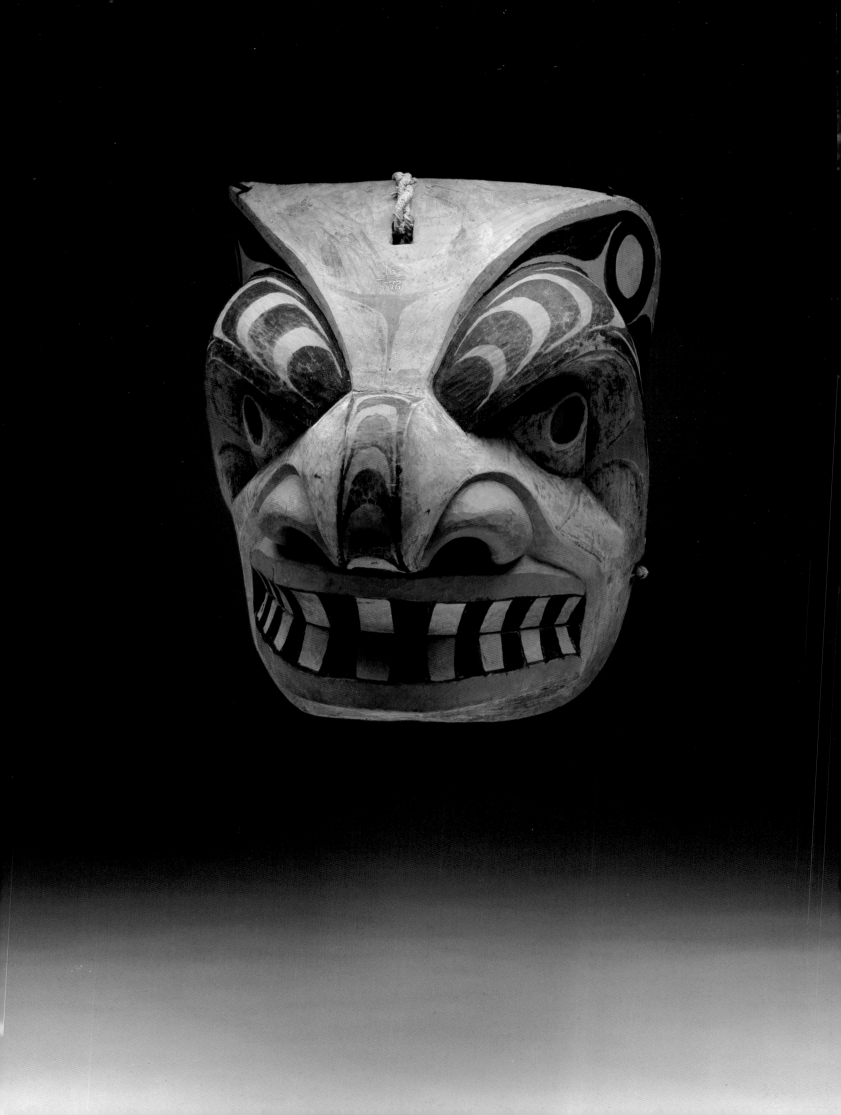

Bibliography

Arnove, Robert F.
 1980 "Introduction," in *Philanthropy and Cultural Imperialism: The Foundations at Home and Abroad,* ed. R. F. Arnove, pp. 1–24. Boston: G. K. Hall and Co.

Baird, Donald
 1965 "Tlingit Treasures: How an Important Collection Came to Princeton," *Princeton Alumni Weekly* 65:6–11, 17.

Banks, Judith Judd
 1970 "Comparative Biographies of Two British Columbian Anthropologists: Charles Hill-Tout and James A. Teit." Masters Thesis, University of British Columbia.

Barbeau, Marius
 1953 "Haida Myths Illustrated in Argillite Carvings," *National Museum of Canada Bulletin 127.*
 1957 "Haida Carvers in Argillite," *National Museum of Canada Bulletin 139.*

Bender, Thomas
 1975 *Toward an Urban Vision: Ideas and Institutions in Nineteenth-Century America.* Lexington: University Press of Kentucky.

Berkhofer, Robert F., Jr.
 1978 *The White Man's Indian: Images of the American Indian from Columbus to the Present.* New York: Vintage Books.

Berlo, Janet Catherine
 1986 "Recent Scholarship on Northwest Coast Indian Art," *American Indian Quarterly* 10:119–25.

Bickmore, Albert
 n.d. "Autobiography." Manuscript in the American Museum of Natural History archives.

Blackman, Margaret
 1976 "Creativity in Acculturation: Art, Architecture and Ceremony from the Northwest Coast," *Ethnohistory* 23:387–413.
 1981 "Windows on the Past: The Photographic Ethnohistory of the Northern and Kaigani Haida," *Canadian Ethnology Series Paper Number 74.*
 1982a " 'Copying People': Northwest Coast Native Response to Early Photography," *BC Studies* 52:86–112.
 1982b *During My Time: Florence Edenshaw Davidson, A Haida Woman.* Seattle and London: University of Washington Press.
 1985 "Contemporary Northwest Coast Art for Ceremonial Use," *American Indian Art Magazine* 10:24–37.

Boas, Franz
 1887a "Museums of Ethnology and Their Classification," *Science* 9:587–89.
 1887b "The Occurrence of Similar Inventions in Areas Widely Apart," *Science* 9:485–86.
 1894 "Human Faculty as Determined by Race," *Proceedings of the American Academy for the Advancement of Science* 43:302–27.
 1897a "The Decorative Art of the Indians of the North Pacific Coast," *Bulletin of the American Museum of Natural History* 9:123–76.
 1897b "The Social Organization and Secret Societies of the Kwakiutl Indians," *United States National Museum Report for 1895:*311–788.
 1898a "The Jesup North Pacific Expedition," *American Museum of Natural History Memoirs* 2:1–12.
 1898b "Facial Paintings of the Indians of Northern British Columbia," *American Museum of Natural History Memoirs* 2:13–24.
 1898c "The Mythology of the Bella Coola Indians," *American Museum of Natural History Memoirs* 2:25–127.
 1900 *Ethnological Collections from the North Pacific Coast of America.* Guide to Hall 105, American Museum of Natural History.

Pl. 96. Bella Coola mask representing Komokoa's wife. Talio. H 34 cm, W 29.5 cm. *Purchased from Boas before 1895. 16/772*

1901	"The Mind of Primitive Man," *Journal of American Folklore* 14:1–11.
1902	"The Development of the Department of Anthropology at the American Museum of Natural History," *American Museum Journal* 2:47–53.
1903	"The Jesup North Pacific Expedition," *American Museum Journal* 3:69–115.
1907	"Some Principles of Museum Administration," *Science* 25:921–33.
1909	"The Kwakiutl of Vancouver Island," *American Museum of Natural History Memoirs* 8:301–522.
1911	*The Mind of Primitive Man.* New York: Macmillan.
1927	*Primitive Art.* Oslo: Instituttet for Sammenlignende Kulturforskning, H. Aschehoug.
1930	"Religion of the Kwakiutl Indians," *Columbia University Contributions to Anthropology* 10. New York: Columbia University Press.
1966	*Kwakiutl Ethnography.* Edited by H. Codere. Chicago: University of Chicago Press.
n.d.	Manuscript on the Jesup North Pacific Expedition. Anthropology Department, American Museum of Natural History.

Boas, Franz, and George Hunt

| 1902–5 | "Kwakiutl Texts," *American Museum of Natural History Memoirs* 5. |
| 1906 | "Kwakiutl Texts, Second Series," *American Museum of Natural History Memoirs* 14. |

Bogart, Michele

| 1984 | "In Search of a United Front: American Architectural Sculpture at the Turn of the Century," *Winterthur Portfolio* 19:151–76. |

Boller, Paul

| 1969 | *American Thought in Transition: The Impact of Evolutionary Naturalism 1865–1900.* Chicago: Rand McNally and Co. |

Boyer, Paul

| 1978 | *Urban Masses and Moral Order in America, 1820–1920.* Cambridge, Mass: Harvard University Press. |

Bremner, Robert H.

| 1960 | *American Philanthropy.* Chicago: University of Chicago Press. |

Brinton, Daniel G.

| 1891 | "Races and Peoples: Lectures on the Science of Ethnography," *American Anthropologist* 4:36–88. |
| 1896 | "The Aims of Anthropology," *Proceedings of the 44th Meeting of the American Association for the Advancement of Science* 44:1–17. |

Brown, Thomas M.

| 1980 | "Cultural Evolutionists, Boasians, and Anthropological Exhibits: A New Look at American Anthropology, 1887–1905." Masters Thesis, Johns Hopkins University. |

Brown, William A.

| 1910 | *Morris Ketchum Jesup: A Character Sketch.* New York: Charles Scribner's Sons. |

Bryan Liz

| 1982 | *British Columbia.* Vancouver: Douglas and McIntyre. |

Cannizzo, J.

| 1983 | "George Hunt and the Invention of Kwakiutl Culture," *Canadian Review of Sociology and Anthropology* 20:44–58. |

Carlson, Roy

| 1983 | "Prehistory of the Northwest Coast," in *Indian Art Traditions of the Northwest Coast,* ed. R. Carlson, pp. 13–32. Burnaby, B.C.: Archeology Press. |

Carnoy, Martin

| 1974 | *Education as Cultural Imperialism.* New York: Longman, Inc. |

Codere, Helen

| 1966 | "Daniel Cranmer's Potlatch," in *Indians of the North Pacific Coast,* ed. T. McFeat, pp. 116–18. Seattle: University of Washington Press. |

Cohen, David, and Marvin Lazerson

| 1977 | "Education and the Corporate Order," in *Power and Ideology in Education,* eds. J. Karabel and A. H. Halsey, pp. 373–86. New York: Oxford University Press. |

Cole, Douglas
 1982 "Tricks of the Trade: Northwest Coast Artifact Collecting, 1875–1925,"
 Canadian Historical Review 63:439–60.
 1983 "The Value of a Person Lies in His *Herzenbildung*," in *Observers Observed:*
 Essays on Ethnographic Fieldwork, ed. G. Stocking. Madison: University of
 Wisconsin Press.
 1985 *Captured Heritage: The Scramble for Northwest Coast Artifacts.* Seattle and
 London: University of Washington Press.

Collins, Henry B.
 1968 "John Reed Swanton," *International Encyclopedia of the Social Sciences,*
 pp. 439–41. New York: Macmillan and the Free Press.

Cowling, Elizabeth
 1978 "The Eskimos, the American Indians and the Surrealists," *Art History*
 1:485–500.

Darnell, Regna
 1969 *The Development of American Anthropology, 1879–1920: From the Bureau*
 of American Ethnology to Franz Boas. Ph.D. dissertation, University of
 Pennsylvania.

Dexter, Ralph W.
 1966a "Putnam's Problems Popularizing Anthropology," *American Scientist*
 54:315–32.
 1966b "F. W. Putnam and the Development of Museums of Natural History
 and Anthropology in the United States," *Curator* 9:151–55.
 1970 "The Role of F. W. Putnam in the Founding of the Field Museum,"
 Curator 13:17–24.
 1974 "The Role of F. W. Putnam in Developing Anthropology at the American
 Museum of Natural History," *Curator* 19:303–10.
 1980 "F. W. Putnam's Role in Developing the Peabody Museum of American
 Archaeology and Ethnology," *Curator* 23:183–94.

Dickerson, Mary C.
 1910 "Herculean Task in Museum Exhibition: Foreword Regarding the
 Ceremonial Canoe Scene in the North Pacific Hall," *American Museum*
 Journal 10:227–28.

Dorsey, George A.
 1900 "The Department of Anthropology of the Field Columbian Museum—
 A Review of Six Years," *American Anthropologist* 2:247–65.
 1907 "The Anthropological Exhibits at the American Museum of Natural
 History," *Science* 25:584–89.

Douglas, Frederic H., and Rene D'Harnoncourt
 1941 *Indian Art of the United States.* New York: Museum of Modern Art.

Drucker, Philip
 1940 "Kwakiutl Dancing Societies," *Anthropological Records* 2.
 1951 "The Northern and Central Nootkan Tribes," *Smithsonian Institution*
 Bureau of Ethnology Bulletin 144.

Duff, Wilson
 1964 "The Impact of the White Man," *The Indian History of British Columbia* 1.
 Victoria: British Columbia Provincial Museum.
 1981 "Mungo Martin, Carver of the Century," in *The World is as Sharp as a*
 Knife, ed. D. Abbott, pp. 37–40. Victoria: British Columbia Provincial
 Museum.

Emmons, George Thornton
 1903 "The Basketry of the Tlingit," *American Museum of Natural History*
 Memoirs 3:229–77.
 1907 "The Chilkat Blanket. With Notes on the Blanket Design by Franz Boas,"
 American Museum of Natural History Memoirs 3:329–401.
 1911 "Native Account of the Meeting Between La Pérouse and the Tlingit,"
 American Anthropologist 13:294–98.
 1930 "The Art of the Northwest Coast Indians," *Natural History* 30:282–92.
 n.d. Manuscript on the Tlingit Indians. Department of Anthropology,
 American Museum of Natural History.

Ernst, Alice H.
 1952 *The Wolf Ritual of the Northwest Coast.* Eugene, Ore: University of Oregon
 Press.

Fagan, Brian M.
1984 *Clash of Cultures*. New York: W. H. Freeman and Co.

Farrand, Livingston
1900a "Basketry Designs of the Salish Indians," *American Museum of Natural History Memoirs* 2:391–99.

1900b "Traditions of the Chilcotin Indians," *American Museum of Natural History Memoirs* 4:1–54.

1902 "Traditions of the Quinault Indians," *American Museum of Natural History Memoirs* 4:77–132.

Fassett, E. C. B.
1911 "Foreword on the New Mural Paintings in the American Museum," *American Museum Journal* 11:129–37.

Feest, Christian F.
1984 "From North America," in *"Primitivism" in Twentieth Century Art*, ed. William Rubin, pp. 85–98. New York: Museum of Modern Art.

Field, Kate
1893 "Alaska Curios at the Fair," *The Alaskan*, October, pp. 1–4.

Fisher, Robin
1977 *Contact and Conflict: Indian-European Relations in British Columbia, 1774–1890*. Vancouver: University of British Columbia Press.

Fisher, Robin, and J. M. Bumstead
1982 "Editors' Introduction," in *An Account of a Voyage to the North West Coast of America in 1785 and 1786*, by Alexander Walker, pp. 7–24. Vancouver: Douglas and McIntyre.

Fladmark, Knut R.
1986 *British Columbia Prehistory*. Ottawa: National Museum of Man.

Freed, Stanley A.
1980 "The American Museum of Natural History Department of Anthropology," *American Indian Art Magazine* 5:68–75.

Freed, Stanley A., Ruth S. Freed, and Laila Williamson
1988 "Where the New World Is Revealed: At the Turn of the Century, the Jesup Expedition Probed the Siberian Roots of the American Indian." *Natural History Magazine*, Spring.

Frese, Herman Heinrich
1960 *Anthropology and the Public: The Role of the Museums*. Leiden: E. J. Brill.

Gossett, Thomas
1963 *Race: The History of an Idea in America*. Dallas: Southern Methodist University Press.

Grant, Madison
1916 *The Passing of the Great Race, or the Racial Basis of European History*. New York: Charles Scribner's Sons.

Gratacap, L.
1900 "The Development of the American Museum of Natural History," *American Museum Journal* 1:36–40.

Guédon, Marie-François
1984 "An Introduction to Tsimshian World View and Its Practitioners," in *The Tsimshian—Images of the Past: Views for the Present*, ed. M. Seguin, pp. 137–59. Vancouver: University of British Columbia Press.

Gunther, Erna
1972 *Indian Life on the Northwest Coast of North America*. Chicago: University of Chicago Press.

Haller, John
1963 *Eugenics: Hereditarian Attitudes in American Thought*. New Brunswick, N.J.: Rutgers University Press.

1971 *Outcasts from Evolution: Scientific Attitudes of Racial Inferiority, 1859–1900*. Urbana: University of Illinois Press.

Halpin, Marjorie
1981 *Totem Poles: An Illustrated Guide*. Vancouver: University of British Columbia Press.

1984 " 'Seeing' in Stone: Tsimshian Masking and the Twin Stone Masks," in *The Tsimshian—Images of the Past: Views for the Present*, ed. M. Seguin, pp. 281–307. Vancouver: University of British Columbia Press.

Hammack, David
 1982 *Power and Society in New York.* New York: Russell Sage Foundation.

Harris, Marvin
 1968 *The Rise of Anthropological Theory: A History of Theories of Culture.*
 New York: Harper and Row.

Hawthorn, Audrey
 1967 *Kwakiutl Art.* Seattle and London: University of Washington Press.

Henry, John Frazier
 1984 *Early Maritime Artists of the Pacific Northwest Coast, 1741–1841.* Seattle and
 London: University of Washington Press.

Higham, John
 1971 *Strangers in the Land: Patterns of American Nativism, 1860–1925.* New
 Brunswick, N.J.: Rutgers University Press.

Hinsley, Curtis M., Jr.
 1981 *Savages and Scientists: The Smithsonian Institution and the Development of
 American Anthropology, 1846–1910.* Washington, D.C.: Smithsonian
 Institution Press.
 1985 "From Shell-Heaps to Stelae: Early Anthropology at the Peabody
 Museum," in *Objects and Others: Essays on Museums and Material Culture,*
 ed. G. Stocking, pp. 49–74. Madison, Wisconsin: University of
 Wisconsin Press.

Hinsley, Curtis M., Jr., and Bill Holm
 1976 "A Cannibal in the National Museum: The Early Career in Franz Boas
 in America," *American Anthropologist* 78:306–16.

Holm, Bill
 1965 *Northwest Coast Indian Art: An Analysis of Form.* Seattle and London:
 University of Washington Press.
 1972 "Heraldic Carving Styles of the Northwest Coast," in *American Indian
 Art: Form and Tradition,* pp. 77–84. New York: E. P. Dutton and Co.
 1981 "Will the Real Charles Edenshaw Please Stand Up?: The Problem of
 Attribution in Northwest Coast Indian Art," in *The World is as Sharp as a
 Knife,* ed. D. Abbott, pp. 175–200. Victoria: British Columbia Provincial
 Museum.
 1982 "A Wooling Mantle Neatly Wrought: The Early Historic Record of
 Northwest Coast Pattern-Twined Textiles, 1774–1850," *American Indian
 Art Magazine* 8:34–47.
 1983 *Smoky-Top: The Art and Times of Willie Seaweed.* Seattle and London:
 University of Washington Press.

Hoover, Alan
 1983 "Charles Edenshaw and the Creation of Human Beings," *American Indian
 Art Magazine* 8:62–67, 90.

Horowitz, Helen
 1975 "Animals and Man in the New York Zoological Park," *New York History*
 56:426–55.
 1976 *Culture and the City: Cultural Philanthropy in Chicago from the 1880s to 1917.*
 Lexington: University Press of Kentucky.

Howe, Barbara
 1980 "The Emergence of Scientific Philanthropy, 1900–1920: Origins, Issues
 and Outcomes," in *Philanthropy and Cultural Imperialism: The Foundations
 at Home and Abroad,* ed. R. Arnove, pp. 25–54. Boston: G. K. Hall & Co.

Jacknis, Ira
 1984 "Franz Boas and Photography," *Studies in Visual Communication* 10:2–60.
 1985 "Franz Boas and Exhibits: On the Limitations of the Museum Method of
 Anthropology," in *Objects and Others: Essays on Museums and Material
 Culture,* ed. G. Stocking, pp. 75–111. Madison: University of Wisconsin
 Press.
 n.d. "George Hunt, Collector of Indian Specimens." Manuscript.

Jonaitis, Aldona
 1986 *Art of the Northern Tlingit.* Seattle and London: University of Washington
 Press.
 1988 "Women, Marriage, Mouths and Feasting: The Symbolism of the Tlingit
 Labret," in *Marks of Civilization: Artistic Transformations of the Human Body,*
 ed. A. Rubin. Los Angeles: UCLA Museum of Culture History.

Karabel, Jerome, and A. H. Halsey, eds.
 1977 *Power and Ideology in Education*. New York: Oxford University Press.
Kennedy, J. M.
 1968 *Philanthropy and Science in New York: The American Museum of Natural
 History, 1868–1969*. Ph.D. dissertation, Yale University.
Khlebnikov, Kyrill
 1976 *Colonial Russian-American: Kyrill T. Khlebnikov's Report, 1817–1832*.
 Portland, Oregon: Oregon Historical Society.
Kluckhohn, Clyde, and Olaf Prufer
 1959 "Influences During the Formative Years," in *The Anthropology of Franz
 Boas*, ed. W. Goldschmidt. *American Anthropological Association Memoir*
 89:4–28.
Krause, Aurel
 1956 *The Tlingit Indians*. Seattle and London: University of Washington Press.
 (Translation of 1885 text.)
Laguna, Frederica de
 1972 "Under Mount Saint Elias: The History and Culture of the Yakutat
 Tlingit," *Smithsonian Contributions to Anthropology* 7.
Leach, Edmund
 1970 *Claude Lévi-Strauss*. New York: Viking Press.
Lerman, Leo
 1967 *The Museum: One Hundred Years and the Metropolitan Museum of Art*.
 New York: Viking Press.
Lesser, Alexander
 1968 "Franz Boas," *International Encyclopedia of Social Sciences*, pp. 99–110. New
 York: Macmillan and The Free Press.
Lévi-Strauss, Claude
 1943 "The Art of the Northwest Coast at the American Museum of Natural
 History," *Gazette des Beaux-Arts* 24:175–82.
 1982 *The Way of the Masks*. Seattle and London: University of Washington
 Press. (Translation of 1975 French edition.)
Low, Jean
 1977 "George Thornton Emmons," *The Alaska Journal* 7:2–11.
MacDonald, George
 1981 "Cosmic Equations in Northwest Coast Indian Art," in *The World is as
 Sharp as a Knife*, ed. D. Abbott, pp. 225–38. Victoria: British Columbia
 Provincial Museum.
 1983a *Haida Monumental Art*. Vancouver: University of British Columbia Press.
 1983b *Ninstints: Haida World Heritage Site*. Vancouver: University of British
 Columbia Press.
 1983c "Prehistoric Art of the Northern Northwest Coast," in *Indian Art
 Traditions of the Northwest Coast*, ed. R. Carlson, pp. 99–120. Burnaby,
 B.C.: Archaeology Press.
 1984 "The Epic of Nekt: The Archeology of Metaphor," in *The Tsimshian—
 Images of the Past: Views for the Present*, ed. M. Seguin, pp. 65–81.
 Vancouver: University of British Columbia Press.
Macnair, Peter, and Alan L. Hoover
 1984 *The Magic Leaves: A History of Haida Argillite Carving*. Victoria: British
 Columbia Provincial Museum.
Macnair, Peter, Alan L. Hoover, and Kevin Neary
 1980 *The Legacy: Continuing Traditions of Canadian Northwest Coast Indian Art*.
 Victoria: British Columbia Provincial Museum.
Mark, Joan
 1980 *Four Anthropologists: An American Science in Its Early Years*. New York:
 Science History Publications.
Mason, Otis T.
 1890 "The Educational Aspect of the United States National Museum," *Johns
 Hopkins University Studies in Historical and Political Science* 48:505–19.
Maurer, Evan
 1984 "Dada and Surrealism," in *"Primitivism" in Twentieth Century Art*, ed.
 W. Rubin, pp. 535–94. New York: Museum of Modern Art.

McGee, W J
 1894 "The Citizen," *American Anthropologist* 7:352–57.
 1899 "The Trend of Human Progress," *American Anthropologist* 1:401–47.

Meyer, A. B.
 1903 "Studies in the Museums and Kindred Institutions of New York City, Albany, Buffalo, Chicago, with Notes on Some European Institutions," pp. 311–608, *Report of the U.S. National Museum for the Year Ending June 30, 1903.*

Miller, Howard S.
 1970 *Dollars for Research: Science and Its Patrons in Nineteenth-Century America.* Seattle: University of Washington Press.

Miller, Polly, and Leon G. Miller
 1967 *Lost Heritage of Alaska.* New York: Bonanza Books.

Morgan, Lewis Henry
 1877 *Ancient Society, or Researches in the Lines of Human Progress from Savagery, through Barbarism to Civilization.* [1963 ed.] New York: Meridian Books.

Muir, John
 1979 *Travels in Alaska.* Boston: Houghton Mifflin Company. (Originally published in 1915.)

Munro, Thomas
 1963 *Evolution in the Arts and Other Theories of Culture History.* Cleveland: Cleveland Museum of Art.

Neandross, S.
 1910 "Work on the Ceremonial Canoe," *American Museum Journal* 10:238–43.

Newman, Barnett
 1946 *Northwest Coast Indian Painting.* New York: Betty Parsons Gallery.

Nuytten, Phil
 1982 *The Totem Carvers: Charlie James, Ellen Neel, and Mungo Martin.* Vancouver: Panorama Publications Ltd.

Oliver, James
 1963 "Behind New York's Window on Nature," *National Geographic* 123:220–59.
 1970 "American Museum of Natural History at 100," *Nature* 225:1199–1203.

Osborn, Henry F.
 1911 *The American Museum of Natural History: Its Origins, Its History, the Growth of Its Departments to December 31, 1901.* New York: Irving Press.

Paalen, Wolfgang
 1943 "Totem Art," *Dyn* 4–5:7–39.

Porter, Charlotte M.
 1983 "The Rise of Parnassus: Henry Fairfield Osborn and the Hall of the Age of Man," *Museum Studies Journal* 1:26–34.

Rohner, Ronald
 1969 *The Ethnography of Franz Boas.* Chicago: University of Chicago Press.

Roosevelt, Theodore
 1903 *The Winning of the West.* 6 vols. New York: G. P. Putnam's Sons.

Rydell, Robert W.
 1980 *All the World's a Fair.* Ph.D. dissertation, UCLA.
 1984 *All the World's a Fair: Visions of Empire at American International Expositions, 1876–1916.* Chicago: University of Chicago Press.

Samuel, Cheryl
 1982 *The Chilkat Dancing Blanket.* Seattle: Pacific Search Press.

Seltzer, Ulli
 1984 *A Haida Potlatch.* Seattle and London: University of Washington Press.

Shadbolt, Doris
 1986 *Bill Reid.* Seattle and London: University of Washington Press.

Shapiro, H.
 1957 "The Department of Anthropology at the American Museum of Natural History." Manuscript.

Sheehan, Carol
 1981 *Pipes That Won't Smoke; Coal That Won't Burn: Haida Sculpture in Argillite.* Calgary, Alberta: Glenbow Museum.

Smith, Harlan
1899 "Archaeology of Lytton, British Columbia," *American Museum of Natural History Memoirs* 2:129–61.

1900 "Archaeology of the Thompson River Region, British Columbia," *American Museum of Natural History Memoirs* 2:401–42.

1907 "Archaeology of the Gulf of Georgia and Puget Sound," *American Museum of Natural History Memoirs* 4:301–441.

Stewart, Hilary
1977 *Indian Fishing: Early Methods on the Northwest Coast.* Seattle: University of Washington Press.

1979 *Robert Davidson: Haida Printmaker.* Seattle: University of Washington Press.

Stocking, George W.
1968 *Race, Culture and Evolution: Essays in the History of Anthropology.* New York: The Free Press.

1974 *A Franz Boas Reader: The Shaping of American Anthropology, 1883–1911.* Chicago: University of Chicago Press.

1979 "Anthropology as Kulturkampf: Science and Politics in the Career of Franz Boas," *The Uses of Anthropology,* ed. W. Goldschmidt, pp. 33–50. Washington, D.C.: American Anthropological Association.

Swanton, John R.
1905 "Contributions to the Ethnology of the Haida," *American Museum of Natural History Memoirs* 8:1–300.

1908 "Haida Texts—Masset Dialect," *American Museum of Natural History Memoirs* 14:271–812.

1917 "Some Anthropological Misconceptions," *American Anthropologist* 19:459–70.

Suttles, Wayne
1982 "The Halkomelem Sxwayxwey," *American Indian Art Magazine* 8:56–65.

1983 "Productivity and Its Constraints: A Coast Salish Case," in *Indian Art Traditions of the Northwest Coast,* ed. R. Carlson, pp. 66–87. Burnaby, B.C.: Archaeology Press.

Taylor, Will S.
1910 "Results of an Art Trip to the Northwest Coast," *American Museum Journal* 10:42–49.

Teit, James A.
1896 "A Rock Painting of the Thompson River Indians, British Columbia," *Bulletin of the American Museum of Natural History* 8:227–30.

1900 "The Thompson Indians of British Columbia," *American Museum of Natural History Memoirs* 2:163–392.

1906 "The Lillooet Indians," *American Museum of Natural History Memoirs* 4:193–300.

1912 "Mythology of the Thompson Indians," *American Museum of Natural History Memoirs* 12:199–416.

Thomas, Alan
1982 "Photography of the Indian: Concept and Practice on the Northwest Coast," *BC Studies,* 52:61–85.

Thomas, Susan J.
1967 "The Life and Work of Charles Edenshaw: A Study of Innovation." Master's thesis, University of British Columbia.

Thoresen, Timothy
1977 "Art, Evolution and History: A Case Study of Paradigm Change in Anthropology," *Journal of the History of the Behavioral Sciences* 13:107–25.

Tomkins, Calvin
1970 *Merchants and Masterpieces: The Story of the Metropolitan Museum of Art.* New York: E. P. Dutton and Co.

Trachtenberg, Alan
1982 *The Incorporation of America: Culture and Society in the Gilded Age.* New York: Hill and Wang.

Tyack, David
1977 "Centralization at the Turn of the Century," in *Power and Ideology in Education,* eds. J. Karabel and A. H. Halsey, pp. 397–411. New York: Oxford University Press.

Varnedoe, Kirk
 1984 "Abstract Expressionism," in *"Primitivism" in Twentieth Century Art*,
 ed. W. Rubin, pp. 615–60. New York: Museum of Modern Art.

Vaughan, T., and B. Holm
 1982 *Soft Gold: The Fur Trade and Cultural Exchange on the Northwest Coast*
 of America. Portland, Ore: Oregon Historical Society.

Walker, Alexander
 1982 *An Account of a Voyage to the North West Coast of America in 1785 and 1786*.
 Edited by R. Fisher and J. Bumstead. Vancouver: Douglas and McIntyre.

Wardwell, Alan
 1978 *Objects of Bright Pride: Northwest Coast Indian Art from the American*
 Museum of Natural History. New York: Center for Inter-American
 Relations and the American Federation of Arts.

Warner, Sam Bass, Jr.
 1972 *The Urban Wilderness: A History of the American City*. New York: Harper
 and Row.

Weiss, J.
 1983 "Science and Primitivism: A Fearful Symmetry in the Early New York
 School," *Arts*, pp. 81–87.

Weitzner, Bella
 n.d. "A year-by-year summary of the Department of Anthropology based on
 the Annual Reports of the American Museum of Natural History from
 1871–1912." Manuscript, Department of Anthropology, American
 Museum of Natural History.

Welter, Rush
 1962 *Popular Education and Democratic Thought in America*. New York: Columbia
 University Press.

Widerspach-Thor, Martine de
 1981 "The Equation of Copper," in *The World Is as Sharp as a Knife*,
 ed. D. Abbott, pp. 157–74. Victoria: British Columbia Provincial
 Museum.

Wiebe, Robert H.
 1967 *The Search for Order, 1877–1920*. New York: Hill and Wang.

Wike, Joyce
 1984 "A Reevaluation of Northwest Coast Cannibalism," in *The Tsimshian and*
 Their Neighbors of the North Pacific Coast, eds. J. Miller and C. M. Eastman,
 pp. 239–54. Seattle and London: University of Washington Press.

Wingert, Paul
 1949 *American Indian Sculpture: A Study of the Northwest Coast*. New York:
 J. J. Augustin.

Wintemberg, W. J.
 1940 "Harlan Ingersoll Smith," *American Antiquity* 6:63–64.

Wissler, Clark
 1942–43 "Survey of the American Museum of Natural History." Manuscript,
 American Museum of Natural History Archives.

Woodcock, George
 1980 *A Picture History of British Columbia*. Edmonton, Alberta: Hurtig
 Publishers.

Wright, Robin
 1979 "Haida Argillite Ship Pipes," *American Indian Art Magazine* 5:40–47.
 1980 "Haida Argillite Pipes—The Influence of Clay Pipes," *American Indian*
 Art Magazine 5:42–47, 88.
 1982 "Haida Argillite—Made for Sale," *American Indian Art Magazine* 7:48–55.
 1983 "Anonymous Attributions: A Tribute to a Mid-19th Century Haida
 Argillite Pipe Carver, the Master of the Long Fingers," in *The Box of*
 Daylight, ed. B. Holm, pp. 139–42. Seattle: Seattle Art Museum and
 University of Washington Press.
 1986 "The Depiction of Women in Nineteenth Century Haida Argillite
 Carving," *American Indian Art Magazine* 11:36–45.

Wyatt, Victoria
 1978 "A Study of C. F. Newcombe's Haida Collection for the Field Columbian
 Museum, 1900–1906." Manuscript.
 1984 *Shapes of Their Thoughts: Reflections of Culture Contact in Northwest Coast*
 Indian Art. Norman: University of Oklahoma Press.

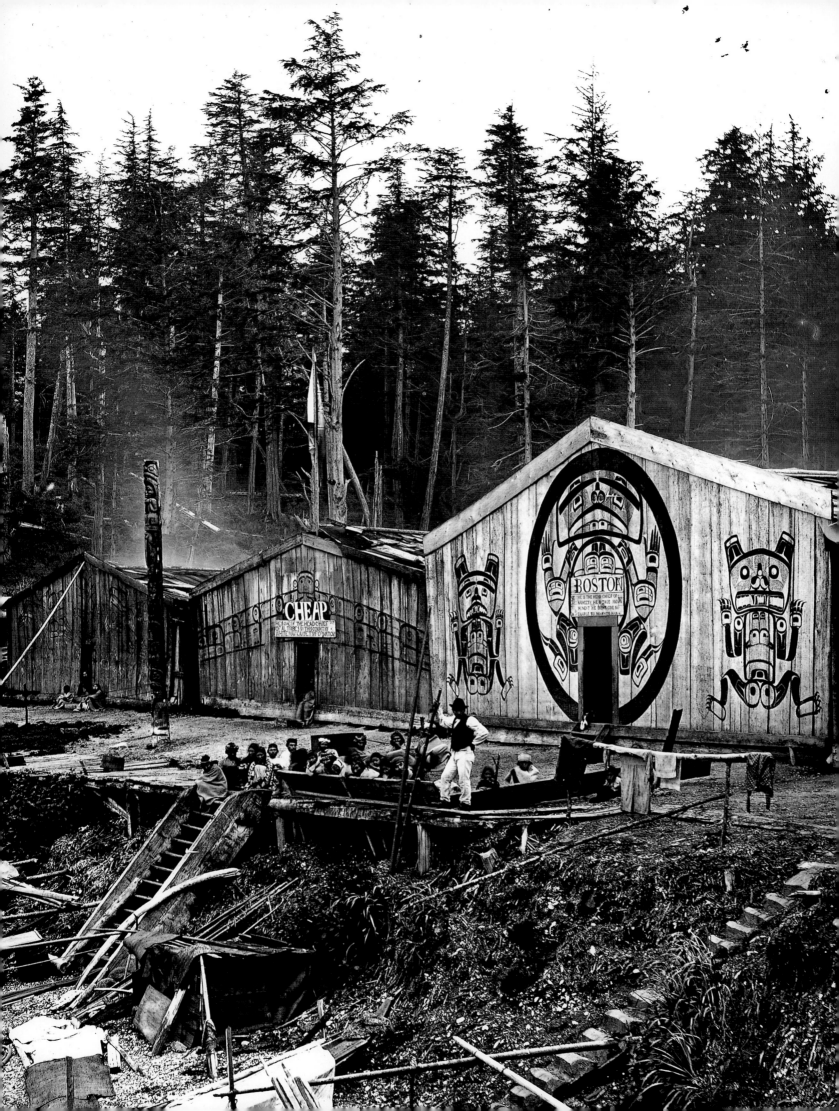

Acknowledgments

T HERE are numerous individuals whose help I wish to acknowledge here. I especially thank Stanley A. Freed, Curator of American Ethnology at the American Museum of Natural History. It was Dr. Freed who first encouraged me to pursue this project, who supported my efforts to write the book, and who carefully read over several drafts of the manuscript. My debt to Dr. Freed extends far beyond the writing of this particular work, for throughout my professional career, he has been immensely helpful as my intellectual mentor.

Another person to whom I am extremely grateful is Bill Holm, Professor Emeritus at the University of Washington. Professor Holm is without a doubt one of the most generous individuals in the field of Native American art. He is always willing to answer questions, provide information, and share his dazzling knowledge with anyone interested in Indian art. Professor Holm took time from his busy schedule to read and comment on this manuscript in his usual extraordinarily thorough fashion.

Another scholar who read the entire text is Douglas Cole, Professor of History at Simon Fraser University. Dr. Cole has devoted much of his recent professional career to the study of Northwest Coast Indian artifact collecting, and I am very appreciative of his detailed and critical reading of this manuscript. He has also been very generous with information and with his own translations of Boas's writings.

Several people generously read and commented on sections of the text: Jean Low read the section on George Emmons; Evan Maurer of the University of Michigan Museum of Art read parts of the last chapter, as did Katie Pasco. I thank them for their input and assistance. Ira Jacknis, in addition to being very generous with information and unpublished manuscripts, kindly read the sections on Boas. However, I, of course, take full responsibility for any errors in the text.

I wish to give special thanks to an extraordinarily helpful person, Robert Davidson. Mr. Davidson made time in his active art schedule for several interviews. In addition, he very graciously read the section of the text that described his artistic development as well as his work.

Since this book concerns the American Museum of Natural History, there are many individuals at that institution who assisted me in its production. Several people in the Department of Anthropology were especially helpful. Anibal Rodriguez was, as always, an immense help in locating objects, transporting them to the photographer, and finding information on them. Judith Levinson did an excellent job restoring the objects that were photographed. Geraldine Santoro did very thorough and expert archival work and research. Others who provided tremendous help were Stuart Rockefeller, Belinda Kaye, and Barbara Conklin.

I would like to thank other members of the Museum staff and their affiliates. Rick Sheridan provided excellent advice on the photographs. Douglas Preston, Colleen Mehegan, and Marc Breslav of *Natural History* magazine facilitated the actual production of this book. Jim Torok created the map and Carol Tucker prepared the index.

There are a great number of individuals who provided useful information during my research, and answered numerous questions. These include Norman Teit, Carol Ivory, Marvin Cohodas, Margaret Blackman, Nancy Tomes, Wilbur Miller, Stephen Catlett, Michele Bogart, Barry Herem, Robert W. Rydell, and Curtis Hinsley. Barbara Scanlon and Marilyn Strange helped greatly with the numerous correspondences concerning this book.

Detail of back endpaper, Kwakiutl village of Newitti

My work at other institutions was facilitated by the helpful staff members I dealt with. These included A. B. Isaac of the Peabody Museum at Harvard, Bill McLennan of the University of British Columbia Museum of Anthropology, Linda Ziemer of the Chicago Historical Society, H. Thomas Hickerson of Cornell University, Cammie Naylor of the New York Historical Society, and Dan Savard of the Provincial Museum in Victoria.

I also thank Steve Myers whose exquisite photographs have enhanced this book. Both Mr. Myers's photography and my own research were supported by a generous grant from the National Endowment for the Humanities.

I am grateful to all the outstanding professionals at the University of Washington Press. Special thanks go to Naomi Pascal, Audrey Meyer, and Marilyn Trueblood.

Finally, I would like to express my deepest appreciation for the emotional support, intellectual guidance, and confidence given to me by my husband, Gene Lebovics. I simply could not have written this book without his loving help.

Index

Nootka: fur trade, 20; invitation to Europeans, 26; stories of cannibalism, 28; Whaler's Washing Shrine, 182–84. *See also* Northwest Coast Indians

Northwest Coast Hall. *See* Hall of North Pacific Peoples

Northwest Coast Indian art: European impressions of, 28–29; effect of fur trade on, 30; Emmons collection of, 87; and evolutionism, 209–12 *passim*; acceptance in the art world, 237–38; exhibition of, at Museum of Modern Art, 237–38; effect on Surrealism, 238–39; effect on Abstract Expressionism, 239–40; revival of, 241–43, 247; loss of "northern style," 244; analysis of, by Bill Holm, 244–46

Northwest Coast Indians: arrival in North America, 17; prehistoric culture of, 17–18; and stories of cannibalism, 28; and smallpox epidemic, 49; and tourist trade, 78–79. *See also* Costume; *individual groups*

Northwest Tribes Committee, 129

Olmsted, Frederick Law, 59
Osborn, Henry Fairfield, 217–218

Paalen, Wolfgang, 239
Peabody, George, 116
Peabody Academy of Science. *See* Peabody Museum of Salem
Peabody Museum of American Archaeology and Ethnology, 116
Peabody Museum of Salem, 116
Pérez, Juan, 20
Pérouse, Jean François de la, 26
Philadelphia Centennial Exhibition. *See* Centennial Exhibition
Philanthropy: in education, 58–59
Photography: on Northwest Coast, 82–85, 152, 171
Pidcock, R. H., 173
Plunkitt, G. W., 69
Population: decimation of Indian, 49–50
Potlatch, 18, 21, 74; effect of fur trade on, 30; as symbol of wealth, 37, 42; attempts to eradicate, 52; law prohibiting, 53–54, 124–25, 229; Kwakiutl, 136–38; for Myth House, 204; "Christmas Tree," 229–31 *passim*; revival of, 242–43
Powell, Israel Wood, 52, 72–73, 82
Powell, John Wesley, 126, 131
Powell-Bishop Collection, 74, 77, 81–82
Princeton-*New York Times* Expedition to Alaska, 92–93
Princeton University, 92–93, 112
Prostitution. *See* Social problems
Putnam, Frederic Ward: work with Emmons, 112; background, 115–16; and World's Columbian Exposition, 116–20; and Field Museum, 121; position at AMNH, 121; friendship with Boas, 122; use of display models, 135

Queen Charlotte Islands, 12, 21, 42, 46, 49, 163; John Swanton on, 197; revival of art on, 246–49
Quileute, 191
Quinault, 191

Racism, 47. *See also* Craniometry; Evolutionism
Realism: in Northwest Coast art, 110
Reid, Bill, 247
Relief carvings, 11
Religion: and Northwest Indians, 51–53, 93, 126
Religious communities, 52
Ridley, Bishop William, 52
Roosevelt, Eleanor, 237
Roosevelt, Theodore, Sr., 57
Rothko, Mark, 239
Russian-American Company: and New Archangel uprising, 22; fur trade monopoly, 22; seizure of, by Gen. Davis, 48
Russians in Alaska, 20, 22, 45, 48

St. Elias, Mount, 92–93
Schwatka, Frederick: on Princeton-*New York Times* Expedition, 92–93
Science: evolutionism debate in, 126–27
Seaweed, Willie, 243
Seligmann, Kurt, 239
Seton-Karr, Heywood: on Princeton-*New York Times* Expedition, 92–93
Shakerism, 191
Shamanism: attempts to eradicate, 52; missionaries and, 93
Shamans: and Princeton-*New York Times* Expedition, 91, 93; cures by, 94–95; and witches, 95–96, 104; costumes of, 96–97; charms and masks, 102; masquerade, 104; graves, 105; art collection at AMNH, 106
Shaughnessy, Arthur: arrest for potlatch participation, 229; completion of totem poles, 232
Shrines: Nootka Whaler's Washing Shrine, 182–84
Siberia, 17, 154–55, 156–57
Sigai (Haida chief), 44
Sisiutl, 149
Sitka, 21, 22, 48
Skidegate village, 42, 83, 85, 198
Skiff, Frederick J. V., 121
Smallpox: 1862 epidemic of, 49
Smith, David, 239
Smith, Harlan, 160–61, 193, 197; conflicts in the field, 195; discovery of petroglyphs, 196; returns to Northwest Coast, 221, 226. *See also* Jesup North Pacific Expedition
Smithsonian Institution: display of Indian art, 54, 135; World's Columbian Exposition display, 119; debate with Boas, 126–28; re-creation of Winter Ceremonial, 150; mentioned, 113
Social Darwinism. *See* Evolutionism

Social problems: alcoholism, 48; prostitution, 48; immigrants and impoverished, 59–60; suppression of traditional ways, 198
Speck, Henry, 244
Spitzka, Edward, 131
Starr, Frederick, 115
Strange, James, 28
Stuart, Robert, 63
Surrealism: and "primitive art," 238–39
Swanton, John, 112, 197; linguistic studies, 198; and Jesup Expedition, 198–99; dislike for collecting, 198–200; acquisition of carved models, 204

Tait, Norman, 250
Tamanawas: law against, 53
Tanguy, Yves, 239
Taylor, Will S., 221–23
Teit, James, 160–61, 186–90 *passim. See also* Jesup North Pacific Expedition
Terry, James, 87, 115
Thompson River Indians: publications on, by Teit, 187–88, 190; mentioned, 186. *See also* Northwest Coast Indians
Tlingit, 18; New Archangel uprising, 22; relations with George Emmons, 89–92 *passim*; Hudson's Bay Company attack, 92; shamans, 93–106 *passim*; belief in witches, 95–96; Emmons Collection of, art, 106–13 *passim. See also* Northwest Coast Indians
Tobey, Mark, 239
Toogwid, 147
Totem poles, 11; as symbols of wealth, 37; scarcity of, 226; in Hall of North Pacific Peoples, 229, 232; pole-raising ceremony, 243
Trade. *See* Fur trade
Trustees, AMNH, 60, 67–68, 108, 121
Tsaxwasap: owns Whalers' Washing Shrine, 182
Tsibasa (Tsimshian chief), 42

UNESCO, 12
U.S. Government: attitude toward Indians, 238
U.S. National Museum. *See* Smithsonian Institution
Uprising: New Archangel, 22

Vancouver, Capt. George, 26
Vancouver, B.C., 11, 17
Vaux, Calvert, 61
Veniaminof, Ivan, 48
Victoria, B.C., 11, 46, 48–49

Walker, Alexander, 38
Warrior Society, 147
Whalers' Washing Shrine, 182–84
Wiah (Haida chief), 43, 50
Winter Ceremonial, Kwakiutl: description of, 140–49 *passim*; re-creation at Smithsonian Institution, 150; raid on, by Canadian officials, 173; masks worn at, 191
Wissler, Clark, 216, 218
Witches: in Tlingit belief, 95–96, 104
Wolfe, John David, 60
Women: status of Northwest Coast Indian, 26, 27; and marriage, 51
Wood. *See* Jesup Collection of North American Woods
World's Columbian Exposition: Emmons Collection, 108, 110, 112, 119; description of, 116–20

Yakutat, 21, 92

Library of Congress Cataloging-in-Publication Data

American Museum of Natural History
 From the land of the totem poles.
 Bibliography: p
 Includes index.
 1. Indians of North America—Northwest coast of North America—Art—Collectors
and collecting—History. 2. American Museum of Natural History—History. I. Jonaitis,
Aldona, 1948– . II. Title. E78.N78A45 1988 704'.03970975'07401471 87–21677
ISBN 0–295–97022–7 pbk.

Canadian Cataloguing in Publication Data

American Museum of Natural History.
 From the land of the totem poles.

 Co-published by The American Museum of Natural History.
 Bibliography: p
 Includes index.
 ISBN 0–88894–719–4 (pbk.)
 1. Indians of North America—Northwest coast of North America—Art—Collectors
and collecting—History. 2. American Museum of Natural History—History.
I. Jonaitis, Aldona, 1948– . II. Title.
E78.N78A45 1988 704'.0397074'01471 C87–091536–3

Aldona Jonaitis is director of the University Museum and adjunct professor of anthropology at the University of Alaska, Fairbanks. She has published widely on native art of North America, and is the author of *Art of the Northern Tlingit* (1986) and *Chiefly Feasts: The Enduring Kwakiutl Potlatch* (1991).

Stephen Myers is a freelance photographer and conservationist whose photographs have appeared in *Esquire, Harper's, Fortune, New York Magazine,* and *Natural History* magazine, among other publications.

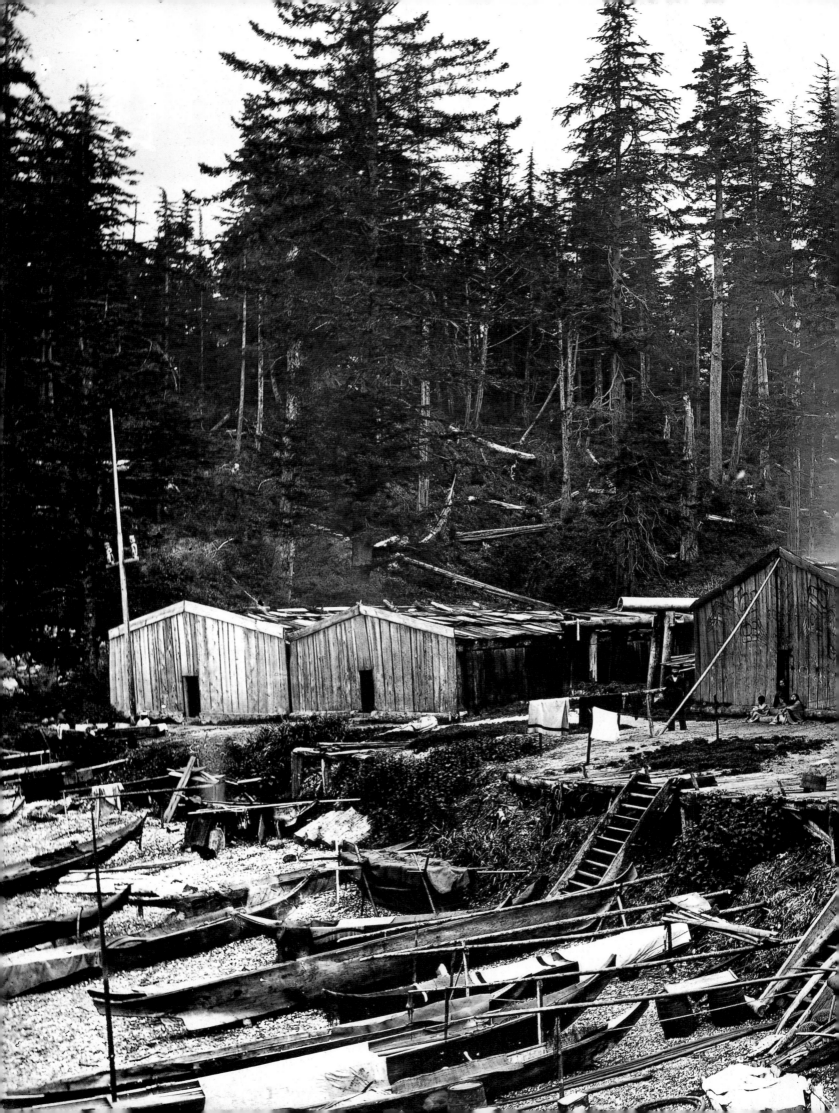

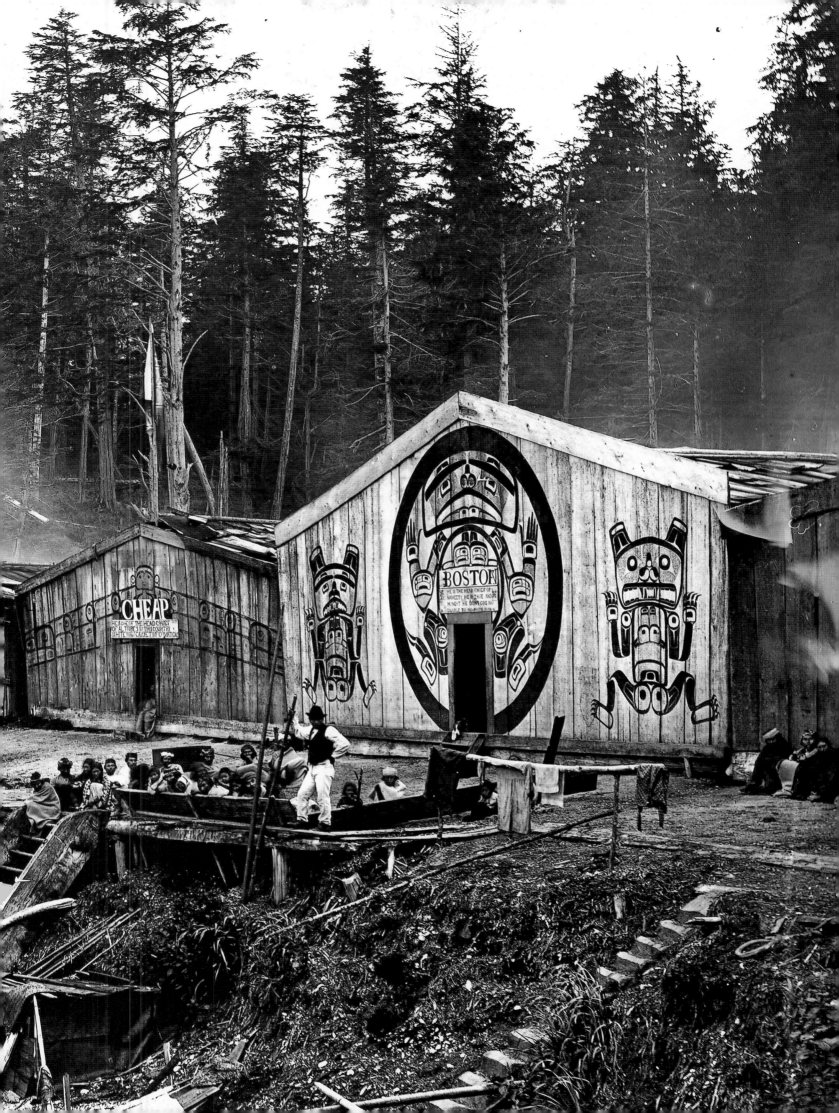